Sandy,
Sandy,
t'en
de souviens-tu
cette cravate
chenille !

ADLAN
amb
d'aquella
Sert i Prat
al "mas"
de Mont-Roig
amb tots
els tots
pagesos

ALEXANDER CALDER
JOAN MIRÓ

LENDERS TO THE EXHIBITION

Mr. and Mrs. William Acquavella

Addison Gallery of American Art, Phillips Academy,
 Andover

Albright-Knox Art Gallery, Buffalo

The Art Institute of Chicago

The Eli and Edythe L. Broad Collection

Calder Family

Calder Foundation, New York

Carnegie Museum of Art, Pittsburgh

Centre Georges Pompidou, Paris, Musée National
 d'Art Moderne

Cincinnati Art Museum

Colección Cisneros, Caracas

Collection Ernst and Hildy Beyeler

Collection of Samuel and Ronnie Heyman

Collection Larock-Granoff

Collection Francis Lombrail

Ulla Dreyfus-Best

The Engle Family

Hans Erni

Aaron I. Fleischman

Fondation Beyeler, Riehen/Basel

The Fukuoka Art Museum Collection, Japan

Fundació Joan Miró, Barcelona

Milly and Arne Glimcher

Guggenheim, Asher Associates

Hirshhorn Museum and Sculpture Garden,
 Smithsonian Institution, Washington

Honolulu Academy of Arts

Ruth P. Horwich

IVAM, Instituto Valenciano de Arte Moderno,
 Generalitat Valenciana

Kimbell Art Museum, Fort Worth

Kokaido Gallery, Tokyo

Kukje Gallery, Seoul

Kunsthaus Zürich

Kunstmuseum Bern

Kunstmuseum Winterthur

Kunstsammlung Nordrhein-Westfalen, Düsseldorf

MACBA Museu d'Art Contemporani
 de Barcelona

Werner and Gabrielle Merzbacher

Moderna Museet, Stockholm

Museo Nacional Centro de Arte Reina Sofía, Madrid

Museo Tamayo Arte Contemporáneo,
 CONACULTA/INBA, Mexico City

Museum of Fine Arts, Boston

Museum Ludwig, Cologne

The Museum of Modern Art, New York

Helly Nahmad Collection

Národní Galerie, Prague

National Gallery of Art, Washington

New Orleans Museum of Art

Öffentliche Kunstsammlung Basel, Kunstmuseum

Philadelphia Museum of Art

The Phillips Collection, Washington, D.C.

Private collection, courtesy Caratsch de Pury &
 Luxembourg, Zurich

Private collection, courtesy Guillermo de Osma
 Galería, Madrid

Private collection, courtesy Phyllis Hattis Fine Arts,
 New York

Private collection, courtesy Proarte, Mexico City

O'Hara Gallery, New York

Scottish National Gallery of Modern Art, Edinburgh

Jon and Mary Shirley

Joan Margot Smith

Solomon R. Guggenheim Museum, New York

Staatsgalerie Stuttgart

Tate, London

The Tehran Museum of Contemporary Art

Toledo Museum of Art

University of California, Berkeley Art Museum

The University of Iowa Museum of Art, Iowa City

Wadsworth Atheneum Museum of Art, Hartford

Whitney Museum of American Art, New York

Hansjörg Wyss

Yale University Art Gallery, New Haven

Other lenders who wish to remain anonymous

MIRÓ, MIROIR
MIROMESNIL
ET TOUT ça
C'EST MIRÓ

~Sandy

CALDER
MIRÓ

EDITED BY
ELIZABETH HUTTON TURNER AND OLIVER WICK
PHILIP WILSON PUBLISHERS IN COLLABORATION WITH
THE PHILLIPS COLLECTION AND
FONDATION BEYELER

Calder, Miró illuminates the friendship between two of the most visionary artists of the twentieth century and reveals how this dialogue led to new vocabularies in modern art. At Ford Motor Company, we are proud to support a project that pays tribute to an extraordinary collaboration between two important innovators.

Ford is committed to supporting the creativity and collaboration that leads to new ideas. The partnership between Alexander Calder and Joan Miró demonstrates the important innovations that can come from lifelong exploration and discourse. These are the same qualities we honor at Ford.

Ford is proud to support the only U.S. presentation of this exhibition and to continue its partnership with The Phillips Collection, which has included the presentations of *Degas to Matisse: Impressionist and Modern Masterworks from The Detroit Institute of Arts* and *Impressionists on the Seine: A Celebration of Renoir's "Luncheon of the Boating Party."*

Ford congratulates The Phillips Collection for bringing this vibrant exhibition to the nation's capital for the enjoyment of visitors from all over the world.

William Clay Ford, Jr.
Chairman and Chief Executive Officer
Ford Motor Company

CONTENTS

FOREWORD

Alexander S.C. Rower,
Emilio Fernández Miró, and Joan Punyet Miró

Recently, a small treasure that Calder gave to Miró was discovered in Barcelona at the Parellada Foundry: a jawbone of some long-deceased animal with Calder's incised words, "Hoy/a Casa de Calder" (figs. 137, 138). Miró was surely delighted by Calder's affectionate gesture, for he incorporated a cast of the jawbone into one of his own bronze sculptures. This work, *Maternité*, 1969 (fig. 136), is a symbol of their long and harmonious relationship.

Their first meeting was in December 1928: Miró showed Calder a large Spanish Dancer collage at the Montmartre studio, and Calder, in turn, invited Miró to a performance of the *Cirque Calder*. Immediately responding to each other's sensibilities, our grandfathers struck up a friendship that lasted their entire lives. They championed each other's art, exchanged many works over the years, and celebrated birthdays as well as exhibition openings together. Visits between our families were happy occasions, as Calder and Miró could always be counted on to trade jokes and stories. The vigorous personalities of the two were compelling – when we found ourselves in their midst the intensity was undeniable. Their bonhomie survives even today as the succeeding generations of their families, despite living on separate continents, have continued to work closely together and support each other's diverse projects. And our own reunions, like Calder and Miró's, are eagerly anticipated and not entirely antic-free.

While other exhibitions have shown Calder's and Miró's work side by side, the present show is unprecedented in its breadth and scope. We appreciate the great efforts of Elizabeth Hutton Turner and Oliver Wick, who have brought together so many masterpieces. Their exhibition skillfully demonstrates the fond and inspired connection between the artists.

PREFACE AND ACKNOWLEDGMENTS

Ernst Beyeler and Jay Gates

From Miró, Calder *to* Calder, Miró

The exhibition *Miró, Calder,* on view at the Galerie Beyeler in the winter of 1972–1973, was a highly memorable event. Apart from the many thematic exhibitions we mounted in our venerable townhouse on Bäumleingasse, such focused juxtapositions brought intriguing and surprising visual challenges. Not only did common ground between the artists become apparent, but their works mutually augmented each other thanks to the specific qualities intrinsic to each. Naturally I was aware of the close friendship that existed between Joan Miró and Alexander Calder, although my own acquaintance with them was no more than fleeting and sadly, I was not able to collaborate directly with them or arrange a monographic exhibition for either of them. My real contacts were their longtime dealers, Aimé Maeght, Pierre Matisse, and Klaus Perls, and we were able to make acquisitions from them and from private collectors rather than from the artists themselves.

Individual works by Miró and Calder became available at Galerie Beyeler in the late 1950s, a circumstance in which my contacts and business relations with G. David Thompson of Pittsburgh played a not unimportant role. By 1956 I was attracted by Miró's poetic charm and acquired a first, at that time contemporary work, *The Star Rises, the Birds Fly Away, the Figures Dance,* 1954 (Dupin 974), from Galerie Maeght in Paris. A year earlier we had already been able to take on consignment a wonderful picture from the collection of Gustav Zumsteg, the great Swiss Miró aficionado (*The Bird Flies Off to Where Down Grows on the Gold-Rimmed Hills,* 1950, Dupin 887), and soon a further acquisition from a Swiss private collection (*Hair Disheveled by the Fleeing Constellations,* 1954, Dupin 968) would underscore our preference for the powerful personal symbolism of the painterly Miró. This superb *peinture* was not only capable of holding its own alongside the earlier modern classics – Bonnard, Braque, Degas, Kandinsky, Klee,

Léger, Monet, Picasso, Renoir, and Rouault – but also introduced refreshing accents to our exhibitions of "Maîtres de l'art moderne," held annually from 1955. Miró was regularly represented, starting in 1956 with an early work from the mid-1920s, the erotic *Painting (The Lovers – Adam and Eve)*, 1925 (Dupin 132).

The first work by Calder listed in our inventory was a mobile executed around 1945, *Fourteen Leaves and Two Discs*, which was acquired from the Calder exhibition mounted by Arnold Rüdlinger at the Kunsthalle Basel in 1957. This was followed a year later by an early woodcarving of 1927 from the Thompson Collection and a further Miró with spare motifs set dramatically against a dark ground (*The Morning Rain in Moonlight*, 1947, Dupin 814). In 1959 a group of Miró's collages on sandpaper (Dupin 446, 450, 458) came to the gallery from the same source, followed in 1960 by one of the finest *Paintings* based on collages (cat. 112). This work, then under the title "Constellation," traveled as a Miró highlight with the Thompson Collection from Zurich to Düsseldorf, The Hague, New York, and Turin.

The Calder-Miró connection was also indirectly addressed in 1961 in our show of artists' carpets by Marie Cuttoli, and in the sale of her collection through Galerie Beyeler, in which such key works as Miró's *The Siesta*, 1925 (Dupin 119), and his poetic *Painting-Object* (cat. 102) were compellingly juxtaposed with early Calders, such as the mobile *Poisson*, ca. 1939, further sharpening our eye to the intrinsic relationships between the two artists' work. Until the *Miró, Calder* show, only one work by each had found its way into our own private collection. In 1961 we retained Calder's stabile-mobile *Les Abattis* (cat. 62) from the Constellations series, which ever since has had its permanent place on the window sill of my wife's office in the gallery. This purchase was supplemented exactly ten years later by the acquisition of Miró's small picture *The Sun's Embrace of the Woman in Love*, 1952 (Dupin 914), which would form the beginning of the Miró collection in the future Fondation Beyeler. Then came *Composition (Small Universe)* (cat. 106), the superb gouache in pure colors that adorned the cover of the *Miró, Calder* catalogue. *Painting* of 1930 (cat. 99), in the same show, remained with the gallery long after the exhibition ended, and so we eventually secured it for our own collection.

Our other Mirós were not acquired until very much later, around 1990, when the plan to establish our own museum had matured. We took advantage of the art market when treasures that had been cherished during a lifetime of collecting suddenly appeared in rapid sequence in the trade. In 1990 we acquired *Painting (Personage, The Fratellini Brothers)* and *Spanish Dancer* (cats. 96, 139) for the Fondation Beyeler collection, followed in 1993 by the monumental bronze cast of *Moon Bird*, and finally, in 1996, by *Landscape (Landscape with Rooster)* (cat. 90).

The case was entirely different with Calder, whose playful charm we had long been unable to resist. As early as 1972 we acquired *Untitled* (cat. 40), a filigree stabile-mobile for my desk, and a *Mobile* of 1962 for our home, where, together with *Critter bleue assise*, 1974, it still exudes joie de vivre. On the other hand, we had to wait patiently until 1989 to obtain Calder's *The Tree*, 1966, which we envisaged as a sculptural focal point for the planned museum park. And despite the acquisition of *Otto's Mobile*, 1952, we still cannot say that all of our wishes regarding the Calder collection have been fulfilled.

Against this background, the idea of responding to the early *Miró, Calder* exhibition after just over thirty years with *Calder, Miró* seemed extremely appealing. We are very much obliged to The Phillips Collection in Washington, its director, Jay Gates, and senior curator, Elizabeth Hutton Turner, who initiated the project, for the trust they have shown by selecting the Fondation Beyeler as the European venue for the exhibition. We also wish to thank them for the suggestion that we contribute, as a partner, to the conception of this complex undertaking. It provides another opportunity to cast a discerning eye on the artists' unusual friendship and, at the same time, to display once again a number of masterpieces that passed through our hands many years ago (cats. 54, 81, 88, 112, 118).

An Early Pairing by Duncan Phillips

It has been a great pleasure for The Phillips Collection to be a partner with the Fondation Beyeler on *Calder, Miró*. Together we are the first institutions to fully document the friendship between the two artists. We are indeed extremely grateful for the marvelous enthusiasm and intellectual rigor with which Mr. Beyeler and his guest curator, Oliver Wick, have adopted this project. Ernst Beyeler's vision and

experience in many ways complement our own since Mr. Beyeler's career and collecting history began when that of our founder, Duncan Phillips (1886–1966), ended around the mid-twentieth century.

In the 1920s Duncan Phillips and his wife, American artist Marjorie Acker – who had been a friend to Alexander Calder since their childhood days in Ossining, New York – were among the artist's earliest patrons. Margaret Hayes, Calder's sister, remembered the Phillips' purchase of several of his animal sketches – simple line drawings portending the artist's lifelong passion for motion. Phillips' appreciation for Miró began only after the artist had exhibited his soaring blue Cincinnati Mural at the Museum of Modern Art in 1948. In 1951, on the eve of the publication of the first catalogue of his collection in nearly two decades, Phillips rushed to purchase Miró's *Red Sun*, 1948 (Dupin 823), from Pierre Matisse. On 13 February 1951, Phillips wrote Matisse regarding the timing of his decision, "I would like to have Miró well represented in the Collection as we go to press with the Catalogue." He added, "It is a new phase of Miró but one which I find goes better in our Collection than his more characteristic style" – revealing his long-held bias in favor of expressive color and, not surprisingly, against what he understood to be the literary emphasis of surrealism. In May 1952, Phillips reached a similar conclusion when he rejected Marcel Duchamp's offer of an early Miró, *Painting*, 1926 (Dupin 213), from Katherine Dreier's estate. On the other hand, Duchamp's offer of Calder's *Untitled*, 1948 (cat. 75), with its tiny white discs floating at the ends of a lengthy wire armature, was accepted.

Most interesting in light of our current *Calder, Miró* investigation is the fact that Phillips' determinations about the mature Miró came in concert with his conclusions about Calder during the full flowering of the mobile and the mobile-stabile in the late 1940s. Doubtless Phillips could be categorized with many other American collectors for whom Calder's constructed abstractions – so closely tied to the model of the Universe – enhanced the perception of the structure underlying Miró's pictorial space. By mid-century Phillips had spent a lifetime building a collection crossing boundaries of time and nationalities and seeking out artistic kinships such as those of Van Gogh and Monticelli, Renoir and Bonnard, Bonnard and Vuillard. Calder and Miró clearly added a new and decidedly contemporary pairing

to his collection. The purchase of Miró's *Red Sun* coincided with Phillips' purchase of Calder's *Red Flock,* ca. 1950, later called *Red Polygons* (cat. 78). In fact, the two works had been exhibited together at the Institute of Contemporary Art in Washington in 1951. The movement of Calder's red shapes together with Miró's floating forms – so free from the gravity of pictorial convention – not only spoke volumes to Phillips about the friendship between an American and a Catalan artist, but also addressed his most fundamental beliefs about art as a universal language.

Our exhibition of *Calder, Miró* expands upon the idea that the language spoken by artists – however abstract in form and color – is something to be apprehended and shared. We invite you to be present at the conversation between Calder and Miró, to understand their shared conception of pictorial space, and to discover the world anew through two of the greatest inventors in the history of modern art. As Phillips once observed, "When we feel the sense of rhythm in the universe and in ourselves, we can understand the artist's application of certain laws to bring his own sense of order out of the chaos in the visible world and thus to produce a new creation."

Acknowledgments

We are immensely grateful to all those who have participated in the making of this exhibition. Our gratitude extends first and foremost to the families of the artists, who were united in their enthusiastic support of this project from the beginning. We express our great appreciation to the artists' daughters, Sandra Calder Davidson, Mary Calder Rower, and Dolores Miró. At the Calder Foundation, Alexander S.C. Rower contributed his profound knowledge, wise counsel, and access to the extensive Calder Archive as well as generously making available many magnificent loans from the Calder family. We are likewise deeply indebted to the Successió Miró, where Emilio Fernández Miró and Joan Punyet Miró lent us their trust and dedicated assistance. They unstintingly supported our extensive research efforts and granted us full access to the Miró Estate's vast archive of letters and photographs. Joan Punyet Miró's essay on the friendship of his grandfather, Joan Miró, with Alexander Calder provided manifold inspiration for our study. The artists' friendship lives on in their grandchildren, making our collaboration particularly

pleasant, and we thank both families for the permission to publish, for the first time, the correspondence between Calder and Miró.

In addition to acknowledging all lenders to the exhibition, we wish to thank Timothy Rub, director of the Cincinnati Art Museum, for his dedication and the spectacular loans of Miró's mural and Calder's mobile for the Terrace Plaza Hotel, Cincinnati. He supported our bold request from the beginning and initiated the restoration of the painting, so expertly executed by Stephen D. Bonadies and Frederick Wallace.

Our cordial thanks are due to the anonymous owner of Miró's first murals, created for the nursery of Pierre Loeb's children, as well as to the Toledo Museum of Art and its director, Don Bacigalupi, for agreeing to lend the mural executed for the nursery of Pierre Matisse's children. Thanks to these outstanding loans, all the early murals by Miró are on exhibition here for the first time. Some loans are so exceptional that they have been made available to only one of the two exhibition venues. It is a sign of special friendship that The Museum of Modern Art, New York, and its director, Glenn D. Lowry, facilitated the loan to Basel of *The Birth of the World*, the epochal precursor to Miró's later mural paintings. We are equally grateful to the owner of Miró's major work *The Port*. This generous loan has made possible the presentation of the complete series of works on a gray ground at Fondation Beyeler. Rudy Chiappini, director, and Barbara Paltenghi of the Museo d'Arte Moderna, Lugano, are to be thanked for helping us obtain *Woman in the Night* from a private collection for the exhibition in Basel. We expressly thank the Albright-Knox Art Gallery and its director, Louis Grachos, for the loan of Miró's early masterpiece *Carnival of Harlequin* to The Phillips Collection. Our gratitude is also due to all the collectors of Miró's Constellations for making available to us such a representative selection of these precious works.

Special thanks go to Aaron I. Fleischman and Eli and Edythe L. Broad, who selflessly lent major Calder works they had only recently acquired for their own collections. Finally, we would like to express our appreciation to Ali Reza Sami-Azar, director of the Tehran Museum of Contemporary Art, for the loan of Calder's mobile *Ogunquit (Orange Fish)* and for a renewed collaboration with the Fondation Beyeler.

In preparing the exhibition and catalogue, and in locating documents and photographs, we enjoyed the support of numerous institutions, archives, and persons. Above all, we would like to thank the Pierpont Morgan Library, New York, and its director, Charles E. Pierce, as well as Robert E. Parks, Sylvie Merian, and their colleagues, for allowing us complete access to the Pierre Matisse Gallery Archives. Generous support was also provided by the Fundació Joan Miró, Barcelona, especially by its director, Rosa Maria Malet, and by Teresa Montaner and Ingrid Fontanet, who contributed greatly to our archival research. At the Fundació Pilar i Joan Miró, Palma de Mallorca, María Luisa Lax was particularly helpful in providing information concerning the writings in the Miró estate, in supporting Oliver Wick during a research sojourn, and in contributing her great personal expertise to the project. At the Successió Miró, Xisca Borrás, Cristina Calero, Gloria Moragues, and Pilar Ortega, and at the Calder Foundation, Eliana Glicklich, Alexis Marotta, Kate Murphy, and especially Jessica Holmes deserve our sincere thanks for their cooperation. We are grateful to Leigh Weisblat for her diligent archival research in New York. The helpful suggestions and information provided by Jacques Dupin, the doyen of Miró studies, and Ariane Lelong-Mainaud of the Association pour la Défense de l'Œuvre de Joan Miró, editors of the catalogue raisonné of Miró's paintings, have been invaluable to the success of our project. We thank Claude Billaud of the Bibliothèque historique de la Ville de Paris, Albert Loeb, and especially Jacqueline Matisse Monnier for information about Miró's murals. Michelle Elligott, Museum of Modern Art Archives, was, as always, extremely helpful in responding to our inquiries, as was Kevin Grace, Blegen Library, University of Cincinnati. Research on Miró's *Jeux d'enfants* was facilitated by Madeleine M. Nichols, Dance Division, New York Public Library, and by Tatiana Massine Weinbaum, New York.

For access to historical photographs and the permission to reproduce them, we thank: Martí Català-Pedersen, Archive Francesc Català-Roca, Barcelona; Charles D. Scheips Jr., Michael Stier, and Leigh Montville, Condé Nast Publications, Archives and Permissions, New York; Odette Gomis, Arxiu Joaquim Gomis, Barcelona; Antonia, Carmela, and Valentina Mulas, Archivio Ugo Mulas; and Valentina Balzarotti Barbieri for the copyright permissions of Mulas, Milan;

Arnold Newman, New York, and Getty Images, Los Angeles; Irving Penn, New York; as well as Erica Stoller and Christine Cordazzo, Ezra Stoller Esto, Mamaroneck, New York, and Diane Bouchard, Cape Cod.

In the execution of this transatlantic project, we are indebted to Elizabeth Hutton Turner, senior curator and project director, The Phillips Collection, and Oliver Wick, guest curator at the Fondation Beyeler, for the collaboration that has resulted in this magnificent exhibition and its beautiful catalogue.

At the first venue, in Basel, we thank the director of the Fondation Beyeler, Christoph Vitali, and all colleagues for their devoted participation. Oliver Wick shepherded the project with great care and decisively participated in the selection for and the conception of the exhibition. Pascale von Planta-Zoller supported the exhibition with her customary reliability. Judith Meier assisted the research. Ben Ludwig led the technical team, assisted by Ahmed Habbech. Markus Gross and Friederike Steckling were responsible for all aspects of the conservation of the works in the exhibition. Nicole Rüegsegger and Tanja Narr supervised the loans, and Alex C. Pfenniger coordinated insurance. Claudia Carrara, Andrea Schaller, and Catherine Schott managed advertising and public relations, and Philippe Büttner and Michèle Klöckler, the museum's educational program. Dieter Thiel designed the visual presentation of the exhibition with great skill.

Publication of the German edition of the catalogue at Fondation Beyeler was supervised by Delia Ciuha who, with great scholarly care, was responsible for the editing and also the collaboration with the publisher. Lilian Schmidt assisted her efficiently. Johanna Halford-MacLeod, director of programming and publications at The Phillips Collection, was instrumental in all phases of the catalogue and a supportive, reliable partner in the preparation of the English edition. We are also deeply indebted to the editors Jürgen Geiger and Ulrike Mills for their supreme skill and diligence, and to Renate Heidt Heller and Susan Behrends Frank for their assistance. The essays, the chronology, and main parts of the correspondence were expertly translated by John W. Gabriel, Hubertus von Gemmingen, and Karen Lauer. Sandra Alboum, Odile Demange, Dana Farouki, Allison Freeman, Maria Elena Gutierrez, Helga Hediger, Sarah Leusch, Ronat O'Neill, and Christina Peschke were in charge of further translations. For their unfailing helpfulness,

reassurance, and calm we thank our trade partner, Philip Wilson Publishers, London, and its staff: Philip Wilson and Anne Jackson, Cangy Venables, Norman Turpin, and Peter Ling. Jean-Jacques Nobs and Robert Bayer, LAC AG Basel, took on color management and photo retouching with brilliant results. We are especially indebted to Heinz Hiltbrunner, Munich, for the outstanding graphic design of the present volume.

At The Phillips Collection, we thank the entire team, led by Elizabeth Hutton Turner. The following individuals worked with intelligence and enthusiasm on the project: we are deeply grateful for the remarkable expertise of assistant curator, Susan Behrends Frank, as well as to Elsa M. Smithgall, associate curator; Linda Clous, associate registrar; Chris Ketcham, assistant registrar; and Johanna Halford-MacLeod, director of publications. We would like to acknowledge our development office; Julie A'Hearn-Lantz, director of visitor services and business ventures; and Elizabeth Steele, conservator. For the creative solutions to the installation and design of this exhibition, we are indebted to Val Lewton, Robyn Kennedy, and Leslie London, as well as Bill Koberg, Shelly Wischhusen, and Alec McKaye. We thank Karen Schneider, librarian, for her research assistance. This project has also benefited from the contributions of the following interns: Sarah August, Evelyn Braithwaite, Holly Garner, Christina Gehring, Pat Goode, Nathan A. Manuel, Alison Pruchansky, and Sandy Schlachtmeyer. For their expertise we are indebted to Jonathan Fineberg and Victoria Combalía; Charles S. Moffett, Sotheby's executive vice-president; Marc Glimcher, chairman, Pace Wildenstein; and, of course, Alice M. Whelihan, National Endowment for the Arts.

The Fondation Beyeler thanks the Municipality of Riehen, Kultur Basel-Stadt, Basler Kantonalbank, Basler Zeitung, MANOR, Novartis, Sarasin & Cie AG, and UBS for their unflagging support, especially the Stiftung Patronatskomitee Basler Kunstmuseen. Our cordial thanks go to Hansjörg Wyss for the generous contribution he forwarded to us by way of the American Friends of Fondation Beyeler.

An exhibition on this scale would never have been possible at The Phillips Collection without the generous support of corporations, individuals, and federal agencies. We are extremely grateful to Ford Motor Company for its generous financial commitment and its enthusiasm for this project. The exhibition and catalogue

were supported in part by a grant from the National Endowment for the Arts and supplemented by matching funds from Gerry and Marguerite Lenfest, the Jon and Mary Shirley Foundation, The Aaron I. Fleischman Foundation, and The Broad Art Foundation. Additional support for the catalogue was provided by España Acción Cultural Exterior and the Embassy of Spain in Washington, D.C. The exhibition is supported by an indemnity from the Federal Council on the Arts and the Humanities. Toni A. Ritzenberg has graciously given funds in support of *Calder, Miró* educational programming. We are pleased to enjoy the full and enthusiastic support of Javier Rupérez, Spanish ambassador to the United States, and his wife Rakela. Carmen González de Amezúa, minister for cultural affairs at the Embassy of Spain, has lent her assistance to many aspects of the exhibition, catalogue, and educational outreach programming.

We also wish to acknowledge the tremendous support given us by the following individuals and institutions:

William R. Acquavella and Esperanza Sobrino, Acquavella Galleries, New York; Susan Saxon, director, Addison Gallery of American Art, Andover; Pamela P. Willeford, ambassador, and Bruce Armstrong, public affairs officer, American Embassy, Bern; Doris Ammann, Thomas Ammann Fine Art, Zurich; James Cuno, director and president, Stephanie D'Alessandro, and Suzanne McCullagh, The Art Institute of Chicago; Viktor Berger, Basel; Joanne Heyler, curator, The Eli and Edythe L. Broad Collection, Santa Monica; Bettina Berndt, Bundesarchiv, Filmarchiv, Berlin; Rupert Burgess, London; Andrea Caratsch, Caratsch de Pury & Luxembourg, Zurich; Richard Armstrong, director, Carnegie Museum of Art, Pittsburgh; Alfred Pacquement, director, Agnès de la Beaumelle, and Isabelle Monod-Fontaine, Centre Georges Pompidou, Musée National d'Art Moderne, Paris; Julie Aronson, Linda Bailey, Terrie Benjamin, and Scott Hisey, Cincinnati Art Museum; Catherine Couturier, Paris; Ruth Cürlis, Berlin; Majid Takht Ravanchi, ambassador, and Mohammad Hassan Habibollah Zadeh, cultural attaché, Embassy of Iran, Bern; Armin Ritz, ambassador, and Isabelle Petersen, cultural attaché, Embassy of Switzerland, Buenos Aires; Tim Guldiman, ambassador, and Guillaume Scheurer, chargé d'affaires, Embassy of Switzerland, Tehran; Leslie A. Feely, Fine Art, New York; Jeffrey Figley, New York; Trude Fischer, Lucerne; Kouki Inoue, director, Fukuoka Art Museum; Alejandra Borody and Pere Manel Mulet, Fundació Pilar i Joan Miró, Palma de Mallorca; Patricia Phelps de Cisneros, Rafael Romero Diaz, director, and Guillermo Ovalle, Fundación Colección Patricia Phelps de Cisneros, Caracas; Guillermo de Osma, Galería Guillermo de Osma, Madrid; Patrick Cramer, Galerie Patrick Cramer, Geneva; Adrien Lelong and Anne Blümel, Galerie Lelong, Paris and Zurich; Isabelle and Yoyo Maeght, Galerie Maeght, Paris; Carmen Giménez,

Madrid; Abigail Asher and Karen Fasano, Guggenheim, Asher Associates, New York; Juan Ignacio Vidarte, director, and Petra Joos, Guggenheim Bilbao; Erhart Hauswirth, Boujeons; Ned Rifkin, director, and Valerie J. Fletcher, Hirshhorn Museum and Sculpture Garden, Washington; Stephen Little, director, and Jennifer Saville, Honolulu Academy of Arts; Kosme de Barañano, director, Instituto Valenciano de Arte Moderno; Helena Kanyar, Basel; Heidrun Keller-Exner, Riehen; Timothy F. Potts, director, Kimbell Art Museum, Fort Worth; Ann Freedman, Knoedler & Company, New York; Christoph Becker, director, and Christian Klemm, Kunsthaus Zürich; Dieter Schwarz, director, Kunstmuseum Winterthur; Armin Zweite, director, and Volkmar Essers, Kunstsammlung Nordrhein-Westfalen, Düsseldorf; Carolyn Lanchner, New York; Alessandra Carnielli, director, Pierre and Maria-Gaetana Matisse Foundation, New York; Lars Nittve, director, Moderna Museet, Stockholm; Inge Dupont, Vanessa Pintado, and Eva Soos, The Pierpont Morgan Library, New York; Kees Mulderij, Hamburg; Juan Manuel Bonet Planes, director, and Mercedes Roldán Sanchez, Patronato, Museo Nacional Centro de Arte Reina Sofía, Madrid; Ramiro Martínez Estrada, director, Museo Tamayo Arte Contemporáneo, Mexico City; Manuel Borja, director, Museu d'Art Contemporani de Barcelona; Malcolm Rogers, director, Museum of Fine Arts, Boston; Kasper König, director, and Gerhard Kolberg, Museum Ludwig, Cologne; Glenn D. Lowry, director, and John Elderfield, Gary Garrels, Cora Rosevear, and Anne Umland, The Museum of Modern Art, New York; Helly Nahmad, Helly Nahmad Gallery, London; Milan Knížák, director general, and Tomáš Vlček, director, Národní galerie v Praze, Prague; Earl A. Powell III, director, and Jeffrey Weiss, National Gallery of Art, Washington; E. John Bullard, director, New Orleans Museum of Art; Bernhard Mendes Bürgi, director, Hartwig Fischer and Charlotte Gutzwiller, Öffentliche Kunstsammlung Basel, Kunstmuseum; Jonathan O'Hara, O'Hara Gallery, New York; Laura Paulson, New York; Anne d'Harnoncourt, director, and Ann Temkin, Philadelphia Museum of Art; Phyllis Hattis, Phyllis Hattis Fine Arts, New York; Marla Prather, New York; Maria Eugenia Kocherga, director, Proarte, Mexico City; Gabriel Ramon, Palma de Mallorca; Mercer Reynolds, Cincinnati; Margit Rowell, Paris; William R. Rubin, New York; Daniel Schulman, Chicago; Richard Calvocoressi, director, Scottish National Gallery of Modern Art, Edinburgh; Akémi Shiraha, Paris; Thomas Krens, director, and Lisa Dennison, Solomon R. Guggenheim Museum, New York; Claudia Steinfels, Sotheby's, Zurich; Christian von Holst, director, Staatsgalerie Stuttgart; Seán Sweeney, New York; Nicholas Serota, director, Tate, London; Eugene Thaw, E. W. Thaw & Co. Inc., New York; Markus Sprecher and Jangeer Bahrami, Transimpex Altstätten/Tehran; Kevin E. Consey, director, and Lucinda Barnes, University of California, Berkeley Art Museum; Howard Creel Collinson, director, The University of Iowa Museum of Art, Iowa City; Michel S. Vignau, Paris; Karin von Maur, Stuttgart; Willard Holmes, director, Wadsworth Atheneum Museum of Art, Hartford; Adam Weinberg, director, and Barbara Haskell, Whitney Museum of American Art, New York; Jock Reynolds, director, Yale University Art Gallery, New Haven; and Kazuhito Yoshii, Yoshii Gallery, New York.

CALDER AND MIRÓ:
A NEW SPACE FOR THE IMAGINATION

Elizabeth Hutton Turner

Picturing Friends

Alexander Calder and Joan Miró were friends. The big Calder kissing the diminutive, smiling Miró was reported as celebrity news in the daily papers. One could observe them seated together at Miró's 1974 retrospective at the Grand Palais in Paris (fig. 139), or at Calder's seventieth-birthday celebration at the Fondation Maeght in Saint-Paul-de-Vence. From the time they met in 1928 until the time of Calder's death in 1976, they were a constant and integral presence in each other's lives. Yet it was also plain to see that Calder and Miró were markedly different individuals. Calder's daughter, Sandra, said, "My father was always outgoing and very noisy, whereas Miró was contained and quiet."[1] What attracted the two artists to one another – call it their insatiable curiosity about seeing new aspects of the world – also led to their unique appreciation for one another's inventions. Their friendship opened a dialogue that permits us a glimpse of how artists form new avenues of creativity – a new space for the imagination.

In the earliest days of their friendship, Calder and Miró must have made an odd pair on the streets of Paris. Picture a short man in a bowler hat and bow tie, accompanied by a much taller man in an orange tweed suit.[2] In 1929 Calder and Miró were simply two bachelors on their way to a dance or to the gym to practice breathing and exercises: "The air was drawn in through the nose and exhaled through the mouth with a great whistling noise."[3]

In 1960, when the dealer Klaus Perls asked each artist to speak about the other's work, they looked back fondly. Miró wrote a poem: "My old Sandy, this burly man with the soul of a nightingale who blows mobiles...." Calder told a story: "We became very good friends and attended many things together, including a gymnasium. I came to love his painting, his color, his personages, and we exchanged works. He made me a wonderful painting in 1933 [cat. 113], and I gave

him a sort of mechanized volcano, made of ebony. Gymnasium is a thing of the past, but Miró and I go on."[4] Looking at the early work by Miró and the late work by Calder filling the Perls Galleries in the spring of 1961, a visual poetry and measure were in evidence – a beauty not easily explained. If it were merely a matter of shared form, one might rightfully ask who had arrived first. Were Calder's shapes borrowed from Miró or Miró's shapes borrowed from Calder?[5] Did both artists find their shapes in Jean Arp or Paul Klee? No matter: their true originality and purpose lay elsewhere, in certain defiance of categories of style or media. Seeing the work together, the critic John Canaday spoke of a new appreciation for the constructivist side of Miró and the surrealist side of Calder.[6] Had an exchange in effect taken place? Calder admitted as much when he said, "Well, the archaeologists will tell you there's a little bit of Miró in Calder and a little bit of Calder in Miró."[7]

The Calder-Miró kinship can be documented. Postcards and letters, gallery announcements and checklists, as well as an array of paintings, mobiles, and assorted gifts – from ashtrays to elephants and from shirts to grammar textbooks – attest to the fact that Miró and Calder conversed, corresponded, and exhibited with one another for nearly fifty years. The artists visited each other in Paris, Barcelona, Montroig, Varengeville, and New York. Their notes, about seeking out one another's company, inquiring after one another, exchanging works, sending photographs, making connections for one another, evoke youthful lives. Encouraging and helping one another, both Calder and Miró remained adventurous spirits. They believed that their friendship was a matter of vital artistic importance, and this exhibition seeks to examine their careers in parallel and closely track the artists' dialogue during the years when both were developing their formal language.

The First Meeting

The first point of contact between Calder and Miró was a letter. On 10 December 1928, soon after his arrival on his fourth trip to Paris from New York, in the best French he could muster (Miró did not speak English), Calder wrote, introducing himself to Miró and asking him to get in touch (fig. 68).

An encounter with Elizabeth (Babe) Hawes in New York had apparently prompted Calder to look up Miró in Paris.[8] Miró's radically simple designs for the

Ballets Russes had been featured in *Vogue*,[9] and the American correspondent and aspiring fashion designer Hawes (1903–1971), who wrote for *Vogue*, had written an article on Calder for *Charm* in April 1928. Hawes was well connected in Paris. For a time she lived above Sylvia Beach's bookstore, Shakespeare and Co., where the composer George Antheil had resided.[10] Hawes most likely met Calder through her future husband, the stage designer Ralph Jester. Jester and Calder both sketched at the Grande Chaumière.[11]

Had it not been for Hawes, it is unlikely that the two artists would have met as early as 1928. Miró lived on the rue Tourlaque and worked on the opposite side of the city from Calder, whose studio was on the rue Daguerre. Miró, a friend of Pablo Picasso, was hailed by Dada poets, and, among the Americans, championed by Ernest Hemingway and the literati of the *Little Review* who gathered at Shakespeare and Co. While Miró was acclaimed by André Breton, the leader of the surrealist movement, Calder conversed with the second tier of the School of Paris.[12] His most prominent exposure came when, on the advice of the Spaniard José de Creeft, Calder exhibited at the Salon des Humouristes.[13]

Calder and Miró's initial visits to one another's studios seem to have yielded nothing that looked like art to either artist. In Miró's nearly empty studio on rue Tourlaque, Calder remembered no paintings, only assemblies of found objects. These "collage-objects" included materials such as hat pins, feathers, cork, and string, affixed with glue and nails to flocked paper, linoleum, and wood, and were puzzling to him.[14] Miró first saw Calder's studio on rue Daguerre crowded with onlookers. Calder, even though he was on his hands and knees in the midst of performing his Circus, later distinctly remembered that Miró had left without comment.[15] Miró admitted, "When I first saw Calder's art very long ago I thought it was good, but not art."[16] This was not necessarily a criticism: it may have been a compliment.

Common Ground

The young American and the young Catalan in Paris had more in common than a first impression might reveal (figs. 1, 3). Above all, they shared a spirit of iconoclasm. Calder and Miró considered themselves outsiders. Early correspondence from Paris shows them disdainful of convention.[17] Miró at the time said that he was

out "to destroy painting" (including his own).[18] In his spare collage-objects, the Spanish Dancer series of 1928, he had practically eliminated drawing and paint. Calder, too, an alumnus of New York's Art Students League, strayed from his training when he made figures out of cork and cloth or wire and string and performed a circus instead of painting. The dealer Pierre Loeb marketed Miró's work as "a new kind of comic painting."[19] The critic Douglas Haskell asked of Calder, "Which is his greater claim to distinction: that he likes to make toys into art or that he is able to treat art itself as a grand plaything?"[20]

Calder and Miró kept treasures of childhood in sight for themselves and for their audiences.[21] A passion for toys, matched by a capacity for play, became clear to anyone who visited their studios. The poet Robert Desnos' earliest recollections of Miró's first Paris studio at 45, rue Blomet included a description of toys. "In one corner of the studio was a table covered with Balearic toys, little gnomes, strange animals in plaster illuminated in lively colors.... They gave the studio a holiday, fairytale air, and I tried in vain to rack my brains for a memory of which I was only able to call back the ghost, the savor, so to speak – a childhood tale in which mushrooms played the principal roles."[22] Collecting toys would be a lifelong pursuit for Miró. In 1947, the only tangible souvenir he brought back to Spain from the United States was a collection of American sidewalk toys.[23]

Calder turned his narrow room at 22, rue Daguerre into a workshop. Despite his promises to paint, he told his parents in 1927, "When I'm in my *chambre* all I can think of is toys" (fig. 58, cats. 1, 7).[24] Hawes recalled audiences of the Circus sitting on Calder's bed, "slightly in fear of one of the hundred toys that hung on the wall falling on their collective head...."[25] She asked her readers to imagine playing with them: "Had you, in fact, ever stopped to realize the delight of a wire cat or a wooden duck?"[26] In the same way, we can imagine how Miró delighted in making his Balearic toys whistle (fig. 117).

The toys of Calder and Miró served as vital constructs. Without needing to follow rules of exacting representation, their sounds and contours elicited a range of associations. On a metaphysical plane, somewhere between the real and the imagined, surprising shapes and unfamiliar rhythms took flight. As James Johnson Sweeney once stated simply, "Toys pointed the way."[27] From early on and quite

Fig. 1 Alexander Calder in his studio, rue Cels, Paris, November 1930, photo Thérèse Bonney

Fig. 2 Alexander Calder with his Circus, 1927, photo André Kertész

Fig. 4 Mementos of Paris pinned to Calder's Roxbury studio wall, 1965, photo Ugo Mulas

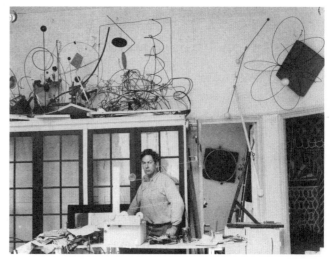

Fig. 3 Joan Miró, 1930, photo Man Ray

Fig. 5 Alexander Calder in his studio, rue de la Colonie, Paris, fall 1931, photo Marc Vaux

separately from one another, Calder and Miró designed toys that adopted the expressiveness of line drawing. From 1920 to 1924, Miró's paintings of toys daringly but delicately defied gravity and description. In *Horse, Pipe, and Red Flower* (cat. 80) the toy horse rests on a tabletop beside a book of poetry, its position defined not by light and shadow but by patterns of ecstatic color. In a reprise, Miró dispensed with conventional cues of earth or sky or tabletop. With only the faintest grid serving as a net, in *The Toys* (cat. 81) the now translucent horse tilts and pivots, rocking up and down, its round haunches turned into a pictorial field animated by a thin wash of color. Ultimately, the finest line or the smallest dot would be sufficient to convey a horse's movement (cats. 91, 92). Miró gave straight, taught lines new meaning by suggesting curving motion.[28]

Sometime in the fall of 1926, Calder likewise drew in thin air as he performed his toy circus to pay the rent. Attached to an armature tense with guy wires, the aerialist, made from bundled bits of cloth sewn around wire, was hanging from the trapeze (cat. 5, fig. 2). Calder pulled the string and set the apparatus in motion. Figure and hook must meet at the exact moment in order to perform the catch. The trapeze artist swings back and forth. Will he fall? But Calder is a master of his technique.[29] His sculpture has no ordinary base or posed equilibrium; it is a figure in vigorous motion, demonstrating what Calder later called "this freedom from the earth."[30] Was Calder serious without seeming to be?

Calder, for his part, always admired Miró's capacity for ribaldry[31] – a peculiar kind of folk humor.[32] In Miró's 1924–1925 *Carnival of Harlequin* (cat. 83), a subworld appears of uncensored medieval marvels whose last vestiges echo in the spontaneous street demonstrations of Barcelona. Miró interprets this world as a profusion of shapes rising up like helium balloons from a proscenium where commingling creatures and confounding contraptions abound – a bird with the body of a woman, a flying fish, a pipe-smoking peasant whose penis waves like a flag, a mustachioed insect playing ball. Miró gladly substituted this unraveling world for the hierarchical one he had inherited from the academy. At a surrealist demonstration Miró shouted, "A bas la Mediterranée [sic]!" (Down with the Mediterranean!),[33] as if by the force of this remark to cast off centuries of enslavish conceits of Greco-Roman culture. Calder surely sympathized with Miró's struggle.[34] Having

experienced classicism firsthand in his father's and grandfather's sculpture studios, Calder, the engineer, had been fighting, as he said, "the impression of mud piled up on the floor" all his life.[35] At the 1928 exhibition of the Society of Independent Artists in New York, when audiences pulled the breasts of an over-lifesize allegorical figure entitled *Spring* (cat. 9), Calder cast off the weighty mud of his father's sculptural medium. At the time one reporter mused, "Convoluting spirals and concentric entrails; the kid is clever, but what does papa think?"[36]

Miró preferred Calder's brand of extroversion to avant-garde manifestos and theories. Calder's Circus firmly adhered to Miró's heart when Calder performed it in Spain. In September 1932, at a performance at Miró's farm in Montroig, the country folk of the district were "transfixed and totally overwhelmed by it." There in Montroig, as Miró said, "where the trees, the mountains, the sky, the house, the vineyards, have remained the same. There where the mules have always eaten carobs, and where we have the same warming red wine," Miró, too, felt transported.[37] There, watching Calder's Circus amid the laughter, amid "squalling babies, etc., & one little boy [who] had to piss,"[38] Miró found something more authentic than any manifesto.

Companions on the Road to Abstraction

In 1931, at the Galerie Percier, a wire portrait of Calder's friend Miró floated high above Calder's first exhibition of abstractions (cat. 15, fig. 60).[39] Did the wire face have anything to do with Calder's newfound simplicity, with "sphériques" or "volumes, vectors, and densities," as Calder called them? The portrait was possibly Calder's first gift to Miró. A single wire circumscribes a youthful face devoid of complication, within which float tightly coiled spiral eyes. As early as 1929 Calder had written about the new direction in his work, "These new studies in wire, however, did not remain the simple modest little things I had done in New York. They are still simple, more simple than before."[40] Calder's shift away from descriptive caricature moved him closer to abstraction. Turning his thoughts toward basic questions about medium and method, he said, "But these recent things have been viewed from a more objective angle...objects behind other objects should not be lost to view but should be shown through the others by making the latter transparent. The wire sculpture accomplishes this in a most decided manner."[41] Calder's

bent and twisted wire objects opened a new world that shared the dynamic of drawing with the three-dimensional presence of sculpture.

By 1929 Miró applied a similarly conceived process of simplification to his paintings as he emptied the pictorial field of all predictable forms and actions (cats. 85, 93, 94).[42] Triggered by chance glimpses in the real world, Miró's line traveled with concentration and force through a clear and open picture plane.[43] His shimmering, transparent man with a pipe, for example, blows a sphere through a serene, limitless space (cat. 86). In *Painting*, 1930 (cat. 99), Miró's looping gestures create a monumental figure amid dense knots of black and white paint.

Paul Klee, no doubt an influence on Miró's line and movement, may also have been Calder's point of departure for abstraction in 1929 when he created a simple machine with a wire frame and crank (cat. 12).[44] Turning the crank moved a series of interconnected rods and levers, setting into play a sequence of actions with fish flipping back and forth across an open, airy tank. Calder's three-dimensional machine extended the action of Klee's painting *Twittering Machine*, 1922. Calder's object, after all, had three movements, Klee's painting only one.

Concerning the question of abstraction, Calder in retrospect made it clear that it took "a shock" for him to start things.[45] That shock was meeting Piet Mondrian – a painter as visionary as Klee and whose work was seemingly the antithesis of surrealism and of the art of Miró. As when he visited Miró's studio in December 1928, Calder did not even recall seeing paintings when he visited Mondrian's studio on rue du Départ in October 1930. He remembered the victrola, painted white, and "high white walls with cardboard rectangles painted red, yellow, blue, black, and white in various shades tacked on one wall" (fig. 8).[46] Mondrian's remarks at the time advocated the elimination of individual works of art in favor of creating a "new Form" and a "new Space."[47] At the sight of colored shapes floating on the wall, unframed, Calder suggested to Mondrian that his colors be "made to oscillate in different directions at different amplitudes." Mondrian rejected the suggestion, saying, "No, it is not necessary, my painting is already very fast."[48] But Calder was looking for lift-off. He began his experiments in abstraction on canvas but soon abandoned the effort.[49] He made "sphériques," round hoops within which orbited red and white wooden balls and cantilever wire armatures capable of sway-

ing and turning. Regarding his abstractions, Calder later said, "the underlying sense of form in my work has been the system of the Universe, or part thereof."[50]

While the shock of Calder's meeting with Mondrian resulted in his embrace of abstraction, Miró's reaction to neoplasticism resulted in a critique.[51] Miró gave up painting and began to make three-dimensional objects. He would test the proposition that total abstraction was "free from the figurative formalism of the past."[52] However foreign to his gifts as a painter, he invoked the "gods of wood and iron"[53] in order to purge the last remnants of illusionism from his work.

Whereas Mondrian demanded an uninterrupted equilibrium, as he said, "a unity formed by planes composed in neutralizing opposition that destroys all exclusiveness," Miró's geometries were neither neutral nor inclusive but functioned by way of tension and opposition.[54] In *Construction*, 1930 (cat. 98), Miró punctuated the center of a pivoting metal rod and impaled three wooden dowels at varying distances upon a picture plane of unpainted wooden boards. Smoothly painted black and white rectangles are applied to two dowels. The round end of the third dowel is painted black. At the edge of this raw wooden picture plane Miró, in *Painting-Object*, 1931 (cat. 102), also showed himself capable of reversing course by building up disassembled objects on a white rectangular field. Here, in contrast to Mondrian, he applied mysteriously isolated parts to the pristine surface. The rhythm conferred variety and complexity on the intervening white spaces.

After a hiatus of almost a year Miró returned to painting in 1931 with, as he said, a strong black line following the hand as Matisse instructed.[55] To Miró the result nearly always suggested a human aspect.[56] The linear armature of Miró's *Head of a Man III* and *IV*, 1931 (cats. 100, 101), like Calder's portrait of *Joan Miró*, ca. 1930 (cat. 15), reads in many ways like an x-ray of a human body. Geometry structured but never fundamentally altered the desire of both artists to create a pictorial universe that contained dynamic but contingent relationships of both fixed and floating forms.[57]

Ballet Mécanique

In the spring of 1932, Calder and Miró shared one ambition:[58] both hoped to achieve a performance of objects. The idea of the mechanical ballet had captivated the

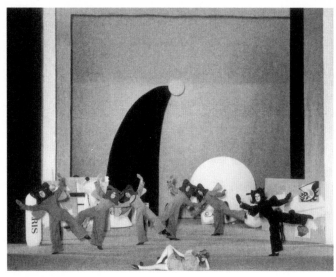

Fig. 6 The Ballets Russes de Monte Carlo performing *Jeux d'enfants*, Scene 4, "The Hobby-Horses," Monte Carlo, 1932, photo Raoul Barba

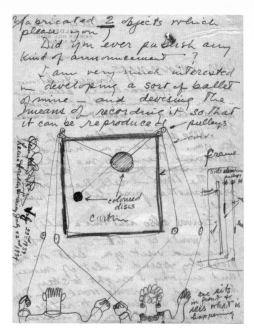

Fig. 7 Letter from Alexander Calder to James Johnson Sweeney describing *Ballet-Object*, 19 July 1934, Calder Foundation, New York

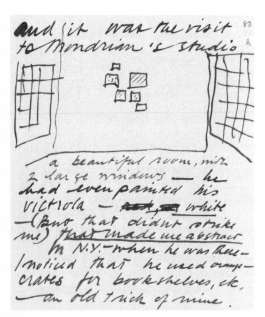

Fig. 8 Alexander Calder, recollection of Piet Mondrian's 1930 studio in Paris, ca. 1952, Calder Foundation, New York

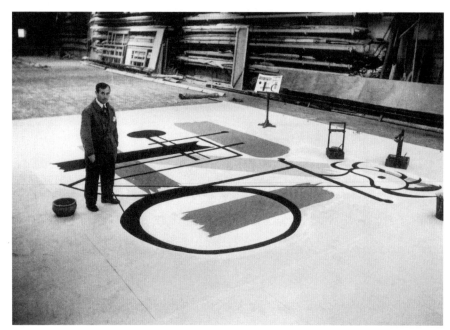

Fig. 9 Joan Miró painting the curtain for *Jeux d'enfants*, Monte Carlo, 1932, photo Raoul Barba

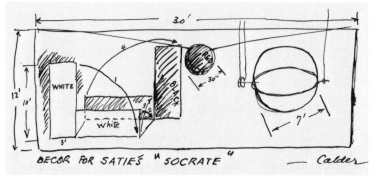

Fig. 10 Alexander Calder, sketch for the mobile stage set of Erik Satie's *Socrate*, First Hartford Festival of the Arts, 1936

avant-garde for nearly a decade. Fernand Léger had said in 1924, "Let us gradually take away the 'little man,' and I assure you the stage will not be empty, for we will make *the objects move*."[59] Léger had created a film entitled *Ballet mécanique*, and George Antheil had already spoken with Miró about a *ballet mécanique* in 1927. Calder reported to his parents that, following Miró's example, he was hoping to do a ballet the next year.[60] Miró imagined "something as sensational as…[a] heavy-weight prize fight," a "rain of swings, uppercuts, and straight right and lefts to the stomach and everywhere throughout the entire event – a round lasting about twenty minutes."[61] Calder envisioned something similar to what he had seen in "a movie made in a marble quarry…the delicacy of movement of the great masses of marble, imposed of necessity by their great weight…."[62] Now Calder and Miró would operate their gravity-defying shapes on stage (fig. 7).

The theme of Boris Kochno's libretto for the ballet *Jeux d'enfants*, about toys and games coming to life and a child and a traveler setting forth on a journey in the middle of the night, particularly suited Miró's predilection for toys.[63] After seeing Miró's exhibition of objects (cat. 102) at the Galerie Pierre in December 1931, Léonide Massine commissioned Miró to design the costumes, curtain, set, and props. Massine later recalled potential motion he found in Miró's dual propensities for drawing and volume as well as the dynamism in the special sharpness in his colors.[64] Miró was taken by the idea of dancers (whom he covered completely, hands and all, in body tights) spinning colors in revolutions, and he was attracted by the verve of Georges Bizet's music.[65]

Miró designed the stage for *Jeux d'enfants* as "a magic box" – a cube with black, scarlet, and white wings (fig. 6). Against a bluish-gray backdrop he set two massive, mobile constructions. A comet's tail and a luminous sphere housed male and female spirits, respectively, who ruled the toys. Periodically these shapes moved up and down like a ball in slow motion. The white legs of the male spirit, seen through the lower part of the comet's tail, and the blue arm of the female extended from the sphere and created unexpected shapes. Their gestures commanded the curtain to rise or fall at the beginning and end of the performance. Assorted characters and props circulated between the cone and sphere. The dance was meant literally to effervesce from these geometrical solids.[66]

The potential for performance that Massine saw in Miró's "Painting-Objects," Léger found in Calder's Sphériques. In 1931, on the occasion of Calder's Galerie Percier show, Léger suggested: "Satie by Calder. Why not?" In 1920 Erik Satie had composed *Socrate*, a musical setting for Plato's texts about Socrates. Satie's score assigned one note to each syllable of Plato's *Dialogues*. By virtue of the pianist's very deliberate pace, the audience was drawn hypnotically to a new awareness of time and space. In 1936 Virgil Thomson offered Calder the opportunity to fill the stage in *Socrate* at the First Hartford Festival of the Arts. Just as Léger suggested, Satie and Calder proved a perfect combination.[67] Thomson observed, "It was as though the music itself moved the set."[68]

Calder designed "a majestic cosmological machine" (fig. 10).[69] He divided the action into three sections: nine minutes for each of the first two parts and eighteen minutes for the last.[70] He filled the stage with three simple geometrical forms: a sphere that rotated on its own axis; a second, smaller disc that traversed the length of the stage on a hidden wire; and a third, rectangular element that lowered itself gradually to the ground and changed from black to white by turning over and rising again to its full height. Movement was not accomplished by way of motors as Calder originally intended; instead, stagehands with pulleys and ropes affected a kind of monumentality in slow motion.

Calder reveled in the mechanistic aspect of his ballet while Miró concealed the mechanism that moved the objects.[71] Nevertheless, the two artists remained linked by concepts of motion in their future endeavors.

Like Living Mirós!

In February 1936, on the occasion of Calder's second show in two years at the Pierre Matisse Gallery, the headline of the review in the *New York World-Telegram* declared emphatically: "Calder's 'Mobiles' Are Like Living Miró Abstractions." The latest paintings by Miró remained on hand at Matisse to provide comparisons with Calder's newly suspended arrangements within moveable frames. The reviewer was quick to note: "They are very much like Miró abstractions come to life – simple, naïve and yet immeasurably subtle – but with the bright spots of reds, yellows and blues imbued not with plastic implied movement but actual physical movement."[72]

From the standpoint of marketing, the comparison had obvious appeal. The paintings of Miró provided the as yet uncategorized objects of Calder with a foothold in the realm of modern art. By the same token, the tangibility of Calder's objects provided access to Miró's "cabalistic" shapes and colors.[73] Certainly as early as 1932, the animation of "the French surrealist abstractionists, especially Miró," was linked to Calder's first show of mechanized abstractions in America, at least in the opinion of one reviewer.[74] By 1934 the dealer Pierre Matisse had come to believe in the connection when he solicited the commentary of poet and curator, James Johnson Sweeney. "I personally have noticed during the Miró exhibition how much the excerpt that you were so kind to let me include in the catalogue had helped the people in their approach to Miró's work. Sandy [Calder] is very enthusiastic over this idea and as for myself, I do hope that you will be able to do this."[75] Sweeney could have been referring to Calder when he wrote the following about Miró in 1935: "His effects are achieved primarily through the rhythmic evocations of line and color – organizations that have grown out of a thorough assimilation of physical forms, not of literary images."[76] Beyond Matisse or Sweeney and the New York art world lies the question whether Calder and Miró recognized or were even seeking to develop a rapport in their work (figs. 14, 16).

Common Language

Calder hoped that his inventions would captivate Miró as they had Jean Arp. His October 1931 postcard from Paris to Miró on the eve of the departure from Montroig stated, "come… as soon as you arrive in Paris. I am working very hard – and have made many objects with movements that are rather interesting, I think (as do Jean Arp and others) and I believe that these works will interest you." In 1933 Miró accepted Jean Hélion's invitation to exhibit with Calder and the Abstraction-Création group, an international group of painters and sculptors active from 1931 to 1936.[77] Calder's memoirs mention that during this period he and Miró, in fact, had planned to create an object together.[78]

Calder's embrace of Miró's Spain was another gesture of friendship. Each year from 1930 to 1933, in the rhythm of work and exhibition that took Calder annually from New York to Paris, he made a trip to Spain. Among the highlights

were his performances of the Circus for Miró in 1932 and for the avant-garde group ADLAN in Barcelona 1932. Most vivid in the Calder-Miró correspondence and recollections was the summer of 1932 as it inaugurated an intense period of exchange, which extended into 1933. Calder's performance of the Circus at Miró's country home in Montroig in 1932 particularly appealed to Miró. If you listened carefully, the song of the woman with sequined breasts called the paper birds, one by one, down the guy wire to her shoulder.[79] Miró told Calder that he liked these floating papers best.[80] On this trip to Spain Calder remembered a performance of another sort. Two train stops from Montroig, in Cambrils, they watched the fishermen one day arranging their catch in spiral motifs in large flat baskets. To Calder's amazement there came a moment when all the fishermen stooped, picked up a handle from the basket on each side, and, thus joined as a chain, marched in a line into the square. The first fisherman turned in a circle until all had followed, posing their wares as one large spiral.[81] Calder purchased one of the yard-long baskets as a souvenir and brought it back to Paris.

In June 1933, at the end of a visit with the Calders at 14, rue de la Colonie, Miró inscribed a cobalt-blue painting: "à Louisa et Sandy Calder, /avec ma plus affectueuse amitié. / Miró. / Paris 24 Juin 1933," which provided Calder with the color and the personages he had come to adore (cat. 113).[82] Calder in turn gave Miró a mechanized volcano made of ebony. Perhaps these gifts also served as parting remarks since Alexander and Louisa were giving up residence in Paris and moving back to the States. Knowing Miró's own painted volcanoes and his love of word play, Calder left his friend with a pun from "los Calderos," as the Calders referred to themselves in correspondence:[83] the uncertain time of the volcano's eruption was meant to remind Miró to keep the Parisian art world on the edge of its seat while Calder was away. Perhaps the two transparent, bewhiskered amoebas docking noses in the midst of Miró's painting reminded Calder, as Miró later admonished Georges Duthuit, "wherever you are, you can find the sun, a blade of grass, the spirals of the dragonfly. Courage consists of staying at home, close to nature, which could not care less about our disasters. Each grain of dust contains the soul of something marvelous" (fig. 12).[84]

Calder's late June 1933 departure for America was the start of a four-year hiatus in the shared company of the two artists, but not a cessation of their mutual interests and friendship. Their conversation continued by mail, and Calder could be counted upon to attend their annual exhibitions at the Pierre Matisse Gallery. Alexander and Louisa set down roots; in August 1933 they purchased and began renovating an eighteenth-century farmhouse in Roxbury, Connecticut. Calder set up a studio in the adjacent icehouse. Within a year he created his first outdoor pieces (fig. 11).[85] He cut discs – according to Calder the simplest form in the universe – of metal, and, by way of metal bars, rings, and cords, he framed and balanced their mass and movement. In addition to the whirring action of motor-driven mobiles set against color backgrounds, Calder's 1936 show at the Pierre Matisse Gallery, *Mobiles and Objects by Alexander Calder*, contained a host of finely balanced configurations and sculpted wooden shapes. Fewer motors also meant fewer repetitions in motion. The multitude of floating configurations of carved organic shapes suspended on cords emphasized irregular movements instead of machine-activated ones.[86] Calder thereby clarified his connection to simple tools and materials, obvious since his earliest wire figures, and gave further credence to the notion of accident as critical to the success of a work of art.[87] Born out of the trial and error of pivoting carved or cut shapes, one by one, from cords along a horizontal wire balancing on the ends of his fingers,[88] these abstractions approached the very core of Calder's dexterity and fluency as an artist. In silent undulation they achieve a vital presence. Searching for an alternative to abstraction, Calder said at this time, "I like the idea of synthesis."[89]

In 1936 *Abstract and Concrete: An Exhibition of Abstract Painting and Sculpture Today* at the Lefevre Gallery in London demonstrated that the two artists had continued along a similar path. A small wooden object, carved and stained red by Calder and titled *T and Swallow* (cat. 30), exhibited with a large 1933 *Painting* by Miró, displayed a newly codified vocabulary of shape. The observations of the critic Anatole Jakovski in 1933 were borne out: he had proposed that Miró would return to the source of sculptural language[90] and that Calder would abandon the mathematical approach in favor of forms more archaic, more primitive.[91] "The mathematical cycle has ended. The organic cycle begins...."[92] Calder's organic shapes

seem to refer to experiences in nature half-glimpsed and half-remembered. In the T-shape of Calder's standing mobile, the gliding, winged form, suspended on a brass wire hanging from the slender knife-edged beam atop an inflected post, does not describe a bird or a bat or a butterfly so much as capture the suspense of flight itself.

Miró's *Painting*, 1933 (cat. 110), dominated by a large, quasi-geometric shape – Calder would have described it as a "spherical triangle" – pivots above an improbable pyramid of interlocking elastic forms, presenting itself like the face on a grand portrait. The work belongs to a series of paintings in which Miró, working scrupulously from the model, examines the rapport between the hand and the machine.[93] During January and February 1933, in assembly-line fashion, the artist made eighteen preparatory collages in seventeen days (figs. 13, 15).[94] He meticulously inscribed the date on each one and then placed them on his wall.[95] Over the next four months, between March and June, he created a painting inspired by each collage (cats. 107–112). Cut and pasted compositions constructed the pretext for Miró's freest, most expansive gestural works to date.

The collages do not obviously foretell the appearance of the final painting. Equally mysterious are the curious combinations of clipped advertisements for mechanical contraptions – from baby carriages to hot-water heaters, from airplane propellers to a parade of umbrellas – pasted on the collages themselves (fig. 13). In *Painting*, 1933 (cat. 110), Miró launches repetitive, simple shapes – triangle within triangle, lozenge crossing lozenge, expanding as both transparent and opaque appendages – to fill a lush atmosphere of tonal color. Simple shapes create rhythm but certainly not representation. Is it important to know that the preparatory pretext for this painting was a single advertisement that vertically aligns a lathe, a grinder, and a vise? Miró never took the machine at face value, even if he may have contemplated the physics of its potential action or achieved a rhythm with mechanical efficiency.[96] His message resides not in naming things but in seizing the reality of movement. Calder once similarly asserted this prerogative when he told a reviewer, "The pigeon is a dumb animal. Yet it has a handsome motion. To enjoy that motion, why must I tolerate an unpotted squab?"[97]

Between Calder and Miró there was never a question of imitation.[98] They

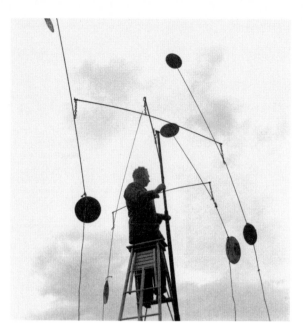

Fig. 11 Alexander Calder installing *Nine Discs*, 1935, Roxbury, photo Herbert Matter

Fig. 12 Joan Miró on the roof terrace of his farmhouse in Montroig, between 1946 and 1950, photo Joaquim Gomis

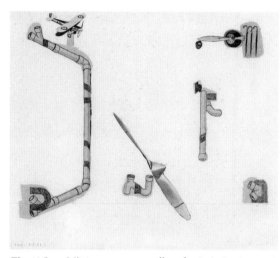

Fig. 13 Joan Miró, preparatory collage for *Painting* (cat. 107), 28 January 1933, Fundació Joan Miró, Barcelona, FJM 1291

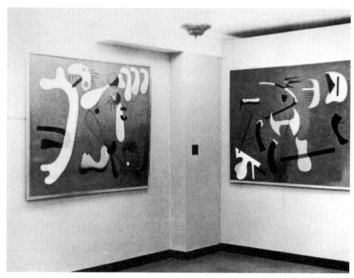

Fig. 14 Installation view of Joan Miró exhibition with cats. 107, 109, Pierre Matisse Gallery, New York, 1933–1934

Fig. 15 Joan Miró, preparatory collage for *Painting* (cat. 112), 8 February 1933, Fundació Joan Miró, Barcelona, FJM 1302

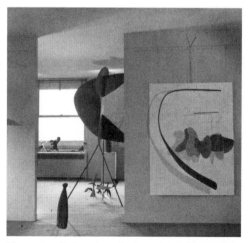

Fig. 16 Installation view of *Alexander Calder: Stabiles and Mobiles*, Pierre Matisse Gallery, New York, 1937, with *Big Bird* (cat. 32), *White Panel*, and maquettes, photo Herbert Matter

never quarreled about shapes, never claimed this form or that. Yet in their work after 1935 there were indeed moments, even if not by specific intent, when the flat colors and clipped abbreviations of the two artists seemed to work in rhyme.

Miró's *Portrait of a Young Girl*, 1935 (cat. 115), has a squeegee-like gold shape abbreviating torso and neck, and a head topped off with a red post and grand black oval. She poses like a mannequin, complete with hat and green pendant swinging against the yellow ground. Tone for tone, Calder appears to answer with *Yellow Panel (Form Against Yellow)*, 1936 (cat. 31), in a black shape, pierced and crossed by a white pendant floating before a plywood panel that is painted yellow. Calder, no doubt for his own reasons, came close to painting in his 1936–1937 constructions. In *Snake and the Cross*, 1936 (cat. 29), Calder addresses questions of field and frame by combining sheet-metal cut-outs in mobiles that change color in rotation. He solidifies and contours his gestures in his first freestanding stabile, *Devil Fish*, 1937 (cat. 33).[99] A year later Miró performed his own spatial inversions and reversals of figure and ground for his own purposes by lyrically writing in script, "une étoile caresse le sein d'une négresse," in white, complete with pivoting red and yellow quadrangles and dangling, white, staccato personages on a solid black field. Despite appearances, and certainly contrary to the dealers and reviewers, Calder no more enacted Miró than Miró enacted Calder. Calder would have stated uncategorically that his work was abstract: he made "not extractions, but abstractions...."[100] For his part, Miró vehemently stated the opposite.[101]

Enlisting Calder

On the occasion of the 1937 Paris World's Fair, the abstract objects of one sent the same message of political protest as the "songs" of the other. Since 1933 Calder had been looking forward to a reunion with Miró in Spain. In the meantime, speaking Spanish became a topic of jokes in their correspondence.[102] The reunion came in April 1937 at the home of their friend, the American architect Paul Nelson, in Varengeville-sur-Mer (fig. 21).[103]

Within a week of Calder's arrival, he and Miró were in Paris. They visited the site of the Spanish Pavilion. Miró and Picasso had been invited to choose spaces in it for their work.[104] Josep Lluís Sert's pavilion was meant to project the clarity

and openness of a robust and resilient future for Spanish culture. The sweeping exhibition spaces in the predominantly glass-and-steel pavilion left only a few solid walls for murals. Calder immediately recognized opportunities for a mobile in the stairwell. He may not have stopped to consider the fact that he was not Spanish. Calder's spontaneous offer to help was rejected by Sert on the spot. Within a month, however, Sert had reconsidered.[105]

The pavilion itself, symbolically faced in red, was close to completion.[106] The exhibits were to be set along the major axis of the building (fig. 19). To the right of the entrance, like political graffiti, Picasso's black-and-white mural *Guernica* would memorialize the brutal bombing and devastation of the Basque town of Guernica on 26 April 1937.[107] Miró's work was to exclaim the ongoing Catalonian resistance to Franco and the suffering of its people, an anthem of defiance on the eighteen-foot span of wall on the stairwell between the second and the third level. A fountain of mercury had been planned to illustrate the plight of the miners of Almadén. The location, providing 60 percent of the world's mercury supply, was much sought after by the fascists and admirably defended by republican loyalists.[108] Calder was to create this fountain.

Miró worked on site. Photographs capture Miró in workman's overalls standing on the scaffolding in the stairwell, or on a very simple ladder, similar to the ladders of Montroig in his earlier paintings (fig. 18). Another photograph shows just the ladder, propped against the completed mural. Judging from appearances, very little was done to prepare the paint surface. Miró seems to have painted directly on the Celotex wall surface. The effect of repeated applications of paint piled up or stained into this ground is revealed in the appearance of rough, granular splotches and orbs of color across the surface. Against this patterned ground Miró drew a single, immense symbol of the Catalan peasant that easily fills nine-tenths of the composition.[109] A far cry from fascist neoclassicism, the ungainly figure consisted of a gigantic head perched on a long stalk of a neck, around which coil tendril arms wielding a sickle. This grotesque image so violently overreaches its subject that the exaggeration itself becomes a source of power. In the case of Miró's mural configuration, the caricature is a curious mix of animal-vegetable-mineral, tapping into the force of the defiant peasant. Against the ominous explosions of sky,

the figure becomes birdlike with its beaked nose and open mouth. In the stairwell of the pavilion, the uncomely reaper with its discolored and bruised complexion rises to the seemingly unstoppable height of eighteen feet, a disturbing and incongruous presence in the sleekly designed building. Miró captures the attention of the audience by way of a bold disruption, and his message of protest is delivered with stunning immediacy and effect.[110]

By contrast, Calder's *Mercury Fountain,* set on axis in the foyer,[111] lured the eye with the exquisite shape and shimmer of a black-and-silver cauldron harmonizing perfectly with the materials of its surroundings (fig. 17). Recognizing its significance, Calder was quick to publish a step-by-step description of how he approached and solved problems in his sculpture.[112] Calder's first and foremost consideration in conceiving the fountain was a practical one, namely how to make the mercury flow. The circulating action of the pumps, pipes, and reservoir had to be taken into account. After setting up the pumping system, it had to be hidden under the floor and the adjacent stairs. Three metal plates were to be fashioned – Calder called them "dynamic" shapes – to maximize the action and surface area of the mercury. Pumped to a height of 76 cm (30 in.) from the center of a circular pool, the mercury made its way down three terraced levels. Calder presented his model to Sert for approval.

After this point, Calder worked on the full-scale fountain in situ at the pavilion and began to improvise. He was told that only glass and polished steel could withstand the corrosive action of the mercury. Once Calder saw the coating of pitch used to line the concrete basin, he began to envisage the design possibilities for the contrasting action of the silver against the black-painted metal. He built the supports to hold the low-lying plates in place. To increase height, Calder added a second pipe from the basin and suspended a tall rod from a ring attached to the end,[113] weighting it with a large paddle. It was positioned to interrupt the mercury stream just as it returned to the basin. To the upper end of the rod he attached another ring from which he suspended and balanced another, lighter rod. He weighted one end of this rod with a red metal disc. He then attached the word "Almadén," fashioned from a single piece of wire, to the highest point of the fountain. The mercury batting the paddle caused the wire word to move in a perpetual figure eight.

Calder was not mentioned in the first review of the pavilion that hailed the design of the architects Luis Lacasa and Sert as a "masterpiece."[114] Presumably, Miró would have regarded such anonymity as a sign of mastery, as in the days of medieval craftsmen. In the spirit of friendship, Calder donated the fountain to the Fundació Joan Miró, Barcelona, in 1971 and oversaw its installation in 1975 (fig. 140).

Summoning Miró

The prospect of transatlantic travel always provided a needed stimulus not only for Calder but also for Miró. In truth, Miró had dreamed of New York. Francis Picabia's images of New York as well as Marcel Duchamp's paeans to American plumbing had been associated with the future from the earliest days of the Dada movement in Barcelona. As early as 1917, a restless Miró, ready to extoll new Catalan painting, wrote to his friend, Enric C. Ricart, "Let's transplant the primitive soul to the ultramodern New York, inject his soul with the noise of the subway, of the 'el,' and may his brain become a long street of buildings 224 stories high."[115] Not surprisingly, Miró investigated opportunities for a commission among the skyscrapers of postwar New York. Aiding Miró's dreams in the 1930s, Calder sent alluring postcards of the Brooklyn Bridge, the East River Bridge, the Empire State Building, and the Statue of Liberty with passing zeppelin (fig. 71). By the 1940s the postcards arrived by airmail. Calder, sporting a Catalan beret, greeted Miró at La Guardia airport on 12 February 1947.[116]

It was expected that Miró and his family would come to America when their friends the Serts left Europe at the start of the war in 1939,[117] but in the summer of 1939 Sert and his wife arrived at Calder's doorstep in Roxbury without Miró. Instead, the Mirós were trapped in Europe, first in a rented cottage in Varengeville and later in Palma and Montroig where Miró painted, named, and dated twenty-three works on sheets of the same size in gouache and oil wash, which were connected, he said, by "momentum and mental state."[118] Against a subtle wash of colors, a wiry black line weaves an elaborate, indefinite journey, soaring upward to form chains of dots and crooked stars. The line changes the color of birds and personages it meets along the way. Amorphous tonal areas, balancing light and dark with strong shapes in primary colors, complete the composition of seemingly

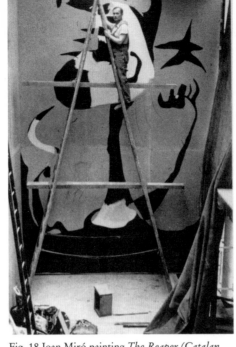

Fig. 18 Joan Miró painting *The Reaper (Catalan Peasant in Revolt),* Spanish Pavilion, Paris World's Fair, June 1937, photo Pierre Matisse

Fig. 19 Spanish Pavilion, Paris World's Fair, 1937

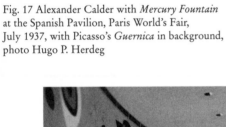

Fig. 17 Alexander Calder with *Mercury Fountain* at the Spanish Pavilion, Paris World's Fair, July 1937, with Picasso's *Guernica* in background, photo Hugo P. Herdeg

Fig. 21 Joan Miró and Alexander Calder in Varengeville-sur-Mer, August 1937, photo Paul Nelson

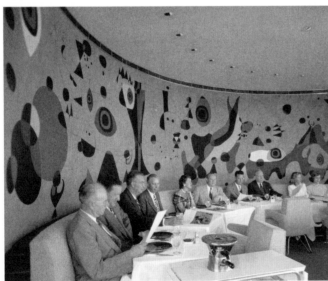

Fig. 20 Joan Miró, Cincinnati Mural (cat. 143) in Gourmet Restaurant, Terrace Plaza Hotel, Cincinnati, 1948, photo Ezra Stoller

Fig. 22 Terrace Plaza Hotel, Cincinnati, Skidmore, Owings & Merrill Architects, 1948, photo Ezra Stoller

endless and unique rhythms, to which Miró assigned poetic refrains (cats. 122–131). These paintings were sent by ship through Lisbon to the port of Philadelphia via diplomatic pouch in 1944 and were exhibited in New York at the Pierre Matisse Gallery in January 1945.[119] Convinced of their importance, Miró envisaged that these works, later known as "Constellations," would lead to large-scale images.

Though separated by geography and isolated by war, the two artists continued on parallel courses. Calder's last show at the Pierre Matisse Gallery in 1943 had introduced a new category of work with a Spanish word: "Constellaciónes."[120] Because of shortages of sheet metal during the war, Calder began to carve biomorphic shapes out of wood, in some cases painting them and positioning them on the wall in fixed wire structures (cats. 55–62). Calder's dreams of freedom – the grand model of the universe first visualized in his Sphériques – are apparent here, too. At Duchamp's suggestion, Calder devised ways to dismantle great elaborations on the mobile and the stabile, such as the floor-to-ceiling *S-Shaped Vine* (cat. 65), to fit into packages only two inches high and flown to Europe, to be reassembled for his first exhibition in postwar Paris in 1946.[121] Calder, who made his first transatlantic flight in June 1946, would have viewed Miró's arrival from Europe the following February to complete a mural commission as an equivalent gesture.

During the war Calder and Miró, who both enjoyed retrospectives at the Museum of Modern Art in 1941 and 1943, respectively, had become widely known and associated with one another. The exhibitions that made the artists prominent in the New York art world during the 1940s also resulted in a commission for each at the same site. Thomas Emery's Sons, Inc., built the new Terrace Plaza Hotel in Cincinnati, a nineteen-story brick-faced skyscraper designed by Skidmore, Owings & Merrill in 1946 (fig. 22). Miró received a commission for a mural to be installed in the hotel's Gourmet Restaurant on the nineteenth floor, Calder one for a mobile in the lobby of the eighth floor (figs. 20, 54).

Unlike the work for the Spanish Pavilion, neither Miró's nor Calder's Cincinnati commission was created on site. The final appearance of his work would not be known even to Miró himself until he began to work on the large canvas that was installed in Carl Holty's studio at 149 East 119th Street. Miró used the nub of a housepainter's brush to rub and scuff a surface of cerulean blue paint; he then

suggested shapes in charcoal. With the charcoal affixed to a long wand, Miró made long, sweeping movements like a dancer-skywriter zooming into the wild blue yonder – marking the blue surface, then dusting off the composition in three separate trials before deciding on the final version. Once attaining the balance of what Miró called "long monumental lines," he executed the final version in paint. As Holty observed, "He never sketched, he always knew exactly what he was doing."[122]

Calder similarly approached his Cincinnati commission without the need for reference to a sketch. The empirical process of cutting, filing, assembling, configuring, cutting again, hanging, and balancing, which by now had become second nature to him, resulted in the ten-foot mobile later called *Twenty Leaves and an Apple* (cat. 66). Its flickering contours reached across the bright, sleek corridor of the elevator reception area, providing a suitable transition to Miró's sonorous blue painting ten stories further up.

In 1952, when Miró saw his mural for the first time at the Terrace Plaza Hotel, the manager asked, "What does it represent?" Miró replied "Nothing."[123] Jean-Paul Sartre said much the same about Calder's mobiles. "His mobiles signify nothing, refer to nothing but themselves," he said.[124] The animated shapes of Calder's mobile, like the expansive, breathing composition of Miró's mural, were not intended to describe but to trigger associations. Calder likened the experience to a state of mind, namely "elation."[125] Not surprisingly, when Braniff Airways proposed in the 1970s that Calder paint their planes, both Calder and Miró were intrigued by the prospect of paintings that fly.[126] In 1977, when he wrote his last painting-poem for his departed friend (p. 309), Miró kept his gaze on the sky, the wide-open compositional field so integral to their greatest works: "Your ashes will fly to the sky, to make love with the stars. Sandy, Sandy...."[127]

In sum, in the vast scheme of things, does it matter that these two artists traveled the same road as friends? Calder and Miró's friendship did not forge a movement, but their free-floating shapes fostered a new level of communication at the crossroads of physics and poetry. Like Calder, Miró knew that reality does not remain still long enough to be accurately mirrored as a fixed or solid projection onto the picture plane.[128] From this shared understanding emerged a visual dialogue with lessons still valid today. Calder and Miró pointed the way to our increasingly

interconnected world with its hybrid media. The two artists wanted to go beyond painting and sculpture, and we witness the new spaces opened by the creativity and the passion of their work, pointing to the future. A postcard says it all: "I am working hard. Send photos."[129]

I would like to thank Elsa Smithgall, Susan Behrends Frank, and especially Leigh Weisblat for excellent research assistance. I am also deeply indebted to Merry A. Foresta for her thoughtful reading of this manuscript.

[1] Joan Punyet Miró, "Alexander Calder and Joan Miró: A Friendship, a Complicity," in Barcelona 1997, 166.

[2] See Callaghan 1979, 167; Turner 1996, 40; and Clay Spohn memoirs, papers.

[3] Calder 1977, 96.

[4] New York 1961; Miró poem in English cited in Rowell 1986, 255.

[5] Barbara Rose, "Joy, Excitement Keynote Calder's Work," *Canadian Art* 22, no. 3 (May/June 1965), 31.

[6] Canaday, "Calder and Miró," 1961.

[7] Schwartz, "Calder and Miró, Now Past 70, Feted in France," 1968.

[8] Calder 1977, 92.

[9] "Some Dancing Stars: Seen on Stage," *Vogue* (July 1926), 36; Elizabeth Hawes, "More than Modern – Wiry Art, *Charm* 9, no. 3 (April 1928); 47, 68. Hawes also wrote for the *New Yorker*, under the pen name Parasite.

[10] Hawes and Antheil had attended high school together in New Jersey, and Hawes may have met Miró through him. In 1927 Miró created stage designs for a ballet by Antheil.

[11] Berch 1988, 34–39.

[12] Breton 1972, 36.

[13] Calder 1977, 80.

[14] New York 1961.

[15] Calder 1977, 92.

[16] *New York Times* (3 April 1969).

[17] Rowell 1986, 71–72; Calder 1977, 79.

[18] 1927. See Victoria Combalía, "Miró's Strategies: Rebellious in Barcelona, Reticent in Paris," in Düsseldorf 2002, 48, quoted from William Jeffett, *Impactes: Joan Miró, 1929–1941* [exh. cat., Fundació Miró] (Barcelona, 1989); Jeffett refers to Maurice Raynal, *Anthologie de la peinture en France, de 1906 à nos jours* (Paris, 1927), 34.

[19] "'A Conversation with Joan Miró,' by Francesc Trabal, *La Publicitat*, 14 July 1928," in Rowell 1986, 96.

[20] Haskell, "Design in Industry or Art as Toy," 56.

[21] See Fineberg 1997, 138; and Hayes 1977, 76.

[22] Robert Desnos, *Cahiers d'art* 9, nos. 1–4 (1934), 26, quoted in New York 1941, 22, 26.

[23] Judi Freeman, "Miró and the United States," in Washington 1980, 39.

[24] Calder to Nanette and Alexander Calder, February 1927, Calder Foundation, quoted in Hayes 1977, 211.

[25] Hawes, *Charm*, 68; Calder scrapbook, Archives of American Art, Smithsonian Institution, Washington, D.C.

[26] Hawes, *Charm*, 47.

[27] New York 1943, 9.

[28] See discussion of straight and tense lines in Vicenç Altaió, "Autotext on Mobility (From Calder's Autobiography)," in Barcelona 1997, 185.

[29] Legrand-Chabrier, "Paris-Montparnasse et son cirque," *Patrie* (6 May 1927), Calder scrapbook, Archives of American Art.

[30] Calder, "What Abstract Art Means to Me," 8.

[31] Interview with Calder at Saint-Paul-de-Vence, *New York Times* (23 July 1961), quoted in Dore Ashton, "Calder," in Barcelona 1997, 174.

[32] Mikhail Bakhtin, *Rabelais and His World* (Boston, 1968), 4–8, 218, quoted in Hyman and Malbert 2000, 14.

[33] Combalía in Düsseldorf 2002, 41.

[34] Calder later literally fashioned earrings from these words.

[35] Bilbao 2003, 87.

[36] Calder 1977, 86.

[37] Letter written by Miró, 17 March 1964 (*Correspondence* 61).

[38] Alexander Calder, "Evolution," unpublished manuscript, 148.

[39] See Mildred Glimcher, "Calder in Paris: 1929–1933, Transformation from Object to Gesture," in Barcelona 1997, 181.

[40] Calder Typescript, January–February 1929, unpublished writings (vol. 3), 1, Calder Foundation.

[41] Calder Typescript, January–February 1929, unpublished writings (vol. 3), 1, Calder Foundation.

[42] Christopher Green, "Joan Miró, 1923–1933. The Last and First Painter," in Barcelona 1993, 75.

[43] Miró works from things that are seen. See Christopher Green's analysis of Miró's statements in Barcelona 1993, 69, and Sweeney, "Joan Miró: Comment and Interview," *Partisan Review* 15, no. 2 (February 1948), 206–212.

[44] See Dore Ashton, "Cosmos and Chaos at the Guggenheim," *Arts and Architecture* 81, no. 3 (March 1964), 6.

[45] Calder 1977, 113. Similarly, Miró spoke of a "shock" that initiated his creative process. "I begin my work under the effect of shock, which I can sense and which gets me on the run from reality.... In any case, I need a starting point, even if it's just a speck of dust or a gleam of light." See Sylvia Martin, "On the Readability of Signs: Miró's Path from Mysterious to Comic Pictorial Signs," in Düsseldorf 2002, 67.

[46] Letter to Albert Eugene Gallatin, 4 November 1934, discussed in Marter 1991, 103.

[47] "Home and street must be viewed as the city, as a unity formed by planes composed in neutralizing opposition that destroys all exclusiveness. The same principle must govern the interior of the home, which can no longer be a conglomeration of rooms – four walls with holes for doors and window – but a construction of planes in color and noncolor unified with the furniture and household objects, which will be nothing in themselves but which will function as constructive elements of the whole." From Mondrian's essay, "Home-Street-City," *i* 10 (January 1927), quoted in Marter 1991, 101.

[48] Calder 1977, 102.

[49] Alexander Calder, "Mobiles," in *The Painter's Object*, ed. Myfanwy Evans (London, 1937), 63. Margaret Calder Hayes later recounted in her book that Calder once told her he thought "best in wire." See Hayes 1977, 7.

[50] Calder, "What Abstract Art Means to Me," 8.

[51] The term "neoplasticism" was coined by Piet Mondrian and was first used in 1919. It gained currency in the 1920s and 1930s as a descriptive term applied to Mondrian's theories of art and to his style of painting.

[52] "The aim pursued by the new constructive plastic art is not an individualistic one Art has evolved parallel to the science, and today a purely

constructive aesthetic has been created, one free from the figurative formalism of the past; an abstract, plastic art, based on universal values, and on precise, mathematical laws." Jean Gorin, "The Aim of Constructive Plastic Art," *Abstraction, Création Art Non-Figuratif* 5 (1936), 9; ed. and trans. Stephen Bann, *The Tradition of Constructivism* (New York, 1974), 199–200, quoted in Marter 1991, 99–100.

[53] Hugnet, "Joan Miró: ou l'enfance de l'art," 336, quoted in Dupin 1962, 242.

[54] Mondrian, "Home-Street-City," quoted in Marter 1991, 101.

[55] Lluís Permanyer, "'Revelations by Joan Miró about His Work,' *Gaceta Ilustrada* (April 1978)," in Rowell 1986, 291.

[56] Permanyer in Rowell 1986, 291.

[57] Menand 2001, 200.

[58] See Isidre Bravo, "A Theatre Man Named Joan Miró" in *Miró en Escena* [exh. cat., Fundació Joan Miró] (Barcelona, 1994), 346–348, and Calder's statement in *Modern Painting and Sculpture* [exh. cat., Berkshire Museum] (Pittsfield, Mass., 1933), quoted in Marter 1991, 140.

[59] Fernand Léger, "Le Spectacle, Lumière, Couleur, Image Mobile, Objet-spectacle," quoted in Arnauld Pierre, "Staging Movement," in Washington 1998, 337.

[60] As it turned out, Calder did not obtain his work on a ballet through Miró. See Calder to Nanette and Stirling Calder, March 1932, Calder Foundation.

[61] Bravo in Barcelona 1994, 348.

[62] Calder, "Mobiles," in Evans 1937, 67.

[63] Bravo in Barcelona 1994, 347.

[64] Léonide Massine, "Joan Miró," *Cahiers d'art* 9, nos. 1–4 (1934), 50, quoted in Bravo in Barcelona 1994, 347.

[65] Letter from Miró to Sebastià Gasch, 23 February 1932, quoted in Bravo in Barcelona 1994, 347, 357 n. 27.

[66] Bravo in Barcelona 1994, 347. See also Film Archive, Lincoln Center.

[67] Shattuck, "Music and Mobiles," 1977.

[68] Virgil Thompson in Ruth Wolfe, "Calder's Set for Socrate," *The National Tribute to Alexander Calder* (10 November 1977), quoted by Pierre in Washington 1998, 344.

[69] Shattuck, "Music and Mobiles," 1977.

[70] Alexander Calder, "Mobiles," 64.

[71] I thank Susan Behrends Frank for bringing this distinction to my attention.

[72] "Calder's 'Mobiles' Are Like Living Miró Abstractions." *New York World-Telegram* (15 February 1936).

[73] "'Miró.' *The New York Sun* (8 December 1928)" in *The Flow of Art: Essays and Criticisms of Henry McBride*, ed. Daniel Catton Rich (New York, 1975), 244.

[74] Walter Gutman, "In the Galleries: Wire-Work Art." *Worcester Times* (21 May 1932). In 1937, at the time of the first Calder-Miró show, Calder made it clear to the reviewer that he preferred to be labeled a constructivist rather than a surrealist. See *Honolulu Star-Bulletin*, "At the Honolulu Academy of Arts" (29 May 1937). The previous year, Miró made his abhorrence of abstraction clear in an interview with Georges Duthuit; see Georges Duthuit, "'Où allez-vous, Miró?' in *Cahiers d'art* 11, nos. 8–10 (1936)," Rowell 1986, 150–151.

[75] Letter from Pierre Matisse to James Johnson Sweeney, 21 March 1934, Calder Foundation.

[76] James Johnson Sweeney, "Miró and Dalí," *The New Republic* 81 (6 February 1935), 360.

[77] Jean Hélion letter to Miró, dated 15 April 1933, Successió Miró.

[78] Calder, "Evolution," unpublished manuscript, 122.

[79] See L. Joy Sperling, "The Popular Source of *Calder's Circus: The Humpty Dumpty Circus*, Ringling Brothers and Barnum and Bailey, and the Cirque Medrano," *Journal of American Culture* 17, no. 4 (1994), 11.

[80] Calder 1977, 139.

[81] Altaió, "Autotext on Mobility (From Calder's Autobiography)," 185; Calder 1977, 139.

[82] New York 1961.

[83] Postcard from Calder to Miró, 20 June 1932, Fundació Pilar i Joan Miró. The object no longer exists, New York 1961. See *Correspondence* 6.

[84] Georges Duthuit, "Où allez-vous, Miró?" *Cahiers d'art* 11, nos. 8–10 (1936), 262, quoted in Martin in Düsseldorf 2002, 68.

[85] Letter from Calder to Ben Nicholson, 21 December 1934, Calder Foundation.

[86] "Nature. I haven't really touched machinery except for a few elementary mechanisms like levers and balances. You see nature and then you try to emulate it. But, of course, when I met Mondrian I went home and tried to paint. The basis of everything for me is the universe. The simplest forms in the universe are the sphere and the circle. I represent them by disks and then I vary them. My whole theory about art is the disparity that exists between form, masses and movement. Even my triangles are spheres, but they are spheres of a different shape." See "Alexander Calder," in Calder and Kuh 1962, 39.

[87] Calder 1977, 114.

[88] "You put a disk here and then you put another disk that is a triangle at the other end and then you balance them on your finger and keep adding. I don't use rectangles – they stop. You can use them; I have at times but only when I want to block, to constipate movement." See Calder and Kuh 1962, 39.

[89] Letter from Calder to Ben Nicholson, 21 December 1934, Calder Foundation: "I like the idea of synthesis."

[90] Paris 1933, 28.

[91] Paris 1933, 14, 16.

[92] Paris 1933, 16.

[93] New York 1993, 60.

[94] I thank Teresa Montaner at Fundació Joan Miró in Barcelona for showing me the preparatory sketches.

[95] Dupin 1962, 253.

[96] Dupin 1962, 253.

[97] "Objects to Art Being Static, So He Keeps It in Motion," *New York World-Telegram* (11 June 1932).

[98] See Kuh 1962, 41.

[99] Calder, clearly preoccupied by the issue of categories, had posed the question to his dealer: "Which am I?" Letter from Calder to Pierre Matisse, 22 October 1935, The Pierre Matisse Gallery Archives, The Pierpont Morgan Library, New York, copy Calder Foundation.

[100] Alexander Calder, "Comment réaliser l'art?" *Abstraction-Création, Art Non-Figuratif* 1 (1932), quoted in Bilbao 2003, 47. In a 1934 letter to Albert Eugene Gallatin Calder first told his story about meeting Mondrian in the context of his turn to abstraction. He said, "Mondrian made me abstract." See letter from Calder to Gallatin, 4 November 1934, quoted in Marter 1991, 103.

[101] Georges Duthuit, "Où allez-vous, Miró?" trans. in New York 1941, 13.

[102] *Correspondence* 14.

[103] Letter from Calder to his parents, 26 April 1937, Calder Foundation.

[104] Letter from Miró to Pierre Matisse, 25 April 1947, The Pierre Matisse Gallery Archives, The Pierpont Morgan Library, New York.

[105] Alexander Calder, "Mercury Fountain," *Stevens Indicator* 55, no. 3 (May 1938), 3.

[106] Tuchman, "Alexander Calder's Almadén Mercury Fountain," 98.

[107] Punyet Miró in Barcelona 1997, 169.

[108] Tuchman, "Alexander Calder's Almadén Mercury Fountain," 98.

[109] Based on her conversations with Sert, Freedberg asserts that Miró's choice of subjects for the murals were inspired by the anthem "Els Segadors." See Freedberg 1986, 543.

[110] Freedberg 1986, 551–552.

[111] Freedberg 1986, 473.

[112] Alexander Calder, "Mercury Fountain," *The Technology Review* 40, no. 5 (March 1938), 202; Calder, "Mercury Fountain," *Stevens Indicator* 3, 7. For a comparison of the two articles, see Tuchman, "Alexander Calder's Almadén Mercury Fountain," 102, 104.

[113] Freedberg 1986, 478.

[114] André Beucler, "Les Moyens d'Expression," *Arts et Métiers Graphiques* 62 (15 March 1938), 30–31, quoted in Sweeney, "Alexander Calder," 50, and in Tuchman, "Alexander Calder's Almadén Mercury Fountain," 98.

[115] Letter from Miró to Enric C. Ricart, 1 October 1917, quoted in Rowell 1986, 53.

[116] Miró statement cited in the foreword to Palma de Mallorca 1972, as quoted in Punyet Miró in Barcelona 1997, 171.

[117] Rose in Houston 1982, 5.

[118] Letter from Miró to Pierre Matisse, 4 February 1940, The Pierre Matisse Gallery Archives, The Pierpont Morgan Library, New York.

[119] See Lilian Tone, "The Journey of Miró's Constellations," *MoMA Magazine* 3, no. 15 (Fall 1993), 1–6, and Maude Riley, "New Temperas and Ceramics by Miró," *The Art Digest* 19, no. 7 (1 January 1945), 13.

[120] Henry McBride jokingly dubbed them in Spanish, "Constellaciónes." Henry McBride, "Attractions in the Galleries," *New York Sun* (21 May 1943). Coincidentally, in January 1943 Lockheed first tested the revolutionary *Constellation,* the passenger transport that carried Calder and Miró on their first transatlantic flights. I would like to thank Johanna Halford-MacLeod for bringing this information to my attention.

[121] The show was to be at Carré during the summer of 1946 but was postponed for unknown reasons until October. Calder 1977, 188.

[122] Carl Holty, "Artistic Creativity," *Bulletin of the Atomic Scientists* 15, no. 2 (February 1959), 78.

[123] Helen Detzel, "What Does Hotel Mural Show? 'Nothing,' Says Spanish Artist," *Cincinnati Times Star* (12 June 1952), Successió Miró.

[124] "Calder suggests nothing, he fashions real, living motions which he has captured. His mobiles signify nothing, refer to nothing but themselves: they *are*, that is all; they are absolutes....Although Calder has tried to imitate nothing – he has wanted to create only scales and harmonies of unknown motions – his works are both lyrical inventions and almost mathematical, technical combinations." Jean-Paul Sartre, "Existentialist on Mobilist: Calder's Newest Works Judged by France's Newest Philosopher," *ArtNews* 46 (December 1947), 22, 56.

[125] Selden Rodman, ed., "Alexander Calder," in *Conversations with Artists* (New York, 1957), 140.

[126] Daniel Lelong, Galerie Maeght, to Georges Gordon, Gordon & Shortt, Inc., 4 September 1979, copy Calder Foundation Archives.

[127] Joan Miró, "Foreword," in Barcelona 1977.

[128] Menand 2001, 200.

[129] This message is conveyed in various ways in the correspondence: see *Correspondence* 3, 28, 30.

"JE VAIS T'EMPORTER EN AMÉRIQUE. PRÉPARE-TOI": A LONG ROAD TO MONUMENTAL DIMENSIONS – BEYOND PAINTING

Oliver Wick

Exuberant over his first public success,[1] Alexander Calder made the above announcement to Joan Miró in 1929, probably in June, shortly before embarking for New York (fig. 70).[2] With obvious resolve Calder struck out the polite form of address, "vous," and replaced it with the familiar "toi." Some time would pass, however, before Miró could actually go to America; the success of his art would long precede him there.[3] Ever since their first meeting in 1928, in Paris, there was a complete mutual understanding between Calder and Miró, as Miró would later touchingly confirm: "We loved each other immediately. He was a wonderful friend."[4]

They envisaged great things, and the world between Paris and New York – not to mention Barcelona, Montroig, and Palma de Mallorca – lay at their feet. Formality could be dispensed with, and mutual support in their forthcoming transatlantic "campaign" was ensured. The two artists shared their social contacts and friends as a matter of course. The first two decades of their friendship were marked by collaboration on two significant public projects, for the Spanish Pavilion at the Paris World's Fair in 1937[5] and, then ten years later, for the Terrace Plaza Hotel in Cincinnati. It is important to note that the creations of Calder and Miró were aesthetically autonomous rather than collaborative efforts in the narrower sense. Yet both artists, if out of different motivations, shared an attempt to achieve a new dimension, to surpass classical genres and norms, as well as a tendency to monumentality and hence an awareness of lending aesthetic form to an overall space.

The commission from the Spanish republic, a mural for its pavilion at the Paris World's Fair, was significant for Miró in two respects.[6] First, it provided an opportunity to react to the horrors of the Spanish Civil War, which in late 1936 had driven him with his wife and child into exile in Paris and had triggered a

temporary creative crisis. Second, it represented Miró's first chance to execute a public mural. The theme of the painting, *The Reaper (Catalan Peasant in Revolt)* (figs. 28, 109),[7] was drawn from a work of the mid-1920s, yet this time Miró employed expressive distortion to convey a political message: "I wanted to represent the revolt of the Catalan farmers."[8] A design for a postage stamp, likewise commissioned by the republic, was reproduced in a special edition and published in *Cahiers d'art* (fig. 108);[9] it appealed to the viewer with the caption "Aidez l'Espagne" and set the "immense creative resources"[10] of the Spanish people against the dark powers of fascism. This type of purely artistic reaction to political circumstances began as early as 1934, with Miró's first so-called "Peintures sauvages." His explicit use of such pictorial means as coarse painting supports and harsh color contrasts, and a visibly increased emphasis on the paint substance itself, resulted in a straightforward visual vocabulary.[11] When he said, "I believe it will transport you into a world of *real unreality*," Miró summed up the changes his art had undergone in reaction to the political situation.[12]

His enormous mural, painted on six conjoined Celotex panels, reflected Miró's affinity with Catalan romanesque murals.[13] This was part of the work's political statement, since cultural goods rescued by Catalan militia from destruction in the civil war had already been exhibited in Paris in spring 1937.[14] In addition, the painting emphatically demonstrated the way Miró equated the picture surface with a wall, whose particular qualities served as a source of pictorial impulses. The soft texture of the support provoked a "shock effect," in the sense that even a particle of dust or a tiny imperfection could spark the creative process: "A piece of thread, therefore, can unleash a world."[15]

The painting was executed directly on the wall. "I attacked it right there, at the risk of falling off the scaffolding and breaking my neck" (fig. 18).[16] Unity of painting and architecture was important to Miró because he was increasingly convinced that painting could have an effect on the masses only in combination with other artistic disciplines, as a collective effort – that is, through individual works that merged into an overall context. A decreased emphasis on individualism was another aspect in Miró's striving to move beyond the easel picture and advance into a supraindividual, universally valid sphere beyond painting.

The literal equation of picture and wall was already anticipated in the key painting *The Farm*, 1921–1922 (fig. 23), in which the heightened realism of Miró's early style found its culmination. Later comments by Miró underscored and idealized the meaning of the wall. In conscious deference to the *primitifs catalans* and for reasons of pictorial equilibrium, the front wall of the main building was covered with painstakingly rendered cracks and fissures.[17] In a pointed and mocking reply to the surrealists, it was not dreams but hallucinations caused by hunger that subsequently conjured up, on the bare studio walls, forms Miró translated into paintings, as he would later explain the emergence of *Carnival of Harlequin* (cat. 83).[18] Considering Miró's meticulous and intellectual approach, it was only a small step to the entirely empty, brown or blue picture grounds that determined his art from the mid-1920s onward. "Childhood and magic are married in this poem inscribed in infinity, like traces on walls or cracks in venerable walls, superimposed posters lacerated by wind, rain, and poetry; calligraphy and ideograph intermerge in this equation...in this sign."[19] The canvas itself is understood as a wall, a surface whose highly physical treatment leaves traces that now become the point of departure for the painting. The image arises out of itself, out of the process, the traces of the brush and the paint rubbed into the surface with a rag, the splattering and pouring, the marks of the stretcher bar gradually showing through – in short, out of the accidents produced by every conceivable mode of working.[20]

The epoch-making painting *The Birth of the World* (cat. 85, figs. 24, 25) exemplifies this development. It is foremost a wall surface that has become a picture, especially in terms of sheer size, and only then also a field or space. Only in a very superficial sense is it an example of automatism. Miró did not make his sketches public until later, and then only hesitantly. Here they show an unspectacular erotic "graffito" of an ejaculating mannikin,[21] emphasizing the literal equation of the painting as a drawing on a wall. It was very much part of Miró's tactics and symbolic wit that he spoke, not without irony, of "a sort of genesis,"[22] and accordingly maintained an eloquent silence when the picture's first collector titled it *The Birth of the World*.[23] This is a self-generating, pure painting and, with an unmistakable stab at the surrealists, a brilliant "masturbation" that engenders the imagery.[24] "Painting of the most pure ... so pure that it mocks mockery."[25]

The treatment of painting as a wall was the prerequisite for the next steps, which led to paintings in a spatial context and, finally, to true murals such as that for the Spanish Pavilion. With the eighteen "Peintures d'après collages," presented by Pierre Loeb at the Galerie Georges Bernheim in Paris in October/November 1933, Miró established his new working procedure in a series, launching for the first time an extensive sequence of large formats (cats. 107–112, figs. 14, 26).[26] It was probably the overwhelming impression of this space as a whole that prompted Miró to speak of a success and a turning point in his career.[27] The new compositions were based principally on illustrations of machine parts or appliances, cut out and made into collages (figs. 13, 15). Miró had arranged this series of collages on the walls of his small Barcelona studio, to "provoke chance" and to derive further forms from their "motifs of action."[28] From these visual associations emerged painting after painting, lucid and pure.[29] The intrinsic cohesion and spatial effect of the "Peintures d'après collages" now led to the artist's first true mural commission, entirely in the French tradition of "décorations" – paintings in the context of an architectural whole.

Probably as early as the summer of 1933, Miró's French dealer, Pierre Loeb, asked him to create decorations for his children's nursery: *Murals I-II-III* (cats. 114 a–c, figs. 30–32).[30] Loeb's commission was likely prompted by the impression of the new paintings Miró had brought to Paris at the end of June, and by Georges Hugnet's recently published book, *Enfances*, illustrated with three Miró etchings.[31] While the approach of the murals relies strongly on the "Peintures d'après collages," the figures exhibit a greater playfulness and thus an affinity both with the etchings and with small pictures on wood done in the latter half of 1932 (cats. 103, 104). Miró's set designs for *Jeux d'enfants*, a production by the Ballets Russes de Monte Carlo (figs. 6, 9, 62),[32] especially the general subject and the costumes, likewise reverberate in these decorations. They were conceived as a frieze extending between the ceiling and the upper edge of the wall coverings, along all four sides of the room. Yet since Miró was unable to work on site, misunderstandings apparently existed about the dimensions. A fourth, "empty" panel is lost. Whether the paintings were ever actually installed in the children's room remains unclear.[33]

Fig. 23 Joan Miró, *The Farm* (detail), 1921–1922, oil on canvas, 132 x 147 cm (52 x 57 ⅞ in.), National Gallery of Art, Washington, gift of Mary Hemingway

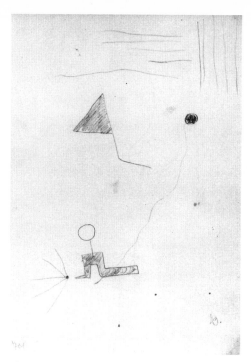

Fig. 24 Joan Miró, preparatory sketch for *The Birth of the World* (cat. 85), 1925, pencil on paper, 26.4 x 20 cm (10⅜ x 7⅞ in.), Fundació Joan Miró, Barcelona, FJM 701

Fig. 25 Joan Miró, revised sketch for *The Birth of the World* (cat. 85), 1944, pencil on paper, 27.2 x 20.5 cm (10¹¹⁄₁₆ x 8¹⁄₁₆ in.), Fundació Joan Miró, Barcelona, FJM 2621

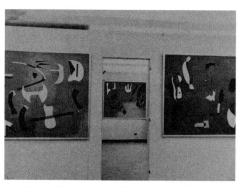

Fig. 26 Installation view of *Joan Miró: Paintings*, Pierre Matisse Gallery, New York, 1933–1934, with "Peintures d'après collages" (cats. 109, 111)

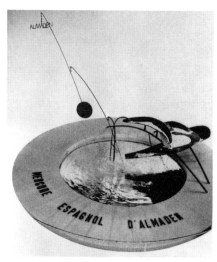

Fig. 27 Alexander Calder, *Mercury Fountain*, Spanish Pavilion, Paris World's Fair, 1937, photo Herbert Matter

Fig. 28 Joan Miró, *The Reaper (Catalan Peasant in Revolt)*, 1937, oil on Celotex, 550 x 365 cm (18 ft. ½ in. x 11 ft. 11 ¾ in.), work lost

Fig. 29 Teeny Matisse with Francine and Paul Nelson in the Nelsons' house at Varengeville-sur-Mer, in front of Joan Miró's wall painting, 1938

Four designs for tapestries, done for Marie Cuttoli in the fall and winter of 1933–1934, likewise relate to the "Peintures d'après collages" and must be seen in the context of the "murals." These were, however, created in a new spirit of freedom, which was already evident in a painting given to Calder (cat. 113). No preliminary drawings for them have come to light. In terms of format, the designs even surpass the painting series, daring for the first time to approach the "grand format" of *The Birth of the World*.[34] Evidently Miró intended to reply here, in his inimitably literal way, to criticism that had been leveled against him.[35] In a review of the Bernheim show in fall 1933, the author maliciously described the artist's liberated painting as follows: "We see ourselves confronted with pure abstraction. Small problems and highly obscure subjects are, if you will, always grand in intention, and the layman would casually and quite undisparagingly trample on them if they were to serve as carpet motifs."[36] The tapestry designs for Marie Cuttoli can therefore also be read as an attempt at self-defense on Miró's part and as a statement of his position.

These works, known collectively as "Peinture,"[37] should be understood precisely not as abstractions but as pure, self-contained painting that neither illustrates nor abstracts. Here Miró overcame easel painting, which he viewed as being trammeled by utilitarianism. From this point on, the painting process itself rather than the making of pictures would determine his artistic activity. A positive press reaction to the Bernheim exhibition provided the keynote: "Miró's painting commences where painting stops and poetry begins."[38]

Alexander Calder's seemingly incidental collaboration on the Spanish Pavilion, leading to his extraordinary *Mercury Fountain* (figs. 17, 27, 61) and, like Miró's murals, the first significant public commission of his career, was based on different premises. In June 1933, shortly before Calder gave up his Paris domicile, a change in his work became apparent. Calder's visit to Piet Mondrian's studio in 1930 had caused a creative shock, and, besides the wire sculptures and the *Cirque Calder* (cats. 2, 5, 7, fig. 2, p. 88), unprecedented abstract, movable or motorized sculptures began to emerge (cats. 17–20, 23, fig. 60). These were based on translations of celestial mechanics, "the system of the Universe."[39] In 1931 Calder joined the Abstraction-Création group, and his works prompted Marcel Duchamp and Jean

Arp to coin the terms "mobile" and "stabile" to describe them. Yet the surrealist practice of working with found objects would remain a latent point of reference, and a confrontation with Miró's "Peintures d'après collages" reminded Calder of his own sensibility and procedures. The biomorphic shapes that came to Miró when viewing his collages in a trancelike state[40] now began to appear in parallel in Calder's work, gradually leading him away from a perhaps all too rigid geometry and back to natural forms. Moreover, Miró's critical distance from every type of theorizing and artistic grouping would not have gone unnoticed by Calder. In 1936 Miró declared his independence firmly and in purposely provocative terms: "Have you ever heard of anything more stupid than 'abstraction-abstraction'? And they ask me into their deserted house, as if the marks I put on a canvas did not correspond to a concrete representation of my mind, did not possess a profound reality, were not a part of the real itself!"[41]

This shift in emphasis was already clearly reflected in the first review of Calder's art in *Cahiers d'art*. Chance, the author wrote, now liberated motion from mechanical schemes and lent it "plus d'élasticité, plus de naturel" (more elasticity, more naturalness),[42] surely a reference to the singular work *Cône d'ébène* with its definite tendency to monumentality (cat. 21). Calder himself spoke in similar terms, describing the conditions that would lead to his Constellations (cats. 55–62) in the early 1940s. "There wasn't much metal around during the war years, so I tried my hand at wood carving in the so-called constellations. I have always liked wood carving, but these were now completely abstract shapes. The shapes, as well as the titles, came from Miró,...they had for me a specific relationship to the *Universes* I had done in the early 1930s."[43]

These were impulses that lent new meaning to the qualities inherent in Calder's art. The two formal tendencies, geometric and biomorphic, ran parallel and gradually merged into a new sculptural configuration, as seen in the panel and frame objects (cats. 29, 31). Calder's related avant-garde stage projects, in which he also began to incorporate motion, can be referred to only in passing.[44] The surrounding space now increasingly became the foremost aspect of his sculptures. New circumstances in the artist's life played a role, namely the purchase of an old farmhouse in Roxbury, Connecticut, in August 1933, which opened up possibilities

Fig. 30 Joan Miró, preparatory drawing for *Mural I* (cat. 114a), 1933, pencil on paper, 23.5 x 63 cm (9¼ x 24¾ in.), Fundació Joan Miró, Barcelona, FJM 1412

Fig. 31 Joan Miró, preparatory drawing for *Mural II* (cat. 114b), 1933, pencil on paper, 23.5 x 63 cm (9¼ x 24¾ in.), Fundació Joan Miró, Barcelona, FJM 1413

Fig. 32 Joan Miró, preparatory drawing for *Mural III* (cat. 114c), 1933, pencil on paper, 15.3 x 53 cm (6 x 20⅞ in.), Fundació Joan Miró, Barcelona, FJM 1414

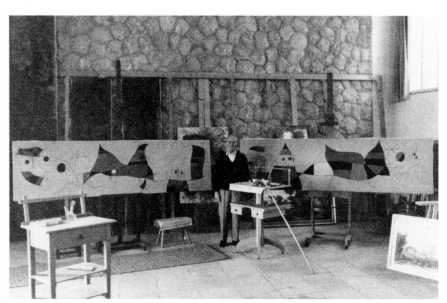

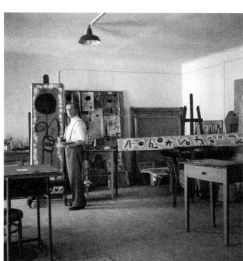

Fig. 34 Joan Miró in his Barcelona studio, next to his frieze *Women, Birds, Drops of Water, Stars* (Dupin 679), 1944, photo Joaquim Gomis

Fig. 33 Joan Miró in his Palma de Mallorca studio, designed by Josep Lluís Sert, flanked by 1964 murals (Dupin 1166, 1165) for his grandchildren, 1965, photo Varian Fry

for work on an unprecedented scale. The ample outdoor space immediately fired Calder's creativity, literally inviting first attempts to take sculptural possession of the open terrain, although at first his energies were largely channeled into repairing the dilapidated house.[45] As early as 1934 the first outdoor sculptures on a considerable scale appeared, elementally combining the force of the wind with the principle of the stabile from the Paris years. They were initially strongly reminiscent of turrets and weather vanes, as in *Untitled* and *Red and Yellow Vane*, but soon began to turn into autonomous sculptural form, as in *Steel Fish* (fig. 38).

Natural shapes began to inform the abstractions as forces and ordering principles, emphasizing certain qualities, and the titles provided points of reference for the viewer. The drawings that accompanied the sculptures with increasing frequency (figs. 41–46) brought this into clear focus. However, it is important to note that Calder's works were done without preliminary drawings, emerging freely and directly from the material. Only after the fact were drawings made, which served as a means to explain his ideas, clarify his installation instructions, or simply as illustrations. Soon Calder received his first commission for a mobile in a garden.[46] For a well head on the property of James Thrall Soby he designed a gigantic mobile mechanism to bring water to the surface; for some time this would remain his most audacious outdoor sculpture (fig. 37).[47] With *Devil Fish* and *Big Bird* (cats. 33, 32), 1937, came the first stabiles assembled with bolts, anticipating the large-scale sculptures of Calder's later career. Small maquettes (cat. 27), placed directly below *Big Bird* in a show at the Pierre Matisse Gallery in New York (figs. 16, 40),[48] were intended to encourage collectors to order large-scale stabiles. A growing interest in collaboration with architects brought further commissions and pointed to Calder's future, all-encompassing conception of sculpture.[49] With a heightened awareness of the potential of large-scale sculpture Calder and his family returned to Paris in April 1937, after a four-year absence.[50]

The actual reason for this journey is not known. Surely a desire to renew ties with his artist friends in Paris played a role. In addition, the forthcoming World's Fair was gradually becoming a general focus of artistic production. Calder rapidly made contact with Miró, who had just received his mural commission, and went with him to inspect the construction site.[51] Seeing the just-started pavilion he soon

discovered a few spots – tellingly all outdoors – where a mobile would be effective.[52] Although he could by no means speculate on receiving a commission, Calder's reaction shows how conscious he was of the possibilities for his art in an architectural context and that he was actively looking for such projects. The request, finally, to design a fountain for the Spanish Pavilion (fig. 17) because a fountain in historical style from a previous exhibition did not conform with the modern conception of the architect, Josep Lluís Sert, was a very effective "going public" for Calder. Apart from the economic and political significance of the material he used for the fountain, namely mercury, and the importance of the mercury mines of Almadén in war-torn Spain,[53] Calder created a singular masterpiece by lending the alchemists' substance delightful, dripping movement (figs. 61, 143). The politically charged name "Almadén," formed of wire and suspended as if on a silk thread, danced precariously (fig. 27). Effortlessly Calder had created an apt metaphor for the approaching catastrophe of the Second World War. Not least because of its wide public impact, Calder's *Mercury Fountain* can be called a decisive turning point in his career.[54]

A restful summer followed at Varengeville-sur-Mer among his friends, including Miró and the architect Paul Nelson (figs. 21, 111).[55] In a recent essay Nelson had praised the spatial quality of the new painting and sculpture, which would be shown to best effect only in a corresponding architectural setting and therefore would require not art dealers in the future but "dealers in architecture"; this in turn helped more precisely define Calder's newly gained awareness.[56] After having made do with a series of improvised studios – rooms, small shops, garages – Calder would begin building a large studio after his return to Roxbury in the fall of 1938 (fig. 39, p. 256), moving in during the spring of 1939.[57] The topic of an art that would be integrated in architecture and the concomitant desire to have a spacious studio were very much in the air during this shared summer of 1937.[58] Statements made a short time later by Miró are a case in point. As early as March 1938 he declared that he could hardly wait for the day when he would finally have a large studio, "which is the first thing I want to take care of."[59] This was soon followed by his famous article, "Je rêve d'un grand atelier," describing his increasingly oppressive situation in Parisian exile (fig. 113).[60] Ideal lighting conditions in the studio were not as important to him as having sufficient space to pursue his diverse

projects and explore new media such as sculpture, pottery, and printmaking. The ultimate objective was "to try also, inasmuch as possible, to go beyond easel painting, which in my opinion has a narrow goal, and to bring myself closer, through painting, to the human masses I have never stopped thinking about."[61]

In 1939 Calder was commissioned by the Museum of Modern Art in New York to produce a mobile for the stairwell of its new building. *Lobster Trap and Fish Tail* (fig. 36) fully established his reputation as an artist for the public space.[62] Numerous projects followed, including an unexecuted outdoor sculpture for Washington, D.C., connected to the stabile *Spherical Triangle* (cat. 38),[63] and collaboration on the redesign of the African habitat at the Bronx Zoo. Calder's friend, the architect Oscar Nitzschké, included him in the planning, which was conducted by the Wallace K. Harrison office.[64] Calder designed tree mobiles for the lion enclosure, including the filigree *Four Leaves and Three Petals* (cat. 41). This slightly exotic idea was never to be executed in monumental scale, although a further project for Harrison, a mobile for the ballroom of the Hotel Avila in Caracas designed in 1941 (cat. 49), was realized. This was Calder's first work for a public building that was not primarily devoted to an artistic purpose.[65] With *Black Beast*, 1940 (cat. 45, fig. 64), Calder further developed the idea of monumental stabiles, in this case without a commission, as a sort of "journeyman's piece" at his own expense. It was also one of the first examples in which he cooperated with specialist metalworkers, who executed the large-scale piece on the basis of a miniature maquette.

An intriguing aspect of these early projects for large-scale sculptures and his more frequent collaboration with architects was Calder's approach to size and monumentality. Small sculptures made for architectural models were the basis for miniature mobiles and stabiles (cat. 73), whose tiny size made them especially popular.[66] Photographed outdoors in the 1940s by Herbert Matter, set on a pedestal seen from the front and looming against the horizon (fig. 35), these pieces reflected a sculptural thinking in which monumentality was present even on the smallest scale. Size, in the sense of a measurable relationship between large and small, was thus negated in favor of a dimension that Calder himself once presciently described as "grandeur-Immense."[67]

The artistic contribution to the Spanish Pavilion had reverberations in Miró's work as well, not only in the wish for a larger studio and his striving to overcome easel painting but also in a desire for further opportunities for projects. Pierre Matisse, who also spent the summer of 1937 in Varengeville, commissioned Miró to decorate his children's nursery, a direct reaction to Miró's recent activities.[68] Matisse had every reason to keep Miró in good spirits because of discussions since 1936 about renewing his contract, which regulated the division of Miró's annual production between Matisse and Pierre Loeb.[69] In view of Loeb's similar commission of 1933, Matisse's idea for the children's room appears to have been a strategic one. Yet one cannot help asking whether Miró's art, even in the eyes of his committed dealers, was truly suitable only for children's rooms and not, for example, also for living rooms. The question apparently did not concern Miró, who maintained what would become a pictorial tradition by later painting friezes for his grandchildren (fig. 33).[70]

After his experience with the nursery for Loeb, the artist insisted this time on exact specifications. Although he did receive a plan, execution was delayed by some uncertainties.[71] It was not until the following August, in 1938, that Miró announced the stretchers and canvas "for the frieze in the children's room" were ready and he could begin work.[72] By September, in the midst of a period of international political disasters – "terrible days with a frightening nightmare" – the painting was already finished, although not dry in places.[73] Miró requested that it be exhibited at Galerie Pierre before being shipped and installed.[74] His self-confidence had increased since the first mural of 1933. Regardless of the circumstances of his commissions, he wanted his works to be seen by as large an audience as possible before they were installed in their final surroundings.[75] The exhibition of the painting in Paris was a success: "Picasso was wild about it and said it was one of the best things I had ever done."[76] Miró was aware that his imagery for the room was strongly influenced by the drama of the period, but hoped the children would grow used to it and come to love it.[77] It was important to him to know whether the picture made "the whole room look just right," or whether it was necessary to "fill in some other corner."[78]

Probably concurrently with the commission from Matisse the idea occurred to Miró to do a mural for Paul Nelson's house in Varengeville, painted directly on

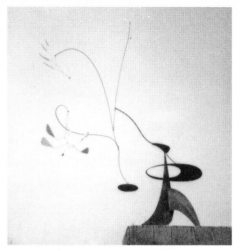

Fig. 35 Alexander Calder, *Bougainvillier* (cat. 70), 1947, photo Herbert Matter

Fig. 36 Alexander Calder, *Lobster Trap and Fish Tail*, sheet metal and wire, height 290 cm (116 in.), in the stairwell of the Museum of Modern Art, New York, 1939

Fig. 39 Alexander Calder in his Roxbury studio, 1944, photo Eric Schaal

Fig. 38 Alexander Calder with *Steel Fish*, 1934, Roxbury, photo James Thrall Soby

Fig. 37 Alexander Calder, sculpture for well head at James Thrall Soby's home, Farmington, Connecticut, 1936

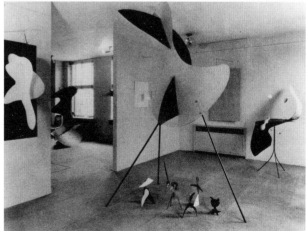

Fig. 40 Installation view of *Alexander Calder: Stabiles and Mobiles*, Pierre Matisse Gallery, New York, 1937, with *Big Bird*, maquettes, and *Cello on a Spindle* (cats. 32, 28), photo Herbert Matter

a wall for the first time (fig. 29).[79] Nelson's interest in art in its spatial environment made him an ideal patron, and his vacation house was a perfect place to experiment. In the fall of 1938 Nelson exhibited his futuristic project for a "Maison suspendue" with Loeb.[80] Jean Arp, Fernand Léger, and Miró intervened artistically by adding sculptures and murals to the model that would lend the rooms "a sensation of poetry and freedom from all dogmatism."[81] Nelson was concerned with the age-old issue of the unity of the arts. "Miró, in attacking the problem of the model, regarded it as a 'landscape' in which the ramp is treated as a flower and the ceiling under one of the study rooms is painted blue as the sky."[82]

At the house in Varengeville the wall truly became a painting for Miró, and his approach corresponded to the tradition of romanesque painting in technical terms as well. From his Easter vacation in 1938 he wrote: "I wanted to attempt a mural painting in Nelson's dining room that could turn out to be interesting."[83] The work was likely finished in the summer, or at the latest in early fall.[84] Miró painted all four walls of the room, from baseboards to ceiling. The rough, randomly textured wall, covered with a special waterproof skim coat,[85] provided the background and painting support for a small number of figures and shapes that were rendered in large areas of black and white and sparingly accented in red and apparently blue. In an impressive way, the equation of wall with painting resulted in pure mural painting. This literal *peinture murale* on the rough wall anticipated the paintings on ceramic tiles Miró would begin in the 1950s (fig. 131), and the free wall-drawings he would make in his later sculpture studio, Son Boter (p. 276). As a spatial ensemble, the project was destined to remain singular.[86]

As war grew ever more imminent, Miró's art, like Calder's, tended increasingly to miniaturization. Although Miró was still concerned with large formats (cats. 116, 117), he had already formed a clear conception of the next phase of his career with its small paintings.[87] After his move to Varengeville in August 1939, tiny pictures were done on a raspberry-colored ground, followed by a series on heavy raw burlap (cats. 119–121),[88] whose texture was not all that different from that of the walls in Nelson's house. These were succeeded in January 1940 by a series of gouaches on paper, 38 x 46 cm (15 x 17 ⅛ in.) in size, which later became known as the Constellations (cats. 122–131, fig. 65).[89] Their grounds emphasized material

substance in "highly agitated, roiled painting."[90] This, in common with the irregular, random texture of walls, became the suggestive point of departure for Miró's imagery. The grounds were thoroughly prepared by rubbing the brush clean over them, working the paint right into the paper, scumbling it or even scouring it off. Further layers in other media – watercolor, tempera, or pastel – were to follow.[91]

Miró had just finished two Constellations when he wrote to Pierre Matisse, "I feel it is one of the most important things I have done, and even though the formats are small, they give the impression of large frescoes."[92] The force and cohesiveness of this series, its density, its juxtaposition of small format and visual cosmogony, would echo for a long time in Miró's art, especially in the 1945 compositions on white, black, or gray grounds (cats. 133–140). In his working notes of the early 1940s he had already intended to keep the Constellations in mind when drawing, not to neglect the evocative energies of cleaning brushes, and, when preparing the ground, to strive for a "fresco substance." This led to techniques that can only be described as physical attacks on the canvas: "rubbing in with a handful of straw, with a rag, a scrubbing brush, a Majorcan brush for applying white, with the hand, etc...."[93] In part his ideas even exceeded the works themselves, for instance when he spoke of a free, spontaneous drawing in a "gigantic rhythm like that of a waterfall cascading down a mountainside" (p. 276), and reminded himself to use, in a future group of works based on "pure signs begun in Varengeville and finished in Palma," a picture ground like the "blue vitriol [a pesticide] that they use for the vines and that splashes against the walls of the farmhouse."[94]

Although the series envisioned here was never executed, it formed the intellectual background for the Cincinnati Mural (*Mural Painting for the Terrace Plaza Hotel*, cat. 143). These free-flowing trains of thought restated the idea to "think, in a certain way, of the power and severity of romanesque paintings."[95] An important source of inspiration, and indicative of Miró's state of mind at the time, were the "pure realizations" of visual thinking he mentioned in the same breath: "Go to the beach and make graphic signs in the sand...draw by pissing on the dry ground, design in space by recording the song of the birds, the sound of water and wind... and the chant of insects...."[96] The artist, disillusioned by war, hoped these images or expressions of an ephemeral poetic force would speak directly to people's hearts.

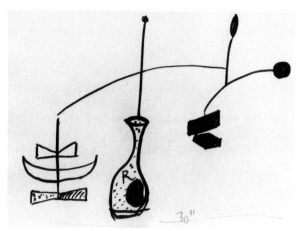

Fig. 41 Alexander Calder, *Untitled (Constellation)* (cat. 55), 1943, ink on paper, 15.1 x 22.7 cm (11 x 8 ½ in.)

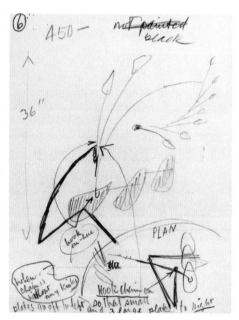

Fig. 42 Alexander Calder, *Wheat* (cat. 54), 1942, pencil on paper, 27.9 x 21.5 cm (11 x 8 ½ in.)

Fig. 43 Alexander Calder, *Red Post, Black Leaves* (cat. 48), 1941, pencil and red colored pencil on paper, 27.9 x 21.5 cm (11 x 8 ½ in.)

Fig. 44 Alexander Calder, *Wooden Bottle with Hairs* (cat. 61), 1943, ink on paper, 22.7 x 15.1 cm (8 ¹⁵/₁₆ x 6 in.)

Fig. 45 Alexander Calder, *Constellation with Quadrilateral* (cat. 59), 1943, ink on paper, 15.1 x 22.7 cm (5 ¹⁵/₁₆ x 8 ¹⁵/₁₆ in.)

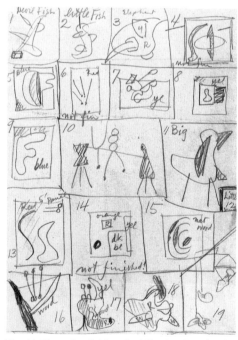

Fig. 46 Alexander Calder, checklist drawing (detail), *Alexander Calder: Stabiles and Mobiles*, 1937 (cats. 29, 25, 32, 28), pencil and blue and red colored pencil on paper, 57 x 22.6 cm (22 ½ x 8 ⅞ in.)

All drawings on this page are in The Pierpont Morgan Library, New York, Pierre Matisse Gallery Archives, MA 5020

With the Cincinnati Mural these ideas came to full fruition, and Miró's life-long friendship with Calder experienced another moment of intimacy, of a kind that the years after the 1950s, during which both artists experienced stupendous success, would no longer hold in store. Even though their shared affinity for a designed environment would bring their works together several more times – at UNESCO in Paris in 1957–1958 (figs. 131, 132); in the gesamtkunstwerk that the Fondation Maeght represented in Saint-Paul-de-Vence, in 1962–1964 (fig. 135); and in La Défense in Paris in 1978 – the circumstances of the commissions were not comparable. In Cincinnati in 1947, as in the Spanish Pavilion, Calder and Miró worked together on a common project, yet their respective pieces could not be viewed together. The Terrace Plaza Hotel (fig. 22), built in the International Style by Skidmore, Owings & Merrill for Thomas Emery's Sons, combined the most advanced technology with a new conception. The hotel was set back on a seven-story socle used for commercial purposes. An elevator led to the lobby on the eighth floor, where Calder's mobile hung (fig. 54). Miró's mural was let into the back wall of the circular Gourmet Restaurant projecting from the rooftop, which offered panoramic views (figs. 20, 55, 57).[97]

This commissioned work, and the first visit to America it entailed for Miró, reflected multiple strategies on his part and that of his dealer, Pierre Matisse. In addition, it fulfilled artistic aims that had long informed Miró's work. A 1946 list of desirable future works included "peintures murales à la fresque,"[98] indicating the persistence of the ideas contained in Miró's working notes of the early 1940s. His recently renewed contract with Matisse included a separate stipulation regarding "every commission, every decoration … etc.,"[99] the dealer granting him a free hand in accepting such orders so long as they did not preempt his regular production.[100] Beyond that, the two agreed that America was the land of the future, the reason Miró absolutely wanted to be personally present at the next exhibition. He expected a month, perhaps six weeks, would be necessary just "to make first contacts – except in case I have to execute some special work," and ultimately his art would profit from this "shock."[101] Much seemed to point to a large commission. Matisse, on the other hand, exponent of European art, found himself confronted with an increasing interest in American works and an "unfavorable spirit in the

art press,"[102] which declared the School of Paris dead: Europe versus America, a challenge to which Miró's fighting spirit could not help but rise.

Miró was very good at positioning himself, as shown by the legendary exhibition of Constellations he launched in New York in 1945, the first time that works by a European artist reached the American continent in the emerging postwar period.[103] Matisse, too, thought it was necessary to prove at "one fell swoop" that "Europe is not dead but, on the contrary, more active and vital than ever."[104] Considering these circumstances it is not surprising that the dealer, to whom Miró's wish was command,[105] offered him a solution in the form of a friend – John J. Emery and his hotel project. Emery "is in the process of constructing an immense building in Cincinnati, part of which is reserved for shops and the upper part for a very nice hotel – on the terrace there will be a very exclusive restaurant, where I suggested to him that a big painting might be installed – there will be no more than fifty seats. Enclosed you will find a plan with a few specifications. As you can see, the wall is circular. One could make the decoration in one or two sections on canvas, mounted on curved wood panels."[106] The proposal was worked out to the last detail, with Miró's desires in mind, and the question whether he was interested seemed merely rhetorical. His affirmative reply thus could not have been more laconic: "The mural painting excites me, too bad one can't do a fresco!" In keeping with his previous experiences, Miró insisted on executing the work on site, since "every mural must be done in view of the surroundings and in close collaboration with the architect."[107] With the unusual and amicable trust that marked his relationship with Matisse, Miró left the price and contract negotiations to his brilliant dealer.[108] It was agreed that the decoration plans soon be made public, in order to arouse interest in further commissions of a similar type.[109]

Travel preparations, difficulties related to more stringent visa and export regulations, and negotiations with the contractor, Thomas Emery's Sons, all needed quick attention. Besides Miró, four or five other artists were still to be chosen. No names were mentioned, not even Calder's.[110] By December everything seemed under control,[111] and on 12 February 1947 Miró flew with his family from Lisbon to New York. Before setting off, he precisely described the working procedure he intended to use on the mural: "Decoration. Very rapidly executed, at one go,

spontaneously. What takes a long time in my case is the work of silent reflection; it is impossible for me to predict the duration of this preparatory period. You have to keep in mind that it is by no means a matter of just doing a large picture, and though it will not be possible to paint a true mural by attacking the wall directly, in fresco, to do so will require persistence while maintaining, as much as possible, the spirit of the great tradition of mural painting. I shall have to go to Cincinnati in advance as soon as I can, to view the architecture and its environs, because otherwise I would only create an easel painting in large format."[112]

As this statement makes especially clear, it was not only Miró's previous work but ideas from his sketchbook that clamored for fulfillment here. Miró mentally girded himself for his most ambitious work ever, and even though, as had become obvious since the Constellations, sheer size played no role in the "qualité de fresque," the Cincinnati Mural was destined to remain the most monumental mural Miró ever painted on canvas. If working directly on site proved unfeasible, "the idea of working in Calder's studio in the country" seemed an excellent alternative to Miró, who wanted a place where he would not be disturbed.[113] As early as spring 1946 he had jokingly asked his friend whether he had "a corner in your studio where I could paint something for you," as thanks for Calder's Christmas gifts (fig. 121).[114] A card announcing his forthcoming arrival, with "a good smack on the butt for you from Joan,"[115] was enough to revive the old days in Paris. Calder arranged a warm reception for Miró and his family at La Guardia airport, but the Mirós did not arrive on the date he expected them: "I have spent a good deal of this week waiting for the arrival of Joan Miró and his family, by plane from Lisbon.... He did [not] come, nor did he send word explaining....Then there was another cable saying he would arrive Wed. eve. – so I drove the La Salle (open, top down) straight to La Guardia, and got there just in time. So we installed them in a little apt. on 1st ave (very nice), and then had a bite at Matisse's."[116]

At the end of March or the beginning of April, Miró traveled to Cincinnati with Matisse to inspect the construction site and the setting for his planned painting. In a studio on East 119th Street, rented from Carl Holty, he tacked up the building plan and a few photographs for inspiration (figs. 52, 67).[117] Especially striking was a view through the hotel's steel skeleton with the circular restaurant

structure perched on top (fig. 51). During Miró's visit a detailed contract with Thomas Emery's Sons was drawn up and signed a short time later.[118] A design sketch was to be submitted by 22 May 1947 at the latest to the contractors, who had a term of preclusion and the right to suggest alterations within seven days.[119] An architectural plan dated 10 April (figs. 49, 67),[120] however, already shows Miró's design sketch (fig. 48) entered in the vertical elevation; it was evidently finished long before the submission deadline. The deadline for the finished work was set at 1 September. Judging by the receipts for canvas and paints, Miró evidently commenced work on the mural in late May or early June.[121]

In the meantime, American audiences were prepared for Miró's innovative imagery by a show at the Pierre Matisse Gallery, opened in May, at which selected works from the period following the Constellations were exhibited for the first time.[122] The major works on view included *The Port* (cat. 138, fig. 66) and *Dancer Hearing an Organ Playing in a Gothic Cathedral* (cat. 137, fig. 124), as well as a first example of compositions on a white ground (cats. 133–136). Also shown for the first time were the sculptures Miró had begun as a respite from painting in 1944 and had cast in 1946 (cats. 144, 145, fig. 119).[123]

In view of the working process anticipated in Miró's notes, the finished Cincinnati Mural, not surprisingly, differed considerably from the sketch submitted. Its sparingly employed figurations and signs more strongly recall overall compositions like that of the Harvard Mural (*Mural Painting*), which would be executed in 1950–1951 (fig. 130). Only a small picture entitled *Women and Bird in the Night* (cat. 142), which was done in the context of the mural[124] and which Miró would exchange as a gift for Calder's *Black Polygons* (cat. 69, fig. 141), corresponded relatively closely to the first design. Otherwise Miró put the ideas of his working notes into practice and immersed himself for one last time in the spirit of the Constellations. This was especially apparent in the paintings on cardboard executed in New York, as if in mental preparation for his work on the mural (cat. 141). By means of rubbing with the brush he lent these truly preparatory works the character and texture of a plastered wall, which served as support for his figurations. Concerning external impulses, Miró would later mention the general impression that the landscape seen from the steel skeleton of the unfinished

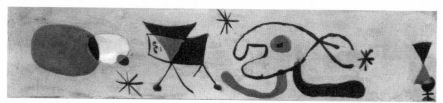

Fig. 47 Joan Miró, sketch of Cincinnati Mural (cat. 143) for a model by interior designer
Benjamin Baldwin, gouache and watercolor on paper, 8.9 x 38.1 cm (3½ x 15 in.), location unknown

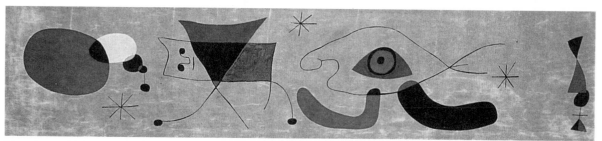

Fig. 48 Joan Miró, preparatory drawing for Cincinnati Mural (cat. 143), 1947, gouache, pastel, ink, and pencil on paper, 48.9 x 126.8 cm (19¼ x 49⅞ in.), Fundació Pilar i Joan Miró, Palma de Mallorca, FPJM 570

Fig. 49 Joan Miró in Carl Holty's studio, New York,
with architectural plan for hotel restaurant with design
for Cincinnati Mural (left) (cat. 143) and *The Moon*
(right) (Dupin 818), 1947, photo Manuel de Agustin

Fig. 50 Alexander Calder, *Twenty Leaves and an Apple* (cat. 66), 15 May 1947,
pencil and red colored pencil on file folder, 29.9 x 47 cm (11¾ x 18½ in.),
Cincinnati Art Museum

Fig. 52 Photograph of Skidmore, Owings &
Merrill artist's rendering of Terrace Plaza Hotel,
Cincinnati, ca. 1946

Fig. 51 Steel skeleton of Terrace Plaza Hotel,
Cincinnati, April 1947

75

building made on him. His treatment of the picture ground, the blue worked into the canvas, and the freely executed drawing brought a long-pursued artistic aim to fruition.[125] When reviewing the works of the mid-1940s, it becomes apparent that Miró was occupied again and again with friezes, devoting himself to this special form even when no specific commission was involved (fig. 34).

Miró had largely finished the work on the Cincinnati Mural by mid-September 1947, as contemporaneous photographs by Arnold Newman indicate (p. 54, fig. 67). Various artists, including William Baziotes, saw the painting while it was still in the studio,[126] but its enormous impact on young American artists would not come until its exhibition at the Museum of Modern Art. Alfred H. Barr Jr., the museum's director, and Monroe Wheeler, director of exhibitions, visited Miró's studio on 22 September with this project in mind.[127] Interestingly, it was Miró's friend, Josep Lluís Sert, who had suggested the showing and set the process in motion.[128] Since the artist added final touches until shortly before his departure on 15 October, the Cincinnati Mural was not removed from the stretchers, rolled, and taken to the Museum of Modern Art until 24 October.[129] The exhibition not only reflected Matisse's and Miró's interest in presenting a European perspective but also offered John J. Emery the perfect framework to make his hotel known to New York society.[130] Due to construction delays, the exhibition opening was postponed from October to March of the following year.[131] The idea of displaying a model of the hotel was abandoned in favor of architectural plans.

It was also decided to present the painting flat (fig. 127), rather than in the concave form it would ultimately have (fig. 57). "It was painted for a circular room, but Miró prefers to have it shown flat."[132] The painting's effect on artists like Mark Rothko and Barnett Newman, who at the time were in the process of defining their own art, especially their ideas of mural painting, cannot be overestimated. The press, on the other hand, scoffed at the ambitious hotel project and denigrated Miró's painting for its restaurant location. This reaction may have surprised the Museum of Modern Art, which was considering a work of this kind for its own collection and whose acquisitions committee was looking for opportunities to place murals of this type in new administration buildings.[133]

Unlike Miró, Calder succeeded as early as fall 1945 in renewing his contacts in Paris. Marcel Duchamp encouraged him to submit his miniature mobiles and stabiles to the Paris dealer Louis Carré for exhibition. What began as a show "par correspondance" and on the smallest format soon turned, thanks to Calder's inventiveness, into a large-scale enterprise. Based on postal regulations in the immediate postwar period, he calculated an ideal package size of 45 x 25 x 5 cm (18 x 10 x 2 in.) to mail his objects. From these dimensions Calder rapidly developed a sort of module, dismantling larger mobiles in order to send them to Paris, along with assembly instructions. "So a whole race of objects that were collapsible and could be taken to pieces was born."[134] In this context, *S-Shaped Vine* (cat. 65, fig. 120) is a particularly superb example of Calder's playful ingenuity. Other quite massive or wonderfully projecting pieces followed, including *Five Branches and 1,000 Leaves*.[135]

In June 1946 Calder finally flew to Paris, taking along earlier works such as *Thirteen Spines* (cat. 46, fig. 120), which could not be sent by mail; presumably he executed one or the other work on site as well. Due to a postponement of the exhibition date, he returned to the United States but was back in Paris in October for the opening at Galerie Louis Carré.[136] He also had the opportunity to collaborate on a performance at the Ogunquit Theater, Maine, of Padraic Colum's play *Balloons*, designing mobiles for the sets. *Ogunquit (Orange Fish)* (cat. 64) resulted and additional mobiles did, too.[137] This is one of the earliest surviving stage works by Calder in existence. Previous theater projects consisted largely of motion sequences of a few geometric shapes, which, like the frames or panels of his 1930s objects (cats. 29, 31), used the stage as a backdrop for action, literally composing movement there. Calder's experiences with such interdisciplinary collaborations led to his abandoning mechanized stage decorations operated by pulleys (fig. 7).

As true "visual preludes,"[138] the objects now became independent of the plot unfolding on stage and began appearing in their own right, as mobiles and "actors." The part played by *Ogunquit (Orange Fish)* in *Balloons* might be described as an autoperformance; it accurately reflects the essence of the existentialist essay in which Jean-Paul Sartre described Calder's mobiles in the Louis Carré show: "A mobile: a little local festival; an object which exists only in, and which is defined by its motion.... His mobiles signify nothing, refer to nothing but themselves: they

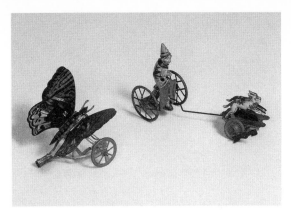

Fig. 53 Sidewalk toys Joan Miró brought home from America in 1947, Fundació Pilar i Joan Miró, Palma de Mallorca

Fig. 55 Terrace Plaza Hotel, Cincinnati, exterior view of the Gourmet Restaurant with Joan Miró's mural (cat. 143), 1948, photo Ezra Stoller

Fig. 54 Terrace Plaza Hotel, Cincinnati, lobby with Alexander Calder's 1946 mobile *Twenty Leaves and an Apple* (cat. 66), 1948, photo Ezra Stoller

Fig. 56 Terrace Plaza Hotel, Cincinnati, the Gourmet Room today

Fig. 57 Terrace Plaza Hotel, Cincinnati, the Gourmet Restaurant with Joan Miró's Cincinnati Mural (cat. 143), 1948, photo Ezra Stoller

are, that is all; they are absolutes."[139] Unusual, if perhaps explained by the stage context, was their range of colors, which one might think would have struck Calder as too blatant – too "filmy," to use his own term. He tended to prefer the structural emphasis of black and employed colors only sparingly, to set accents.[140] This factor also played a role in his "design sketch" for Cincinnati.

The circumstances of the commission for Calder's mobile, *Twenty Leaves and an Apple* (cat. 66, fig. 50), for the new Terrace Palace Hotel, are much less thoroughly documented than is the case for Miró. Calder's work was first displayed in 1942, in a representative selection of four stabiles and nine mobiles shown at the Cincinnati Art Museum.[141] The exhibition was organized by the Cincinnati Modern Art Society in close collaboration with Pierre Matisse, who apparently enjoyed good social connections in Cincinnati thanks to his wife, Alexina or Teeny Matisse-Sattler, a native of the city.[142] It is safe to assume that these contacts, which would later also benefit Miró, were made at this time. The works on display, the largest of which was a mobile about 2.4 meters (8 feet) in length and suspended from the ceiling, included *Wheat, Vertical Foliage*, and possibly *Red Post, Black Leaves* (cats. 54, 53, 48, figs. 42, 43).[143] A sculpture exhibition in fall 1946, again at the Cincinnati Art Museum, drew attention once more to Calder's work, at a time when the plans for the Terrace Plaza Hotel were in full swing (fig. 122).[144]

In the selection of artists for the Plaza Hotel project, Philip R. Adams, curator at the Cincinnati Art Museum since 1945, played a key role. The hotel's contractor, John J. Emery, was president of the museum's board of trustees and not really an advocate of the International Style. Nevertheless, he was guided by the conviction that a public building should reflect the spirit of the age and contain examples of the best contemporary art. Like the architects, Emery initially favored American artists. Calder seemed a good choice, especially because he had begun to make a name for himself in architectural circles, not least thanks to his friends Oscar Nitzschké and Wallace K. Harrison. While Calder had established ideal credentials with his 1941 mobile for the Hotel Avila in Caracas (cat. 49), the decision for Miró was less obvious. Emery's limited selection found objections from his curator, a champion of modernism, who asked, "Well, why get American followers of a style that is still flourishing in the original in Europe, men like Braque himself,

or Dufy, or Miró?"[145] A long discussion ensued about both participants and price, until finally Miró was selected and contact established with Pierre Matisse.[146]

In the absence of surviving sources, we may assume that Calder's participation was subject to similar contractual obligations as those that existed for Miró.[147] Calder, too, was requested to submit a "project sketch" for approval; the submitted design is marked with the date 15 May 1947 (fig. 50). When and by whom he was first contacted is not known. Based on the extant correspondence with Miró, the selection and placement of the commissions must have been completed between November and December 1946. The contact may have been made through Adams. Benjamin Baldwin, the interior designer with Skidmore, Owings & Merrill who was responsible for work at the Terrace Plaza Hotel during 1946, also played a role in the daily exchange with the artists.[148]

Calder's "design sketch" stipulates the colors red, yellow, blue, and white for the four relatively large horizontal elements. Perhaps this unusual range of colors was an echo of his work on the stage mobile for the Ogunquit Theater, or he simply expected it would appeal to the contractors.[149] In the actual execution, however, Calder remained true to his preference of black, accentuating only the circular disk, the sole strictly geometric shape in the piece, with red. This corresponded to the simple logic of the title, *Twenty Leaves and an Apple*, which was already inscribed on the sketch. Thanks to the powerful air conditioning system, the contractors' pride, Calder's mobile exhibited great performance qualities, as is evident even from the few photographs taken in situ (fig. 54).

Calder's art-in-architecture was apparently a phenomenon that had already found a certain acceptance: the press flippantly called it a "ceiling job,"[150] which seems hardly less disparaging than outright rejection. Emery was aware that the modern spirit of the hotel could probably be maintained only under his aegis. When he sold the property to Conrad Hilton in 1959,[151] he excluded the works of art from the transaction, leaving them in situ as loans until a remodeling was undertaken in 1965 (Calder's mobile had already been repainted previously).[152] At this juncture the works of art went as a gift to the Cincinnati Art Museum collection (fig. 134).[153] By the time the Gourmet Restaurant closed, the International Style had given way to "Louis-toujours" (fig. 56).[154]

Replete with new visual impressions, and his luggage full of gifts from Calder and the sidewalk toys he had purchased (fig. 53),[155] Miró returned to Europe. He revisited his romanesque frescoes and was sure that Cincinnati was only the beginning, that the future belonged to a closer collaboration with architects, and that his mural would have "an effect on the young lands of America."[156] Thus this unique transatlantic excursion ended with the wonderful, playful exuberance that engenders art and that motivated Miró's entire picturemaking activity. What he shared in common with Calder was very likely just this humble viewpoint, which could discover greatness in the small and unprepossessing and was receptive to the potentials of wit, play, and chance. It was an affinity that never required many words. The artists' correspondence was anything but a profound or intellectual dialogue on art, and the deeply human dimension of their friendship resists verbal description. Their unspoken mutual understanding was so obvious that occasional meetings at openings or important birthdays sufficed (pp. 12, 14, fig. 139). These were moments of reciprocal respect and lived simplicity – which would not prevent Miró from setting a playfully poetic and moving monument to Calder at an exhibition in Palma de Mallorca in 1972 (pp. 1–3, 310–312). Referring to found objects and their quality as "matière," discovered in such ordinary things as a tin butterfly or a cow's jawbone (figs. 137, 138), picked up in 1947 on Calder's Roxbury farm, Miró would aptly state, "I do not collect pictures; this is my art museum" (fig. 117).[157]

[1] Reason for optimism were especially a show at the Galerie Neumann-Nierendorf in Berlin, as well as a film by Hans Cürlis and a film portrait by Pathé Cinema, Paris, in which Calder portrayed Kiki de Montparnasse in wire (cat. 13, fig. 59).

[2] Postcard from Calder to Miró, early June 1929, *Correspondence 2*.

[3] On the advice of Marcel Duchamp, Katherine S. Dreier acquired a first painting by Miró in 1927 (Dupin 103), and in 1929 Albert Eugene Gallatin acquired another for his Gallery of Living Art. That same year, Gallatin purchased *Dog Barking at the Moon* (Dupin 222), an image that prompted ridicule and scandal and made Miró famous in America overnight. A first one-man show, mounted by Pierre Loeb, followed in 1930 at the Valentine Gallery, New York. In 1932 the New York dealer Pierre Matisse opened his first Miró exhibition, marking the beginning of an extraordinary partnership that would continue until the artist's death in 1983. In 1941–1942 James Johnson Sweeney devoted the first significant retrospective to Miró at the Museum of Modern Art, New York (fig. 114; see New York 2002, 157–158; also Russell 1999, 110–132; Houston 1982).

[4] Barbara Rose, "Interview with Miró," in Houston 1982, 120.

[5] The *Exposition internationale: Arts et techniques dans la vie moderne* opened 24 May 1937. Because of construction delays, the Spanish Pavilion (fig. 19) did not open until 12 July.

[6] See essay Elizabeth Hutton Turner, 44–47; and also Freedberg 1986; *Pabellón español, Exposición internacional de París, 1937* [exh. cat., Centro de Arte Reína Sofía] (Madrid, 1987).

[7] Miró preferred the title *El Segador*, which emphasized the reference to the Catalan anthem of liberation, "Els Segadors" (Miró 1977, 55); see also Juan Larrea, "Miroir d'Espagne. A propos du 'Faucheur' de Miró au Pavillon Espagnol de l'Exposition 1937," *Cahiers d'art* 12, nos. 4–5 (1937), 157. The fate of the mural after the dismantling of the pavilion in 1938 is not known.

[8] Miró 1977, 55.

[9] Color pochoir print in *Cahiers d'art* 12, nos. 4–5 (1937), 156.

[10] Miró's caption reads: "In the current struggle I see the antiquated forces of fascism on one side, and on the other, those of the people, whose immense creative resources will give Spain a drive that will amaze the world." Quoted in Lluís Permanyer, "Revelations by Joan Miró about His Work," *Gaceta ilustrada* (April 1978), in Rowell 1986, 293.

[11] "And then, as you can see, I give greater and greater importance to the materials I use in my work. A rich and vigorous material seems necessary

to me in order to give the viewer that smack in the face that must happen before reflection intervenes. In this way, poetry is expressed through a plastic medium, and it speaks its own language." Miró in Georges Duthuit, "Where Are You Going, Miró?" *Cahiers d'art* 11, nos. 8–10 (1936) (accompanying illustrations show new works on Masonite panels); in Rowell 1986, 249.

[12] Letter from Miró to Matisse, 19 February 1936, correspondence Pierre Matisse Gallery Archives (hereafter "PMG"), The Pierpont Morgan Library, New York, MA 5020.

[13] "At eight or ten years of age I went to the museum of romanesque art alone on Sunday morning.... I was completely bowled over" (Miró 1977, 20).

[14] See exhibition preview by Christian Zervos, "A l'Ombre de la guerre civile. L'Art catalan du X^e au XV^e siècle au Musée du Jeu de Paume des Tuileries, Mars–Avril 1937," *Cahiers d'art* 11, nos. 8–10 (1936), 213–216.

[15] Yvon Taillandier, "Je travaille comme un jardinier..." interview in *XX^e siècle* 1, no. 1 (15 February 1959), quoted in Rowell 1986, 249. The durability of his work was a factor in Miró's choice of painting support: "When the exhibition closes, this painting can be removed from the wall and will belong to us" (PMG, letter from Miró to Matisse, 25 April 1937). Miró began to work on Masonite as early as summer 1936.

[16] Picon 1976, 1:127. No preliminary drawings for this painting have come to light.

[17] Sweeney 1948, 208; Miró 1977, 60.

[18] Lluís Permanyer, "Revelations by Joan Miró" (April 1978); see Rowell 1986, 290–291. See also Sweeney 1948, 209. Miró recognized the pioneering role played by Leonardo da Vinci in this regard: "the shock which suggests the form just as cracks in a wall suggested shapes to Leonardo" (Sweeney 1948, 210).

[19] Georges Hugnet, "Joan Miró ou l'enfance de l'art," *Cahiers d'art* 6, nos. 7–8 (1931), 336.

[20] For a profound discussion of Miró's logic of "picturemaking" see Carolyn Lanchner, "Peinture-Poésie: Its Logic and Logistics," in New York 1993, 15–82.

[21] Picon 1976, 1:70–72. See also Christopher Green, "Joan Miró, 1923–1933: The Last and First Painter," in Barcelona 1993, 66. Also note the genitals in Miró's painting *Catalan Landscape (The Hunter)*, 1923–1924 (Dupin 90).

[22] New York, 1973, 33.

[23] See René Gaffé, "Joan Miró," *Cahiers d'art* 9, nos. 1–4 (1934), 32.

[24] "[Surprising little men] ejaculate with an erect penis, and from their sperm emerge little volcanoes that spit little waves" (Hugnet, "Joan Miró," [1931] 338). Miró would subsequently expand such notions into a fundamental idea behind his work: "A painting must be fertile. It must give birth to a world it must fertilize the imagination" (Taillandier 1959, 6; cited in Rowell 1986, 251).

[25] Hugnet, "Joan Miró" (1931), 337. The provocation in Miró's statement was obvious to his critics: "Miró undermines criticism, torments it, derides it and drives it crazy," 336.

[26] Previously Miró had shown them for one day in Barcelona before taking them with him to Paris. One painting of the series (114 x 146 cm), done on 6 April 1933 on the basis of a collage dated 2 February 1933 (Fundació Joan Miró, Barcelona, FJM 1295), has been lost. Miró stayed in Calder's house on rue de la Colonie, where he apparently stored personal belongings after giving up his studio apartment in early 1932 (see postcard from Calder to Miró, 2 April 1932, *Correspondence* 5). The painting he gave to Louisa and Alexander Calder on this occasion (cat. 113) did not belong to the series and was probably not executed until his stay in Paris. Still, the central motif may have originated from a further collage, on which Miró never based an entire painting (FJM 1306). On this topic, see the "Livre de raison," Fundació Joan Miró, Barcelona (FJM 427 a/b), where the entire series apart from the gift, is listed.

Another indication of the picture's independent status is its *format métrique* (150 x 100 cm [59 x 39⅜ in.]), a format Miró almost never used otherwise. The entire series of "Peintures d'apres collages" was executed on *format proportionnel, figure* (portrait format).

[27] "a great success that might mark a red letter day in my career" (PMG, letter from Miró to Matisse, 5 November 1933).

[28] Christian Zervos, "Joan Miró," *Cahiers d'art* 9, nos. 1–4 (1934), 18.

[29] The constricted conditions forced Miró to remove the finished canvases from the stretchers (New York 1973, 60).

[30] Loeb's daughter, Florence, was born in 1929, his son, Albert, in 1932.

[31] Georges Hugnet, *Enfances* (Paris, 1933); see also Cramer 1989, 28–29, no. 2.

[32] *Jeux d'enfants*, choreography by Léonide Massine, music by Georges Bizet, premiere Monte Carlo, 14 April 1932, further performances in Brussels and Paris, 1932; Barcelona, 1933; New York, 1934 (see also Barcelona 1994, 77–116).

[33] Freedberg 1986 (533–534 and 582–583) has located the oral sources for this otherwise sparingly documented commission. The "empty" panel was removed by the later owner, G. David Thompson. Perhaps it was painted in monochrome simply to ensure the continuation of the pictorial space; it may have been intended for placement above the window, where a figurative frieze between ceiling and window would have been difficult to see because of the back lighting. This assumption is supported by the fact that Miró only made preparatory drawings for three panels (figs. 30–32).

The commission is not listed in Miró's "Livre de raison." Pierre Loeb's archive has been lost; Albert Loeb was unfortunately not able to reconstruct any further details (letter to the author, 16 April 2003). No information about these pictures is found in the business archives of the Pierre Matisse Gallery (PMG, esp. client file "G. David Thompson"). A postcard from Loeb to Miró, dated 1934, with a reproduction of Piero della Francesca's fresco *The Annunciation* (San Francesco, Arezzo) and the message on the reverse, "Look at the front and do something like it," may well refer to the yet unfinished commission (Fundació Pilar i Joan Miró, Palma de Mallorca, FPJM C 0267).

[34] They are *Painting (Figures with Stars)*, The Art Institute of Chicago (Dupin 459), and *Painting ("hirondelle amour")*, The Museum of Modern Art, New York (Dupin 463), both 200 x 250 cm (78¾ x 98½ in.); *Painting (Rhythmic Figures)*, Kunstsammlung Nordrhein-Westfalen, Düsseldorf (Dupin 461), and *Painting ("escargot femme fleur étoile")*, Museo Nacional Centro de Arte Reina Sofía, Madrid (Dupin 462), both approx. 195 x 172 cm (76¾ x 67¾ in.). By comparison, the largest of the "Peintures d'après collages" (of 13 June 1933) measures 173 x 195 cm (68 x 76⅜ in.) and *The Birth of the World* 251 x 200 cm (98⅞ x 78¾ in.).

[35] Lanchner in New York 1993, 49–53, describes Miró's similar reactions to surrealist criticism.

[36] G.-J. Gros, "Le Groupe moderne. Exposition de l'A.B.C. André Vallaud – Gravures de Matisse et Duty [Dufy] – Joan Miró," *Beaux-arts* (3 November 1933); quoted from Miró's painstakingly collected and mounted press clippings, Fundació Pilar i Joan Miró, Palma de Mallorca, FPJM H 561.

[37] This designation was chosen for a reason (Miró himself did not use poetic descriptions like the one cited in note 34 as titles). Regarding the "Peintures d'après collages," he even explained to Pierre Matisse, who showed the works in New York in winter 1933–1934 under the title *Compositions*, that he would have preferred that, "instead of the title *Composition*...you had simply put *Painting*..." (PMG, letter from Miró to Matisse, 7 February 1934; in Rowell 1986, 124). He later explained in greater detail in another letter to Matisse: "I have thought a lot about the question of titles. I must confess that I can't find any for works that take off from an arbitrary starting point and end with something real." He gave Matisse permission, however, to choose titles based on the "real

things" his works suggested, provided these titles did "not evoke some tendency or other [especially surrealism], something I want to avoid completely" (PMG, letter from Miró to Matisse, 12 October 1934; in Rowell 1986, 124). Miró also rejected titles of a literary or art-historical nature.

[38] G. Espinouze, "La Peinture de Joan Miró (Galerie G. Bernheim)," *Coq catalan* (30 December 1933), quoted from a press clipping, Successió Miró, Palma de Mallorca.

[39] Calder 1951, 8.

[40] "letting myself be carried away by the purest and most disinterested mental impulse" (PMG, letter from Miró to Matisse, 7 March 1937; in Rowell 1986, 148).

[41] Duthuit, "Where Are You Going, Miró," 1936, 261; in Rowell 1986, 150–151.

[42] Anatole Jakovski, "Alexandre Calder," *Cahiers d'art* 8, nos. 5–6 (1933), 246.

[43] Calder, commentary for *Constellation*, in H. Harvard Arnason and Hugo Mulas with Alexander Calder, *Calder* (New York and London, 1971), 202 no. 24. The title "Constellation" was suggested by Duchamp and James Johnson Sweeney. It was used before Miró's "Tempera Paintings" of 1940–1941 received their French title, *Constellations*. These works were not formally related to the latter, although they did show a link with the biomorphic figurations of Miró's early "Peintures d'après collages." Calder refers to this in the above-mentioned commentar when he talks about an approximation of Miróesque forms (see also Punyet Miró in Barcelona 1997, 169–170).

[44] See Arnauld Pierre, "Staging Movement," in Washington 1998, 329–347.

[45] See Alexander S. C. Rower, "The Roxbury Home and Studio," in Hartford, 2000, 13–19; also Calder 1966, 143–146.

[46] Calder 1966, 153–154.

[47] Hartford 2000, 46–51.

[48] Pierre Matisse Gallery, New York, *Alexander Calder: Stabiles and Mobiles* (23 February–13 March 1937).

[49] In an article on a project by Oscar Nitzschké, a friend of Calder's, Christian Zervos points out the potential of a "rhythm of forms in movement" ("Un immeuble de publicité par Oscar Nitzschké," *Cahiers d'art* 11, nos. 8–10 [1936], 206. In 1936 followed a brief collaboration with Paul Nelson on a construction project for the Columbia Broadcasting System (see Calder 1966, 155–157).

[50] In his autobiography (Calder 1966, 156) Calder recalled May 1937, yet in a 1938 article he had mentioned mid-April as his arrival date (Calder, Mercury Fountain, May [1938] 3). The date is confirmed by a letter from Miró to Matisse of 25 April 1937: "Calder has already arrived; we have talked a lot about you and New York" (PMG).

[51] PMG, letter from Miró to Matisse, 25 April 1937; also Miró to Sweeney, 6 June 1937, Calder Foundation, New York. This letter also gives the precise date the mural was begun.

[52] See essay Elizabeth Hutton Turner, 45; also Freedberg 1986, 471–524.

[53] The mercury circulating in the fountain represented an enormous sum of money – Calder spoke of 200 liters, worth 500,000 francs – and the Almadén mines were of great strategic significance as suppliers of raw materials for munitions manufacture. In June 1937 Franco intensified his attacks on the mines, which were in republican hands.

[54] See New York 1951, 47, 49.

[55] "This place is 6 miles from Dieppe and is quite densely populated by Montparnos. The Nelsons have a house, so has Braque, and the Pierres (Loeb & Matisse) rented houses here and the Mirós spent a month making the rounds visiting everyone" (letter from Calder to Sweeney, 26 September 1937, Calder Foundation, New York).

[56] Paul Nelson, "Peinture spatiale et architecture. A propos des dernières œuvres de Léger," *Cahiers d'art* 12, nos. 1–3 (1937), 85–88.

[57] It measures 7.5 x 15 m with a maximum ceiling height of just under 10 m (25 x 50 x 32 ft.). For Calder's announcement of the project, see postcard from Calder to Miró, 4 June 1938, *Correspondence* 23; for his announcement of completion, see postcard from Calder to Miró, 2 January 1939, *Correspondence* 27.

[58] Concerning art in the public space and the revival of this genre, see Christian Zervos, "Deux décorations de Henri Matisse. Réflexions sur l'art mural," *Cahiers d'art* 14, nos. 5–10 (1939), 165–178.

[59] PMG, letter from Miró to Matisse, 4 March 1938; in Rowell 1986, 159.

[60] Joan Miró, "Je rêve d'un grand atelier," in *XXᵉ siècle* 1, no. 2 (May 1938), 25–28, Rowell, 1986, 161–162. At that time he lived in an apartment in Paris, at 98, bd. Auguste-Blanqui, where he had only a single room in which to paint (fig. 113). Nelson resided at the same address.

[61] Miró, "Je rêve d'un grand atelier" (1938), 28; in Rowell 1986, 162.

[62] For a listing of all commissioned projects of this type, see Freedberg 1986, 828–892.

[63] On this topic see Marla Prather, "Alexander Calder," in Washington 1998, 138.

[64] See Calder's statement in *Alexander Calder: Recent Gouaches–Early Mobiles* [exh. cat., Perls Galleries] (New York, 1970), unpaginated. Previously Calder had received a commission from Harrison to design a water ballet fountain for the Edison Company pavilion at the New York World's Fair of 1939, which, however, was never realized (see Freedberg 1986, 821–822).

[65] The mobile was later moved by Harrison to an office building he designed for the Aluminum Company of America (Alcoa) in Pittsburgh (see New York 1976, 332–333).

[66] See H. Harvard Arnason and Ugo Mulas with Alexander Calder, *Calder* (New York and London, 1971), 41.

[67] An etching by Calder titled *grandeur-Immense* shows the sequence of movement of a mechanized mobile on a brown ground (in Anatole Jakovski, ed., *23 Gravures* [Paris, 1935]), also Cramer 1989, 30 no. 3.

[68] PMG, letter from Miró to Matisse, 3 November 1937.

[69] PMG, letter from Miró to Matisse, 19 February 1936. Loeb wished to return to the original agreement, by which each dealer received half the work. At that time Matisse was responsible for two-thirds of Miró's monthly income and Loeb for one-third. The works were divided between America and Europe by the same ratio. In a letter to Miró of 11 March 1938 (PMG) Matisse defended his claim for two-thirds by referring to the growing art market in America and his currently low supply of works. As a compromise he suggested the agreement remain unchanged for another year, and an even division thereafter.

[70] In 1963–1965 four paintings were executed for Emili and David Fernández Miró in the same very wide, horizontal format (Dupin 1165–1168). Calder, too, once expressed interest in paintings for his children (letter from Miró to Calder, 8 February 1957, *Correspondence* 56).

[71] PMG, letter from Miró to Matisse, 4 March 1938.

[72] PMG, letter from Miró and Georges Braque to Matisse, 10 August 1938.

[73] PMG, letter from Miró to Matisse, 31 October 1938. Otherwise Paul Nelson would have had to take it with him to America. No preliminary study exists, and presumably Miró worked in the same direct fashion as he had for Loeb's nursery and the carpet designs. The work is dated on the reverse "IX-1938" and dedicated to Matisse's children.

[74] Galerie Pierre, Paris, *Joan Miró. Un panneau décoratif et quelques gouaches* (24 November–7 December 1938).

[75] The same was true for the *Mural Painting for the Terrace Plaza Hotel, Cincinnati* and the *Harvard Mural.*

[76] PMG, letter from Miró to Matisse, 2 January 1939; in Russell 1999, 129.

[77] Pierre Matisse's children, Jackie, Paul, and Peter, were six years old and younger. The title that the family used, "The Battle of the Sea Monsters," was intended to help the children understand the picture. (The author is grateful to Jacqueline Matisse Monnier for conversations of December

2003. Regarding the children's recollections, see also Russell 1999, 129–130). Photographs of the work in situ have not come to light.

[78] PMG, letter from Miró to Matisse, 31 October 1938; more extensively quoted in Russell 1999, 129. Miró also offered to paint another picture or additional panels "so everything harmonizes well."

[79] For documentation on the scarce oral sources see Freedberg 1986, 897–898.

[80] Galerie Pierre, Paris, *Paul Nelson. La Maison suspendue* (early October 1938), and Pierre Matisse Gallery, New York (23 October–12 November 1938 [there in conjunction with *Fernand Léger: Recent Gouaches*]). The model then traveled to the 1939 Golden Gate International Exposition in San Francisco.

[81] Paul Nelson, "The Suspended House," typescript, PMG.

[82] Paul Nelson, "The Suspended House," typescript, PMG.

[83] PMG, letter from Miró to Matisse, 7 April 1938.

[84] Nelson and his wife returned to New York late October 1938. Judging by the photographs, the mural must have been completed.

[85] The first attempts mentioned in April probably refer to the preparation of the wall. It is not clear whether the plaster was removed, but it can be assumed that the wall was prepared by craftsmen under Miró's supervision (see Freedberg 1986, 909 n. 11).

[86] When the Germans occupied Paris in 1940, the house was converted. A few walls were removed and the paintings partially destroyed. The fragments were salvaged in the late 1980s (see *Joan Miró. Exceptionnelles peintures murales,* auction cat., Millon/Jutheau, Drouot Montaigne, Paris, 1988).

[87] "As soon as they are finished, I can begin working on small pictures. I am doing this to make it easier to leave Paris with my work if circumstances require." (PMG, letter from Miró to Matisse, 31 October 1938).

[88] Dupin 614–618 and 619–627. Tristan Tzara took up the idea of emphasized materiality and compared Miró's art to the transformation and "re-création" of a natural cycle from which his imagery originated: "One might say that all of nature is nothing but a universal meal during which the diners are themselves consumed … an enormous digestion of matter" ("A propos de Joan Miró, *Cahiers d'art* 15, nos. 3–4 [1940], 37, illustrated with the works mentioned; the issue's cover was designed by Miró as a pochoir print in the manner of the Constellations and represented the first public reference to this new series).

[89] The designation "Constellation" was used for the first time in the title of a 1937 drawing, and subsequently in that of one of the paintings on burlap (cat. 119). This was exhibited at the Pierre Matisse Gallery, New York, (4–29 May 1941), and depicted in *New Masses* 39, no. 1 (25 March 1941), 29. In addition, there was public enthusiasm about a new type of transcontinental airliner, the Lockheed *Constellation*, the development of which was begun in June 1939 (essay Elizabeth Hutton Turner, 53, n. 120).

[90] PMG, letter from Miró to Matisse, 12 January 1940.

[91] See Miró, "Working Notes, 1941–1942"; Rowell 1986, 187; also Permanyer, "Revelations by Joan Miró" (1978), 295.

[92] PMG, letter from Miró to Matisse, 4 February 1940; in Rowell 1986, 168.

[93] Picon 1976, 2:31.

[94] Miró, "Working Notes, 1941–1942"; in Rowell 1986, 183, 186.

[95] Miró, "Working Notes, 1940–1941"; in Rowell 1995, 187.

[96] Miró, "Working Notes, 1940–1941"; in Rowell 1995, 186.

[97] See "Thomas Emery's Sons, Inc.: Penthouse Hotel for Cincinnati," *Architectural Forum* 85 (December 1946), 2–10; "Arrival in Cincinnati: Prototype of the Mid-Century Hotel Is a Triumphant Marriage of Art and Economics," *Fortune* 38, no. 4 (October 1948), 113–117, 156–160.

[98] PMG, letter from Miró to Matisse, 20 July 1946.

[99] Contract between Miró and Pierre Matisse Gallery, New York, signed 30 July 1946, PMG.

[100] PMG, letter from Matisse to Miró, 16 August 1946.

[101] PMG, letter from Miró to Matisse, 3 September 1946.

[102] PMG, letter from Matisse to Miró, 16 August 1946. See also PMG, letter from Pierre Matisse to Henri Matisse, 18 August 1946.

[103] It was Miró himself who in April 1944 made contact, through diplomatic channels, with the Museum of Modern Art, where Sweeney, who referred to his "new realizations," had devoted the first retrospective to him in 1941–1942. Since a portion of the works belonged to Matisse because of contractual regulations and the museum was unable to assume the considerable expenses, they were shown in January 1945 at the Pierre Matisse Gallery as *Tempera Paintings, 1940 to 1941*. As Miró would soon admit, he was keen on being the first European artist to exhibit in America after the war (PMG, letter from Miró to Matisse, 18 June 1945).

[104] PMG, letter from Matisse to Joan and Pilar Miró, 16 August 1946. See also Russell 1999, 83.

[105] As early as 1945 Miró had declared, in absolute loyalty to his two dealers, that "the mediocre life of a modest little gentleman" was no longer acceptable, and had demanded action (PMG, letter from Miró to Matisse, 18 June 1945; see also letter from Miró to Pierre Loeb, 30 August 1945, in Rowell 1986, 197–198).

[106] Matisse provided him with a detailed description of the hotel design and the conditions of the commission (PMG, letter from Matisse to Miró, 3 October 1946).

[107] PMG, letter from Miró to Matisse, 13 October 1946.

[108] See Russell 1999, 255–271.

[109] PMG, letter from Matisse to Miró, 20 December 1946.

[110] PMG, letter from Matisse to Miró, 20 November 1946.

[111] "Arrangement restaurant closed twelve days" (telegram Matisse to Miró, 19 December 1946). Encoded as usual because of censorship, this meant that a price of $12,000 had been accepted. See also PMG, letter from Miró to Matisse, 22 December 1946.

[112] PMG, letter from Miró to Matisse, 26 January 1947.

[113] PMG, letter from Miró to Matisse, 26 January 1947.

[114] Letter from Miró to Calder, 18 March 1946, *Correspondence* 36.

[115] Miró returned Calder's compliment (postcard from Calder to Miró, 23 March 1934, *Correspondence* 13; letter from Miró to Calder, 21 December 1946, *Correspondence* 37).

[116] Letter from Calder to Keith Warner, 15 February 1947, Calder Foundation, New York.

[117] All four photographs are being conserved at the Fundació Pilar i Joan Miró, Palma de Mallorca.

[118] Contract between Miró, Pierre Matisse, and Thomas Emery's Sons, 15 April 1947, PMG.

[119] Design sketch, inscribed verso "Cincinatti [sic]," 25.5 x 117 cm (10 x 46 in.) (image), 49.5 x 127 cm (19 ½ x 50 in.) (sheet), Fundació Pilar i Joan Miró, Palma de Mallorca. The design was posthumously reproduced on ceramic tiles for the cafeteria of the Fundació. The official acceptance of the design by John J. Emery was confirmed by Ellsworth F. Ireland (letter to Matisse, 22 May 1947, Archive of the Cincinnati Art Museum).

[120] A photograph of the plan is in the archive of the Cincinnati Art Museum, Curatorial Files.

[121] Invoice of Robert Rosenthal Co. for paints, 26 May 1947, and invoice of E. H. + A. C. Friedrichs Co. for canvas, 3 June 1947, Archive of the Cincinnati Art Museum, Curatorial Files. Friedrichs had been recommended to Miró by Calder (postcard, 7 April 1947, *Correspondence* 40).

[122] Pierre Matisse Gallery, New York, *Joan Miró: An Exhibition of Paintings, Gouaches, Pastels and Bronzes from 1942 to 1946* (13 May–7 June 1947). The month of March was marked by difficult negotiations between Matisse and Miró. Matisse had been attempting since 1946 to secure nearly the "entire production of the war years," which his wife, Teeny, had viewed that summer in Barcelona (PMG, letters from Matisse to Miró, 16 August 1946, 6 March 1947, and 19 March 1947). Pierre

Loeb, who initially continued to represent one-third of Miró's work in Europe, gradually withdrew and, in December 1947, concluded his long representation of the artist (see Russell 1999, 260–263).

[123] Around the late 1920s Miró began to devote himself to relieflike collage objects that were referred to as *Peintures-objets* (cat. 102). In 1944 the first plastic works, modeled in clay, appeared. They were cast in bronze in 1966 and formed the point of departure for Miró's monumental sculptures.

[124] The painting is dated 5 May 1947 on the verso and is the only work in direct connection with the mural.

[125] On the process of execution see Carl Holty, "Artistic Creativity," *Bulletin of the Atomic Scientists* 25, no. 2 (February 1959), 77–81; also essay Elizabeth Hutton Turner, 49–50.

[126] See Houston 1982, 35.

[127] See telegram from Alfred H. Barr Jr. and Monroe Wheeler to Miró, 22 September 1947, The Museum of Modern Art Archives, New York. The memo on the telegram regarding its cost, "Charge: Department of Exhibitions (Miro mural)," indicates that the museum had already decided to show the mural.

[128] Miss Sabersky forwarded the following inquiry from Sert to Wheeler: "By the end of this month Miró will have completed the mural commissioned by a Cincinnati hotel. Sert believes this painting to be one of Miró's most interesting and important works and wonders if it would be of interest to the museum to show the mural for a short time in one of our Galleries, before it is being shipped" (Memo, 4 August 1947, The Museum of Modern Art Archives, New York).

[129] See letters from D. H. Dudley to Mr. Warren, 14 October 1947, and to the Hahn Brothers, 23 October 1947, The Museum of Modern Art Archives, New York. Also the supplementary agreement to the contract between Miró, Pierre Matisse, and Thomas Emery's Sons (see note 118 above), 22 October 1947, PMG.

[130] The official request from the Museum of Modern Art for the exhibition, which would also be financed by Emery, came 6 October 1947 (The Museum of Modern Art Archives, New York).

[131] The Museum of Modern Art, New York, *A New Mural by Joan Miró* (3 March–4 April 1948).

[132] Anonymous memo [early September 1947], The Museum of Modern Art Archives, New York. Philip R. Adams of the Cincinnati Art Museum also confirmed that Miró had to accept the stipulated curved surface (interview with Adams, 29 September 1976, Typescript, Archives of American Art, Smithsonian Institution, Washington, D.C., 33).

[133] See PGM, letter from Miró to Matisse, 1 December 1947. Mention was made of Mr. Rockefeller, the "Esso people," and their new administration building (memo by Frances Keech to Monroe Wheeler, 5 August 1948, The Museum of Modern Art Archives, New York). It was not until 1963 that the museum acquired the Harvard Mural of 1950–1951, after it had been removed from the dining room of Harkness Commons and replaced by a ceramic painting by Miró.

[134] Calder 1966, 188.

[135] On this topic see Calder 1966, 194. The mobile was acquired by the Emmanuel Hoffmann-Stiftung in 1948. It was the first work by an American artist to enter a Swiss museum, as a deposit at the Öffentliche Kunstsammlung Basel.

[136] Galerie Louis Carré, Paris, *Alexander Calder. Mobiles, Stabiles, Constellations* (25 October–16 November 1946). An article on a Calder retrospective in 1943 at the Museum of Modern Art, illustrated with photographs of the rooms, reviews his production of the war years (Gabrielle Buffet, "Sandy Calder, forgeron lunaire," *Cahiers d'art* 20–21 [1945–1946], 324–330).

[137] See New York 1951, 75.

[138] Pierre in Washington 1998, 341.

[139] Jean-Paul Sartre, "Les Mobiles de Calder," in *Alexander Calder.*

Mobiles, Stabiles, Constellations [exh. cat., Galerie Louis Carré] (Paris, 1946), 11, quoted in Sartre, "Existentialist on Mobilist," *ArtNews* 46 (December 1947), 22.

[140] Calder seems to have introduced color only gradually. In the early 1940s this was perhaps a concession to collectors' tastes. "I have one or two new mobiles – medium sized... – very 'filmy' – i.e. not much matrial, but many departments – in colors" (PGM, letter from Calder to Matisse, 30 January 1941). The term "filmy" was actually coined by Matisse.

[141] Cincinnati Art Museum, *Paintings by Paul Klee and Mobiles and Stabiles by Alexander Calder* (7 April–3 May 1942). The collaboration with Matisse concerned only Calder. In an undated telegram of early January, Matisse requested, "Please mail list of drawing[s] of all new mobiles black or colored standing or hanging large or small in view of out of town exhibition need twelve to fifteen stop." Calder replied 18 January (PMG), asking whether these really had to be all new works, and "do we get a guarantee of a sale or 2?" On 10 March the organizers were informed that Calder was unwilling to provide loans without a guaranteed museum purchase. Finally, in late March, a box of "broken airplane parts" appeared at the museum, which the curator Marion R. Becker enthusiastically assembled even before the explanatory sketches had arrived. Lee A. Ault, a client of Pierre Matisse and a trustee of the Cincinnati Modern Art Society, had done the background work to convince Calder to participate (all documents Contemporary Art Center Collection, University of Cincinnati; the author wishes to thank Kevin Grace for his research support). The related drawings with relevant catalogue numbers have survived and permit a reconstruction of the exhibition. At least a part of the works shown in Cincinnati was subsequently included in *Alexander Calder: Recent Work* (Pierre Matisse Gallery, New York, 19 May–6 June 1942).

At the end of January, Elodie Courter of the Museum of Modern Art had attempted to raise enthusiasm on the organizers' part for the Miró-Calder combination, saying that Miró's work was so closely related to Calder's that a juxtaposition seemed natural (letter from Courter to Marion Becker, 29 January 1942, Contemporary Art Center Collection, University of Cincinnati).

[142] Little is known about these contacts and their effect. But Matisse's contact with Lee A. Ault, a trustee of the Cincinnati Modern Art Society, and George A. Rentschler, the society's president, must have played a role. In addition, it was Teeny Matisse who sold Henri Matisse's painting *La Blouse roumaine* to Cincinnati (see Russell 1999, 193). In 1939 she apparently began to help out in the gallery more frequently. In 1946 Teeny Matisse visited Miró in Barcelona (fig. 118) and organized a gallery show before the year was out (the author wishes to thank Jacqueline Matisse Monnier for her enlightening information).

[143] *Wheat*, no. 6, $450; *Vertical Foliage*, no. 10, $500. Since the drawing for no. 12 is missing, this catalogue number cannot be definitely associated with a work. It is very likely, however, that *Red Post, Black Leaves* was also on view in Cincinnati, since its presence in the Pierre Matisse show is confirmed for May 1942 and practically all the pieces from Cincinnati were on view there. Additional mobile-stabiles of the same type are confirmed for these years (see PMG, Calder letters with sketches to Matisse, 18 January 1942 and 14 June 1943).

[144] Cincinnati Art Museum, *Four Modern Sculptors: Brancusi, Calder, Lipchitz, Moore* (1 October–15 November 1946). The exhibition was conceived as a supplement to recent acquisitions of ancient sculptures by the museum. Five works by Calder were displayed, of which the room-size mobile *The Forest Is the Best Place* (now Moderna Museet, Stockholm) deserves emphasis in the present context.

[145] Adams (see note 132 above), 33.

[146] The original price envisioned was $8,000. Ellsworth F. Ireland, vice president of Thomas Emery's Sons, suggested that, regarding Miró and Dufy, Adams make contact with Sam Kootz in New York, who was at

the time trying to bypass Matisse and do business directly with Miró (letter from Ireland to John J. Emery, 2 August 1946, Archive of the Cincinnati Art Museum; see also PMG, letter from Pierre Matisse to Henri Matisse, 17 April 1947). Concerning the discussion about choice of artists, see Freedberg 1986, 928.

[147] The author wishes to thank Millard F. Rogers Jr., director emeritus of the Cincinnati Art Museum, for numerous helpful suggestions and a review of relevant sources. Rogers, too, is of the opinion that Emery also signed contracts with Calder and Saul Steinberg, who was to execute a mural in the main restaurant on the lobby floor.

[148] Miró also presented Baldwin with a first design sketch for the model (fig. 47) (see Benjamin Baldwin, *An Autobiography in Design* [New York and London, 1995], 27–29).

[149] According to the Calder Foundation, what Calder submitted as a "design sketch" in 1947 was drawn from a photograph. This would imply that *Twenty Leaves and an Apple* was begun and finished prior to the commission, that is, that Calder referred to an already existing mobile. It seems plausible that this originated from the context of the Ogunquit theater performance and would now be permanently installed in the Terrace Plaza Hotel.

[150] Frank Ashton, "Terrace Plaza Mural Pleases – After Drinks," *Cincinnati Post* (3 March 1948).

[151] "Terrace Sold, Netherland Leased for $25 Million," *Cincinnati Post* (21 May 1956).

[152] "The lobby's new decor even included painting the Calder mobile a new color (this doesn't lower its value)" ("Art Museum Chosen Home for Terrace Plaza Works," *Cincinnati Post*, 30 April 1965). See also Adams' correspondence with Calder in September 1965 concerning the restoration of the mobile. He confirms that, apart from the red disc, the work had been painted black (Archive of the Cincinnati Art Museum, Curatorial Files).

[153] The mural by Saul Steinberg from the lobby restaurant was included (see Confirmation of Receipt, 17 December 1965, Archive of the Cincinnati Art Museum, Curatorial Files).

[154] Amy Culbertson, "Gourmet Room Tradition for Parties Only," *Cincinnati Post* (2 July 1992).

[155] See Washington 1980, 39.

[156] See PMG, letters from Miró to Josep Lluís Sert, 14 October 1947 and 19 November 1947, and to Matisse, 1 December 1947.

[157] Miró 1977, 176. See also *Foreword* by Alexander S.C. Rower, Emilio Fernández Miró, and Joan Punyet Miró, 13.

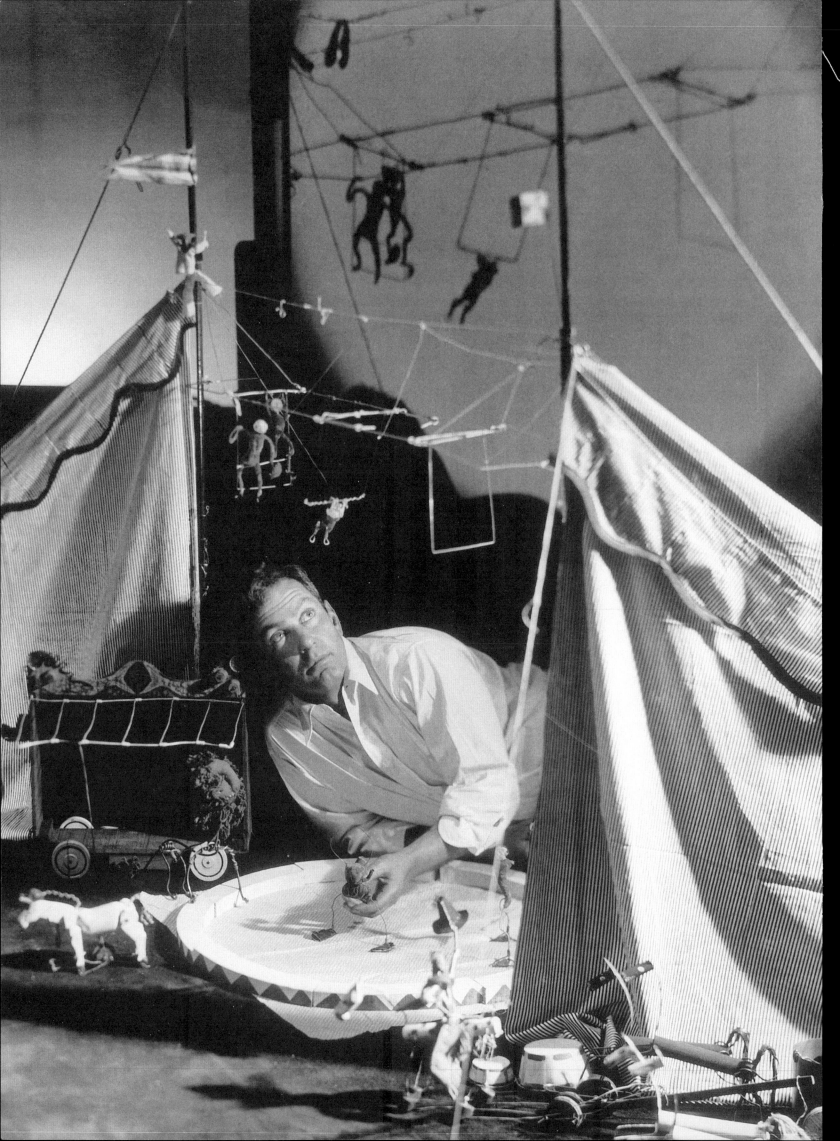

THE WORKS

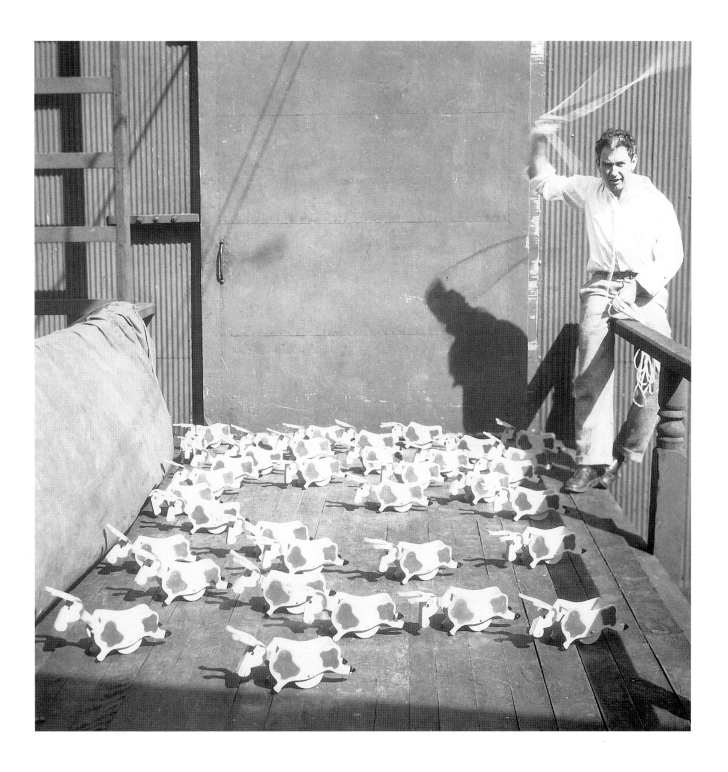

Fig. 58 Alexander Calder swinging a lasso over a herd of toy animals he designed for the Gould Manufacturing Company, photo reproduced in *Vanity Fair*, March 1930

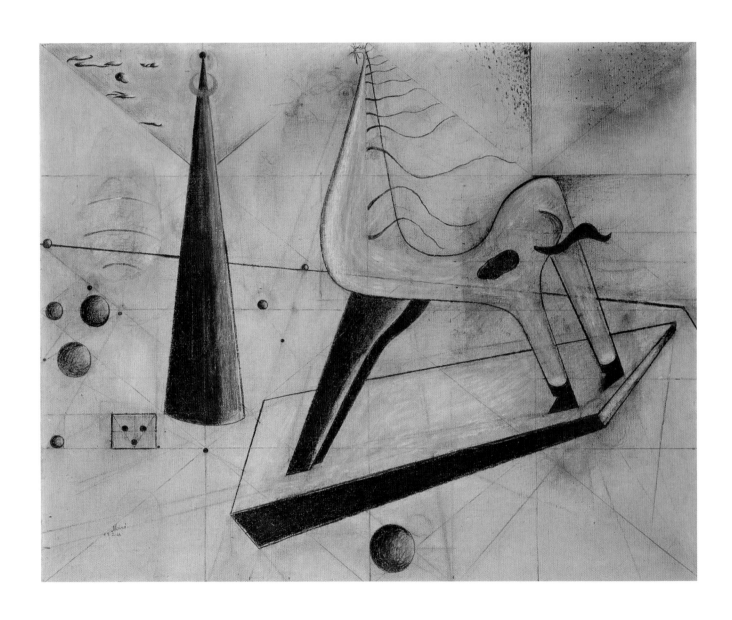

81 Joan Miró, *The Toys*, 1924
Moderna Museet, Stockholm, bequest of publisher Gerard Bonnier, 1989

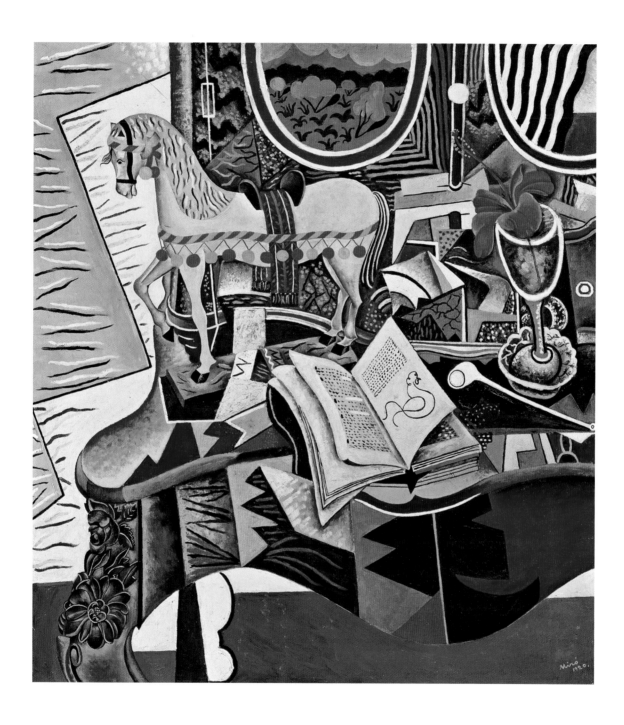

80 Joan Miró, *Horse, Pipe, and Red Flower*, 1920
Philadelphia Museum of Art, gift of Mr. and Mrs. C. Earle Miller, 1986

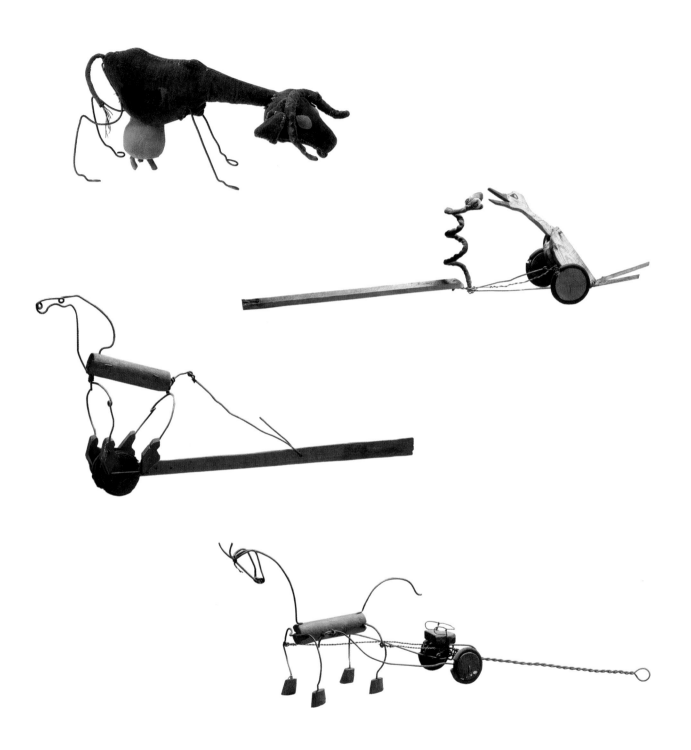

6 Alexander Calder, *Blue Velvet Cow*, ca. 1927
University of California, Berkeley Art Museum, gift of Margaret Calder Hayes, Class of 1940

1 Alexander Calder, *Duck with Snake*, ca. 1926, Courtesy Calder Foundation, New York

3 Alexander Calder, *Galloping Horse*, 1926, Courtesy Calder Foundation, New York

4 Alexander Calder, *Red Horse and Green Sulky*, 1926
Courtesy Calder Foundation, New York

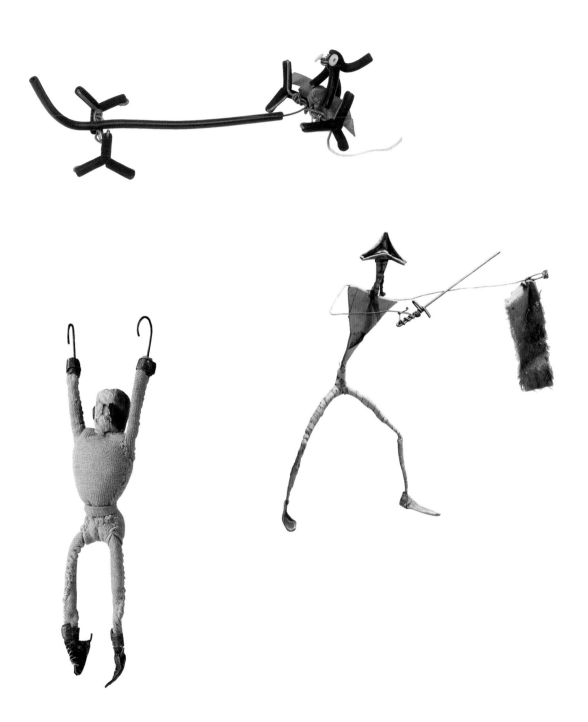

2 Alexander Calder, *Miss Tamara*, ca. 1926
University of California, Berkeley Art Museum, gift of Margaret Calder Hayes, Class of 1917

7 Alexander Calder, *Matador*, 1927, Courtesy Calder Foundation, New York

5 Alexander Calder, *Acrobat*, ca. 1927
University of California, Berkeley Art Museum, gift of Margaret Calder Hayes, Class of 1917

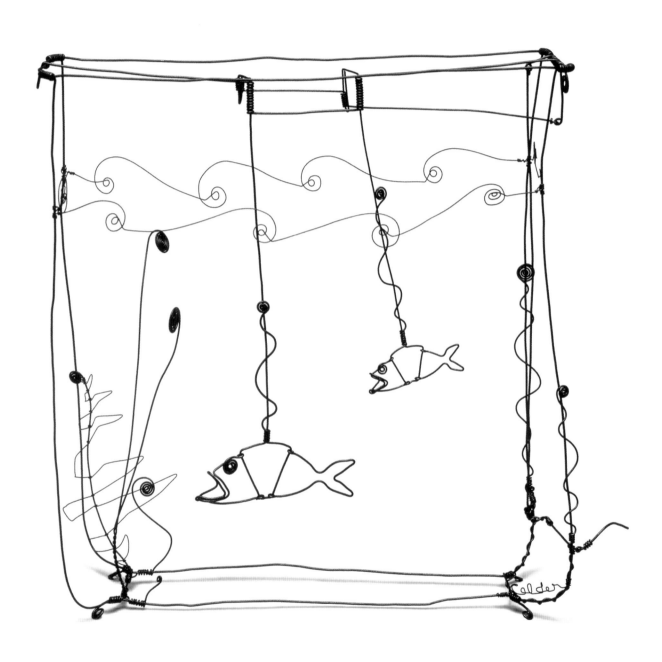

12 Alexander Calder, *Goldfish Bowl*, 1929
Courtesy Calder Foundation, New York

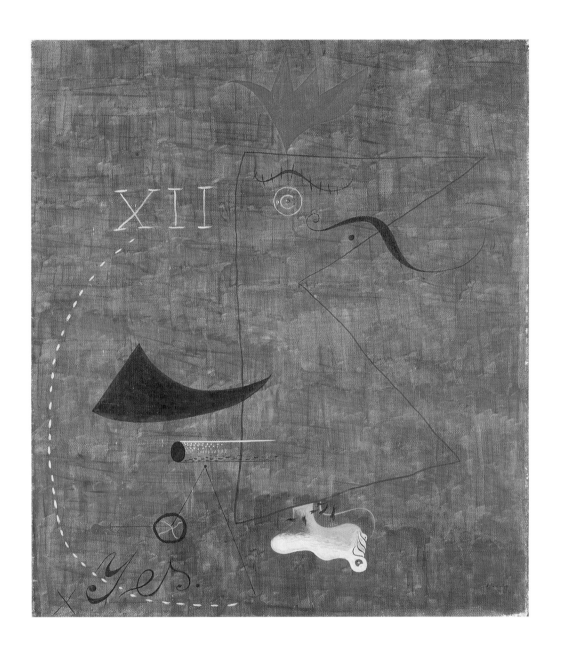

82 Joan Miró, *The Gentleman*, 1924
Öffentliche Kunstsammlung Basel, Kunstmuseum, gift of Marguerite Arp-Hagenbach, 1968

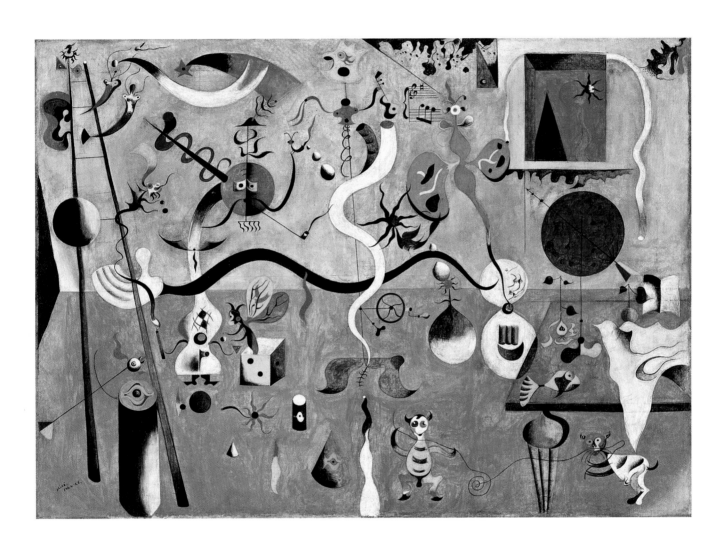

83 Joan Miró, *Carnival of Harlequin*, 1924–1925
Albright-Knox Art Gallery, Buffalo, Room of Contemporary Art Fund, 1940

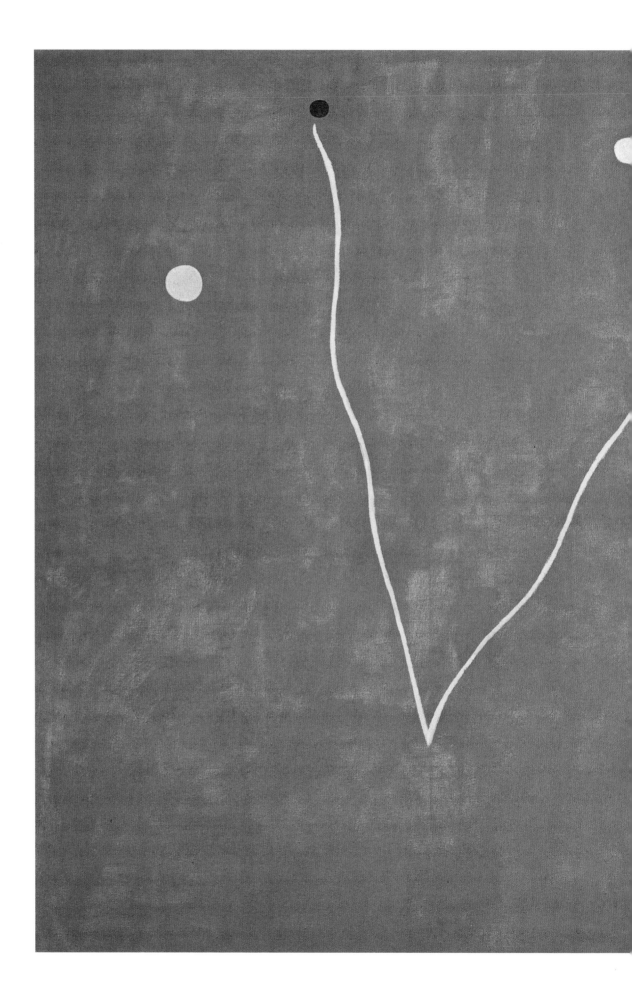

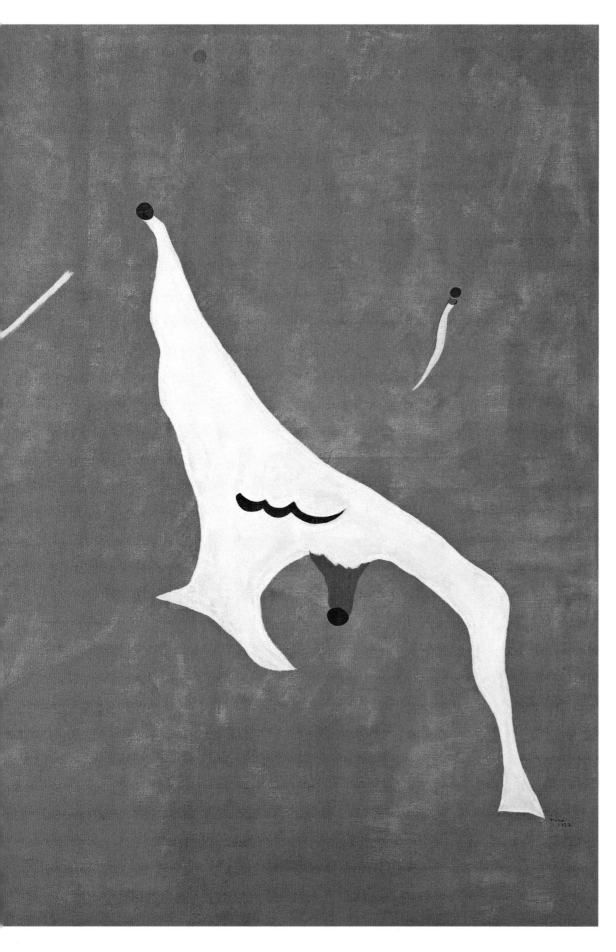

92 Joan Miró, *Painting (Circus Horse)*, 1927
Hirshhorn Museum and Sculpture Garden, Smithsonian Institution

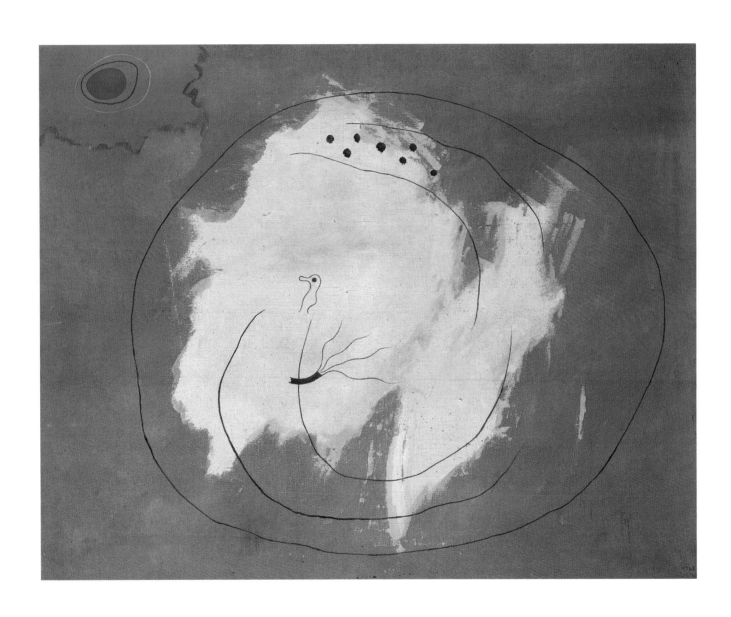

89 Joan Miró, *The Circus*, 1925
Private collection

91 Joan Miró, *Painting (Circus Horse)*, 1927
Private collection

95 Joan Miró, *Painting*, 1927
Centre Georges Pompidou, Paris, Musée National d'Art Moderne, *dation*, 1994

96 Joan Miró, *Painting (Personage, The Fratellini Brothers)*, 1927
Fondation Beyeler, Riehen/Basel

8 Alexander Calder, *Two Acrobats*, ca. 1928
Honolulu Academy of Arts, gift of Mrs. Theodore A. Cooke, Mrs. Philip E. Spalding, and Mrs. Walter F. Dillingham, 1937

10 Alexander Calder, *Arching Man*, 1929
Courtesy Calder Foundation, New York

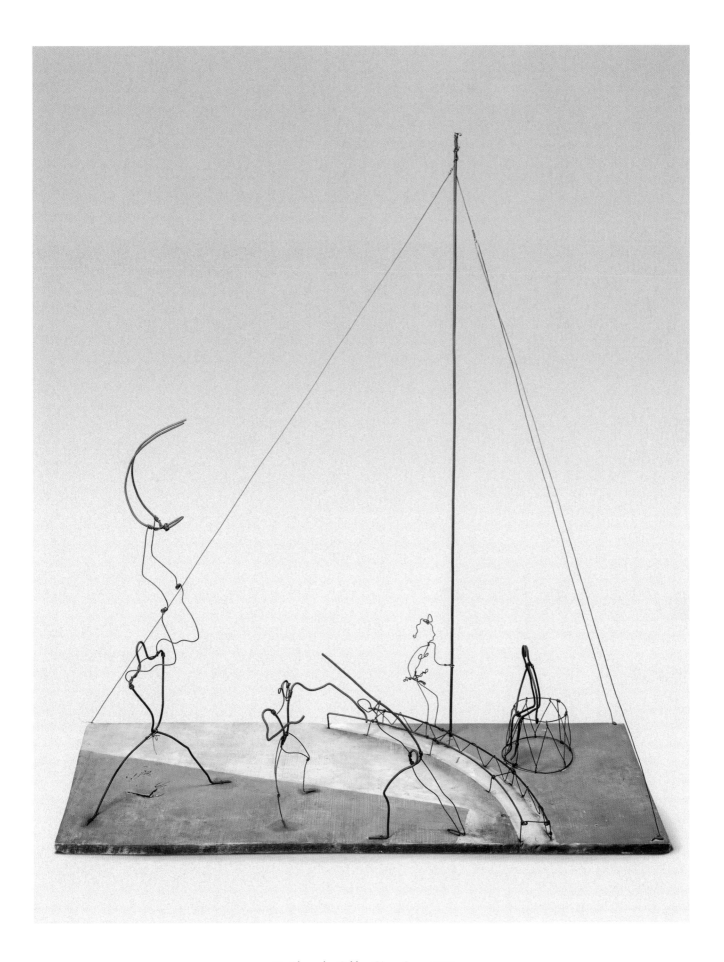

11 Alexander Calder, *Circus Scene*, 1929
Courtesy Calder Foundation, New York

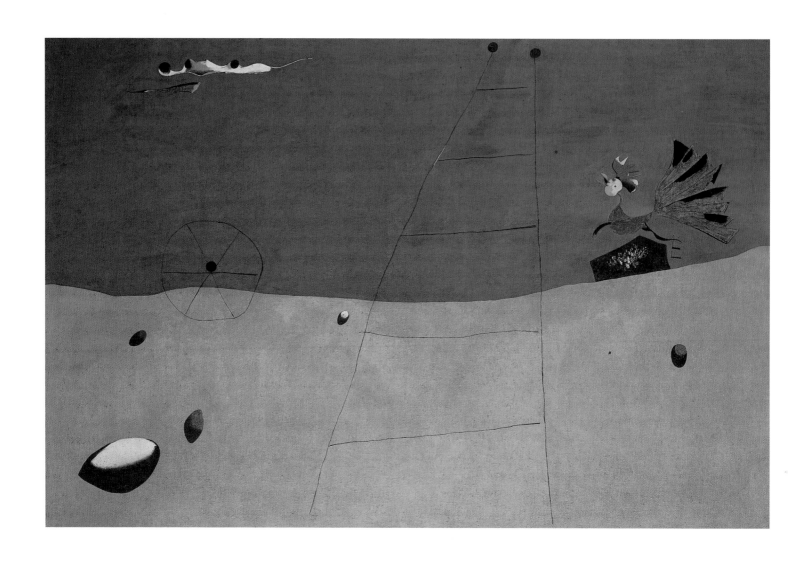

90 Joan Miró, *Landscape (Landscape with Rooster)*, 1927
Fondation Beyeler, Riehen/Basel

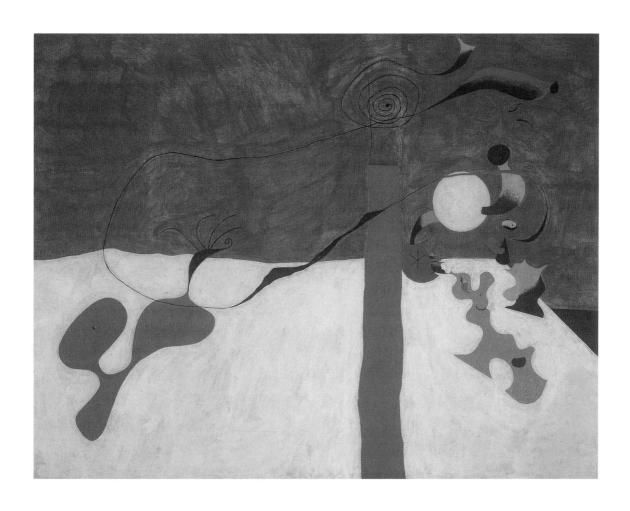

97 Joan Miró, *Still Life (Still Life wtih Lamp)*, 1928
Private collection, courtesy Proarte, Mexico City

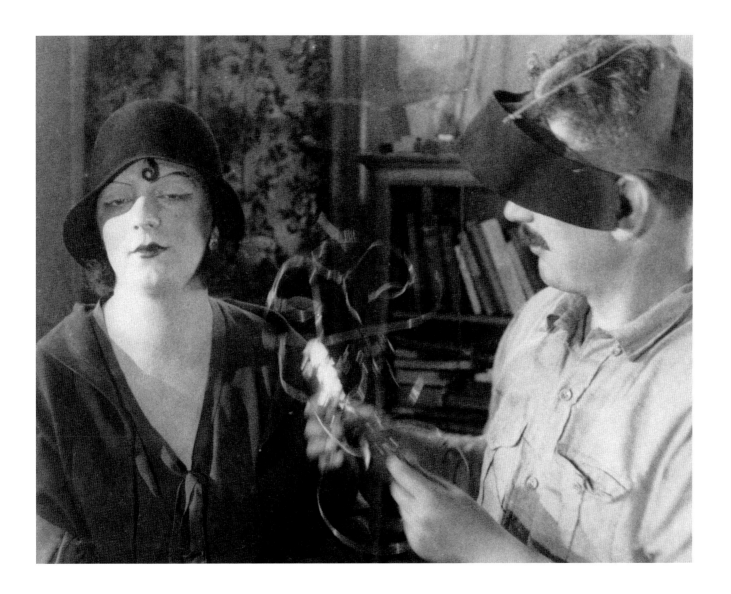

Fig. 59 Alexander Calder making a wire portrait of Kiki de Montparnasse (cat. 13), film still, Pathé Cinema, Paris, May 1929

13 Alexander Calder, *Kiki de Montparnasse*, 1929–1930
Centre Georges Pompidou, Paris, Musée National d'Art Moderne, gift of the artist, 1966

15 Alexander Calder, *Joan Miró*, ca. 1930
Private collection

16 Alexander Calder, *Medusa*, ca. 1930
Courtesy Calder Foundation, New York

14 Alexander Calder, *Amédée Ozenfant*, ca. 1930
Collection Larock-Granoff, Paris

100 Joan Miró, *Head of a Man III*, 1931
Private collection, courtesy Guillermo de Osma Galería, Madrid

101 Joan Miró, *Head of a Man IV*, 1931
Private collection

9 Alexander Calder, *Spring*, 1928
Solomon R. Guggenheim Museum, New York, gift of the artist, 1965

99 Joan Miró, *Painting*, 1930
Fondation Beyeler, Riehen/Basel

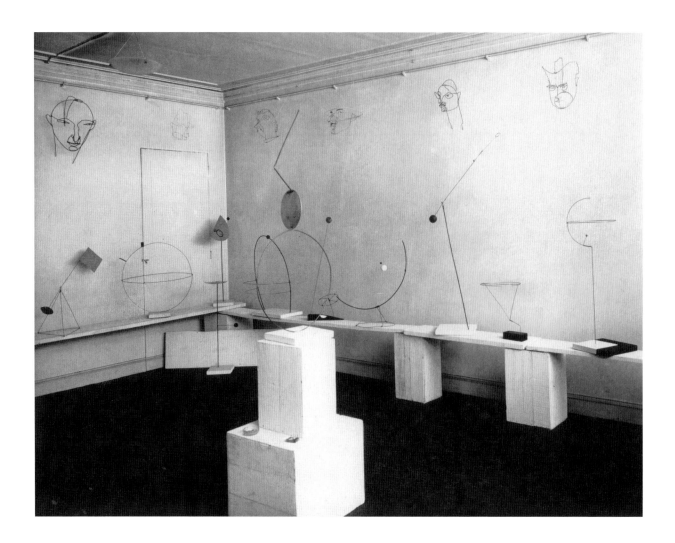

Fig. 60 Installation view of *Alexander Calder: Volumes-Vecteurs-Densités; Dessins-Portraits*, Galerie Percier, Paris, 1931,
photo Marc Vaux

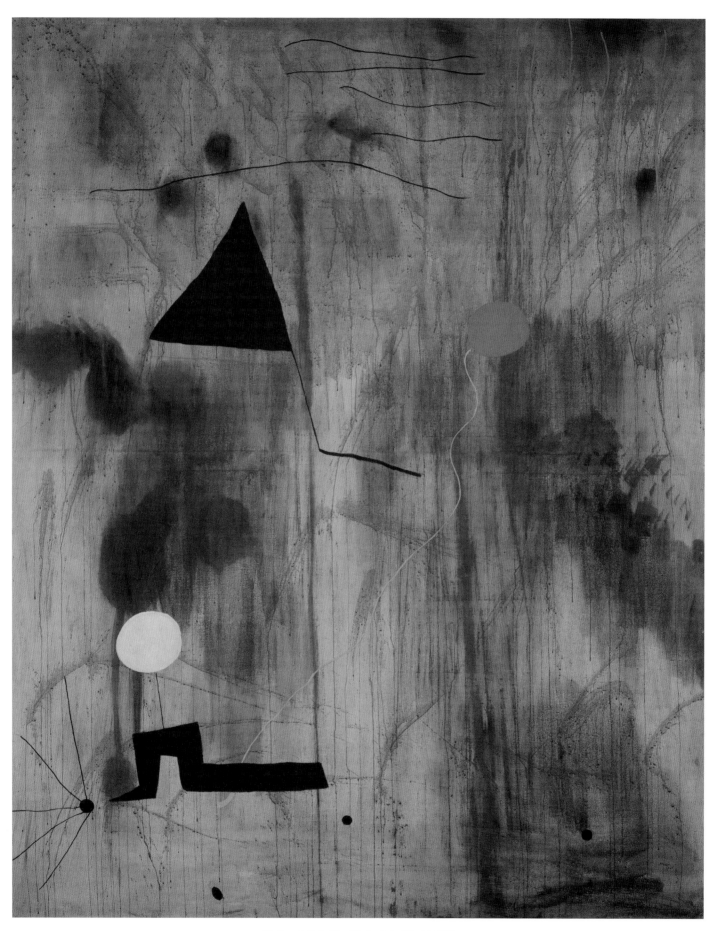

85 Joan Miró, *The Birth of the World*, 1925
The Museum of Modern Art, New York, acquired through an anonymous fund, the Mr. and Mrs. Joseph Slifka
and Armand G. Erpf Funds, and by a gift of the artist, 1972

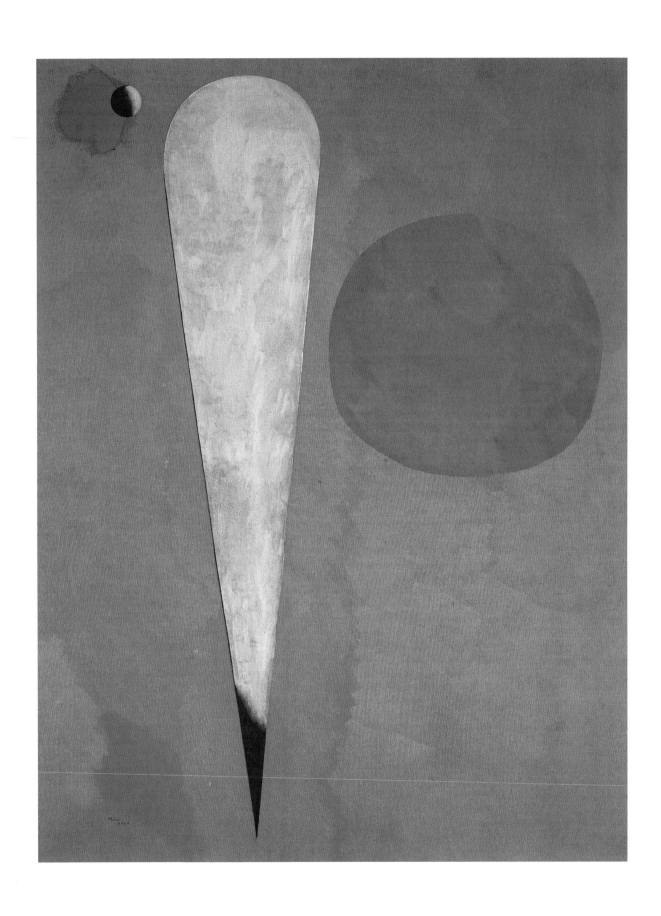

84 Joan Miró, *Memory of Barcelona*, 1925
Private collection

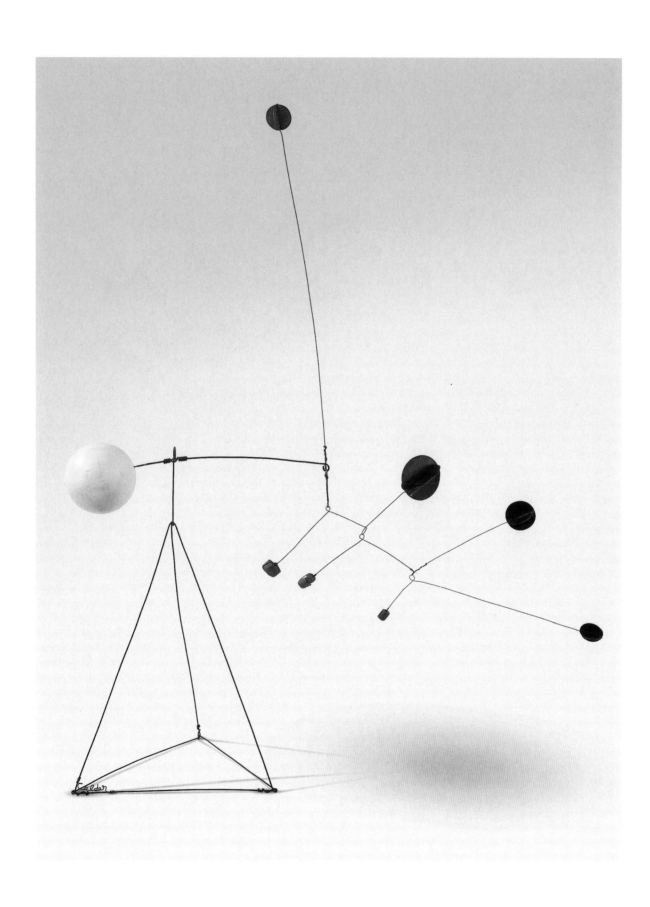

18 Alexander Calder, *Mobile au plomb*, 1931
Aaron I. Fleischman

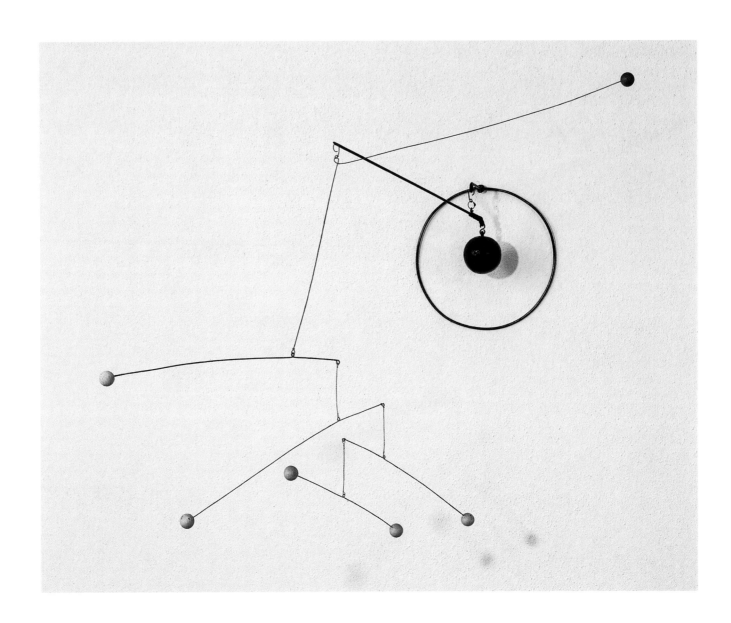

22 Alexander Calder, *Untitled*, 1933
Hans Erni, Lucerne

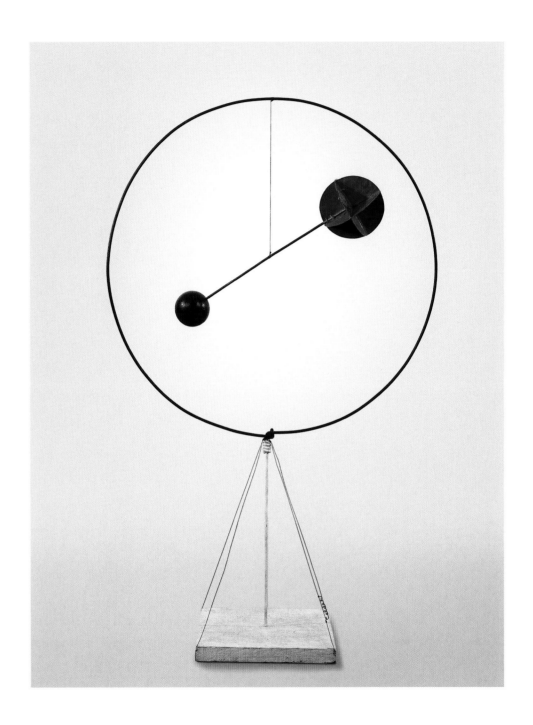

19 Alexander Calder, *Untitled*, 1931
MACBA Collection, Fundació Museu d'Art Contemporani, Barcelona

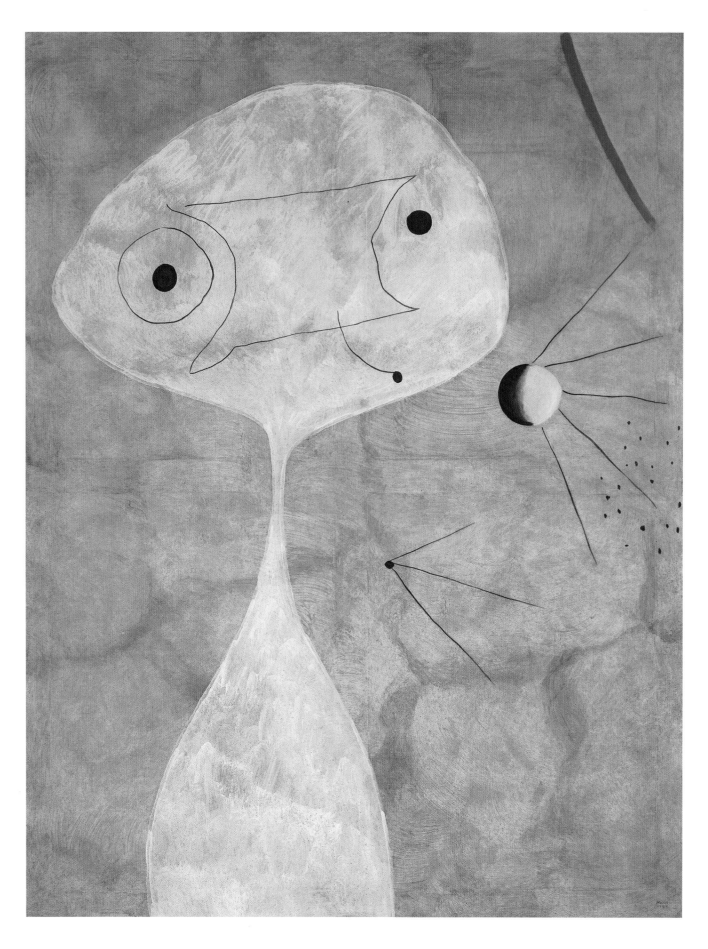

86 Joan Miró, *Painting (Man with Pipe)*, 1925
Museo Nacional Centro de Arte Reina Sofía, Madrid

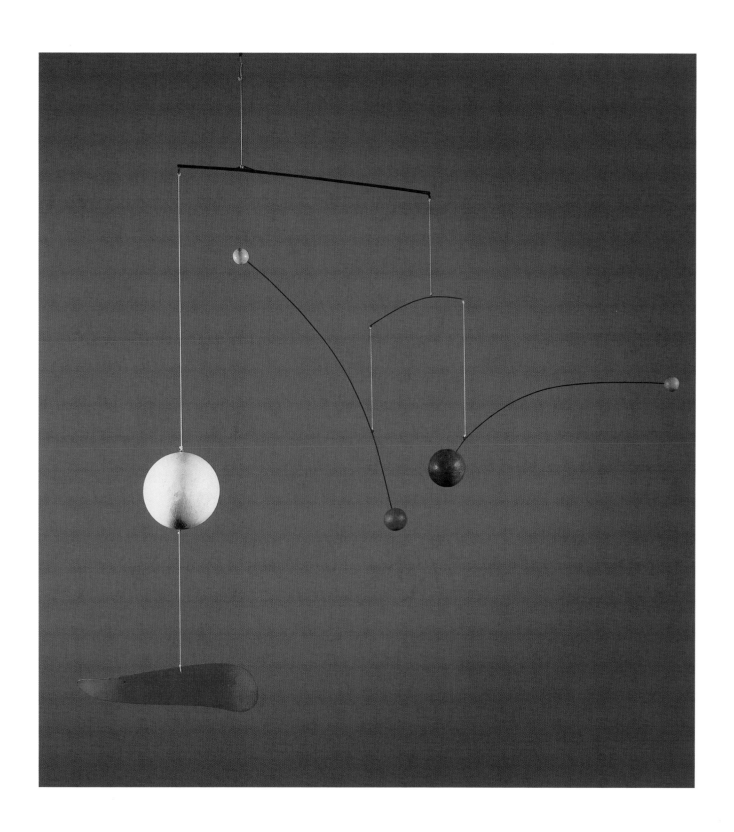

37 Alexander Calder, *Untitled*, ca. 1938
Courtesy O'Hara Gallery, New York

87 Joan Miró, *Painting*, 1925
Öffentliche Kunstsammlung Basel, Kunstmuseum, acquired with funds provided by Dr. h.c. Richard Doetsch-Benziger

88 Joan Miró, *Painting (The Red Spot)*, 1925
Museo Nacional Centro de Arte Reina Sofía, Madrid

93 Joan Miró, *Painting*, 1927
Colección Museo Tamayo Arte Contemporáneo, CONACULTA/INBA, Mexico City

94 Joan Miró, *Cloud and Birds*, 1927
Museum of Fine Arts, Boston, Sophie M. Friedman Fund and Charles H. Bayley Picture and Painting Fund, 1980

98 Joan Miró, *Construction*, 1930
Staatsgalerie Stuttgart

23 Alexander Calder, *Little Blue Panel*, 1934
Wadsworth Atheneum Museum of Art, Hartford, Connecticut, purchased through the gift of Henry and Walter Keney

39 Alexander Calder, *Untitled*, 1938
The Engle Family, USA

20 Alexander Calder, *Untitled*, 1931
MACBA Collection, Fundació Museu d'Art Contemporani, Barcelona

17 Alexander Calder, *Little Ball with Counterweight*, ca. 1931
Ruth P. Horwich

102 Joan Miró, *Painting-Object*, 1931
Kunsthaus Zürich, gift of Erna and Curt Burgauer Collection

FOUND FORMS

Fig. 61 Alexander Calder, *Mercury Fountain* (detail), 1937, Fundació Joan Miró, Barcelona, 1990,
photo Francesc Català-Roca

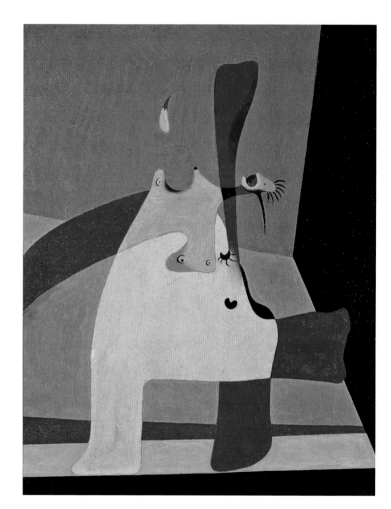

104 Joan Miró, *Figure*, 1932
The Art Institute of Chicago, gift of Mary and Leigh Block, 1988

103 Joan Miró, *Flame in Space and Naked Woman*, 1932
Fundació Joan Miró, Barcelona, gift of Joan Prats

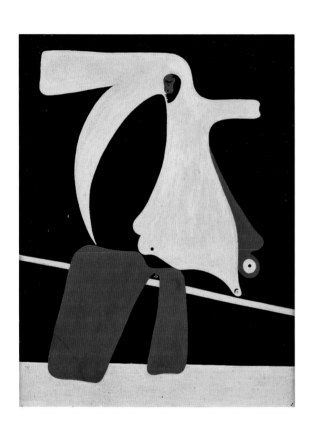

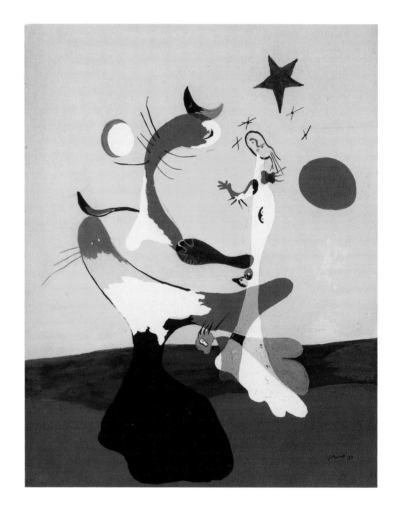

105 Joan Miró, *Painting* (design for stencil of the review *Cahiers d'art* 1–4, 1934), 1932
Kokaido Gallery, Tokyo

106 Joan Miró, *Composition (Small Universe)*, 1933
Fondation Beyeler, Riehen/Basel

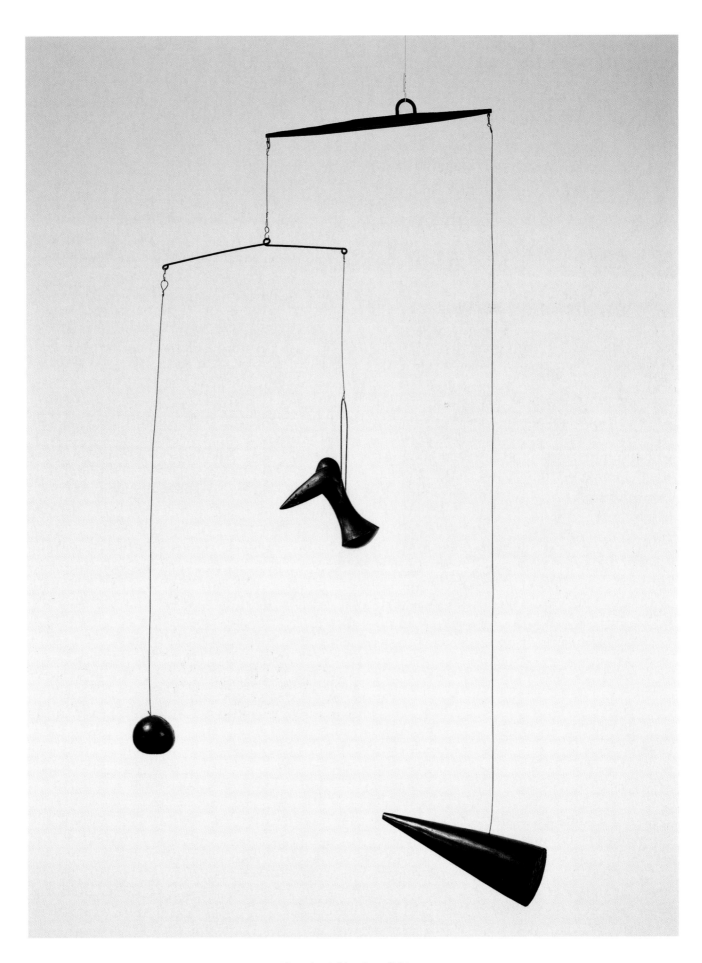

21 Alexander Calder, *Cône d'ébène*, 1933
Courtesy Calder Foundation, New York

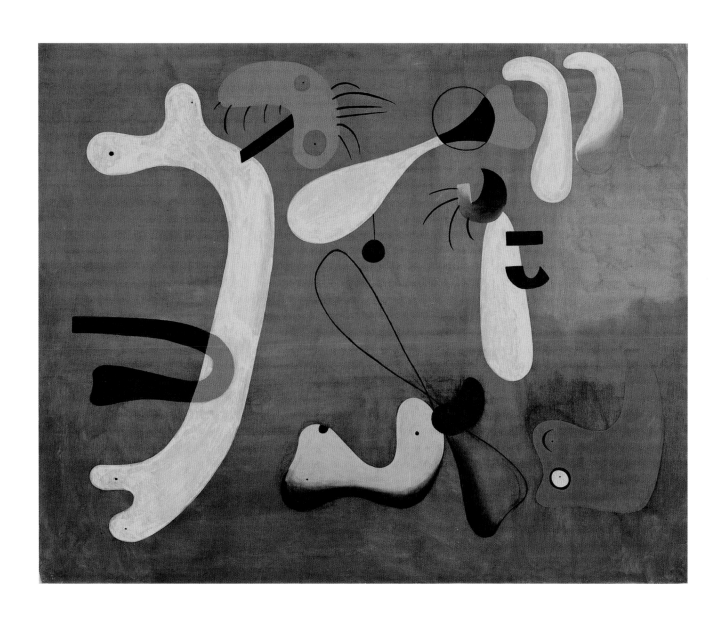

107 Joan Miró, *Painting*, 1933 (8 March)
Philadelphia Museum of Art, the A. E. Gallatin Collection, 1952

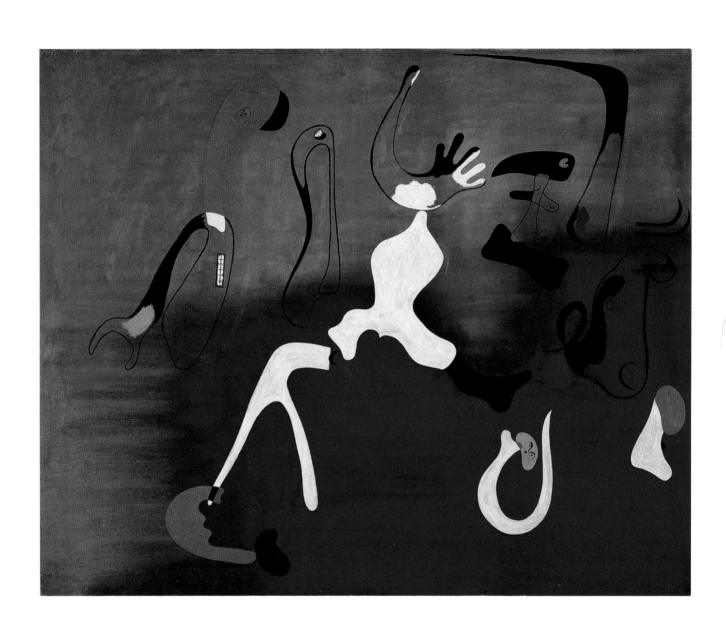

108 Joan Miró, *Painting*, 1933 (31 March)
Kunstmuseum Bern

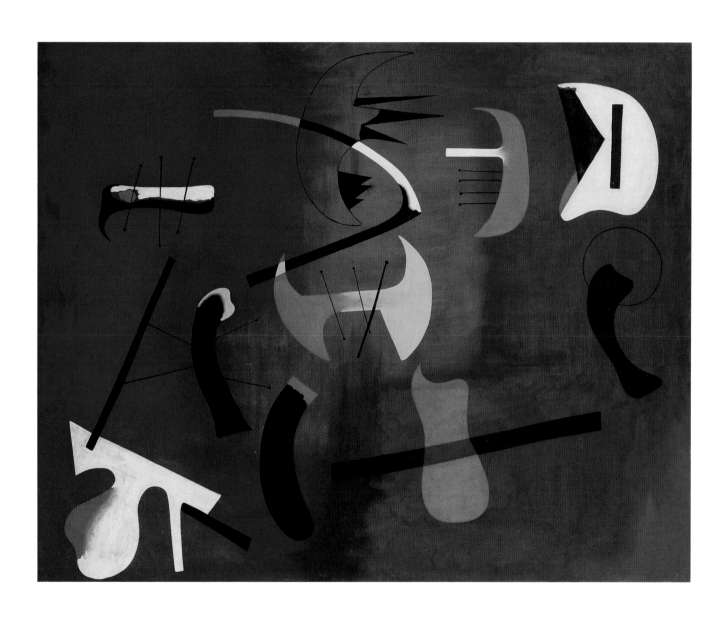

109 Joan Miró, *Painting*, 1933 (12 April)
Národní Galerie, Prague

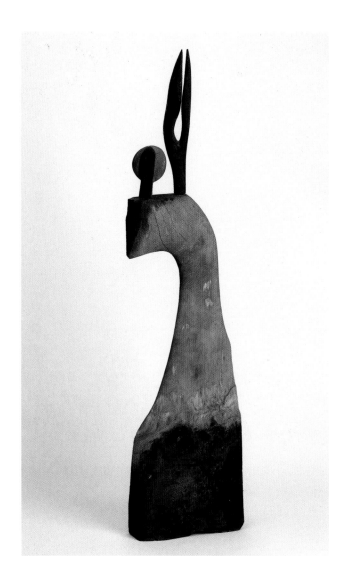 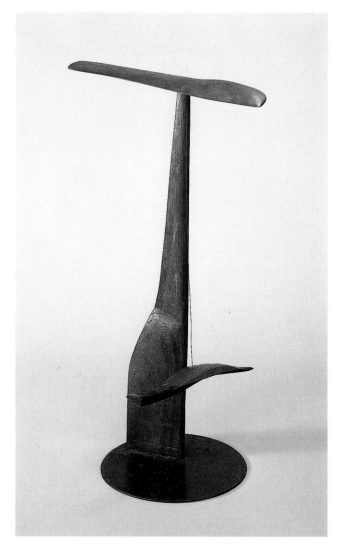

24 Alexander Calder, *Abstraction*, 1935–1936
IVAM, Instituto Valenciano de Arte Moderno, Generalitat Valenciana, Valencia

30 Alexander Calder, *T and Swallow*, 1936
Tate, London, purchased 1969

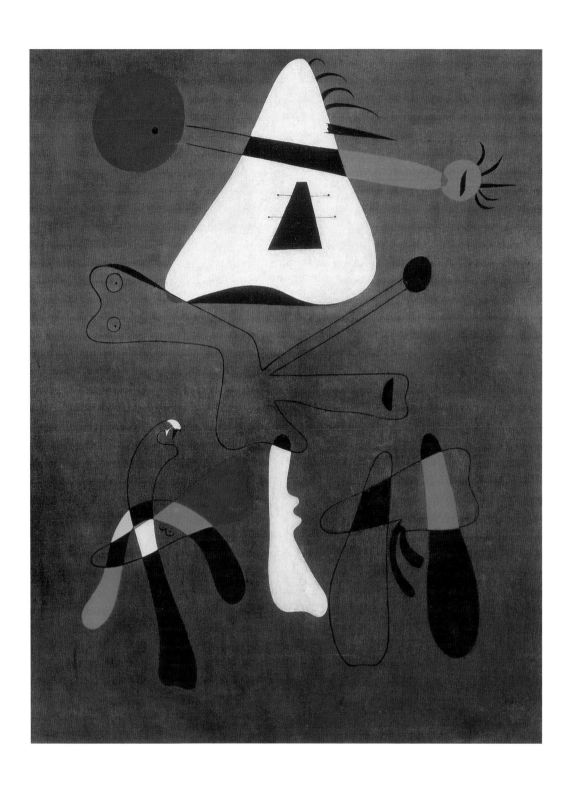

110 Joan Miró, *Painting*, 1933 (29 April)
Helly Nahmad Collection

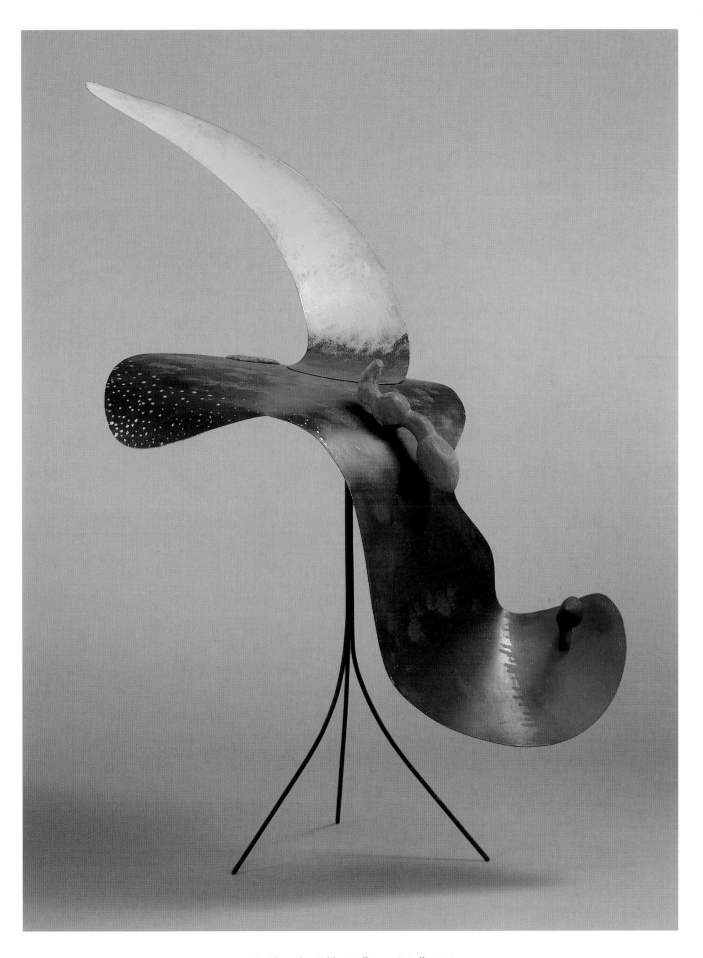

28 Alexander Calder, *Cello on a Spindle*, 1936
Kunsthaus Zürich

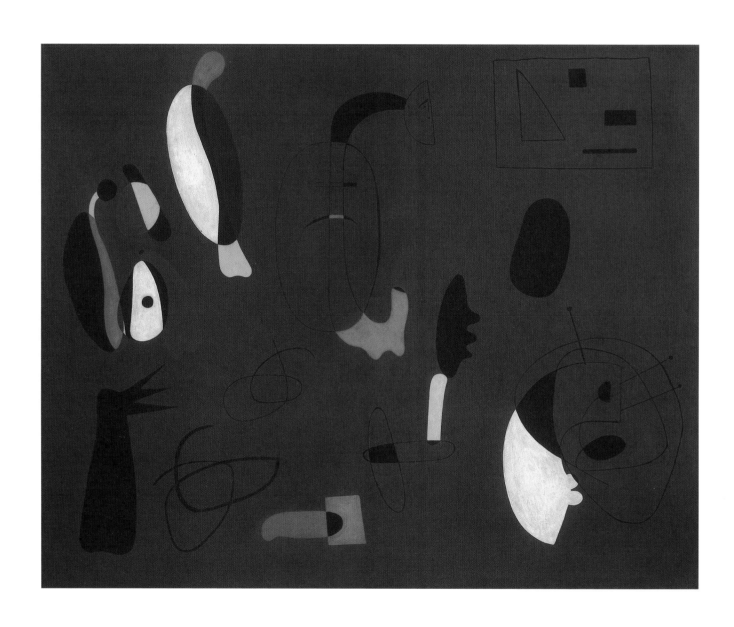

111 Joan Miró, *Painting*, 1933 (8 May)
Courtesy Milly and Arne Glimcher, New York

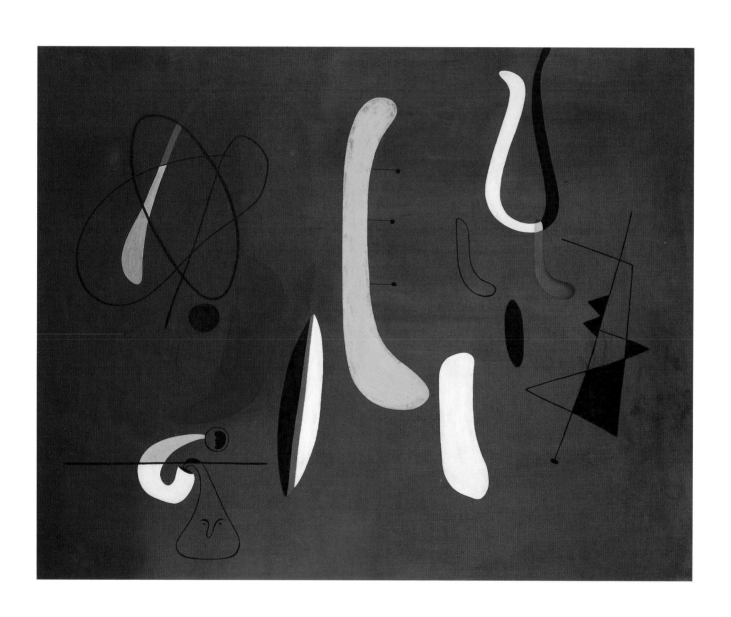

112 Joan Miró, *Painting*, 1933 (27 May)
Private collection, courtesy Proarte, Mexico City

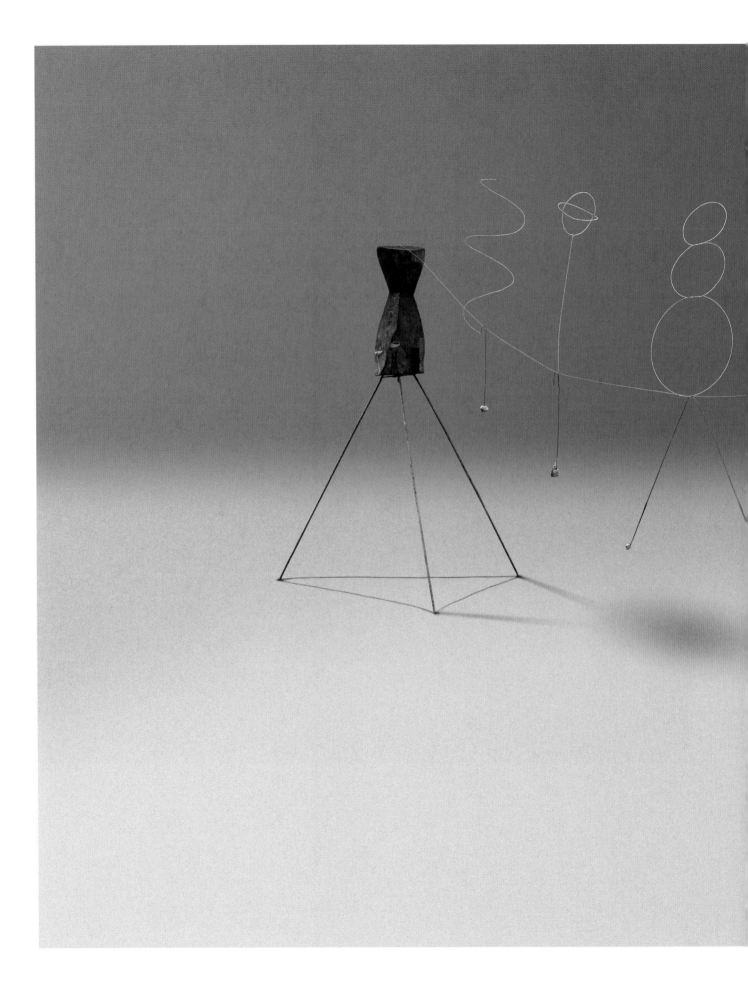

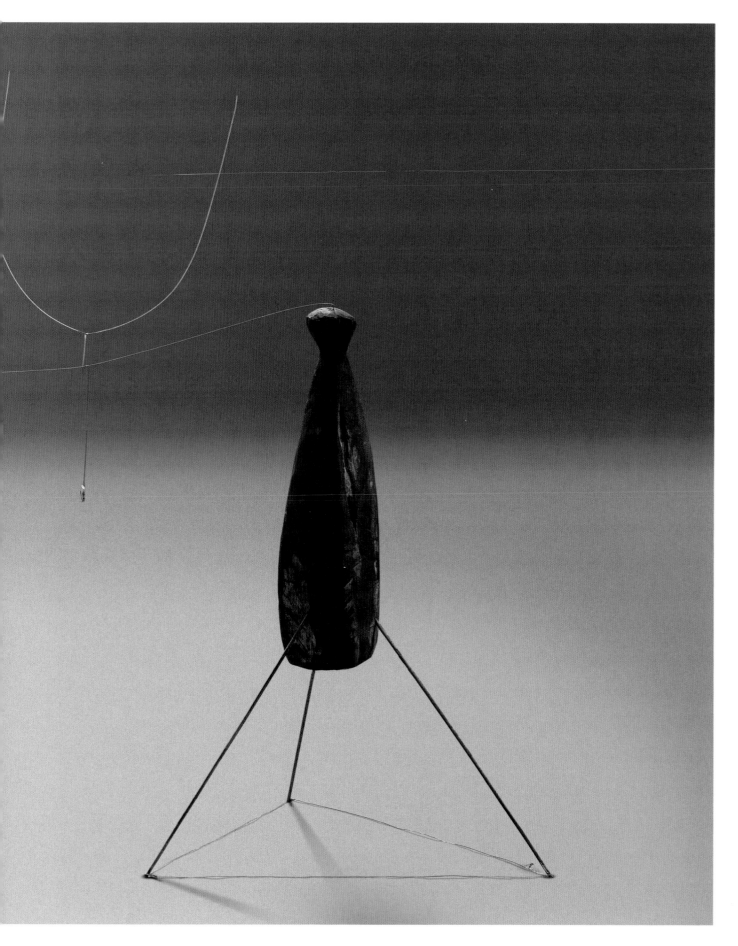

25 Alexander Calder, *Tightrope*, ca. 1936
Courtesy Calder Foundation, New York

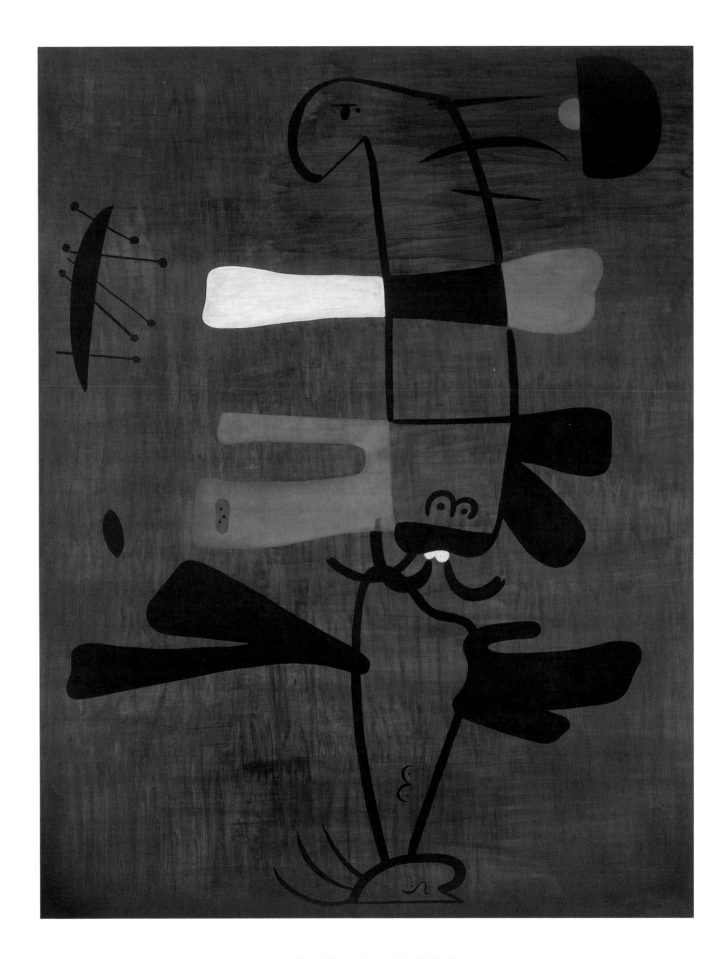

113 Joan Miró, *Painting*, 1933 (24 June)
Courtesy Calder Foundation, New York

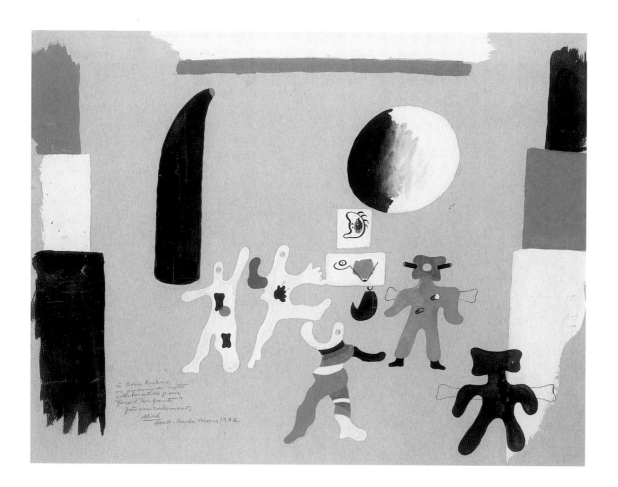

Fig. 62 Joan Miró, design with stage set and figures for *Jeux d'enfants*
by Georges Bizet in the production by the Ballets Russes de Monte Carlo, 1932,
gouache on paper, 49 x 63.5 cm (19 ¼ x 25 in.), Collection Cramer, Geneva

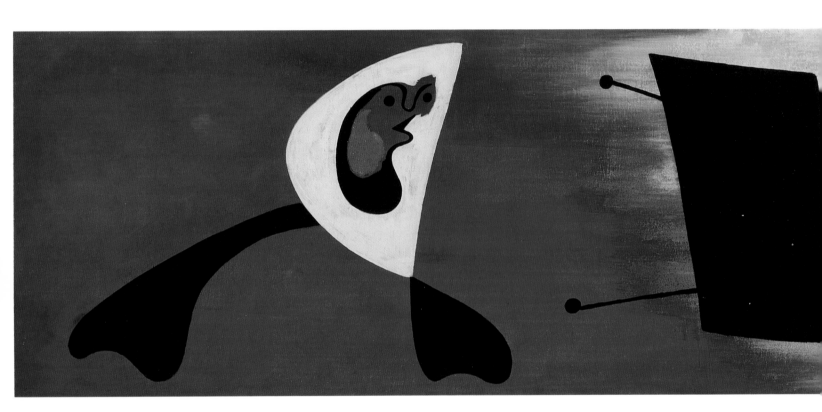

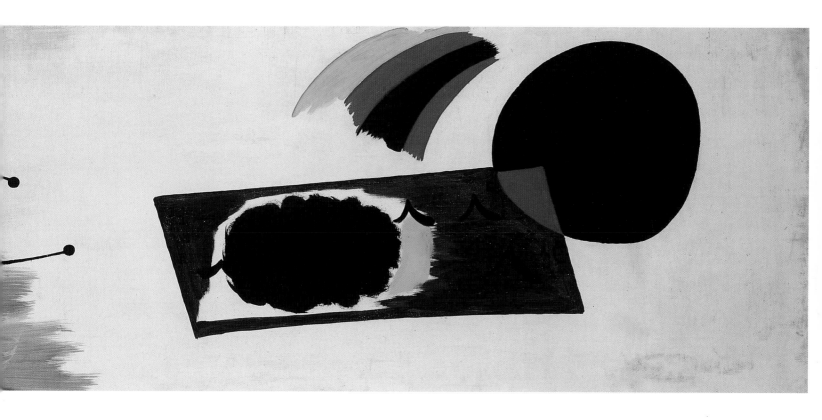

114a Joan Miró, *Mural I*, 1933
Private collection

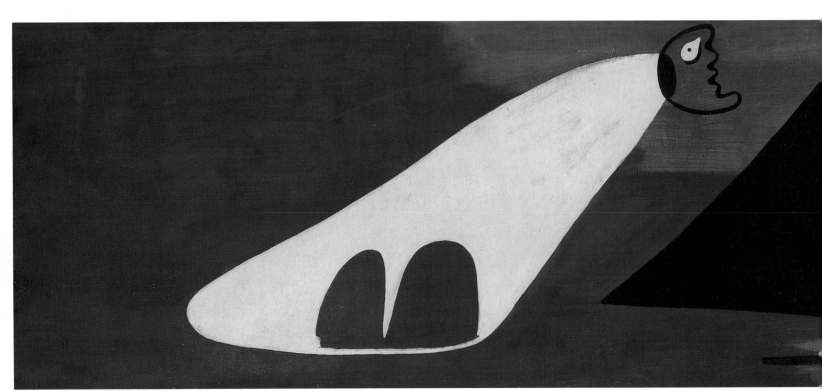

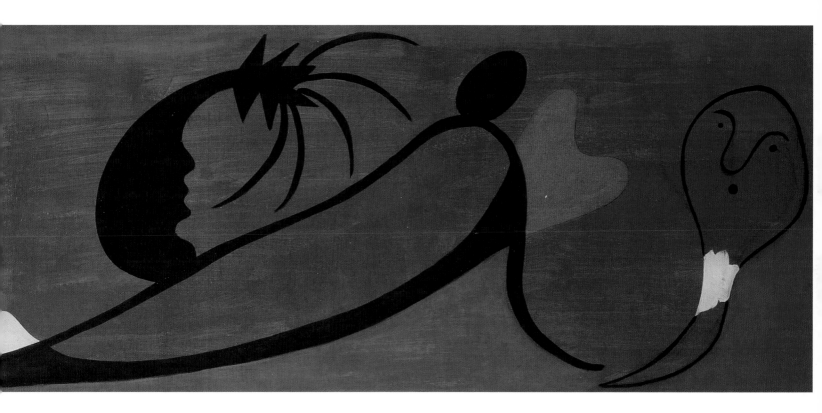

114b Joan Miró, *Mural II*, 1933
Private collection

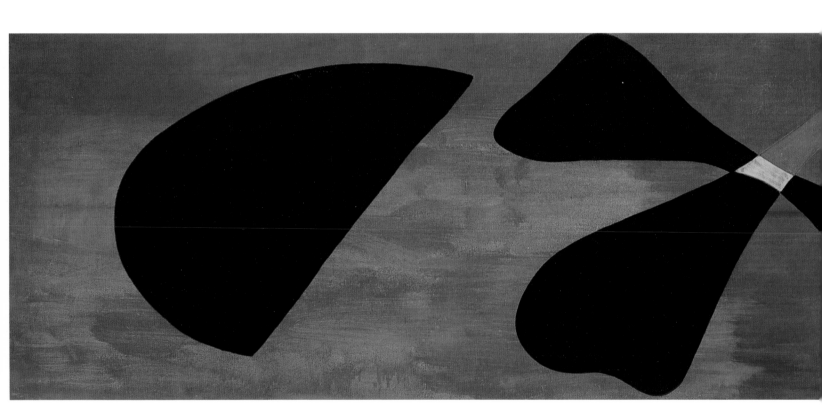

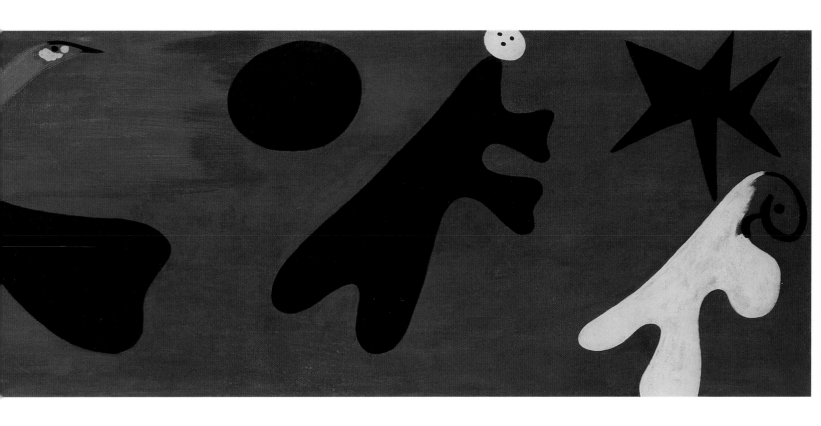

114c Joan Miró, *Mural III*, 1933
Private collection

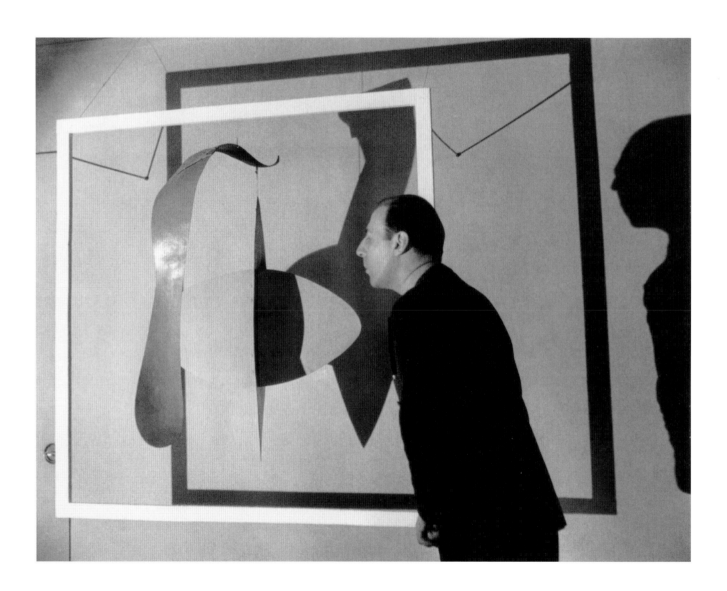

Fig. 63 Pierre Matisse blowing on Alexander Calder's mobile *Snake and the Cross* (cat. 29), 1937, photo Herbert Matter

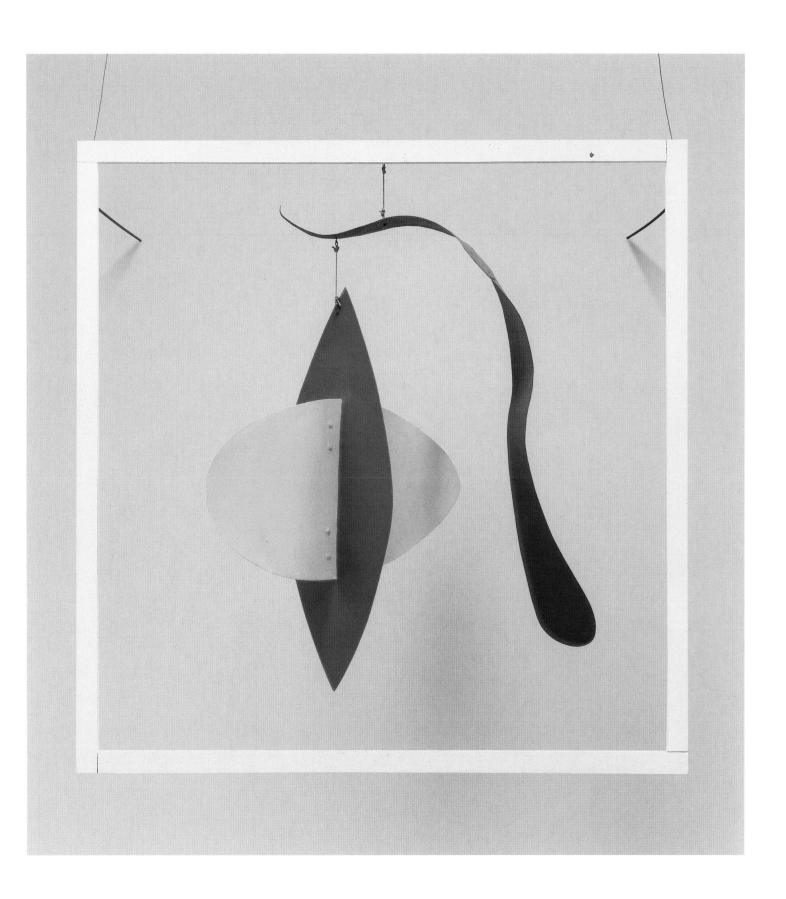

29 Alexander Calder, *Snake and the Cross*, 1936
Courtesy Calder Foundation, New York

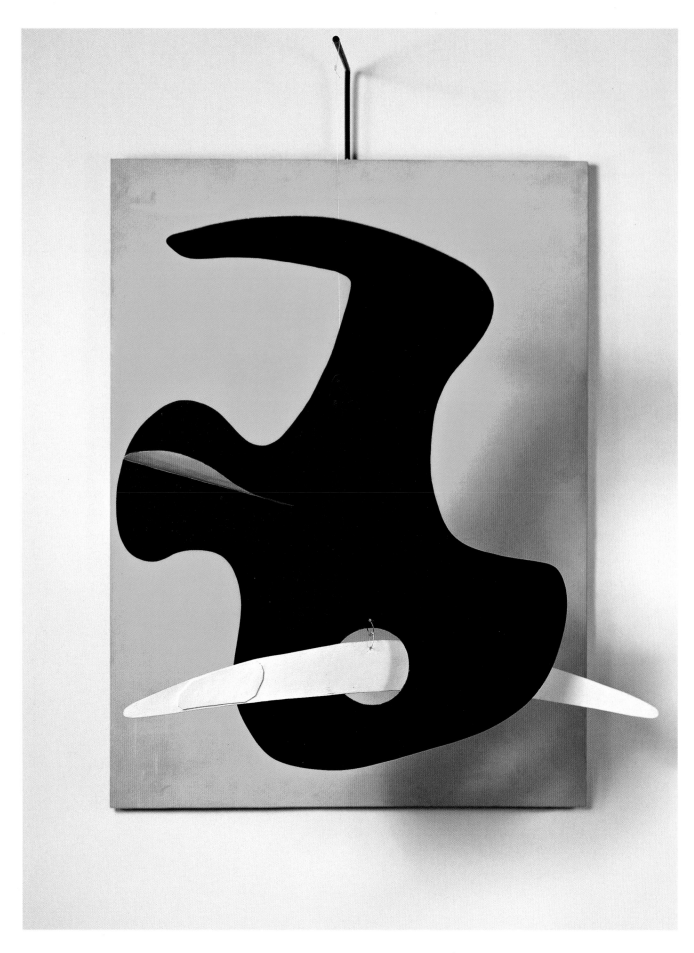

31 Alexander Calder, *Yellow Panel (Form Against Yellow)*, 1936
Hirshhorn Museum and Sculpture Garden, Smithsonian Institution, gift of Joseph H. Hirshhorn, 1972

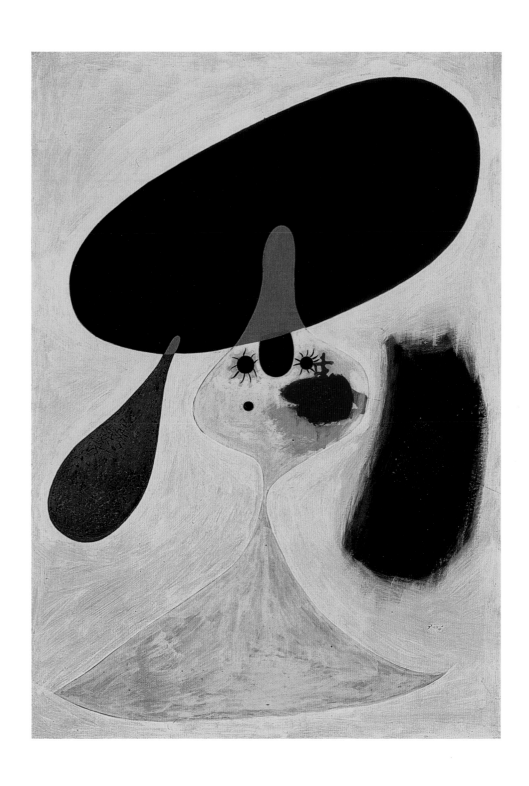

115 Joan Miró, *Portrait of a Young Girl*, 1935
New Orleans Museum of Art, bequest of Victor K. Kiam

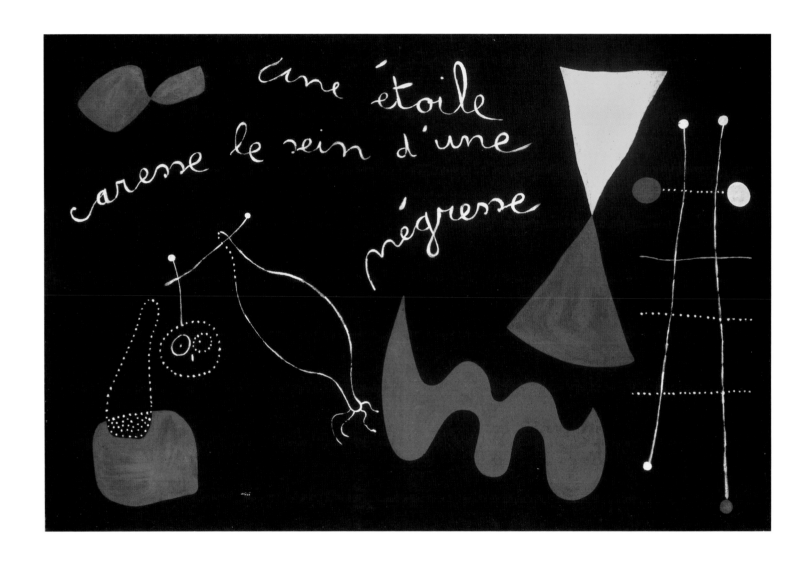

116 Joan Miró, *Une étoile caresse le sein d'une négresse (A Star Caresses the Breast of a Negress [Painting-Poem])*, 1938
Tate, London, purchased 1983

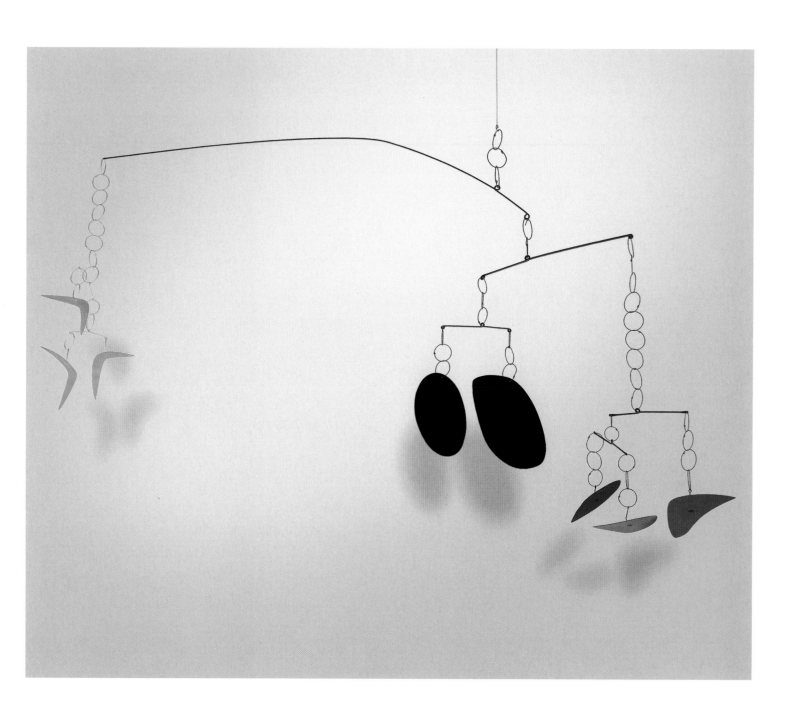

47 Alexander Calder, *Boomerangs*, 1941
Courtesy Calder Foundation, New York

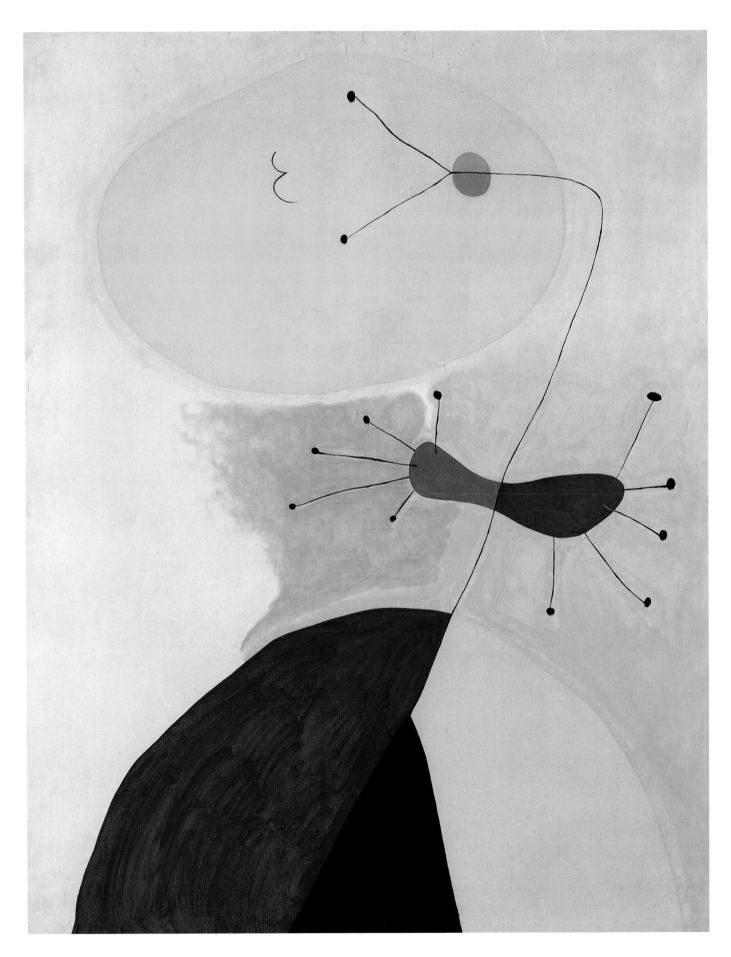

117 Joan Miró, *Portrait III*, 1938
Kunsthaus Zürich

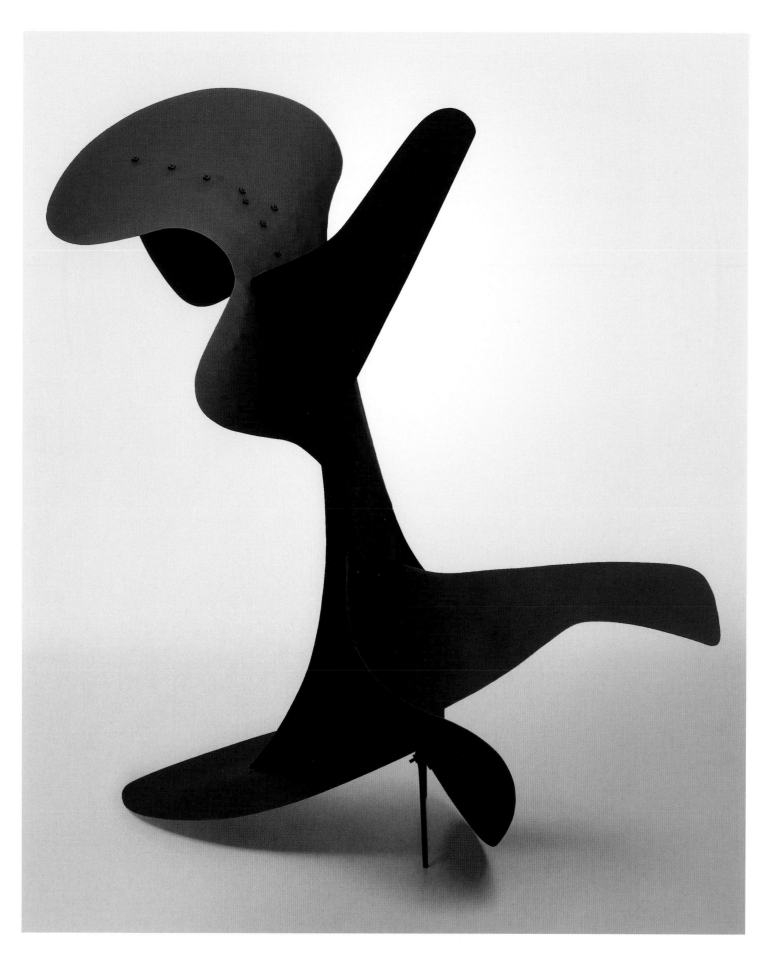

33 Alexander Calder, *Devil Fish*, 1937
Courtesy Calder Foundation, New York

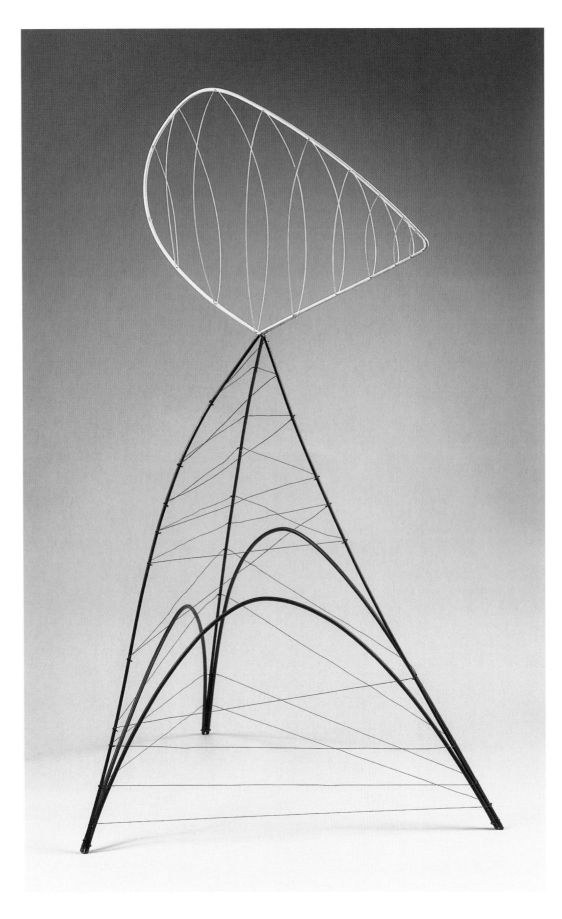

42 Alexander Calder, *Hollow Egg*, 1939
The Phillips Collection, Washington, D.C., partial and promised gift in memory of Betty Milton,
a close friend of Louisa Calder, 2001

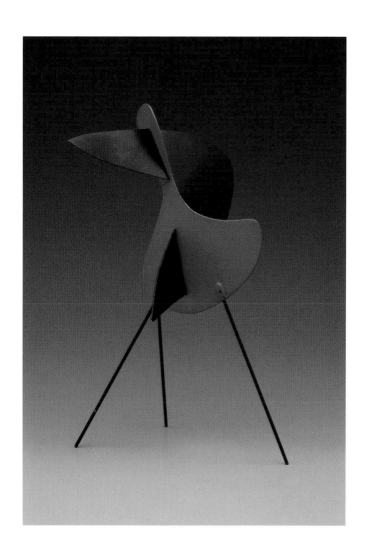

27 Alexander Calder, *Big Bird* (maquette), 1936
Yale University Art Gallery, gift of the estate of Katherine S. Dreier

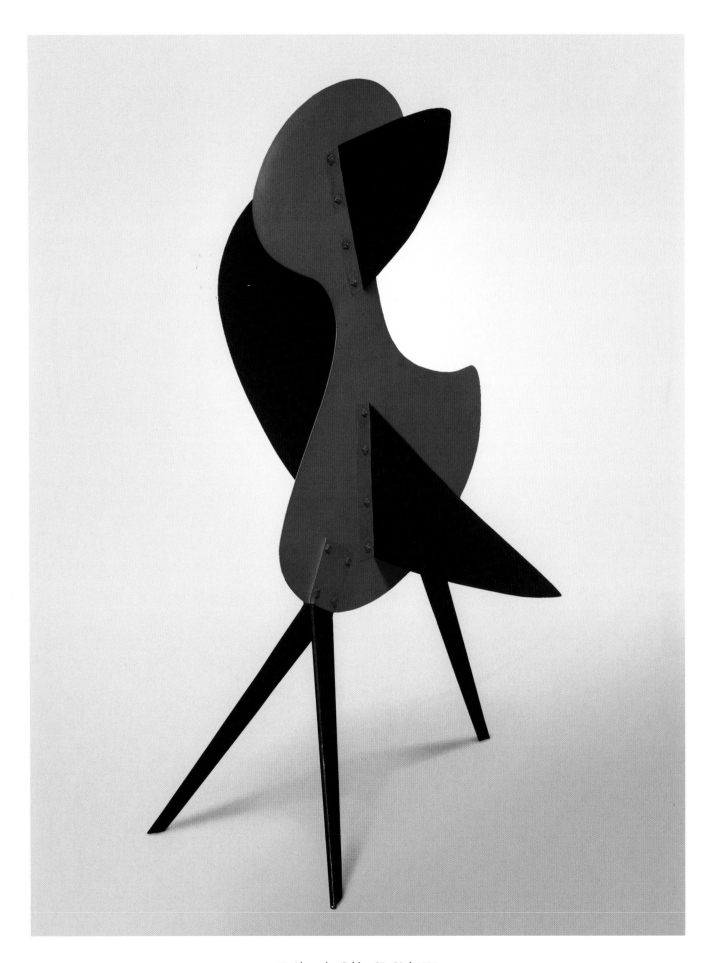

32 Alexander Calder, *Big Bird*, 1937
Courtesy Calder Foundation, New York

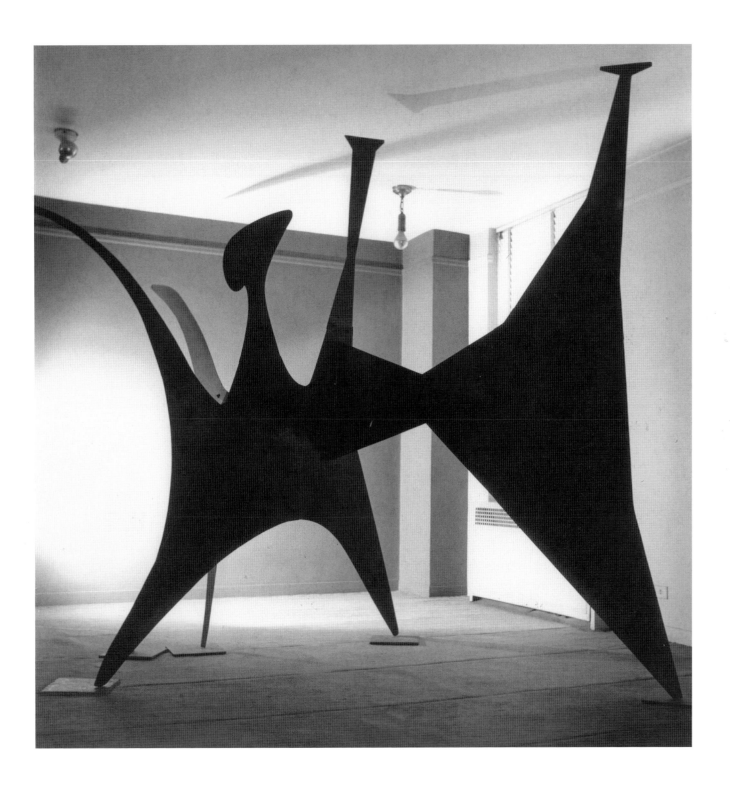

Fig. 64 Installation view of *Calder*, Pierre Matisse Gallery, New York, 1940, with *Black Beast* (cat. 45), photo Herbert Matter

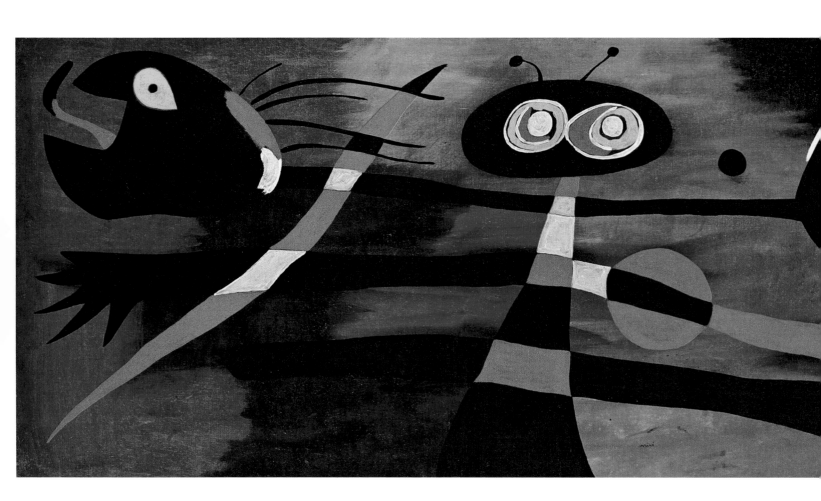

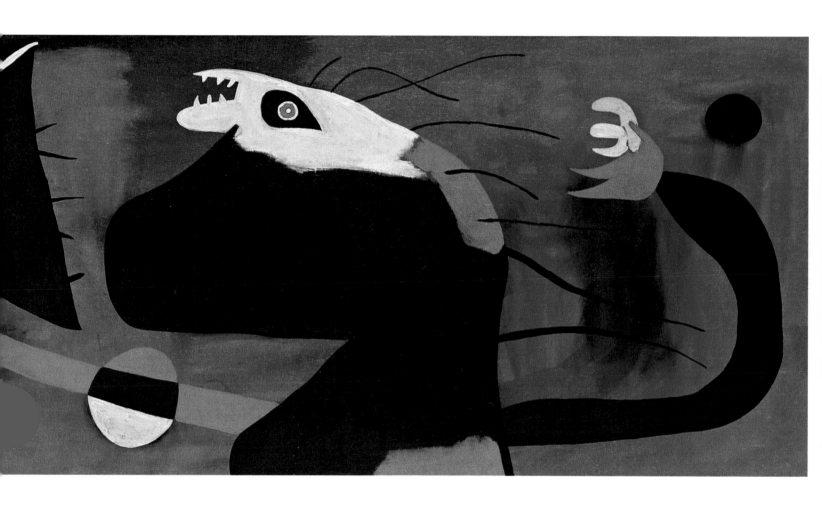

118 Joan Miró, *Woman Haunted by the Passage of the Bird-Dragonfly Omen of Bad News*, 1938
Toledo Museum of Art, purchased with funds from the Libbey Endowment, gift of Edward Drummond Libbey

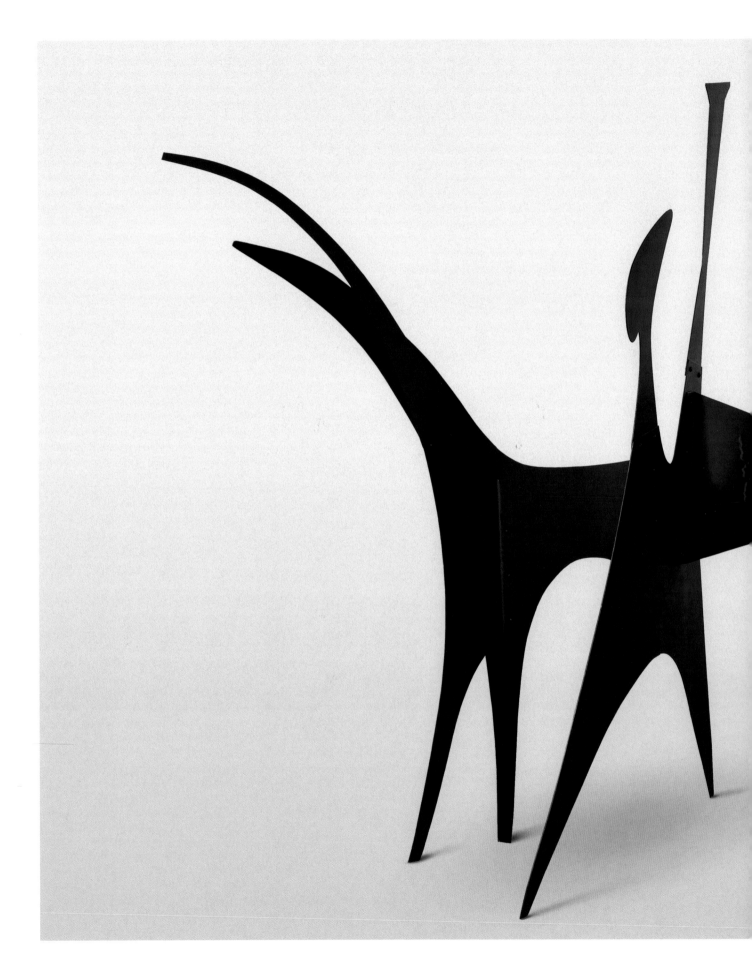

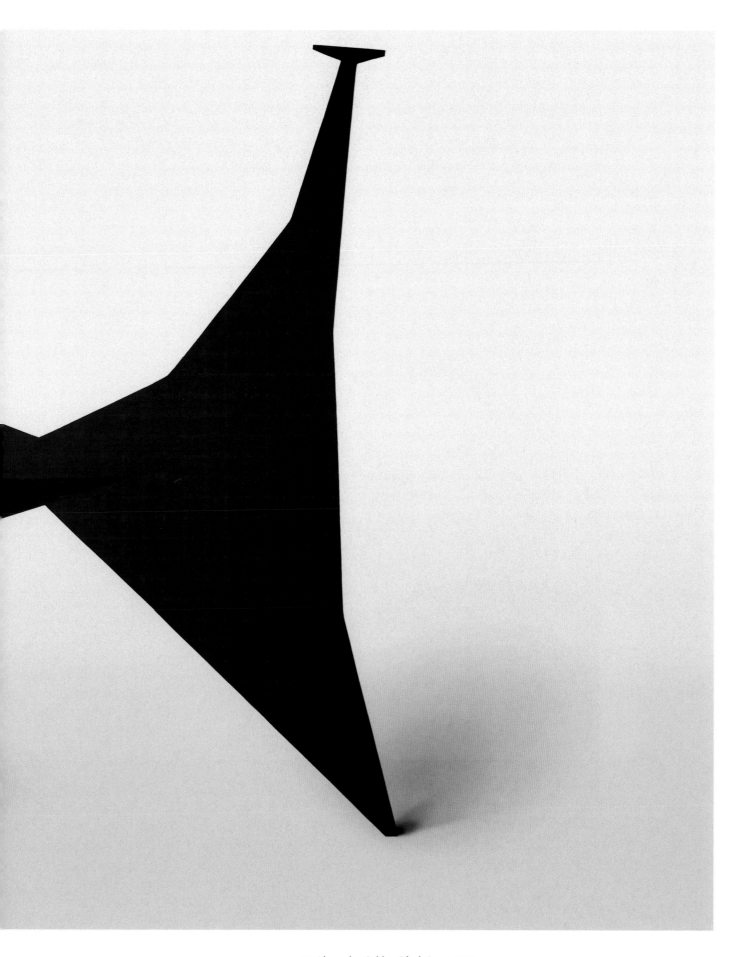

45 Alexander Calder, *Black Beast*, 1940
Courtesy Calder Foundation, New York

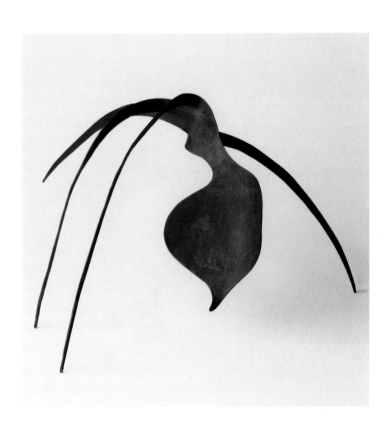

44 Alexander Calder, *Araignée d'oignon*, 1940
Moderna Museet, Stockholm, anonymous gift, 1951

35 Alexander Calder, *The Spider*, ca. 1938
Scottish National Gallery of Modern Art, Edinburgh

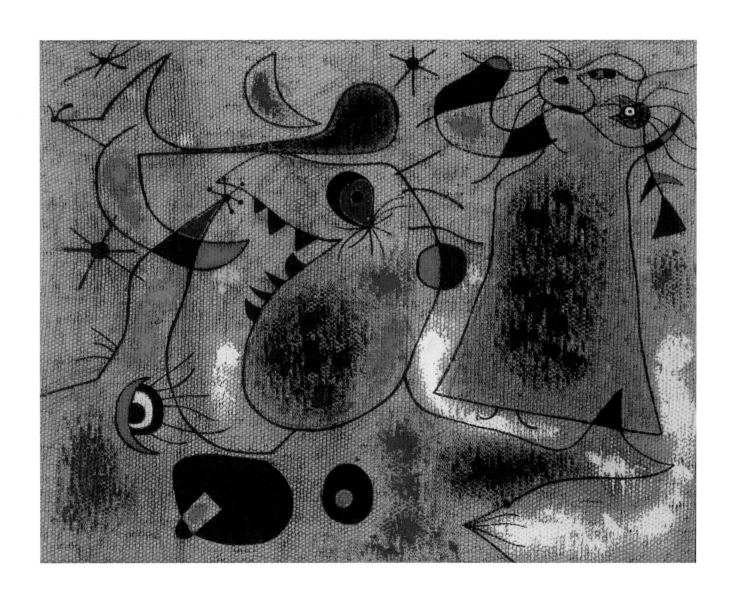

120 Joan Miró, *Figures and Birds in the Night*, 1939
Private collection, Switzerland

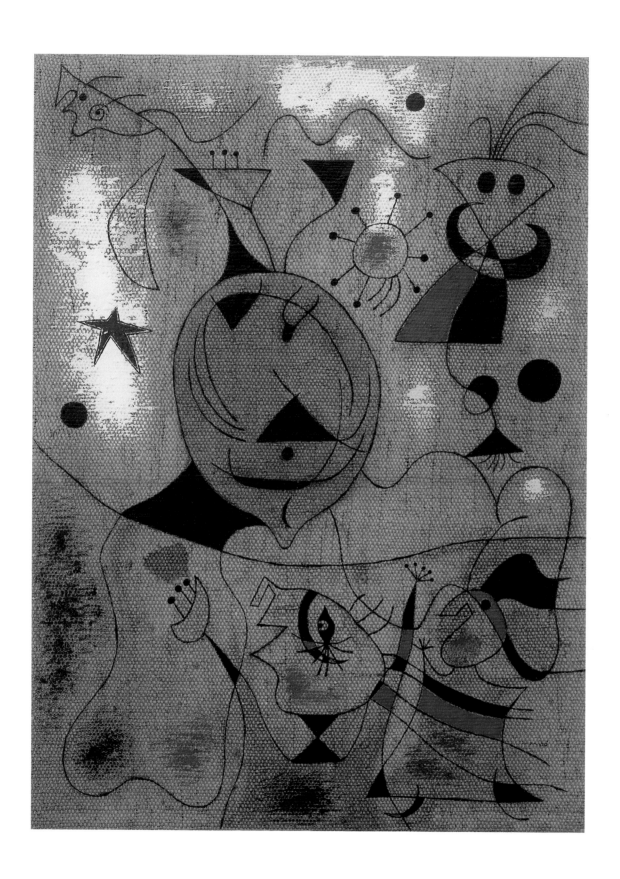

119 Joan Miró, *Women and Kite Among the Constellations*, 1939
Private collection, courtesy Caratsch de Pury & Luxembourg, Zurich

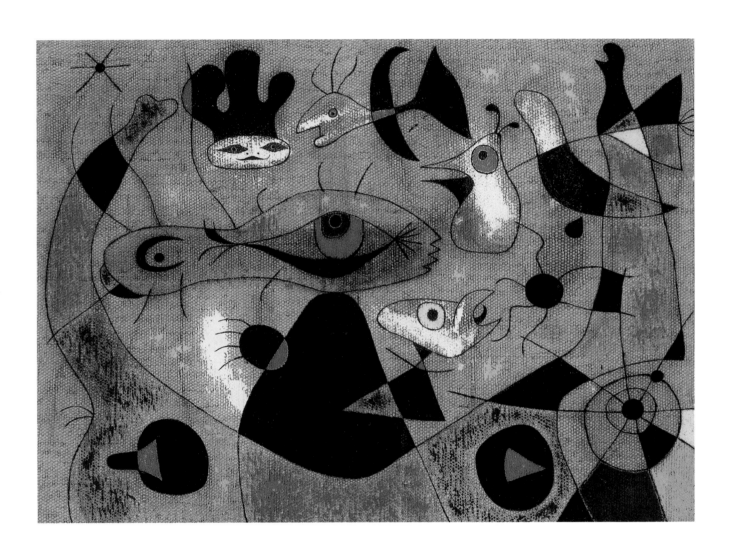

121 Joan Miró, *A Drop of Dew Falling Off the Wing of a Bird Awakens Rosalie Asleep in the Shadow of a Spiderweb*, 1939
The University of Iowa Museum of Art, Iowa City, purchased with the aid of the Mark Ranney Memorial Fund, 1948

THE WAR YEARS: SECLUSION AND CONSTELLATIONS

Fig. 65 Salvador and Gala Dalí looking at Joan Miró's Constellations during Miró's 1959 retrospective
at the Museum of Modern Art, New York

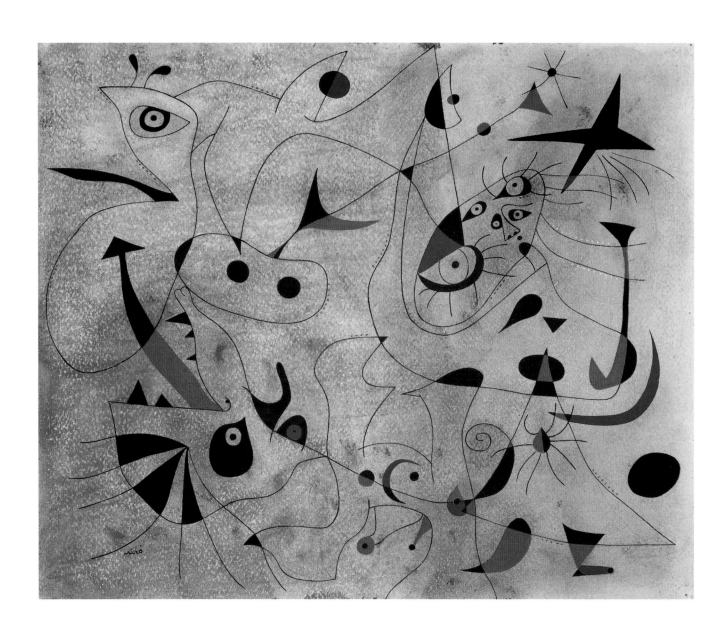

122 Joan Miró, *Morning Star (Constellation)*, 1940 (16 March)
Fundació Joan Miró, Barcelona, gift of Pilar Juncosa de Miró

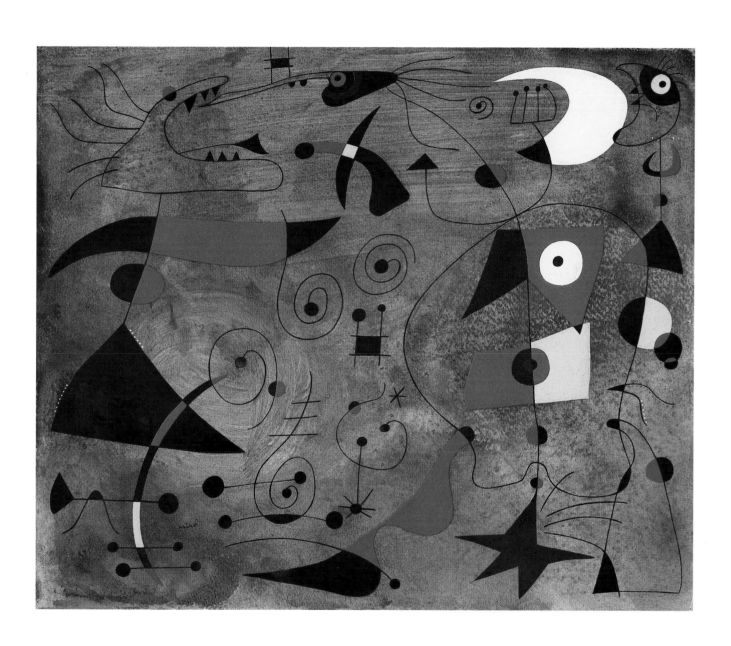

123 Joan Miró, *Woman and Birds (Constellation)*, 1940 (13 April)
Coleccíon Cisneros, Caracas

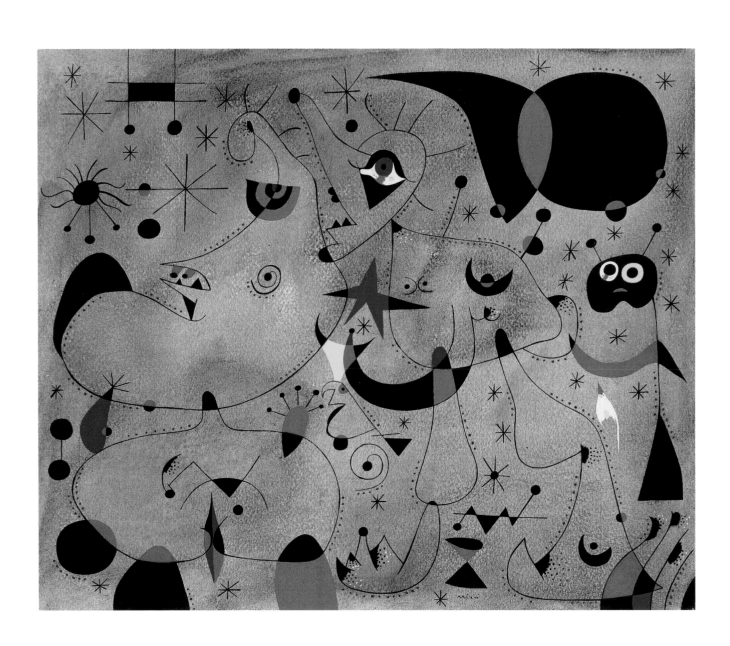

124 Joan Miró, *Nocturne (Constellation)*, 1940 (2 November)
Collection of Samuel and Ronnie Heyman, New York

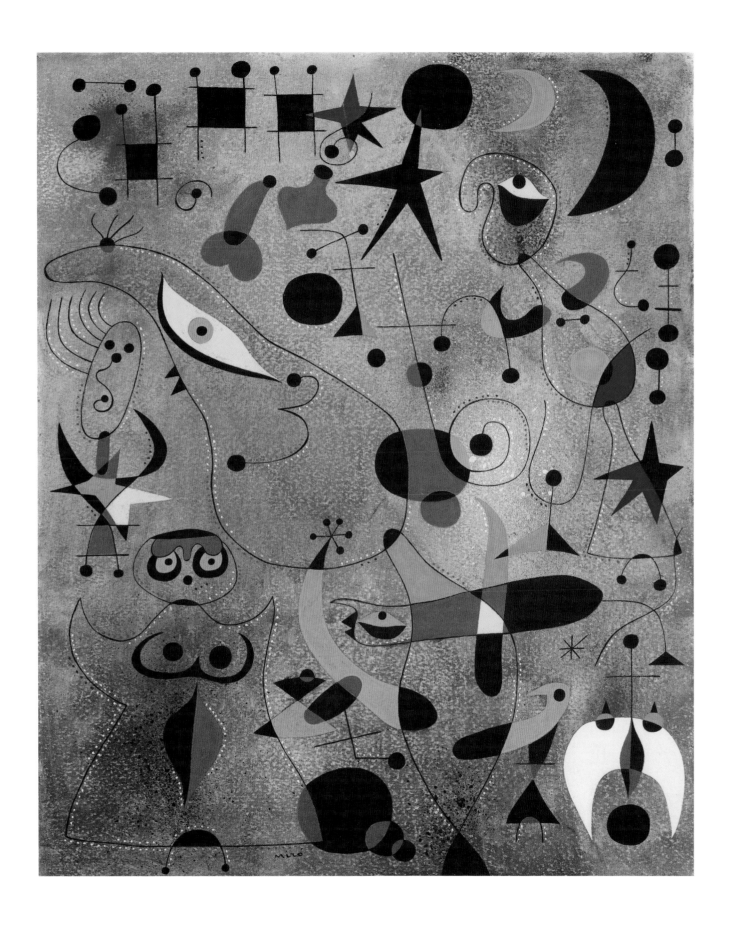

125 Joan Miró, *Awakening in the Early Morning (Constellation)*, 1941 (27 January)
Kimbell Art Museum, Fort Worth, Texas, acquired with the generous assistance of a grant from Mr. and Mrs. Perry R. Bass

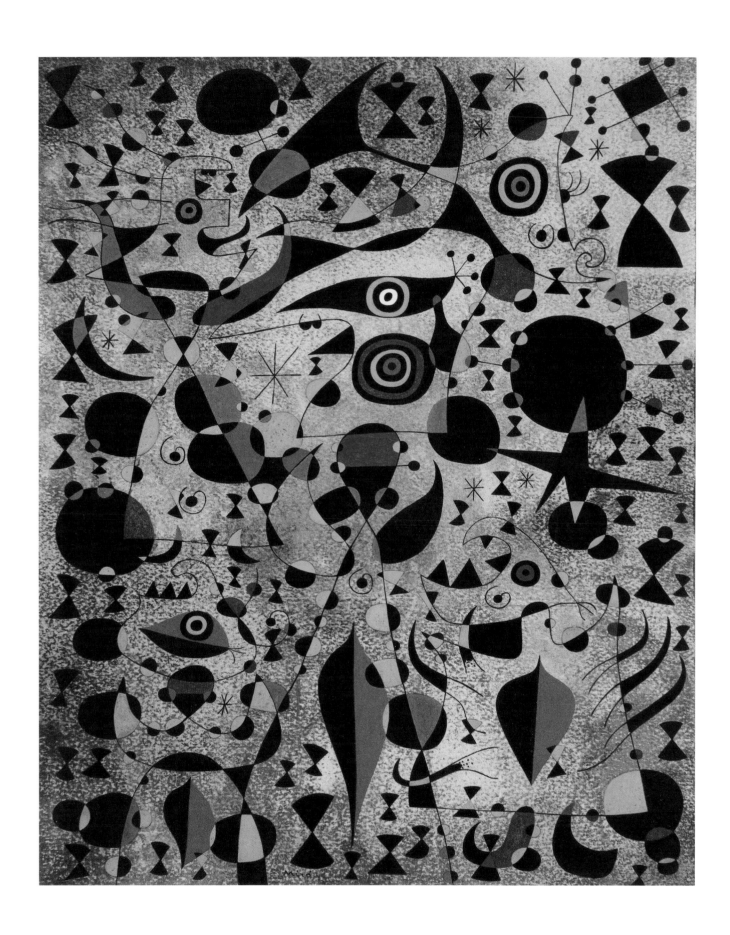

126 Joan Miró, *Women Encircled by the Flight of a Bird (Constellation)*, 1941 (26 April)
Private collection

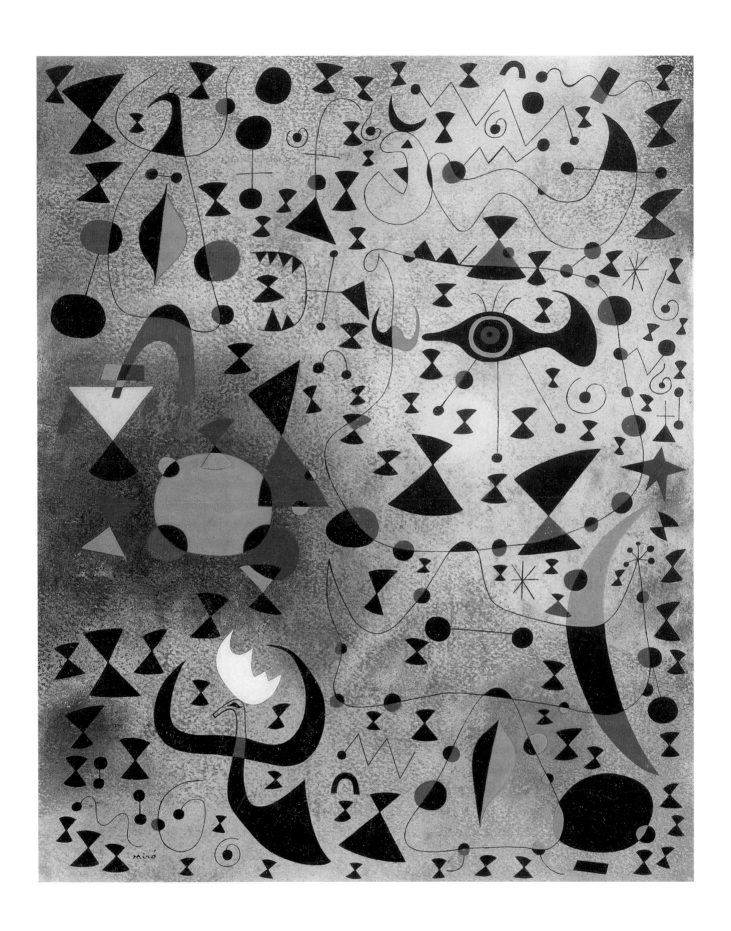

127 Joan Miró, *Women at the Edge of the Lake Made Iridescent by the Passage of a Swan (Constellation)*, 1941 (14 May)
Private collection

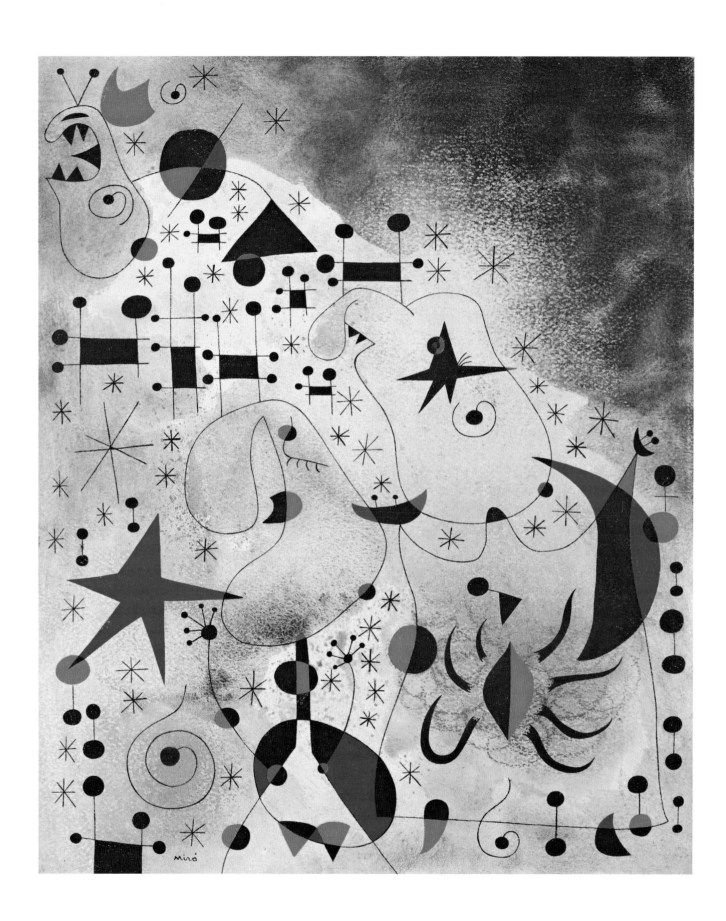

128 Joan Miró, *The Migratory Bird (Constellation)*, 1941 (26 May)
Private collection

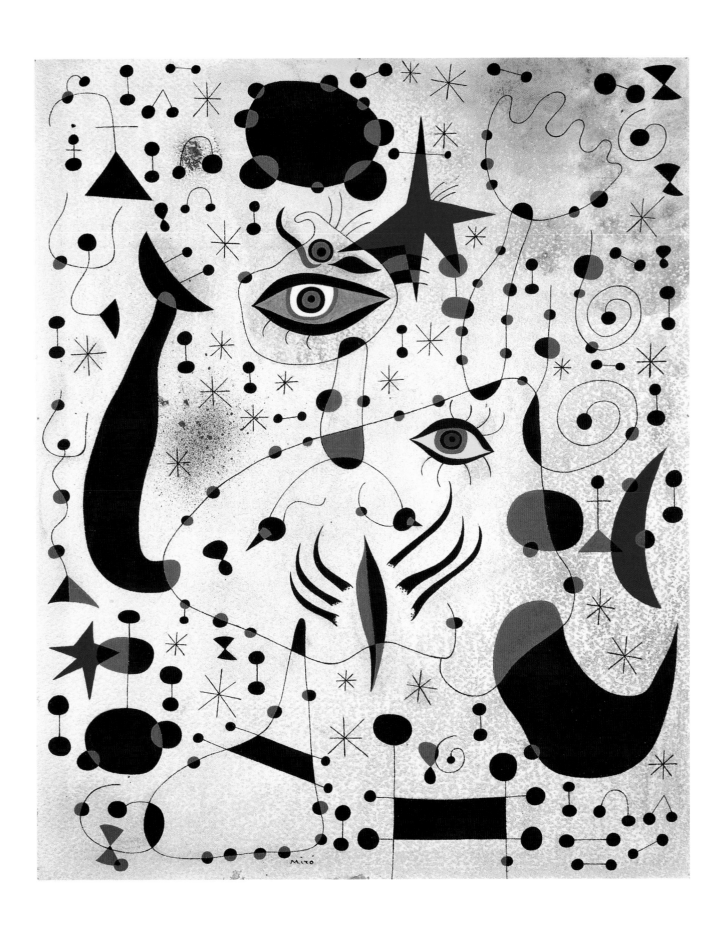

129 Joan Miró, *Ciphers and Constellations in Love with a Woman (Constellation)*, 1941 (12 June)
The Art Institute of Chicago, gift of Mrs. Gilbert W. Chapman, 1953

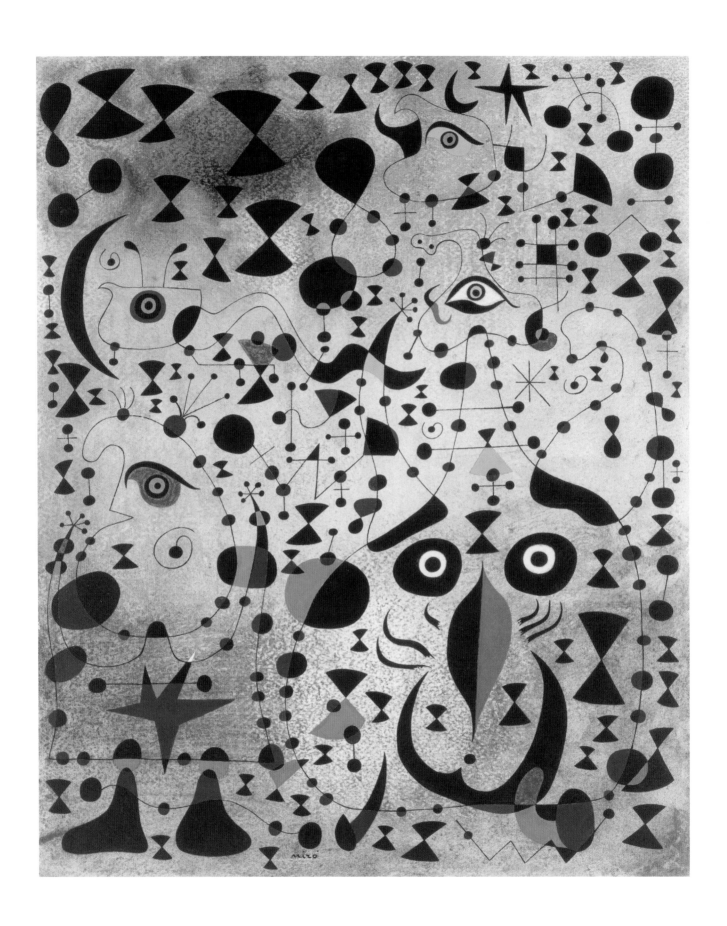

130 Joan Miró, *The Beautiful Bird Revealing the Unknown to a Pair of Lovers (Constellation)*, 1941 (23 July)
The Museum of Modern Art, New York, acquired through the Lillie P. Bliss Bequest

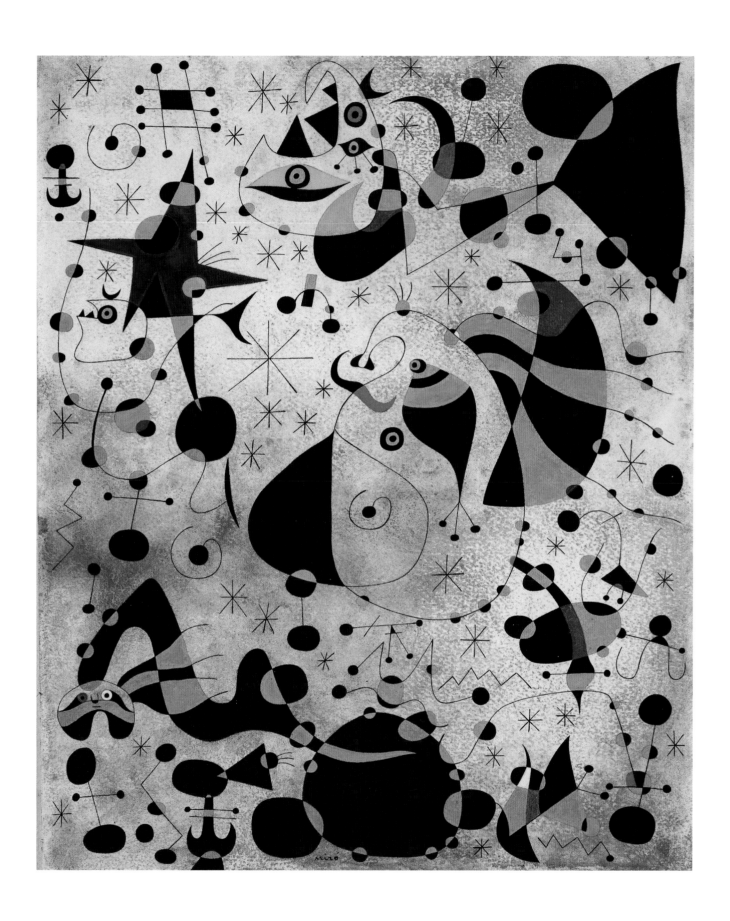

131 Joan Miró, *The Passage of the Divine Bird (Constellation)*, 1941 (12 September)
Toledo Museum of Art, purchased with funds from the Libbey Endowment, gift of Edward Drummond Libbey

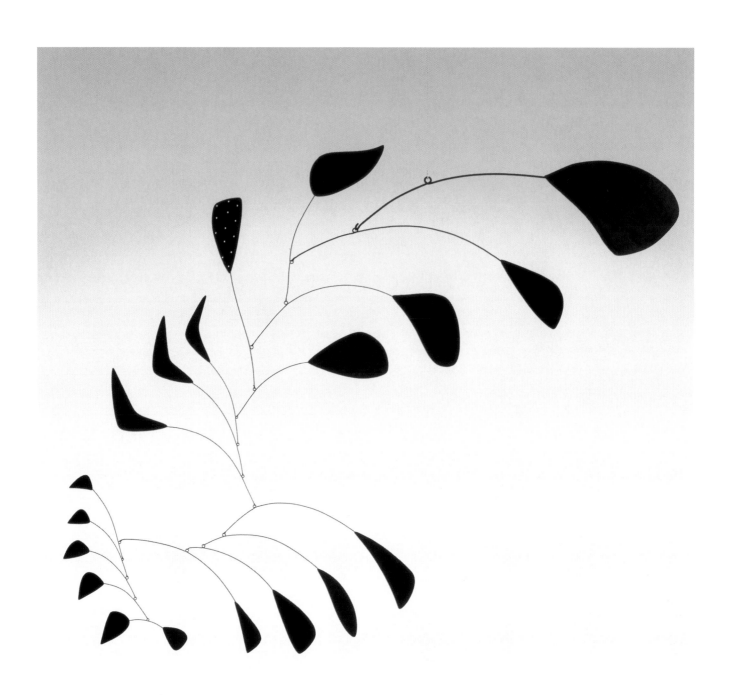

53 Alexander Calder, *Vertical Foliage*, 1942
Courtesy Calder Foundation, New York

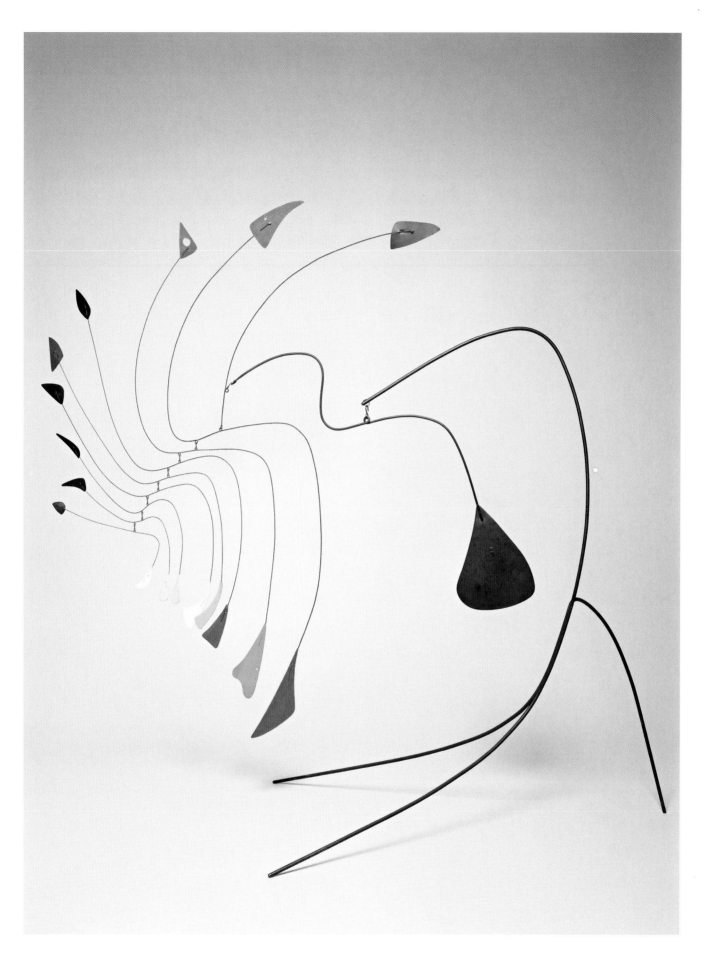

43 Alexander Calder, *Little Spider*, ca. 1940
National Gallery of Art, Washington, gift of Mr. and Mrs. Klaus G. Perls, 1996

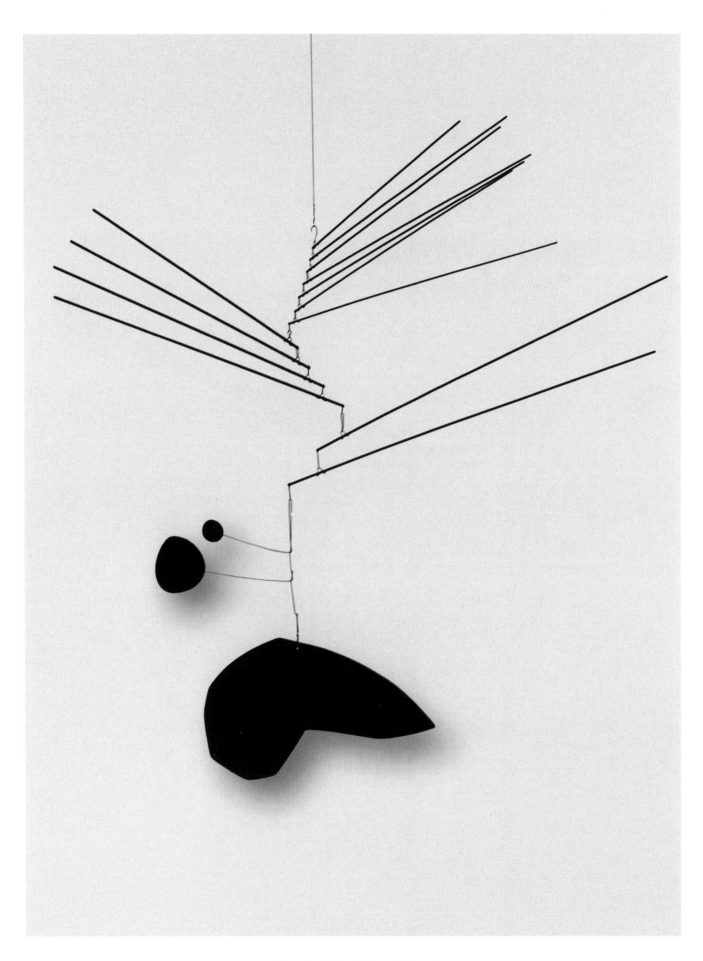

46 Alexander Calder, *Thirteen Spines*, 1940
Museum Ludwig, Cologne

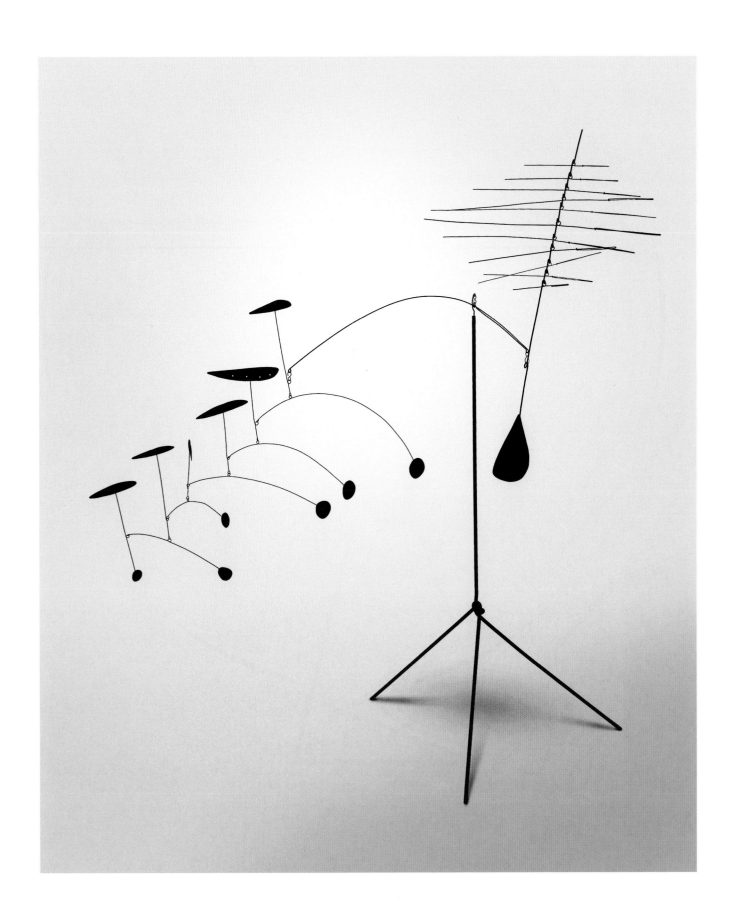

52 Alexander Calder, *Horizontal Spines*, 1942
Addison Gallery of American Art, Phillips Academy, Andover, Massachusetts

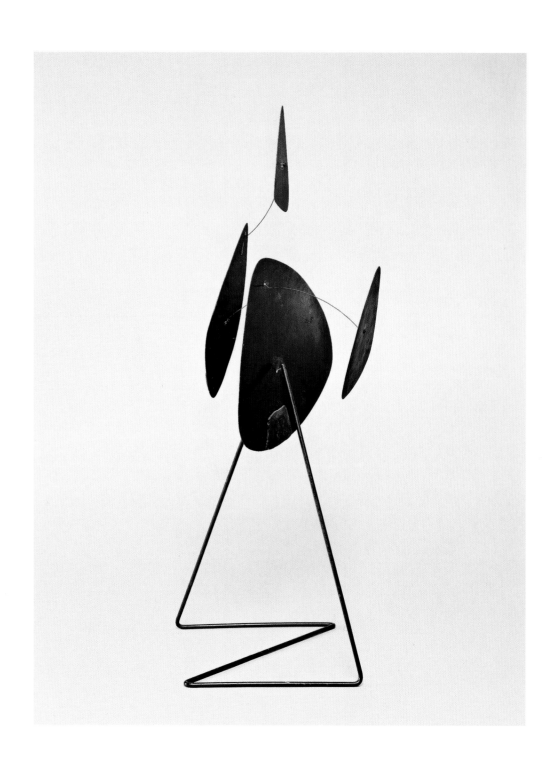

38 Alexander Calder, *Spherical Triangle*, 1938
Aaron I. Fleischman

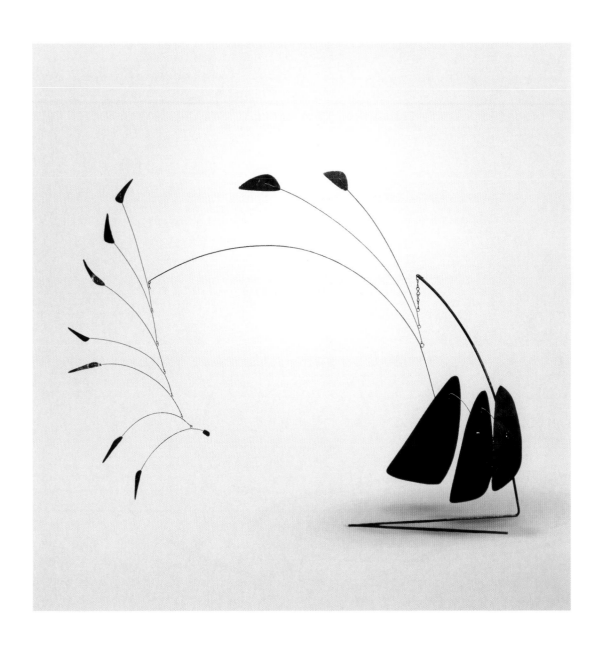

54 Alexander Calder, *Wheat*, 1942
Private collection, USA

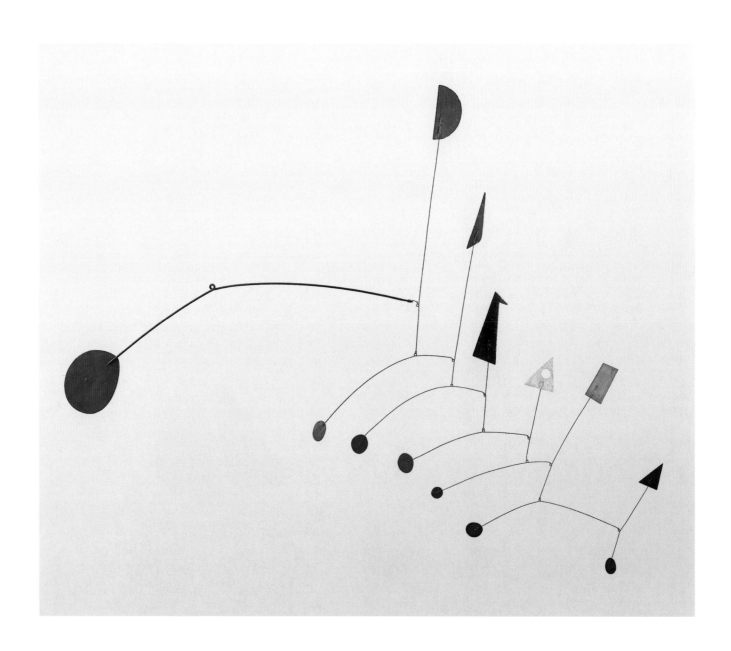

36 Alexander Calder, *Untitled*, ca. 1938
Kukje Gallery, Seoul

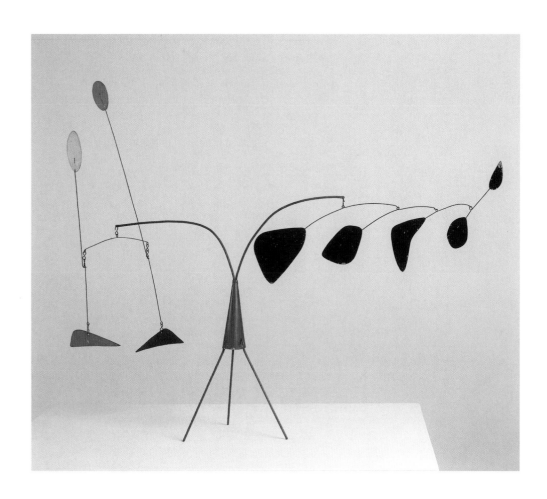

50 Alexander Calder, *Red Cone with Bright Flags and Black Leaves*, ca. 1942
Kunstmuseum Winterthur, gift of Friedrich Jezler Foundation, 1999

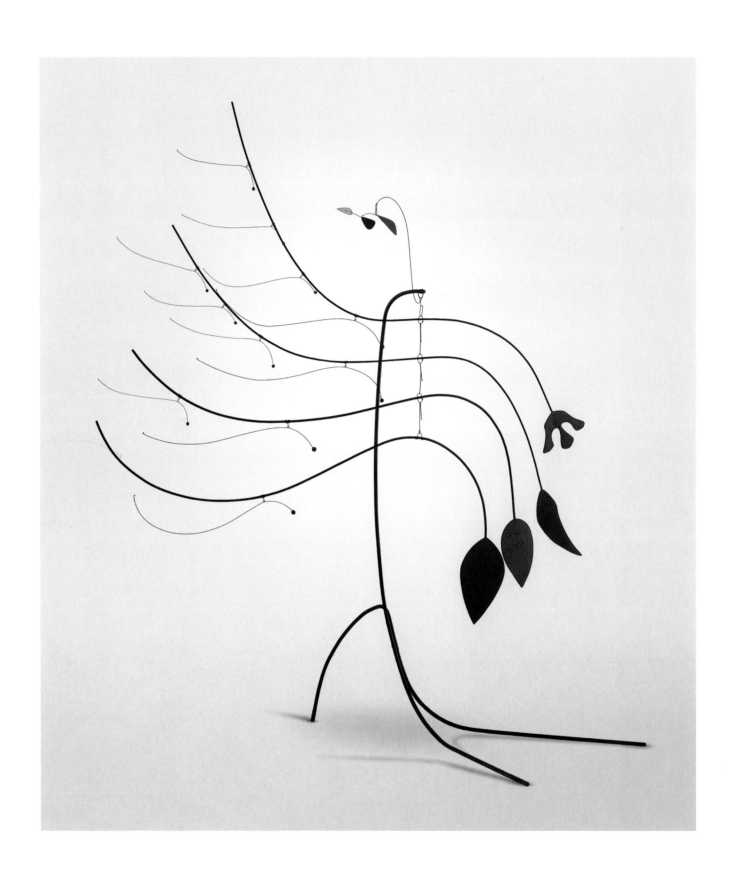

41 Alexander Calder, *Four Leaves and Three Petals*, 1939
Centre Georges Pompidou, Paris, Musée National d'Art Moderne, *dation* to the French State, 1983

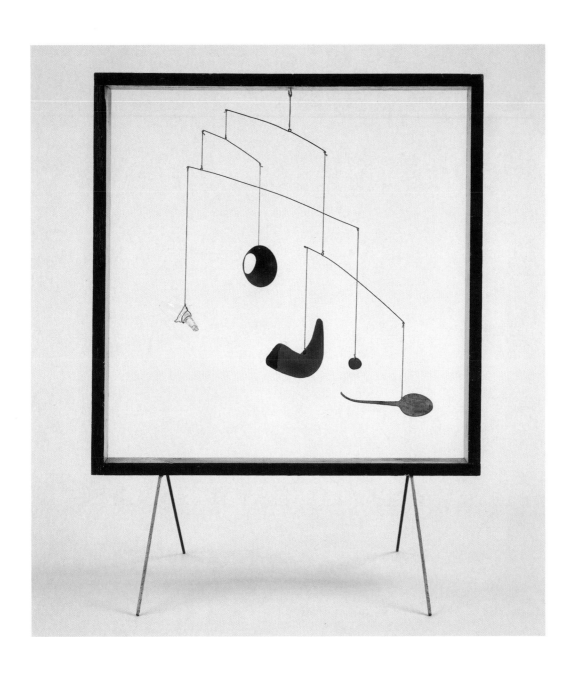

51 Alexander Calder, *Untitled*, ca. 1942
Private collection, courtesy Proarte, Mexico City

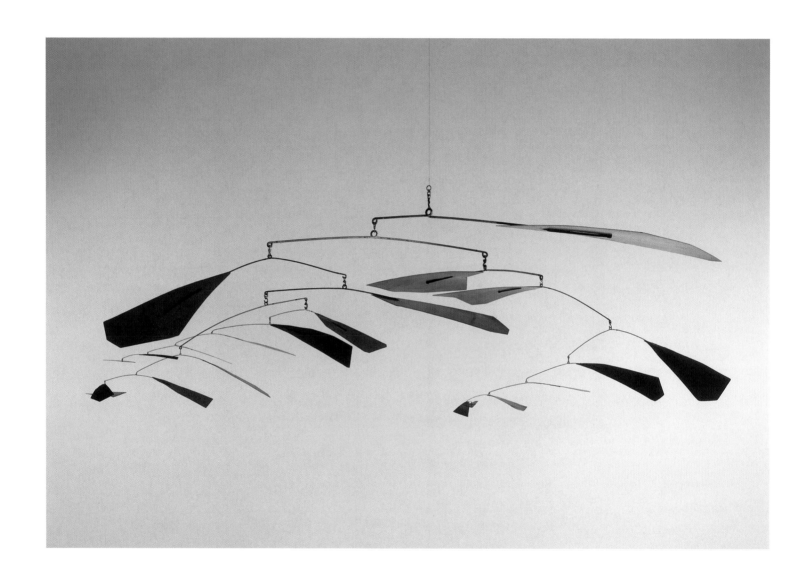

49 Alexander Calder, *Untitled*, 1941
Carnegie Museum of Art, Pittsburgh, gift of Aluminum Company of America, 1995

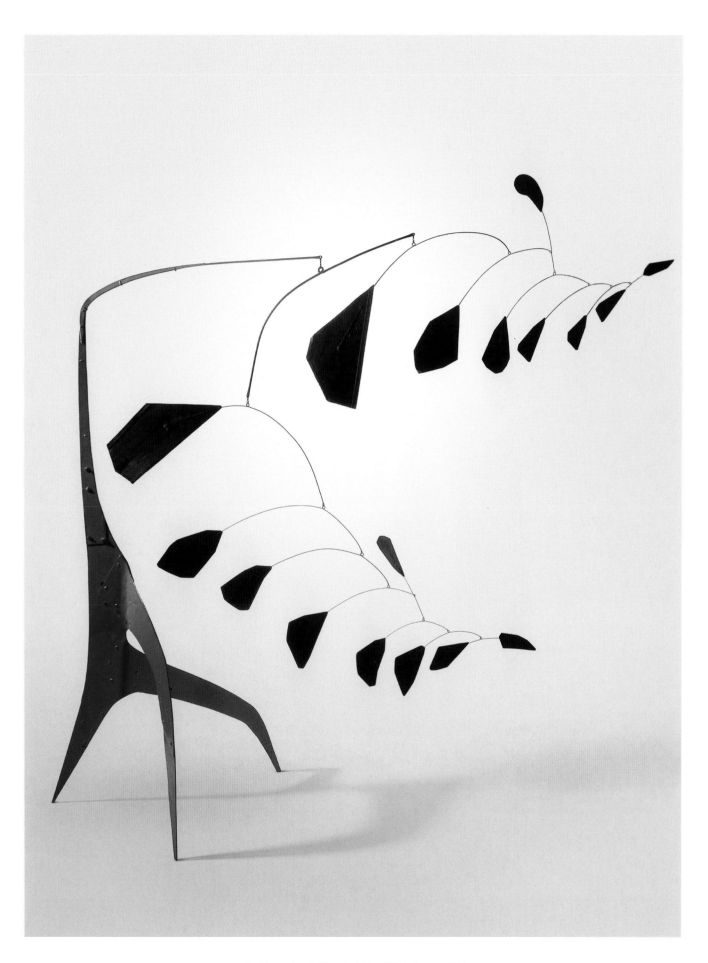

48 Alexander Calder, *Red Post, Black Leaves*, 1941
Private collection, courtesy Guggenheim, Asher Associates

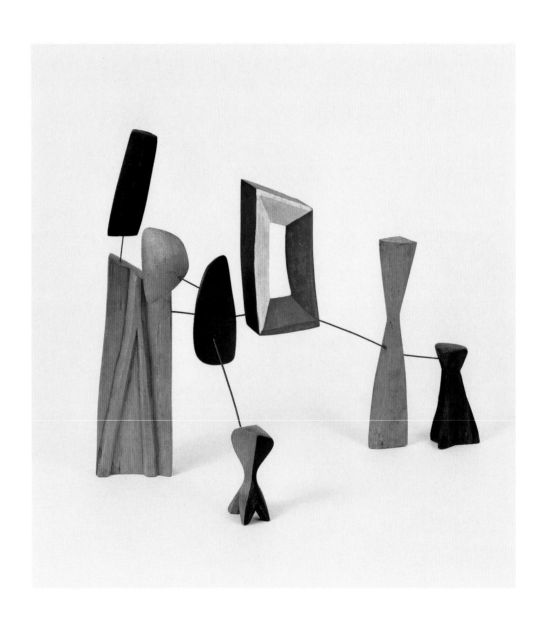

59 Alexander Calder, *Constellation with Quadrilateral*, 1943
Whitney Museum of American Art, New York, 50th anniversary gift of the Howard and Jean Lipman Foundation, Inc.

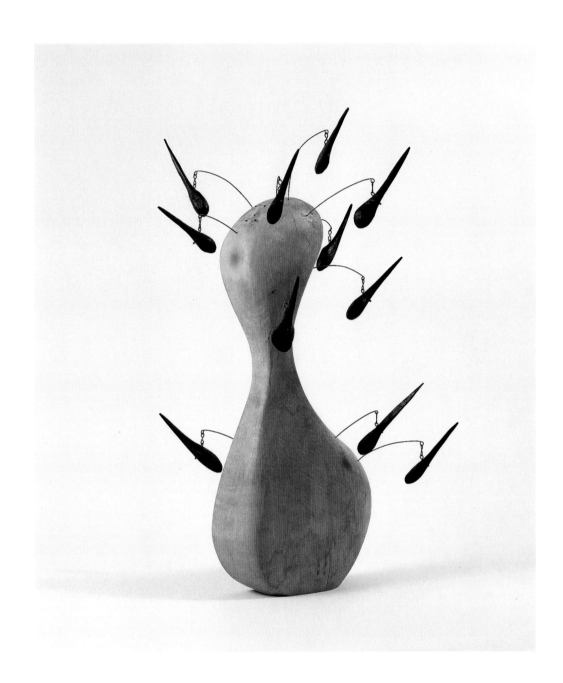

61 Alexander Calder, *Wooden Bottle with Hairs*, 1943
Whitney Museum of American Art, New York, 50th anniversary gift of the Howard and Jean Lipman Foundation, Inc.

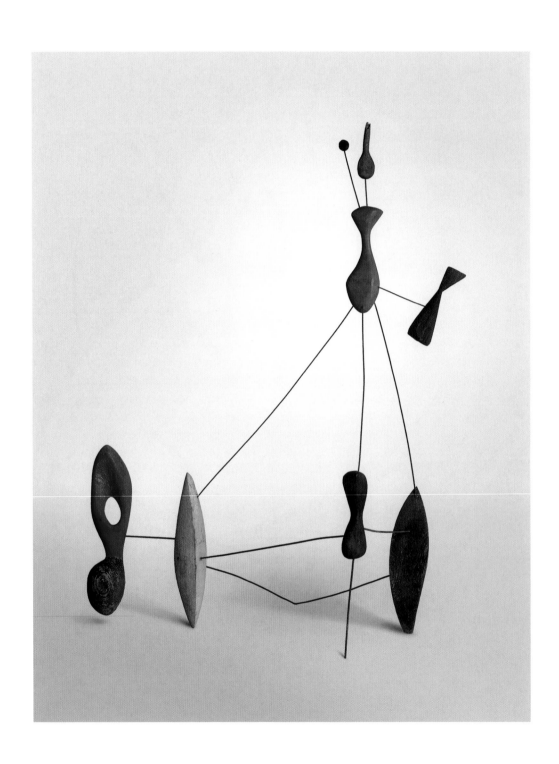

60 Alexander Calder, *Constellation with Two Pins*, 1943
Courtesy Calder Foundation, New York

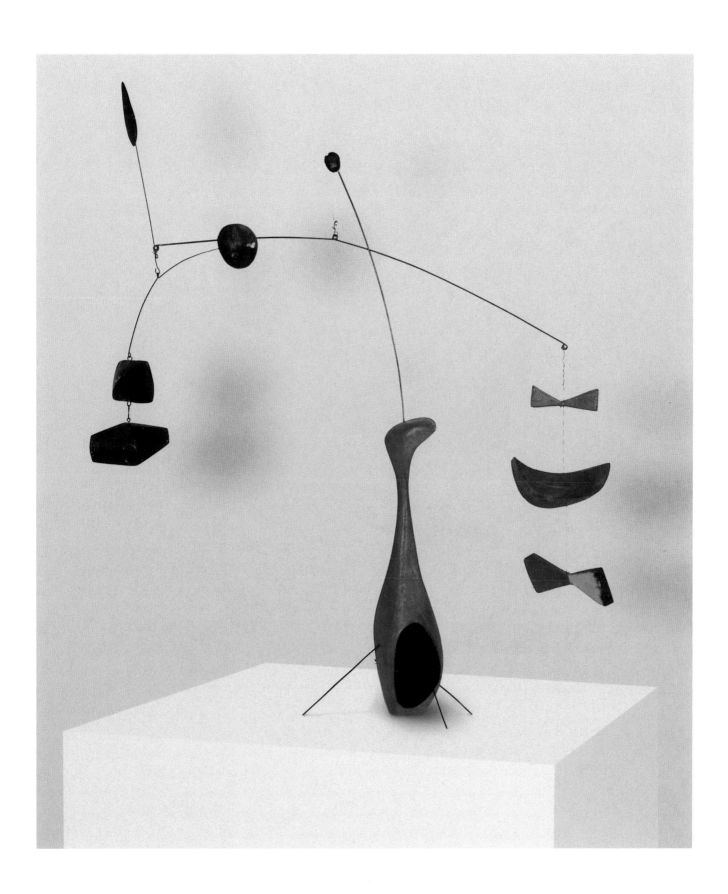

55 Alexander Calder, *Untitled (Constellation)*, 1942–1943
Private collection, Switzerland

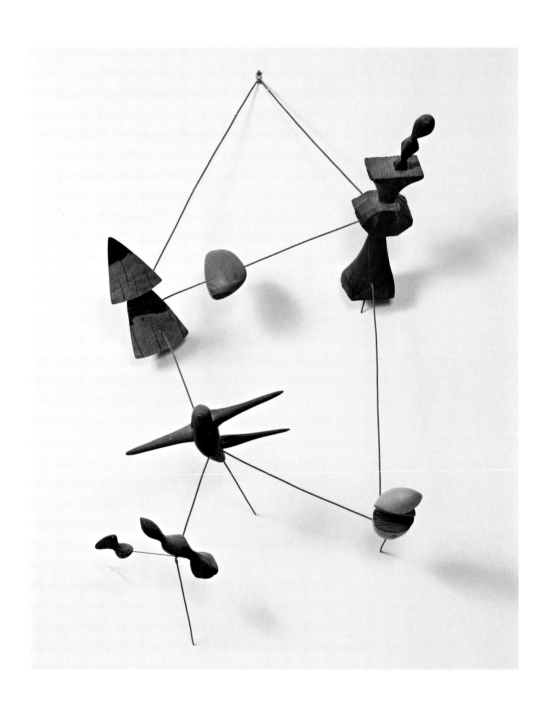

56 Alexander Calder, *Constellation*, 1943
Loaned in memory of Betty Milton, a close friend of Louisa Calder

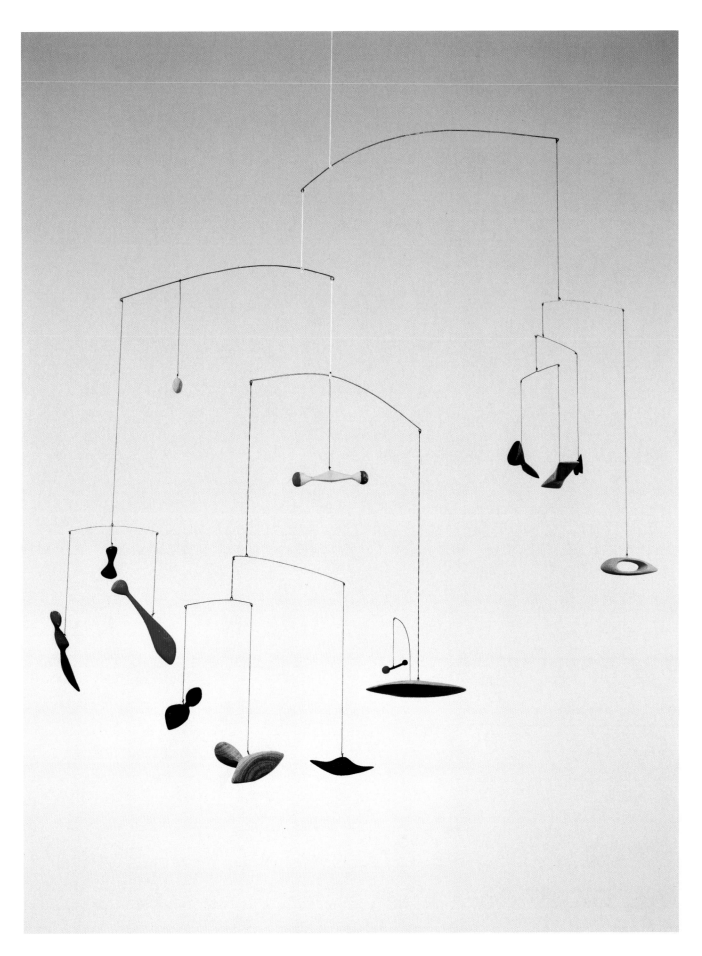

58 Alexander Calder, *Constellation Mobile*, 1943
Courtesy Calder Foundation, New York

Fig. 66 Joan Miró in his Barcelona studio, with early state of *The Port* (cat. 138), 1945, photo Joaquim Gomis

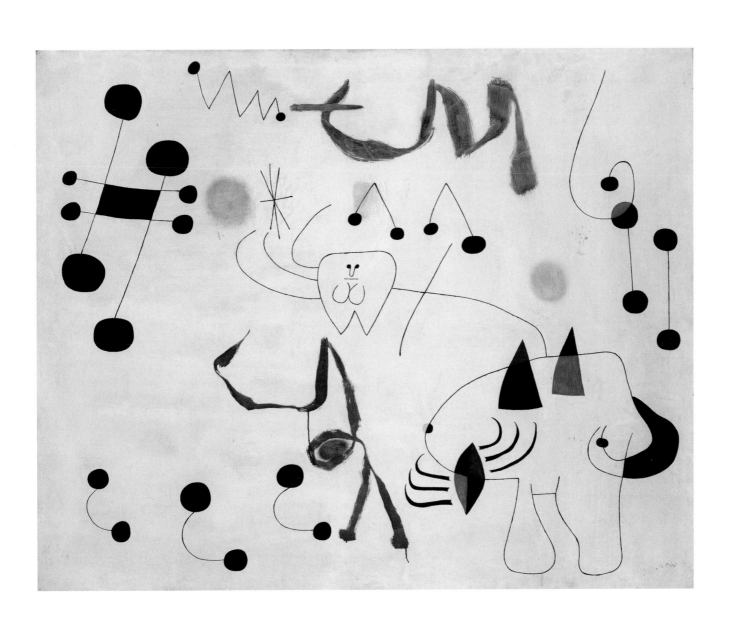

134 Joan Miró, *Woman Dreaming of Escape*, 1945
Fundació Joan Miró, Barcelona

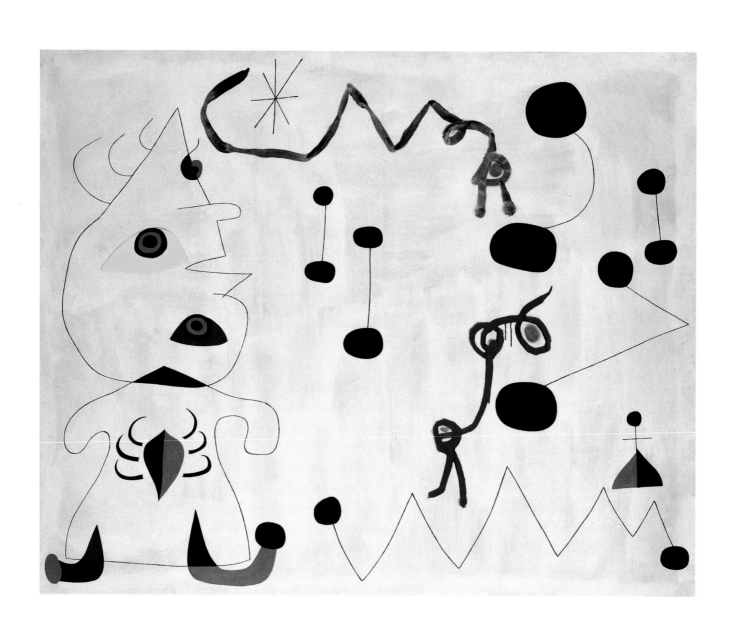

136 Joan Miró, *Woman in the Night*, 1945
Private collection

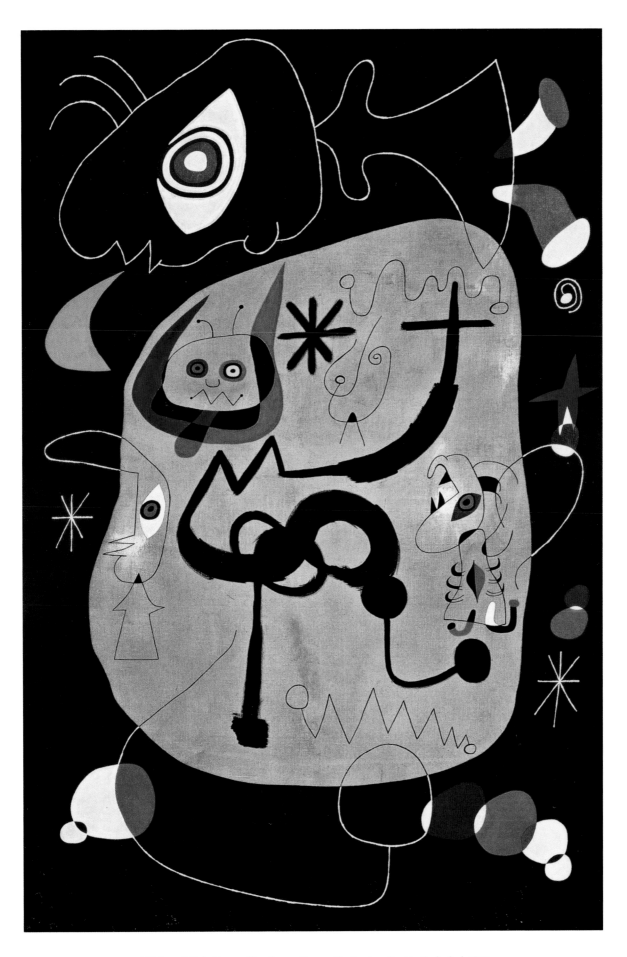

137 Joan Miró, *Dancer Hearing an Organ Playing in a Gothic Cathedral*, 1945
The Fukuoka Art Museum Collection, Japan

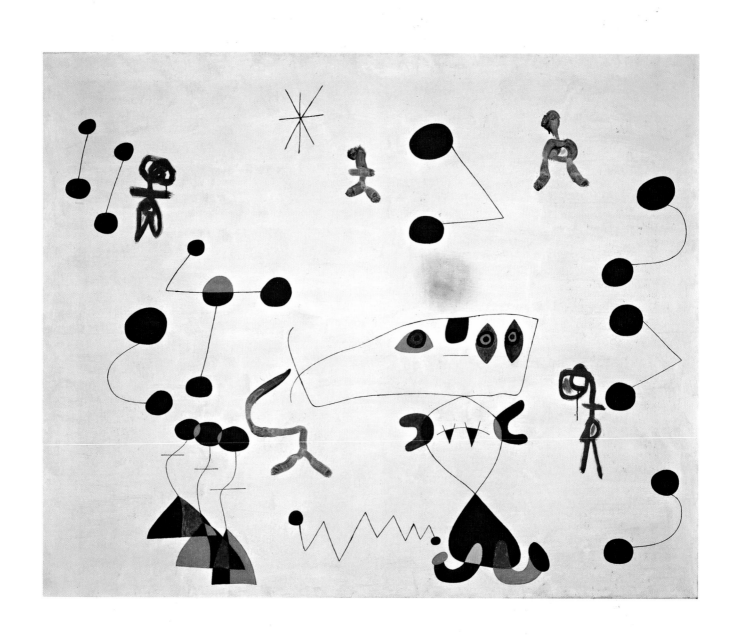

135 Joan Miró, *Woman in the Night*, 1945
Solomon R. Guggenheim Museum, New York, gift of Evelyn Sharp, 1977

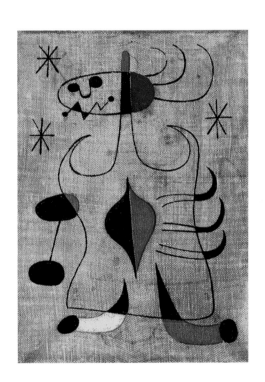

132 Joan Miró, *Woman, Stars*, 1944
Private collection, Switzerland

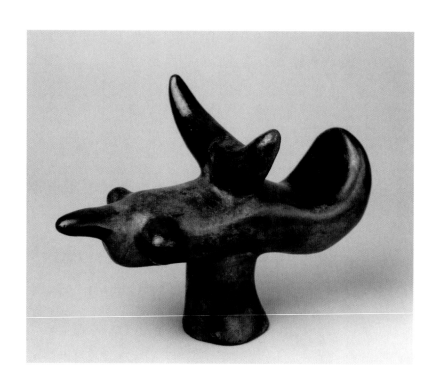

145 Joan Miró, *Sun Bird*, 1946–1949
Private collection

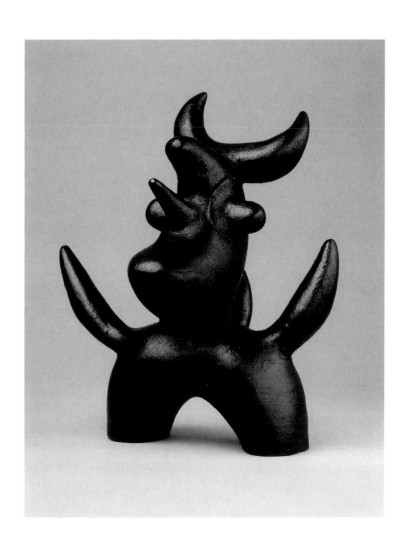

144 Joan Miró, *Moon Bird*, 1946–1949
Private collection

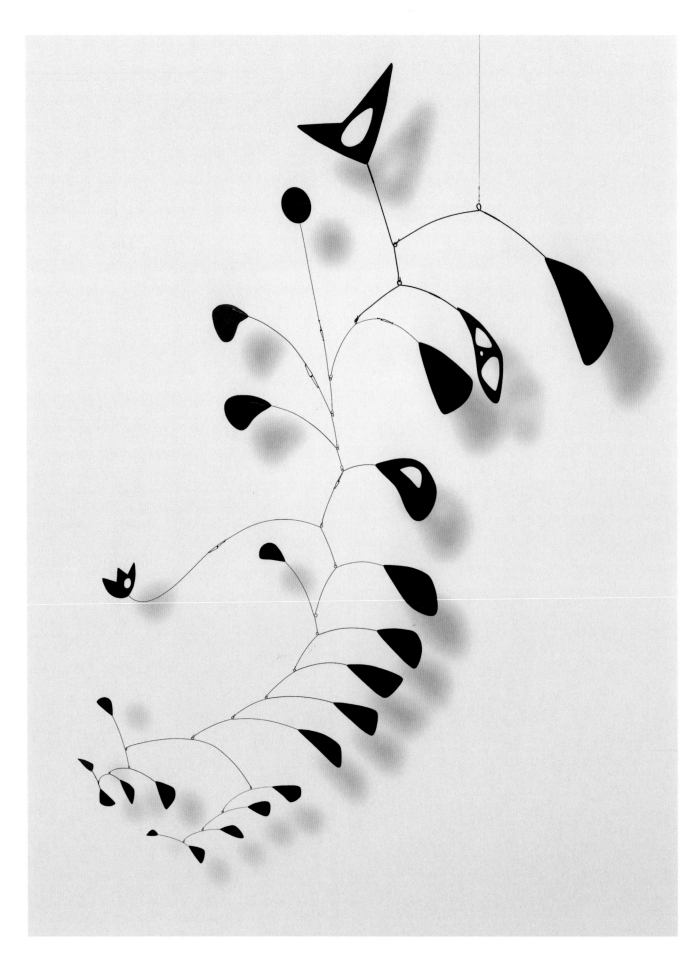

65 Alexander Calder, *S-Shaped Vine*, 1946
The Eli and Edythe L. Broad Collection

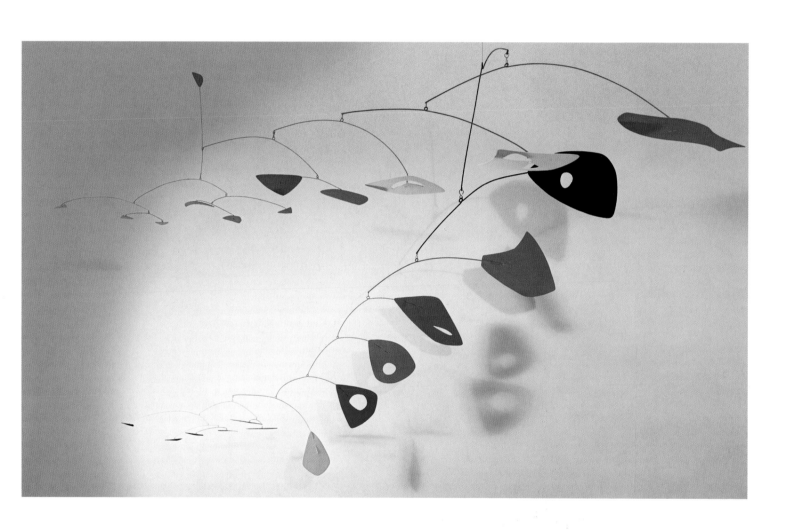

64 Alexander Calder, *Ogunquit (Orange Fish)*, 1946
The Tehran Museum of Contemporary Art

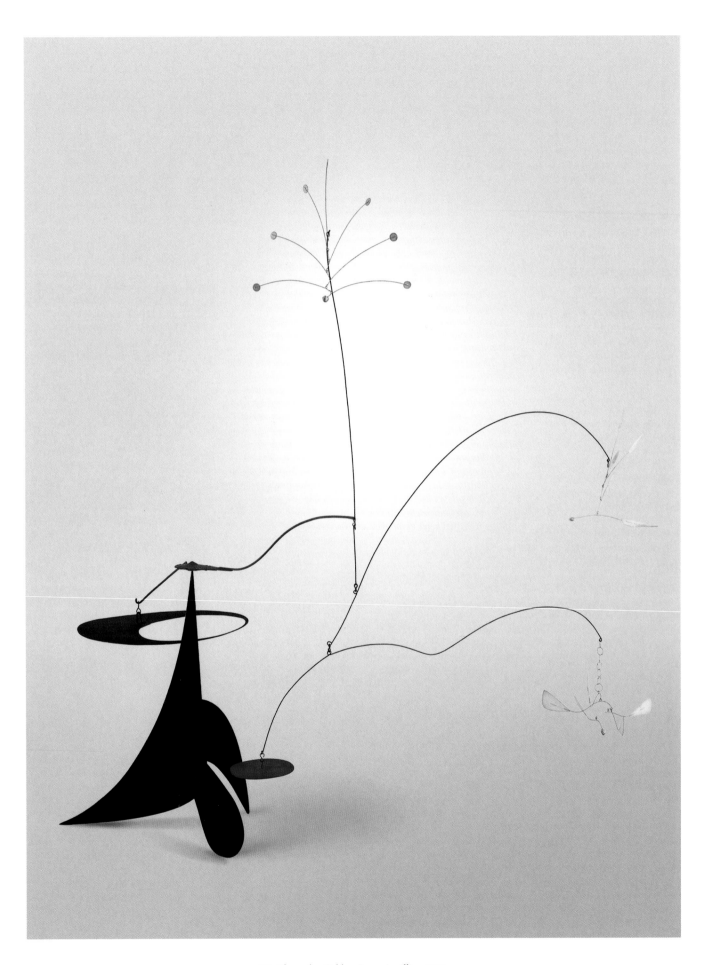

70 Alexander Calder, *Bougainvillier*, 1947
Jon and Mary Shirley

63 Alexander Calder, *Lily of Force*, 1945
Courtesy Calder Foundation, New York

140 Joan Miró, *The Bull Race*, 1945
Centre Georges Pompidou, Paris, Musée National d'Art Moderne, gift of the artist and of Pierre Loeb, 1947

139 Joan Miró, *Spanish Dancer*, 1945
Fondation Beyeler, Riehen/Basel

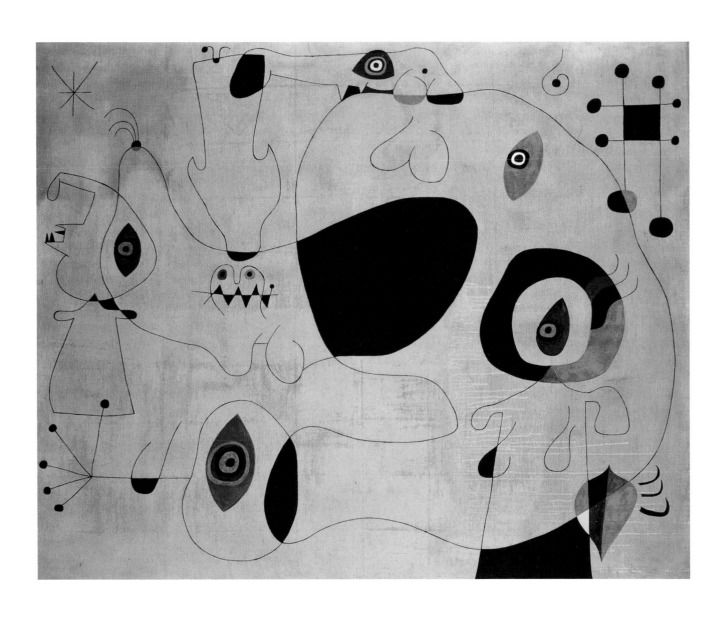

138 Joan Miró, *The Port*, 1945
Private collection

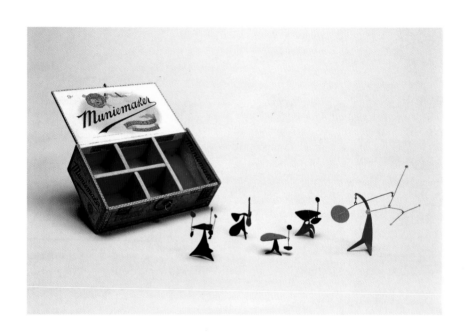

73 Alexander Calder, *Louisa's 43rd Birthday Present*, 1948
Courtesy Calder Foundation, New York

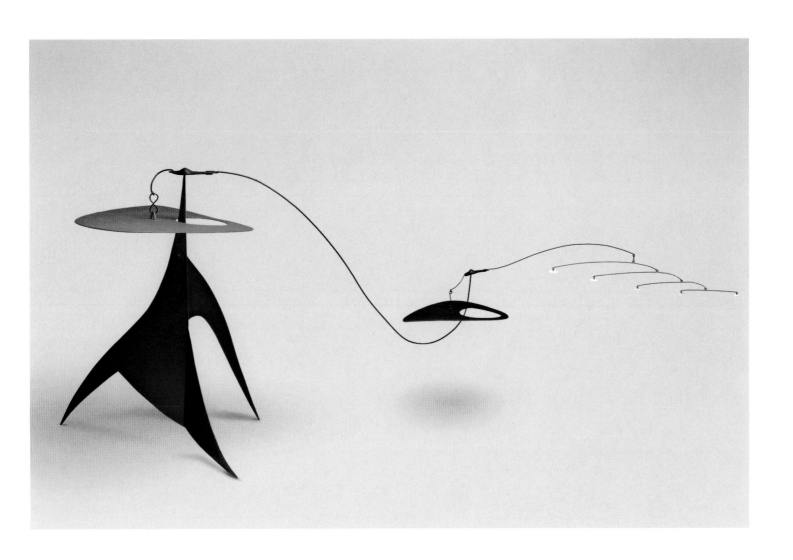

71 Alexander Calder, *Little Parasite*, 1947
Courtesy Calder Foundation, New York

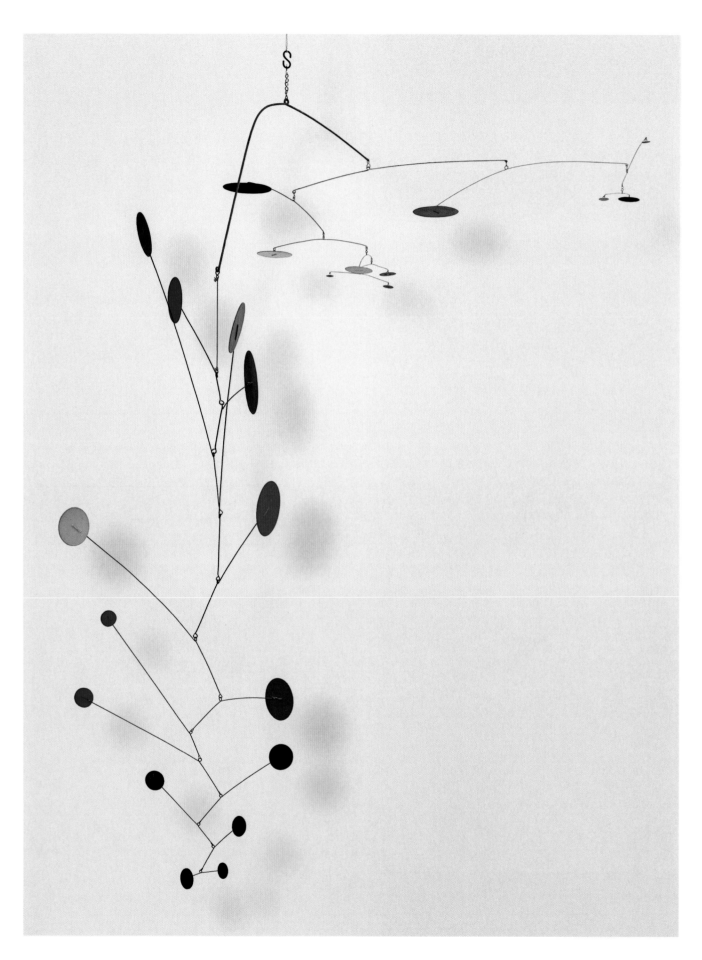

68 Alexander Calder, *Untitled*, ca. 1947
Private collection, USA, courtesy Leslie Feely Fine Art, New York

74 Alexander Calder, *Snow Flurry*, 1948
Courtesy Calder Foundation, New York

77 Alexander Calder, *Untitled*, 1949
Private collection

76 Alexander Calder, *Pomegranate*, 1949
Whitney Museum of American Art, New York, purchase

67 Alexander Calder, *Untitled*, ca. 1947
Private collection, courtesy Phyllis Hattis Fine Arts, New York

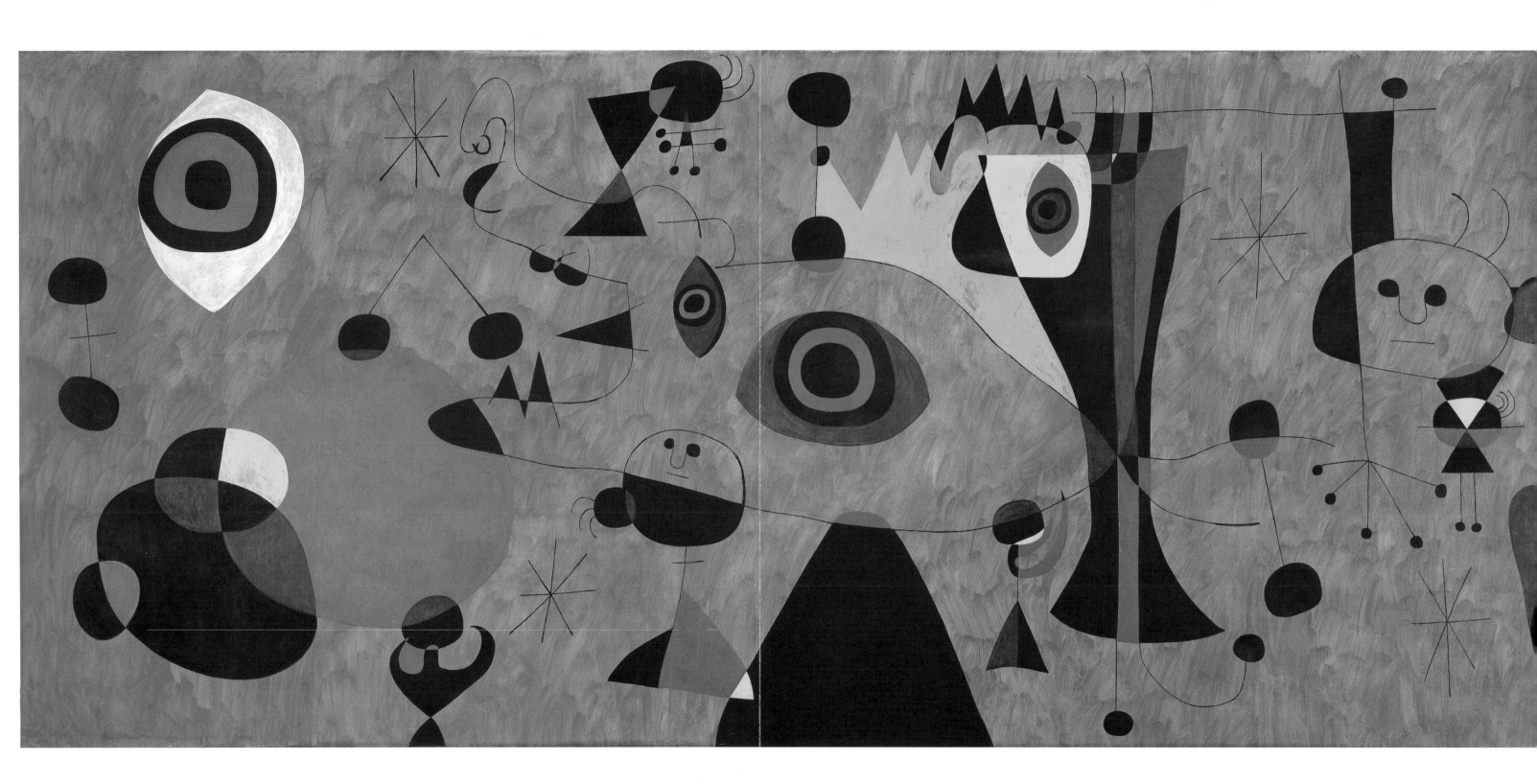

Fig. 67 Joan Miró in Carl Holty's studio, New York, in front of his Cincinnati Mural, September 1947, photo Arnold Newman

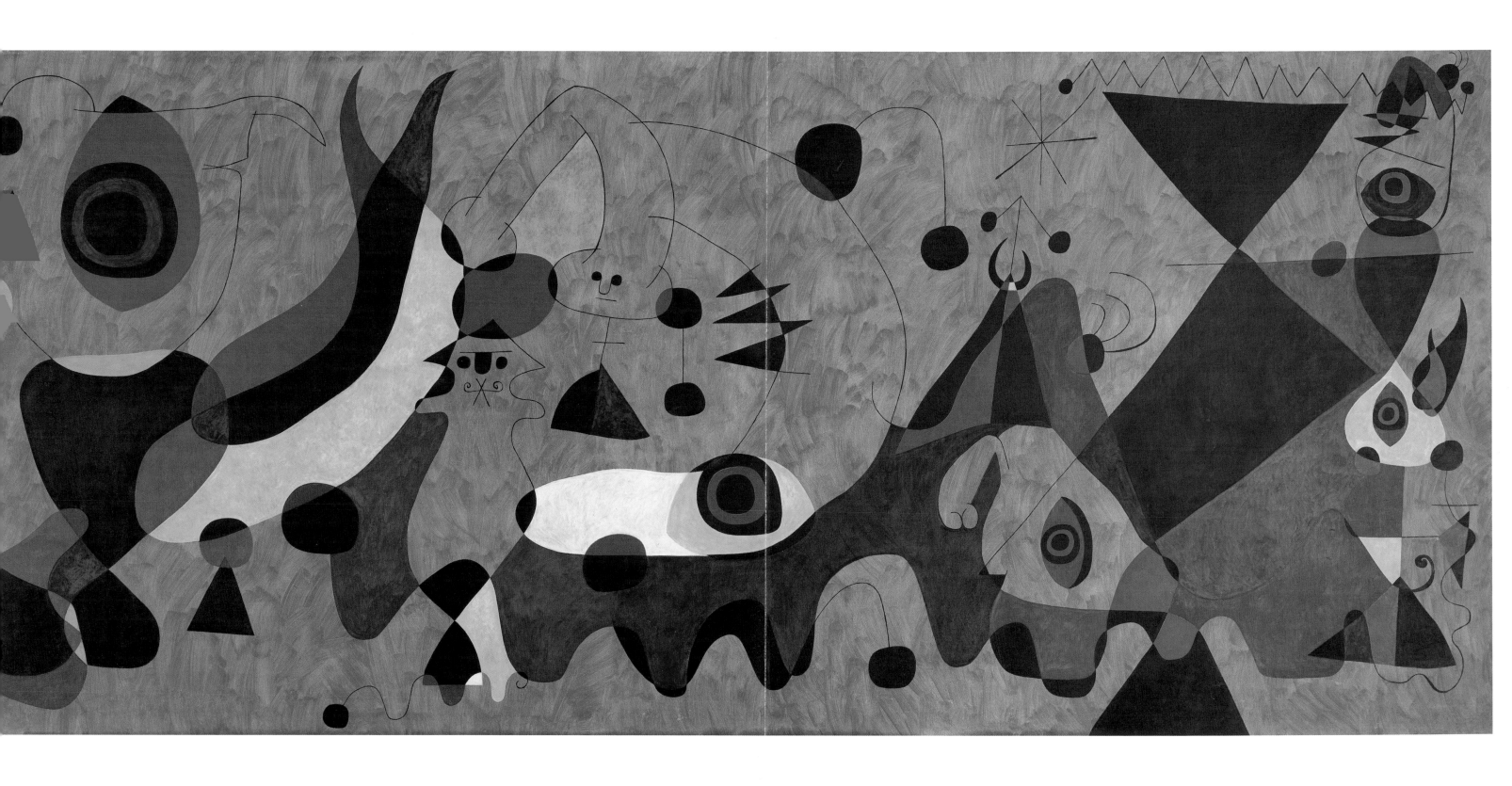

143 Joan Miró, *Mural Painting for the Terrace Plaza Hotel, Cincinnati*, 1947
Cincinnati Art Museum, gift of Thomas Emery's Sons, Inc., 1965

238

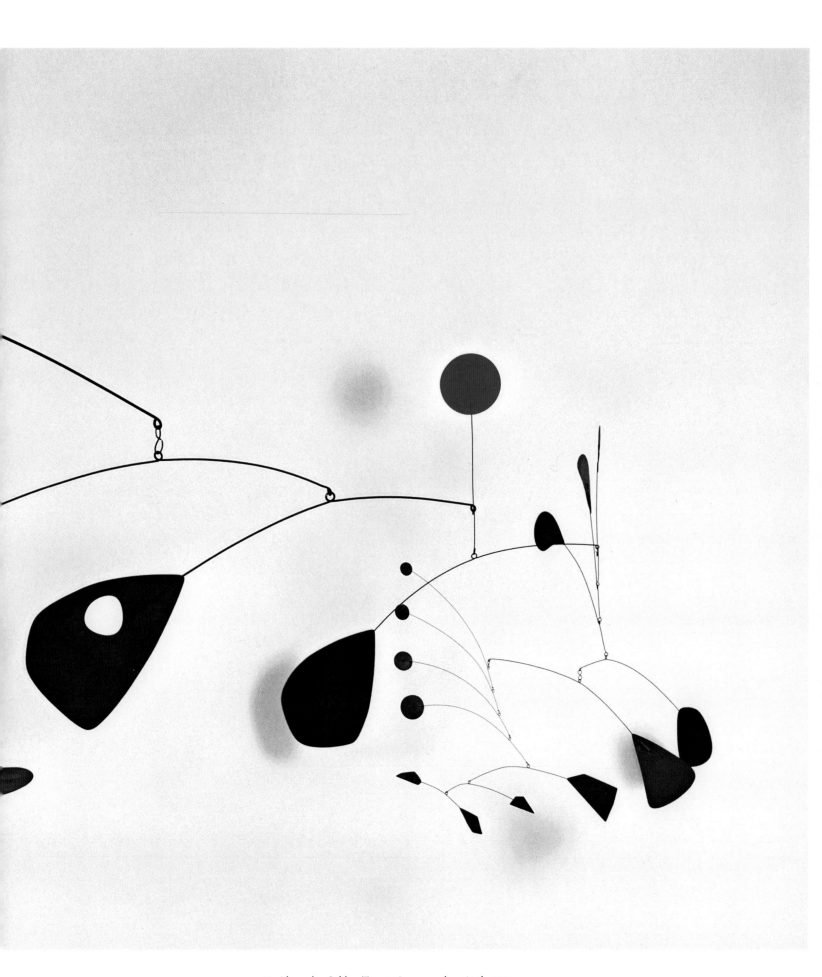

66 Alexander Calder, *Twenty Leaves and an Apple*, 1946
Cincinnati Art Museum, gift of Thomas Emery's Sons, Inc.

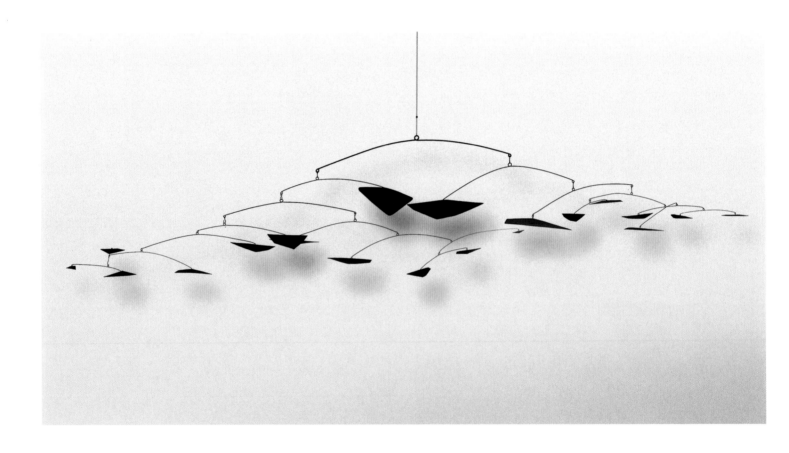

69 Alexander Calder, *Black Polygons*, 1947
Private collection

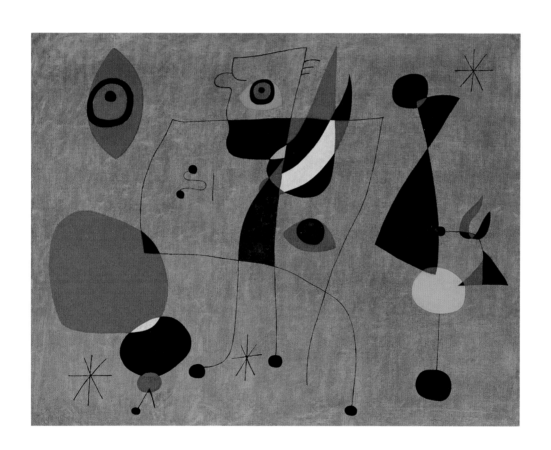

142 Joan Miró, *Women and Bird in the Night*, 1947
Courtesy Calder Foundation, New York

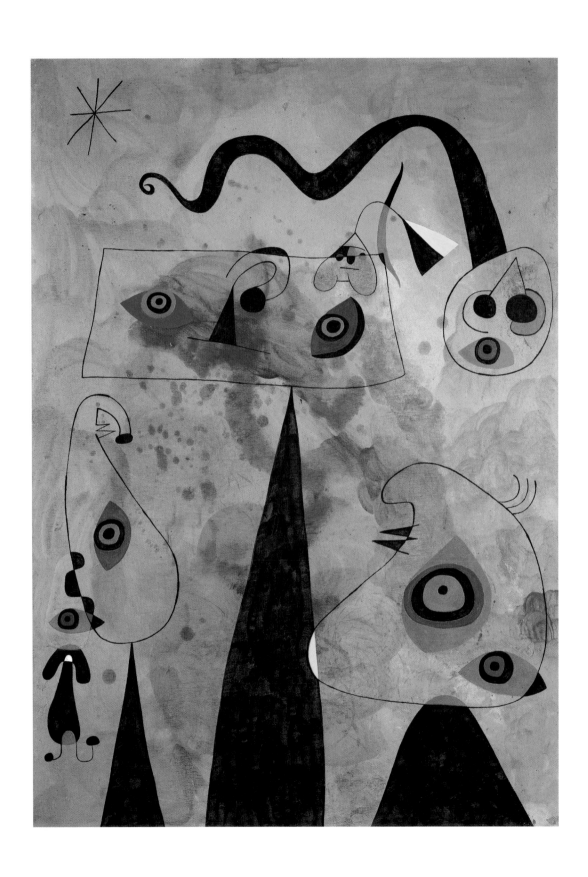

141 Joan Miró, *The Snake with Red Poppies Moving through a Field of Violets Inhabited by Lizards in Mourning*, 1947
Collection Francis Lombrail

LIST OF WORKS

Works are listed in chronological order. Height precedes width. "A" numbers are assigned by the Calder Foundation.

1. *Duck with Snake*, ca. 1926, wire, cloth, wood, and paint, 16 x 66 x 18 cm (6 ¼ x 26 x 7 in.), courtesy Calder Foundation, New York, A15558 (ill. p. 94)

2. *Miss Tamara*, ca. 1926, rubber hose, wire, string, buttons, and ribbon, 7.5 x 25.5 x 7.5 cm (3 x 10 x 3 in.), University of California, Berkeley Art Museum, gift of Margaret Calder Hayes, Class of 1917, A09944 (ill. p. 95)

3. *Galloping Horse*, 1926, wire, wood, and leather, 23 x 48.5 x 12.5 cm (9 x 19 x 5 in.), courtesy Calder Foundation, New York, A00500 (ill. p. 94)

4. *Red Horse and Green Sulky*, 1926, wire, wood, and paint, 20.5 x 66 x 15 cm (8 x 26 x 6 in.), courtesy Calder Foundation, New York, A20211 (ill. p. 94)

5. *Acrobat*, ca. 1927, steel wire, cloth, painted wood, 15 x 12 x 1 cm (6 x 4 ¾ x ⅜ in.), University of California, Berkeley Art Museum, gift of Margaret Calder Hayes, Class of 1917, A09941 (ill. p. 95)

6. *Blue Velvet Cow*, ca. 1927, velvet and wire, 15 x 30.5 x 9 cm (6 x 12 x 3 ½ in.), University of California, Berkeley Art Museum, gift of Margaret Calder Hayes, Class of 1940, A09934 (ill. p. 94)

7. *Matador*, 1927, cloth, paper, wire, leather, and pencil, 38 x 39.5 x 15 cm (15 x 15 ½ x 6 in.), courtesy Calder Foundation, New York, A20457 (ill. p. 95)

8. *Two Acrobats*, ca. 1928, brass wire and wood (base), 92 x 65 x 19 cm (36 ¼ x 25 ½ x 7 ½ in.) (without base), Honolulu Academy of Arts, gift of Mrs. Theodore A. Cooke, Mrs. Philip E. Spalding, and Mrs. Walter F. Dillingham, 1937, A01688 (ill. p. 106)

9. *Spring*, 1928, wire and wood, 233.5 x 63.5 x 63.5 cm (92 x 25 x 25 in.), Solomon R. Guggenheim Museum, New York, gift of the artist, 1965, A00619 (ill. p. 116)

10. *Arching Man*, 1929, painted steel wire, 35 x 89 x 29 cm (13 ¾ x 35 x 11½ in.), courtesy Calder Foundation, New York, A00842 (ill. p. 106)

11. *Circus Scene*, 1929, wire, wood, and paint, 127 x 119 x 46 cm (50 x 46 ¾ x 18 ⅛ in.), courtesy Calder Foundation, New York, A00264 (ill. p. 107)

12. *Goldfish Bowl*, 1929, wire, 40.5 x 38 x 15.5 cm (16 x 15 x 6 in.), courtesy Calder Foundation, New York, A00274, The Phillips Collection only (ill. p. 96)

13. *Kiki de Montparnasse*, 1929–1930, wire, 30.5 x 26.5 x 34.5 cm (12 x 10 ⁷⁄₁₆ x 13 ½ in.), Centre Georges Pompidou, Paris, Musée National d'Art Moderne, gift of the artist, 1966, A00844, Fondation Beyeler only (ill. p. 112)

14. *Amédée Ozenfant*, ca. 1930, wire, 60 x 40 x 37 cm (23 ⅝ x 15 ¾ x 14 ⁹⁄₁₆ in.), Collection Larock-Granoff, Paris, A02455 (ill. p. 113)

15. *Joan Miró*, ca. 1930, wire, 29 x 27 cm (11 ⁷⁄₁₆ x 10 ⅝ in.), private collection, A13668 (ill. p. 112)

16. *Medusa*, ca. 1930, wire, 31 x 44 x 24 cm (12 ¼ x 17 ¼ x 9 ½ in.), courtesy Calder Foundation, New York, A00546 (ill. p. 113)

17. *Little Ball with Counterweight*, ca. 1931, sheet metal, wire, wood, and paint, 162 x 32 x 32 cm (63 ¾ x 12 ½ x 12 ½ in.), Ruth P. Horwich, A00269 (ill. p. 135)

18. *Mobile au plomb*, 1931, sheet metal, lead weights, wood, wire, and paint, 118 x 104 cm (46 ½ x 41 in.), Aaron I. Fleischman, A00841 (ill. p. 121)

19. *Untitled*, 1931, wood, iron, wire, aluminum, paint, and other materials, 120 x 74 x 30 cm (47 ¼ x 29 ⅛ x 11 ¹³⁄₁₆ in.), MACBA Collection, Fundació Museu d'Art Contemporani, Barcelona, A10203 (ill. p. 123)

20. *Untitled*, 1931, wood, iron, wire, and paint, 185/190 x 87 x 151 cm (72 ⅞/74 ⅝ x 34 ¼ x 59 ½ in.), MACBA Collection, Fundació Museu d'Art Contemporani, Barcelona, A10202 (ill. p. 134)

21. *Cône d'ébène*, 1933, ebony, wire, and metal bar, 269 x 139.5 x 61 cm (106 x 55 x 24 in.), courtesy Calder Foundation, New York, A00852 (ill. p. 140)

22. *Untitled*, 1933, metal, wood, wire, and paint, 80 x 100 x 100 cm (31 ½ x 39 ⅜ x 39 ⅜ in.), Hans Erni, Lucerne, A13303, Fondation Beyeler only (ill. p. 122)

23. *Little Blue Panel*, 1934, wood, metal, motor, wire, and paint, 49.5 x 38.5 x 24 cm (19 ½ x 15 ⅛ x 9 ½ in.), Wadsworth Atheneum Museum of Art, Hartford, Connecticut, purchased through the gift of Henry and Walter Keney, A01731 (ill. p. 132)

24. *Abstraction*, 1935–1936, carved and assembled wood, 92 x 23 x 10 cm (36¼ x 9 x 3¹⁵⁄₁₆ in.), IVAM, Instituto Valenciano de Arte Moderno, Generalitat Valenciana, Valencia, A02393 (ill. p. 144)

25. *Tightrope*, ca. 1936, ebony, wire, lead weights, and paint, 115.5 x 70 x 352 cm (45 ½ x 27 ½ x 138 ½ in.), courtesy Calder Foundation, New York, A00271 (ill. pp. 150–151)

26. *White Panel*, ca. 1936, sheet metal, wire, plywood, string, and paint, 214.5 x 119.5 x 129.5 cm (84 ½ x 47 x 51 in.), courtesy Calder Foundation, New York, A15214

27. *Big Bird* (maquette), 1936, sheet metal, wire, and paint, 33.5 x 21 x 18.5 cm (13 ¼ x 8 ¼ x 7 ¼ in.), Yale University Art Gallery, gift of the estate of Katherine S. Dreier, A02814 (ill. p. 169)

28. *Cello on a Spindle*, 1936, metal, wood, and paint, 158 x 118 x 90 cm (62 ¼ x 46 ½ x 35 ⅜ in.), Kunsthaus Zürich, A08023 (ill. p. 147)

29. *Snake and the Cross*, 1936, sheet metal, wire, wood, string, and paint, 205.5 x 129.5 x 112 cm (81 x 51 x 44 in.), courtesy Calder Foundation, New York, A00591 (ill. p. 161)

30. *T and Swallow*, 1936, wood, wire, and steel, 76 x 32.5 x 28.5 cm (30 x 12 ¾ x 11 ¼ in.), Tate, London, purchased 1969, A10134 (ill. p. 144)

31. *Yellow Panel (Form Against Yellow)*, 1936, sheet metal, wire, steel rod, wood, and paint, 122 x 81.5 x 77.5 cm (48 ⅛ x 32 ⅛ x 30 ½ in.), Hirshhorn Museum and Sculpture Garden, Smithsonian Institution, gift of Joseph H. Hirshhorn, 1972, A01862 (ill. p. 162)

32. *Big Bird*, 1937, sheet metal, bolts, and paint, 223.5 x 127 x 150 cm (88 x 50 x 59 in.), courtesy Calder Foundation, New York, A01106, Fondation Beyeler only (ill. p. 170)

33. *Devil Fish*, 1937, sheet metal, bolts, and paint, 172.5 x 162.5 x 119.5 cm (68 x 64 x 47 in.), courtesy Calder Foundation, New York, A00507, Fondation Beyeler only (ill. p. 167)

34. *Model for "Mercury Fountain,"* 1937/1943, plywood, iron, tin, and steel rod, 78 x 105.5 x 106 cm (30 ¾ x 41 ½ x 41 ¾ in.), courtesy Calder Foundation, New York, A00396, The Phillips Collection only (not illustrated; model, 1937, lost; replica of model, 1943)

35. *The Spider*, ca. 1938, metal and paint, 104 x 89 x 0.5 cm (41 x 35 x ¼ in.), Scottish National Gallery of Modern Art, Edinburgh, A12570 (ill. p. 177)

36. *Untitled*, ca. 1938, sheet steel, sheet aluminum, steel wire, and paint, 99 x 142 cm (39 x 55 ⅞ in.), Kukje Gallery, Seoul, A10538, Fondation Beyeler only (ill. p. 198)

37. *Untitled*, ca. 1938, wood, wire, sheet metal, string, and paint, 101.5 x 119.5 cm (40 x 47 in.), courtesy O'Hara Gallery, New York, A08439 (ill. p. 125)

38. *Spherical Triangle*, 1938, sheet metal, wire, lead, and paint, 101.5 x 35.5 x 35.5 cm (40 x 14 x 14 in.), Aaron I. Fleischman, A09494 (ill. p. 196)

39. *Untitled*, 1938, wood, wire, sheet metal, string, and paint, 205.5 x 244 cm (81 x 96 in.), The Engle Family, USA, A12975 (ill. p. 133)

40. *Untitled*, ca. 1939, sheet metal, wire, and paint, 117 cm high (46 in. high), Collection Ernst and Hildy Beyeler, A05595, Fondation Beyeler only (not illustrated)

41. *Four Leaves and Three Petals*, 1939, sheet metal, wire, and paint, 205 x 174 x 135 cm (80 ¾ x 68 ½ x 53 ⅛ in.), Centre Georges Pompidou, Paris, Musée National d'Art Moderne, *dation* to the French State, 1983, A02140 (ill. p. 200)

42. *Hollow Egg*, 1939, wire and paint, 137 x 100 x 79 cm (54 x 39 ½ x 31 ⅛ in.), The Phillips Collection, Washington, D.C., partial and promised gift in memory of Betty Milton, a close friend of Louisa Calder, 2001, A00270 (ill. p. 168)

43. *Little Spider*, ca. 1940, sheet metal, wire, and paint, 111 x 127 x 139.5 cm (43 ¾ x 50 x 55 in.), National Gallery of Art, Washington, gift of Mr. and Mrs. Klaus G. Perls, 1996, A00289 (ill. p. 193)

44. *Araignée d'oignon*, 1940, sheet metal and paint, 21.5 x 25.5 x 39.5 cm (8 ½ x 10 x 15 ½ in.), Moderna Museet, Stockholm, anonymous gift, 1951, A05290 (ill. p. 176)

45. *Black Beast*, 1940, sheet metal, bolts, and paint, 261.5 x 414 x 199.5 cm (103 x 163 x 78 ½ in.), courtesy Calder Foundation, New York, A00511 (ill. pp. 174–175)

46. *Thirteen Spines*, 1940, sheet steel, aluminum, iron wire, steel rods, and paint, 220 x 220 cm (86 ⅝ x 86 ⅝ in.), Museum Ludwig, Cologne, A00313 (ill. p. 194)

47. *Boomerangs*, 1941, sheet metal, wire, and paint, 114.5 x 297.5 cm (45 x 117 in.), courtesy Calder Foundation, New York, A16031 (ill. p. 165)

48. *Red Post, Black Leaves*, 1941, sheet metal, wire, and paint, 203.5 x 172.5 cm (80 x 68 in.), private collection, courtesy Guggenheim, Asher Associates, A05552, Fondation Beyeler only (ill. p. 203)

49. *Untitled*, 1941, sheet metal, wire, and paint, 320 x 320 x 112 cm (127 x 127 x 44 in.), Carnegie Museum of Art, Pittsburgh, gift of Aluminum Company of America, 1995, A13065, Fondation Beyeler only (ill. p. 202)

50. *Red Cone with Bright Flags and Black Leaves*, ca. 1942, sheet aluminum, wire, and paint, 58 x 80 x 16 cm (22 ⅞ x 31 ½ x 6 ³⁄₁₆ in.), Kunstmuseum Winterthur, gift of Friedrich Jezler Foundation, 1999, A18655, Fondation Beyeler only (ill. p. 199)

51. *Untitled*, ca. 1942, horn, glass, wood, string, metal, and paint, 66 x 71 cm (26 x 28 in.), private collection, courtesy Proarte, Mexico City, A03114, Fondation Beyeler only (ill. p. 201)

52. *Horizontal Spines*, 1942, steel, wire, aluminum, and paint, 138 x 127 x 57 cm (54 ¼ x 50 x 22 ½ in.), Addison Gallery of American Art, Phillips Academy, Andover, Massachusetts, A00517 (ill. p. 195)

53. *Vertical Foliage*, 1942, sheet metal, wire, and paint, 136 x 167.5 cm (53 ½ x 66 in.), courtesy Calder Foundation, New York, A15493 (ill. p. 192)

54. *Wheat*, 1942, sheet metal, wire, and paint, 79 x 117 cm (31 x 46 in.), private collection, USA, A10907, Fondation Beyeler only (ill. p. 197)

55. *Untitled (Constellation)*, 1942–1943, wood, wire, and paint, ca. 80 x 74 x 40 cm (ca. 31 ½ x 29 ⅛ x 15 ¾ in.), private collection, Switzerland, A05550, Fondation Beyeler only (ill. p. 207)

56. *Constellation*, 1943, wood, wire, and paint, 61 x 45.5 cm (24 x 18 in.), loaned in memory of Betty Milton, a close friend of Louisa Calder, A15621, The Phillips Collection only (ill. p. 208)

57. *Constellation*, 1943, wood, wire, and paint, 56 x 113 cm (22 x 44 ½ in.), Solomon R. Guggenheim Museum, New York, Mary Reynolds collection, gift of her brother, 1954, A00551, Fondation Beyeler only (not illustrated)

58. *Constellation Mobile*, 1943, wood, string, wire, and paint, 134.5 x 122 x 89 cm (53 x 48 x 35 in.), courtesy Calder Foundation, New York, A16009 (ill. p. 209)

59. *Constellation with Quadrilateral*, 1943, wood, wire, and paint, 38 x 46.5 x 20 cm (14 ⅞ x 18 ¼ x 7 ⅞ in.), Whitney Museum of American Art, New York, 50th anniversary gift of the Howard and Jean Lipman Foundation, Inc., A00245 (ill. p. 204)

60. *Constellation with Two Pins*, 1943, wood, wire, and paint, 39.5 x 44 cm (15 ½ x 17 ¼ in.), courtesy Calder Foundation, New York, A01130 (ill. p. 206)

61. *Wooden Bottle with Hairs*, 1943, wood and wire, 57 x 33 x 30.5 cm (22 ⅜ x 13 x 12 in.), Whitney Museum of American Art, New York, 50th anniversary gift of the Howard and Jean Lipman Foundation, Inc., A00241 (ill. p. 205)

62. *Les Abattis*, 1945, wood and wire, 28 cm high (11 in. high), Collection Ernst and Hildy Beyeler, A05596, Fondation Beyeler only (not illustrated)

63. *Lily of Force*, 1945, sheet metal, wire, lead, and paint, 233 x 205.5 x 226 cm (91 ¼ x 81 x 89 in.), courtesy Calder Foundation, New York, A00566 (ill. p. 221)

64. *Ogunquit (Orange Fish)*, 1946, sheet metal, wire, and paint, ca. 200 x 430 cm (75 x 176 in.), The Tehran Museum of Contemporary Art, A07662, Fondation Beyeler only (ill. p. 219)

65. *S-Shaped Vine*, 1946, sheet metal, wire, and paint, 250 x 175.5 cm (98 ½ x 69 in.), The Eli and Edythe L. Broad Collection, A08962 (ill. p. 218)

66. *Twenty Leaves and an Apple*, 1946, sheet metal, piano wire, and paint, 122 x 366 cm (48 x 144 in.), Cincinnati Art Museum, gift of Thomas Emery's Sons, Inc., A01928 (ill. pp. 240–241)

67. *Untitled*, ca. 1947, sheet metal, wire, and paint, 163 x 110.5 cm (64⅛ x 43½ in.), private collection, courtesy Phyllis Hattis Fine Arts, New York, A10735, Fondation Beyeler only (ill. p. 232)

68. *Untitled*, ca. 1947, sheet metal, wire, and paint, 183 x 194 cm (72 1/16 x 76 ⅜ in.), private collection, USA, courtesy Leslie Feely Fine Art, New York, A20208, Fondation Beyeler only (ill. p. 228)

69. *Black Polygons*, 1947, sheet metal, wire, and paint, 60 x 320 x 120 cm (23 ⅜ x 126 x 47 ¼ in.), private collection, A00323 (ill. p. 242)

70. *Bougainvillier*, 1947, sheet metal, wire, lead, and paint, 199.5 x 218.5 cm (78 ½ x 86 in.), Jon and Mary Shirley, A00307 (ill. p. 220)

71. *Little Parasite*, 1947, sheet metal, wire, and paint, 50.8 x 134.6 x 33 cm (20 x 53 x 13 in.), courtesy Calder Foundation, New York, A14067 (ill. p. 227)

72. *Finny Fish*, 1948, steel rods, steel wire, glass, objects, and paint, 66 x 152.5 cm (26 x 60 in.), National Gallery of Art, Washington, gift of Mr. and Mrs. Klaus G. Perls, 1996, A11509, The Phillips Collection only (not illustrated)

73. *Louisa's 43rd Birthday Present*, 1948, sheet metal, wire, paint, and felt-lined cigar box; box: 6.3 x 22 x 12.8 cm (2 ½ x 8 ¹¹⁄₁₆ x 5 ¹⁄₁₆ in.), object from front left compartment: 5.5 x 5.2 x 7.2 cm (2 ³⁄₁₆ x 2 ¹⁄₁₆ x 2 ¹³⁄₁₆ in.), object from front center compartment: 4 x 4.5 x 2.8 cm (1 ⁹⁄₁₆ x 1 ¾ x 1 ⅛ in.), object from back left compartment: 6.3 x 3 x 3.5 cm (2 ½ x 1 ³⁄₁₆ x 1 ⅜ in.), object from back center compartment: 6.5 x 4 x 3.5 cm (2 ⁹⁄₁₆ x 1 ⁹⁄₁₆ x 1 ⅜ in.), object from right compartment: 13.8 x 3.7 x 14 cm (5 ⁷⁄₁₆ x 1 ⁷⁄₁₆ x 5 ½ in.), courtesy Calder Foundation, New York, A14443 (ill. p. 226)

74. *Snow Flurry*, 1948, sheet metal, wire, and paint, 101.5 x 208.5 cm (40 x 82 in.), courtesy Calder Foundation, New York, A01164 (ill. p. 229)

75. *Untitled*, 1948, sheet metal, wire, and paint, 66 x 66 x 14 cm (26 x 26 x 5 ½ in.), The Phillips Collection, Washington, D.C., gift from the estate of Katherine S. Dreier, A01870 (not illustrated)

76. *Pomegranate*, 1949, sheet aluminum, steel, steel wire, rods, and paint, 181 x 183.5 x 107.5 cm (71 ¼ x 72 ¼ x 42 ¼ in.), Whitney Museum of American Art, New York, purchase, A00407 (ill. p. 231)

77. *Untitled*, 1949, sheet metal, wire, rod, and paint, 106.5 x 228.5 x 76 cm (42 x 90 x 30 in.), private collection, A14599, Fondation Beyeler only (ill. p. 230)

78. *Red Polygons*, ca. 1950, tin, wire, and paint, 86.5 x 162.5 cm (34 x 64 in.), The Phillips Collection, Washington, D.C., A01903, The Phillips Collection only (not illustrated)

79. *Only Only Bird*, 1951, tin cans and wire, 28 x 43 x 99 cm (11 x 17 x 39 in.), The Phillips Collection, Washington, D.C., acquired 1966, A00016, The Phillips Collection only (not illustrated)

Works are listed in chronological order. Height precedes width. "Dupin" numbers refer to the catalogue raisonné of Miró paintings by Jacques Dupin and Ariane Lelong-Mainaud.

80. *Horse, Pipe, and Red Flower*, 1920, oil on canvas, 82.5 x 75 cm (32 ½ x 29 ½ in.), Philadelphia Museum of Art, gift of Mr. and Mrs. C. Earle Miller, 1986, Dupin 76 (ill. p. 93)

81. *The Toys*, 1924, oil and charcoal on canvas, 73 x 92 cm (28 ¾ x 36 ¼ in.), Moderna Museet, Stockholm, bequest of publisher Gerard Bonnier, 1989, Dupin 95 (ill. p. 92)

82. *The Gentleman*, 1924, oil on canvas, 52.5 x 46.5 cm (20 ⅝ x 18 ¼ in.), Öffentliche Kunstsammlung Basel, Kunstmuseum, gift of Marguerite Arp-Hagenbach, 1968, Dupin 107 (ill. p. 97)

83. *Carnival of Harlequin*, 1924–1925, oil on canvas, 66 x 93 cm (26 x 36 ⅝ in.), Albright-Knox Art Gallery, Buffalo, Room of Contemporary Art Fund, 1940, Dupin 115, The Phillips Collection only (ill. p. 99)

84. *Memory of Barcelona*, 1925, oil on canvas, 116 x 89 cm (45 ⅝ x 35 in.), private collection, Dupin 122 (ill. p. 120)

85. *The Birth of the World*, 1925, oil on canvas, 251 x 200 cm (98 ⅞ x 78 ¾ in.), The Museum of Modern Art, New York, acquired through an anonymous fund, the Mr. and Mrs. Joseph Slifka and Armand G. Erpf Funds, and by a gift of the artist, 1972, Dupin 125, Fondation Beyeler only (ill. p. 119)

86. *Painting (Man with Pipe)*, 1925, oil on canvas, 146 x 114 cm (57 ½ x 44 ⅞ in.), Museo Nacional Centro de Arte Reina Sofía, Madrid, Dupin 138 (ill. p. 124)

87. *Painting*, 1925, oil on canvas, 114.5 x 146 cm (45 ⅛ x 57 ½ in.), Öffentliche Kunstsammlung Basel, Kunstmuseum, acquired with funds provided by Dr. h.c. Richard Doetsch-Benziger, Dupin 166, Fondation Beyeler only (ill. p. 126)

88. *Painting (The Red Spot)*, 1925, oil and pastel on canvas, 146 x 114 cm (57 ½ x 44 ⅞ in.), Museo Nacional Centro de Arte Reina Sofía, Madrid, Dupin 172, Fondation Beyeler only (ill. p. 127)

89. *The Circus*, 1925, oil on canvas, 73 x 92 cm (28 ¾ x 36 ¼ in.), private collection, Dupin 229, Fondation Beyeler only (ill. p. 102)

90. *Landscape (Landscape with Rooster)*, 1927, oil on canvas, 130 x 195 cm (51 ⅛ x 76 ¾ in.), Fondation Beyeler, Riehen/Basel, Dupin 225 (ill. p. 108)

91. *Painting (Circus Horse)*, 1927, oil on canvas, 130 x 97 cm (51 ⅛ x 38 ¼ in.), private collection, Dupin 239, Fondation Beyeler only (ill. p. 103)

92. *Painting (Circus Horse)*, 1927, oil and pencil on burlap, 195 x 280.5 cm (76 ¾ x 110 ⅜ in.), Hirshhorn Museum and Sculpture Garden, Smithsonian Institution, gift of Joseph H. Hirshhorn, 1972, Dupin 241 (ill. pp. 100–101)

93. *Painting*, 1927, tempera on canvas, 97 x 130 cm (38 ³⁄₁₆ x 51 ³⁄₁₆ in.), Colección Museo Tamayo Arte Contemporáneo, CONACULTA/INBA, Mexico City, Dupin 252 (ill. p. 128)

94. *Cloud and Birds*, 1927, oil on canvas, 146 x 114 cm (57 ½ x 44 ⅞ in.), Museum of Fine Arts, Boston, Sophie M. Friedman Fund and Charles H. Bayley Picture and Painting Fund, 1980, Dupin 256, The Phillips Collection only (ill. p. 129)

95. *Painting*, 1927, oil on canvas, 116 x 89 cm (45 ⅝ x 35 in.), Centre Georges Pompidou, Paris, Musée National d'Art Moderne, *dation* 1994, Dupin 263 (ill. p. 104)

96. *Painting (Personage, The Fratellini Brothers)*, 1927, oil on canvas, 130 x 97 cm (51 ⅛ x 38 ¼ in.), Fondation Beyeler, Riehen/Basel, Dupin 266 (ill. p. 105)

97. *Still Life (Still Life with Lamp)*, 1928, oil on canvas, 89 x 116 cm (35 x 45 ⅝ in.), private collection, courtesy Proarte, Mexico City, Dupin 307, Fondation Beyeler only (ill. p. 109)

98. *Construction*, 1930, wood, metal, and oil paint, 91 x 71 x 37 cm (35 ⅞ x 28 x 14 ⅝ in.), Staatsgalerie Stuttgart, The Phillips Collection only (ill. p. 131)

99. *Painting*, 1930, oil, charcoal, and plaster on canvas, 231 x 150.5 cm (91 x 59 ¼ in.), Fondation Beyeler, Riehen/Basel, Dupin 317 (ill. p. 117)

100. *Head of a Man III*, 1931, oil on canvas, 66 x 46 cm (25 ¼ x 18 ⅛ in.), private collection, courtesy Guillermo de Osma Galería, Madrid, Dupin 349 (ill. p. 114)

101. *Head of a Man IV*, 1931, oil on canvas, 60 x 65 cm (23 ⅝ x 25 ⅝ in.), private collection, Dupin 350, Fondation Beyeler only (ill. p. 115)

102. *Painting-Object*, 1931, cake tin, gearwheels, cardboard grille, sand, and oil on wood, 13.5 x 20.5 x 5 cm (5 ⁵⁄₁₆ x 8 ¹⁄₁₆ x 2 in.), Kunsthaus Zürich, gift of Erna and Curt Burgauer Collection, Dupin 361, The Phillips Collection only (ill. p. 136)

103. *Flame in Space and Naked Woman*, 1932, oil on cardboard, 41 x 32 cm (16 ⅛ x 12 ⅝ in.), Fundació Joan Miró, Barcelona, gift of Joan Prats, Dupin 396, The Phillips Collection only (ill. p. 138)

104. *Figure*, 1932, oil on panel, 27.5 x 20 cm (10 ¾ x 7 ⅞ in.), The Art Institute of Chicago, gift of Mary and Leigh Block, 1988, Dupin 398 (ill. p. 138)

105. *Painting* (design for stencil of the review *Cahiers d'art* 1–4, 1934), 1932, oil on panel, 31.5 x 25 cm (12 ⅜ x 9 ⅞ in.), Kokaido Gallery, Tokyo, Dupin 409 (ill. p. 139)

106. *Composition (Small Universe)*, 1933, gouache on cardboard, 39.5 x 31.5 cm (15 ½ x 12 ⁷⁄₁₆ in.), Fondation Beyeler, Riehen/Basel (ill. p. 139)

107. *Painting*, 1933 (8 March), oil and aqueous medium on canvas, 130 x 160.5 cm (51 ⅛ x 63 ¼ in.), Philadelphia Museum of Art, the A. E. Gallatin Collection, 1952, Dupin 417 (ill. p. 141)

108. *Painting*, 1933 (31 March), oil on canvas, 130.5 x 163 cm (51 ⅜ x 64 ⅛ in.), Kunstmuseum Bern, Dupin 419, Fondation Beyeler only (ill. p. 142)

109. *Painting*, 1933 (12 April), oil on canvas, 130 x 162.5 cm (51 ⅜ x 64 ⅞ in.), Národní Galerie, Prague, Dupin 421, Fondation Beyeler only (ill. p. 143)

110. *Painting*, 1933 (29 April), oil on canvas, 146 x 114.5 cm (57 ½ x 44 ⅞ in.), Helly Nahmad Collection, Dupin 424 (ill. p. 145)

111. *Painting*, 1933 (8 May), oil on canvas, 131 x 163 cm (51 ½ x 64 ¼ in.), courtesy Milly and Arne Glimcher, New York, Dupin 425, The Phillips Collection only (ill. p. 148)

112. *Painting*, 1933 (27 May), oil on canvas, 127.5 x 162 cm (50 ⅛ x 63 ¾ in.), private collection, courtesy Proarte, Mexico City, Dupin 427, Fondation Beyeler only (ill. p. 149)

113. *Painting*, 1933 (24 June), oil on canvas, 152 x 101 cm (59 ⅞ x 39 ¼ in.), courtesy Calder Foundation, New York, Dupin 432 (ill. p. 152)

114a–c. *Mural I-II-III*, 1933, oil on canvas, 56 x 251.5 cm (22 x 99 in.) (each panel), private collection, Dupin 433 (ill. pp. 154–159)

115. *Portrait of a Young Girl*, 1935, oil with sand on cardboard, 105 x 74.5 cm (41 ⅜ x 29 ⅜ in.), New Orleans Museum of Art, bequest of Victor K. Kiam, Dupin 486 (ill. p. 163)

116. *Une étoile caresse le sein d'une négresse (A Star Caresses the Breast of a Negress [Painting-Poem])*, 1938, oil on canvas, 129.5 x 194.5 cm (51 x 76 ½ in.), Tate, London, purchased 1983, Dupin 580 (ill. p. 164)

117. *Portrait III*, 1938, oil on canvas, 145 x 114 cm (57 x 44 ⅞ in.), Kunsthaus Zürich, Dupin 586, Fondation Beyeler only (ill. p. 166)

118. *Woman Haunted by the Passage of the Bird-Dragonfly Omen of Bad News*, 1938, oil on canvas, 80 x 315 cm (31 ½ x 124 in.), Toledo Museum of Art, purchased with funds from the Libbey Endowment, gift of Edward Drummond Libbey, Dupin 596 (ill. pp. 172–173)

119. *Women and Kite Among the Constellations*, 1939, oil on burlap, 81 x 60 cm (31 ⅞ x 23 ⅝ in.), private collection, courtesy Caratsch de Pury & Luxembourg, Zurich, Dupin 624 (ill. p. 179)

120. *Figures and Birds in the Night*, 1939, oil on burlap, 50 x 65 cm (19 ⅝ x 25 ⅝ in.), private collection, Switzerland, Dupin 625 (ill. p. 178)

121. *A Drop of Dew Falling Off the Wing of a Bird Awakens Rosalie Asleep in the Shadow of a Spiderweb*, 1939, oil on burlap, 73.5 x 100.5 cm (29 x 39 ½ in.), The University of Iowa Museum of Art, Iowa City, purchased with the aid of the Mark Ranney Memorial Fund, 1948, Dupin 627 (ill. p. 180)

122. *Morning Star (Constellation)*, 1940 (16 March), gouache and oil wash on paper, 38 x 46 cm (15 x 18 ⅛ in.), Fundació Joan Miró, Barcelona, gift of Pilar Juncosa de Miró, Dupin 633 (ill. p. 182)

123. *Woman and Birds (Constellation)*, 1940 (13 April), gouache and oil wash on paper, 38 x 46 cm (15 x 18 ⅛ in.), Colección Cisneros, Caracas, Dupin 635 (ill. p. 183)

124. *Nocturne (Constellation)*, 1940 (2 November), gouache and oil wash on paper, 37.8 x 45.7 cm (14⅞ x 18 in.), Collection of Samuel and Ronnie Heyman, New York, Dupin 640 (ill. p. 184)

125. *Awakening in the Early Morning (Constellation)*, 1941 (27 January), gouache and oil wash on paper, 46 x 38 cm (18 ⅛ x 15 in.), Kimbell Art Museum, Fort Worth, Texas, acquired with the generous assistance of a grant from Mr. and Mrs. Perry R. Bass, Dupin 642 (ill. p. 185)

126. *Women Encircled by the Flight of a Bird (Constellation)*, 1941 (26 April), gouache and oil wash on paper, 46 x 38 cm (18 ⅛ x 15 in.), private collection, Dupin 644 (ill. p. 186)

127. *Women at the Edge of the Lake Made Iridescent by the Passage of a Swan (Constellation)*, 1941 (14 May), gouache and oil wash on paper, 46 x 38 cm (18 ⅛ x 15 in.), private collection, Dupin 645, Fondation Beyeler only (ill. p. 187)

128. *The Migratory Bird (Constellation)*, 1941 (26 May), gouache and oil wash on paper, 46 x 38 cm (18 ⅛ x 15 in.), private collection, Dupin 646, Fondation Beyeler only (ill. p. 188)

129. *Ciphers and Constellations in Love with a Woman (Constellation)*, 1941 (12 June), gouache and watercolor with traces of graphite on paper, 45.6 x 38 cm (18 x 15 in.), The Art Institute of Chicago, gift of Mrs. Gilbert W. Chapman, 1953, Dupin 647 (ill. p. 189)

130. *The Beautiful Bird Revealing the Unknown to a Pair of Lovers (Constellation)*, 1941 (23 July), gouache and oil wash on paper, 45.7 x 38 cm (18 x 15 in.), The Museum of Modern Art, New York, acquired through the Lillie P. Bliss Bequest, Dupin 648, Fondation Beyeler only (ill. p. 190)

131. *The Passage of the Divine Bird (Constellation)*, 1941 (12 September), gouache and oil on paper, 45.7 x 37.8 cm (18 x 14 ⅞ in.), Toledo Museum of Art, purchased with funds from the Libbey Endowment, gift of Edward Drummond Libbey, Dupin 650 (ill. p. 191)

132. *Woman, Stars*, 1944, oil on canvas, 22.5 x 16.5 cm (8 ⅞ x 6 ½ in.), private collection, Switzerland, Dupin 671, Fondation Beyeler only (ill. p. 215)

133. *Women and Birds in the Night*, 1945, oil on canvas, 114.5 x 146.5 cm (45 ⅛ x 57 ¾ in.), Kunstsammlung Nordrhein-Westfalen, Düsseldorf, Dupin 746, Fondation Beyeler only (not illustrated)

134. *Woman Dreaming of Escape*, 1945, oil on canvas, 130 x 162 cm (51 ⅛ x 63 ¾ in.), Fundació Joan Miró, Barcelona, Dupin 747 (ill. p. 211)

135. *Woman in the Night*, 1945, oil on canvas, 130 x 162 cm (51 ⅛ x 63 ¾ in.), Solomon R. Guggenheim Museum, New York, gift of Evelyn Sharp, 1977, Dupin 748 (ill. p. 214)

136. *Woman in the Night*, 1945, oil on canvas, 130 x 162 cm (51 ⅛ x 63 ¾ in.), private collection, Dupin 751, Fondation Beyeler only (ill. p. 212)

137. *Dancer Hearing an Organ Playing in a Gothic Cathedral*, 1945, oil on canvas, 197 x 130.5 cm (77 ⅝ x 51 ⅜ in.), The Fukuoka Art Museum Collection, Japan, Dupin 758, Fondation Beyeler only (ill. p. 213)

138. *The Port*, 1945, oil on canvas, 130 x 162 cm (51 ⅛ x 63 ¾ in.), private collection, Dupin 759, Fondation Beyeler only (ill. p. 225)

139. *Spanish Dancer*, 1945, oil on canvas, 146.5 x 114.5 cm (57 ⅝ x 45 ¹⁄₁₆ in.), Fondation Beyeler, Riehen/Basel, Dupin 760, Fondation Beyeler only (ill. p. 223)

140. *The Bull Race*, 1945, oil on canvas, 114 x 144 cm (44 ⅞ x 56 ¹¹⁄₁₆ in.), Centre Georges Pompidou, Paris, Musée National d'Art Moderne, gift of the artist and of Pierre Loeb, 1947, Dupin 761 (ill. p. 222)

141. *The Snake with Red Poppies Moving through a Field of Violets Inhabited by Lizards in Mourning*, 1947, oil on cardboard, 106 x 75 cm (41 ¾ x 29 ½ in), Collection Francis Lombrail, Dupin 809 (ill. p. 244)

142. *Women and Bird in the Night*, 1947, oil on canvas, 71 x 91.5 cm (28 x 36 in.), courtesy Calder Foundation, New York, Dupin 810 (ill. p. 243)

143. *Mural Painting for the Terrace Plaza Hotel, Cincinnati*, 1947, oil on canvas, 259 x 935 cm (102 x 368 ¼ in.), Cincinnati Art Museum, gift of Thomas Emery's Sons, Inc., Dupin 817 (ill. pp. 235–238)

144. *Moon Bird*, 1946–1949, bronze, cast for Pierre Matisse, V. Gimeno, Barcelona, 19 x 17.5 x 12.5 cm (7 ½ x 6 ⅞ x 4 ⅞ in.), private collection, Fondation Beyeler only (ill. p. 217)

145. *Sun Bird*, 1946–1949, bronze, cast 4/8, V. Gimeno, Barcelona, 13.5 x 11 x 18.5 cm (5 ⁵⁄₁₆ x 4 ⁵⁄₁₆ x 7 ¼ in.), private collection, Fondation Beyeler only (ill. p. 216)

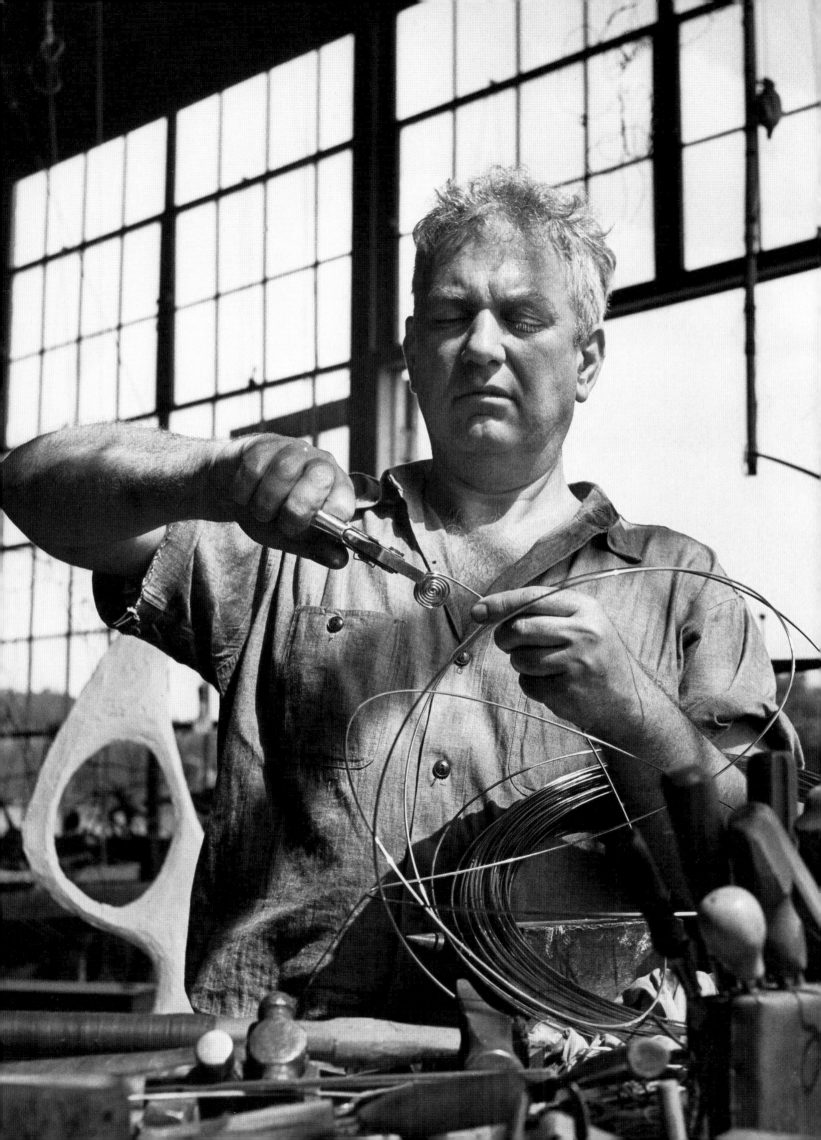

THE CORRESPONDENCE
OF ALEXANDER CALDER AND JOAN MIRÓ

Edited by
Elizabeth Hutton Turner and Oliver Wick
with Susan Behrends Frank, Johanna Halford-MacLeod, Elsa Smithgall,
and Judith Meier

1* CALDER, 7, rue Cels, Paris 14ᵉ, to MIRÓ [22, rue Tourlaque, Paris 18ᵉ]
10 December 1928 (fig. 68)

Cher Monsieur Miró, Je viens de la part de Mlle. Elizabeth Hawes ("Babe" – "Wendie") de New York. Veuillez-vous bien m'envoyer un mot quand vous serez de retour à Paris. Acceptez, monsieur, mes meilleurs compliments. (And I hope you can make this out!) Alexander Calder

Dear Mr. Miró, I have been sent by Miss Elizabeth Hawes ("Babe" – "Wendie") of New York. Would you kindly drop me a line when you next return to Paris. Please accept, Sir, my best wishes. (And I hope you can make this out!) Alexander Calder

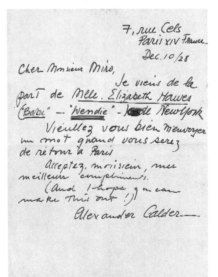

Fig. 68 Letter to Miró from Calder, 10 December 1928

Figs. 69, 70 Postcard to Miró from Calder, June 1929

2* CALDER [7, rue Cels, Paris 14ᵉ] to MIRÓ, 22, rue Tourlaque, Paris 18ᵉ
[June 1929] (figs. 69, 70)

Amitiés! Je vais ~~vous~~ t'emporter en Amérique en 2 ou 3 semaines. Prépare-toi. Calder

Greetings! I am going to carry you off to America in two or three weeks. Get ready. Calder

3* CALDER, 14, rue de la Colonie, Paris 13ᵉ, to MIRÓ [Montroig] [October 1931]

Cher Miró, Comme tu vois je vais faire marcher Le cirque le 29 & 30 Oct. et je veux bien que vous serriez présents. En tout cas, venez nous voir aussitôt arrivés à Paris. Je suis en train de travailler bien fort – et j'ai fait plusieurs choses avec des mouvements qui sont assez intéressants, je trouve (aussi [Jean] Arp, et plusieurs autres) et je crois que ça t'intéressera. J'ai invité Pierre [Loeb] de venir au cirque croyant que peut-être tu as parlé à lui de ça. Tu peux lui dire de venir si tu veux. Toutes mes bonnes salutations à vous 2, Calder

Dear Miró, As you know, I'm going to present the Circus on 29 and 30 October and I really would like you to be there. In any case, come to see us as soon as you arrive in Paris. I am working very hard – and have made many objects with movements that are rather interesting, I think (as do Jean Arp and others) and I believe that these works will interest you. I invited Pierre Loeb to come to the Circus, thinking that perhaps you had mentioned it to him. You can ask him to come if you like. All my best wishes to you both, Calder
["Vous" here refers to Miró and his wife, Pilar. The works with "interesting movements" included such subjects as *Mobile au plomb* (cat. 18).]

Fig. 71 Postcard to the Mirós from Calder, 20 June 1932

4 MIRÓ, Bristol Hôtel, Monte Carlo, to Alexander and Louisa CALDER, 14, rue de la Colonie, Paris 13ᵉ
26 February 1932

Amitiés les meilleures, Miró

With friendliest wishes, Miró

5* CALDER, Antwerp, to MIRÓ, Barcelona [forwarded to Montroig]
postmarked 2 April 1932

Mme Gabriel[le] Picabia est chez nous, rue de la Colonie. Pour entrer tu n'as que lui écrire un mot. On a changé les places de tes choses, mais tu les trouveras bien facilement (le masque aussi). Bien cordialement, Calder

Mme Gabrielle Picabia is at our place, rue de la Colonie. All you have to do to get in is write her a note. Your things have been moved, but you will find them easily enough (the mask too). Kind regards, Calder

6* CALDER, R.F.D. #1, Pittsfield, Mass., to Joan and Pilar MIRÓ, Barcelona
postmarked 20 June 1932 (fig. 71)
[R.F.D. – Rural Free Delivery – is a postal delivery route in rural sections of the United States.]

Holà! los Calderos, nous pensons arriver à Barcelona entre le 1ᵉʳ et le 15 Septembre. Dites-nous si ça vous ira. Parce que nous tenons faire une visite chez vous à Montroig. Calder

Holà! The Calderos are thinking of arriving in Barcelona between the 1st and the 15th of September. Tell us if that will be convenient for you because we want to pay you a visit at Montroig. Calder
[The postcard is typical of the New York tourist images Calder sent Miró.]

7* CALDER, R.F.D. #1, Pittsfield, Mass., to Joan and Pilar MIRÓ, Montroig
postmarked 19 July 1932 (fig. 72)

Nous arrivons à Barcelona le 8 ou 10 Septembre sur le vapeur Cabo Tortosa. *Nous espérons que vous serez là, toi et ta femme, et nous comptons vous rendre visite. Calder*

We will arrive in Barcelona on either the 8th or the 10th of September on the steamer Cabo Tortosa. We hope that you and your wife will be there, and we are planning to pay you a visit. Calder
[Calder has drawn a hairy hand extended in greeting or perhaps for one of the smacks on the bottom with which the two artists later concluded some of their letters to one another.]

Fig. 72 Postcard to the Mirós from Calder, 19 July 1933

8 MIRÓ and CALDER, Montroig to Sebastià GASCH [Barcelona]
12 September 1932

Estimat amic, Els Calders han arrivat avui, estàn encantats dels dies que han passat a Barcelona amb tu i en [Joan] Prats, a tots dos leur agraïment. El meu per haver-los atés. No t'havia respost la teva darrera lletra, no cal dir que estaré encantat de que vinguis, podries aprofitar mentres ells siguin aquí – tenim lloc sobrant – seria més divertit.

T'esperarem per a donar une representació del circ, axi t'en faries càrrec, i podrien esser les primaries d'un reportatge interessant. Estararàn aquí uns vuit o deu dies. De decider-te a venir, lo que ens faries tots molt contents podries escriure'm uns mots, i de decider-te a venir aviat podries enviar un telefonema a l'amo de l'auto dient que anés a l'estació a rebre't i que m'avisés a mi a l'ensems com ha fet en Prats pel Calder. El millor tren es el que surt a les 9 i arriba aquí. La adreça del taxi: Solé, Carrer Galans, 13, Montroig. Fins a ben aviat doncs, espero. Una abraçada, Miró

Holà! Je crois que Miró vous a expliqué ce que nous pensons de la présentation du cirque – et que vous viendrez ici pour le voir. Au moins nous pourrons nous amuser, peut-être. Bien cordialement. Adéu, Calder

Dear friend, The Calders arrived today, and they are delighted with the days they spent with you and Joan Prats in Barcelona. They express their thanks to both of you. And I give you mine for having taken care of them. I hadn't answered your last letter. Needless to say, I would be delighted if you would come and take advantage while they are still here – we have plenty of extra room – and it would be more enjoyable. We will wait for you to perform the Circus, so you can have an idea and it could be a scoop for an interesting article. They will be here for eight or ten days. In deciding whether to come, which would make all of us very happy, you could write me a few words, and if you do decide to come, you could send a telegram to the owner of the car telling him to go to the station to pick you up and telling him to let me know at the same time, like Prats did for Calder. The best train is the one

that leaves at 9:00 for here. The address of the taxi: Solé, Carrer Galans, 13, Montroig. I hope to see you real soon. A hug, Miró

Holà! I think that Miró has explained to you what we are thinking about the Circus presentation and [we hope] that you will come to see it here. Maybe we could have some fun. Cordially, goodbye, Calder [Miró wrote to Gasch, an important Catalan critic and friend, in Catalan. Calder opened his part of the letter with a Spanish greeting and closed in Catalan, a gesture typifying his embrace of Miró's culture.]

9* CALDER, Rome, to Joan and Pilar MIRÓ, Barcelona postmarked 3 March 1933

Nous sommes à Rome depuis une semaine. Nous circulons tout doucement, pour ne pas voir les choses trop vite. Le fond de cette fresque est bleu cobalt (un peu près) et suggère beaucoup tes toiles bleues – malgré que c'est bien bourré. Amitiés à tout le monde, et remerciements al Señor Juncosa – les godasses me vont très bien. Est-ce que je lui dois encore qq. [quelques] sous?? Sandy

We have been in Rome for a week. We are going quite slowly in order not to see things too fast. The background of this fresco is cobalt blue (more or less) and reminds me very much of your blue canvases – despite being plastered. Regards to everyone and thanks to Señor Juncosa. The shoes fit me very well. Do I still owe him a few sous?? Sandy
[Calder, writing about the plaster ground of the fresco, used a French equivalent of "plastered," meaning drunk. Señor Juncosa was a relative of Miró's wife.]

10* CALDER [14, rue de la Colonie, Paris 13ᵉ], to MIRÓ, Barcelona postmarked 15 March 1933

Mon cher ami, Nous sommes rentrés depuis 5 jours, et nous avons vu [Georges] Hugnet et [Edgard] Varèse, et les [Christian et Yvonne] Zervos viennent dîner vendredi avec eux. Tout le monde demande après toi. Quand viens-tu à Paris? Nous étions très contents du voyage sur notre bateau. Moi, je suis content d'être rentré. Merci pour les godasses, ils me vont très bien. Amitiés à ta mère et à Pilar et à ses amis. Sandy

My dear friend, We have been home for five days, and we have seen Georges Hugnet and Edgard Varèse, and Christian and Yvonne Zervos are coming to dinner with them on Friday. Everyone is asking after you. When are you coming to Paris? We were very happy with the trip on our boat. Personally, I am happy to be back home. Thank you for the shoes, they fit me very well. Regards to your mother and to Pilar and her friends. Sandy
[Hugnet was a critic, Varèse a composer, and Zervos the publisher of *Cahiers d'art*.]

11* CALDER [Roxbury] to MIRÓ, Barcelona 15 November 1933

Nous espérons que ton exposition a eu un grand succès et que ça va très bien chez toi. Amitiés à Pilar et ta mère. J'ai eu un télégramme de [Léonide] Massine aujourd'hui. Peut-être j'irai à Londres. Sandy / Bonnes amitiés à tous. Quoi de neuf? Je suis très étonné – j'ai écrit 5 lettres à [Joan] Prats – et n'ai encore reçu aucune réponse de lui. Votre fidèlement, [Edgard] Varèse / Amitiés à tous, Louisa

We hope that your exhibition was a big success and that all is well with

you. Best to Pilar and your mother. I received a telegram from Léonide Massine today. Perhaps I will go to London. Sandy / Best wishes to all. What's new? I am very surprised that after writing five letters to Joan Prats I have received no response. Yours faithfully, Edgard Varèse / Best to all, Louisa
[The exhibition was *Les dernières œuvres de Joan Miró* at the Galerie Georges Bernheim, Paris, 30 October–13 November. Massine was Diaghilev's choreographer and worked with the Ballets Russes from 1929.]

12 MIRÓ, Barcelona, to Alexander and Louisa CALDER, Roxbury 31 December 1933 (fig. 73)

Ils ont du toupet les gens des ballets russes, de t'offrir ce qu'ils t'offrent! Sois très prudent et ne te laisse pas rouler – tiens-moi au courant. As-tu reçu ma dernière lettre concernant mon exposition à New-York? Ma mère, Pilar et moi vous envoyons à vous deux nos meilleurs vœux pour 34. En toute amitié, Joan

Fig. 73 Postcard to the Calders from Miró, 31 December 1933

The people from the Ballets Russes really have some nerve making you that offer. Be very cautious and don't let yourself be swindled. Keep me posted. Did you receive my last letter about my exhibition in New York? My mother, Pilar, and I send you both our best wishes for '34. With all my friendship, Joan

[Calder had complained that Massine had not offered him an original ballet, only the chance to finish someone else's work. The exhibition referred to by Miró opened at Pierre Matisse Gallery, New York, two days prior to this letter.]

Fig. 74 Postcard to Miró from Calder, 23 March 1934

13* CALDER, Roxbury, to MIRÓ, Barcelona postmarked 23 March 1934 (fig. 74)

Mon cher Joan, J'expose chez Matisse le 3 Avril. Je t'enverrai des photos dès que j'en ai. Amitiés à toute ta famille, et aux amis – et à toi une belle gifle sur les fesses. Sandy

My dear Joan, I have a show at Matisse's on the 3rd of April. I will send you photos as soon as I have

them. Regards to all your family and friends, and a good smack on the butt for you. Sandy
[Calder flagged the Bank of The Manhattan Company, signaling profits. His choice of postcard indicates that he planned on making some sales.]

14* Alexander and Louisa CALDER, Eastham, Mass., to Joan and Pilar MIRÓ, Barcelona postmarked 12 July 1934

Nous sommes à la mer pour nager un peu. Aussi, moi, j'étudie l'espagnol pour le prochain voyage en Espagne – mais – Quand? – on n'a pas d'idée. Nos amitiés à tous surtout à Pilar, ta mère, et toi! Hasta luego. Pa sube! Sandy & Louisa
[*Pa sube* is a phonetic transcription of the Catalan *Pasù bé* – "have fun."]

We are by the ocean to do a little swimming. Also, I am studying Spanish for the next trip to Spain. But, when? We don't have a clue. Our friendly regards to all, especially Pilar, your mother, and you! See you later. Have fun! Sandy & Louisa

15* CALDER, New York, to MIRÓ, Barcelona postmarked 13 November 1935

Salud y amistad! Sandy Calder / F[ernand] Léger / [Albert Eugene] A. E. Gallatin / Simone Herman / Laura [Sweeney] / [scribbled signature: James Johnson Sweeney]

Health and friendship! Sandy Calder / Fernand Léger / A. E. Gallatin / Simone Herman / Laura Sweeney / James Johnson Sweeney
[James Johnson Sweeney, critic and poet, signed with a distinctive scribble in the context of the Calder Miró correspondence.]

16 MIRÓ, Barcelona, to CALDER
[New York]
[mid-to-late December 1935]

*Querido amigo, ¿Cómo estáis?
Supongo que la pequeñita se estará
volviendo tan guapa como su Señor
papá. Te escribo en español porque
así harás práctica. Tú escribes unas
cartas que están muy bien; continua
estudiando el castellano, que llegarás
a hacerlo muy bien. Nos gustaría
mucho nos mandaras una foto de la
niña para ver a quién se parece. Mi
pequeña (5 años) habla mucho y hace
unos dibujos estupendos. Yo estoy
trabajando muchísimo. ¿Y tú que
haces? Me gustaría ver fotografías.
Ahora hemos estado en Praga unos
días, deteniéndonos en Alemania y
en París. Praga es una ciudad muy
interesante. He ido allí por una
exposición que han hecho de mis
obras. Hace poco hice también una
exposición en San Francisco. Mi
madre, Pilar y yo os deseamos a
Louisa y a ti un buen año nuevo. Un
abrazo de tu amigo, Joan*

*Dear friend, How are all of you
doing? I suppose your little girl is
getting to be as good-looking as her
father. I'm writing to you in Spanish
because it will give you some prac-
tice. Your letters are very good.
Continue studying Spanish. You'll
get good at it. We would very much
like you to send a picture of your
daughter [Sandra] in order for us to
see who she looks like. My little one
(five years old) talks a lot and draws
some stupendous pictures. I am
working a lot. And you, what are
you doing? I would like to see pho-
tos. We were in Prague recently for a
few days, and stopped in Germany
and in Paris. Prague is a very inter-
esting city. I went there for an exhi-
bition they did of my work. I also
had an exhibition in San Francisco
not too long ago. My mother, Pilar,
and I wish you and Louisa a happy
New Year. A hug from your friend,
Joan*

[Miró's simple Spanish is in defer-
ence to Calder's efforts to learn the
language.]

Fig. 75 Postcard to Miró from Calder et al.,
ca. December 1936

17 CALDER [East 86th Street,
New York, N.Y.] to MIRÓ [Hôtel
Récamier, 3bis, place Saint-Sulpice,
Paris]
[ca. December 1936] (figs. 75, 76)

*[Illegible greeting], Laura Sweeney /
[scribbled signature: James Johnson
Sweeney] / Sandy / Carl Van Vech-
ten / Man Ray à Miró / Amitiés, et
félicitations, Henry McBride /
Eugene Jolas / C'est épatant, Louisa
/ des deux œufs, Paul and Francine
Nelson / Oscar Nitzschké / [William]
Einstein / [Jean] Hélion / [Miguel]
Covarrubias mis felicitaciones! /
Salut! Pierre Matisse*

Fig. 76 Postcard to Miró from Calder
et al., with suggestive additions by Calder,
ca. December 1936

[Translated, the preprinted French
poem reads:]

Your Eyes: It's because of your
eyes that I adore you / Your gentle,
wonderful eyes / Which are rendered
even brighter and softer / By the
silky fringe of your lashes....

*Laura Sweeney / James Johnson
Sweeney / Sandy / Carl Van Vechten
/ Man Ray to Miró / Regards and
congratulations, Henry McBride /
Eugene Jolas / It's terrific, Louisa /
from the two eggs, Paul and
Francine Nelson / Oscar Nitzschké /
William Einstein / Jean Hélion /
Miguel Covarrubias, My congratula-
tions! / Greetings! Pierre Matisse*
[A work by Miró, *Catalan Land-
scape* (*The Hunter*), was purchased
by the Museum of Modern Art for
inclusion in *Fantastic Art, Dada,
Surrealism* (opened 7 December
1936). As Man Ray was not in New
York until fall, it is likely that the
congratulations were offered around
the time the show opened. Van
Vechten was a critic and photo-
grapher who had photographed
Miró on 13 June 1935. McBride was
a critic. Jolas was the publisher of
Transition. Covarrubias was a
Spanish caricaturist.]

Fig. 77 Postcard to Miró c/o Loeb
from Calder et al., ca. late 1936 or early 1937

18 CALDER [East 86th Street,
New York, N.Y.] to MIRÓ c/o
Pierre Loeb, 2, rue des Beaux-Arts,
Paris [Miró was actually staying at
Hôtel Récamier, 3bis, place Saint-
Sulpice, Paris]
[ca. late 1936 or early 1937] (fig. 77)

Ça flotte dans les nuages. Sandy Calder / Oscar Nitzschké / Paul & Francine [Nelson] / [William] Einstein / [Jean] Hélion

It floats in the clouds. Sandy Calder / Oscar Nitzschké / Paul & Francine Nelson / William Einstein / Jean Hélion
[Calder's message mocks the postcard's legend, "Woolworth Building Tower above clouds 792 feet high."]

Fig. 78 Postcard to the Mirós from the Calders, 4 January 1937

19 Alexander and Louisa CALDER [East 86th Street, New York, N.Y.] to MIRÓ family [Hôtel Récamier, 3bis, place Saint-Sulpice, Paris] 4 January 1937 (fig. 78)

Regocijámosnos de saber Pilar y la hija [Maria Dolores] en Paris con su hombre y padre. Buen y salubre año, Sandy, Louisa, et Sandra

We are delighted to know that Pilar and your daughter are in Paris with their husband and father. Happy and healthy New Year, Sandy, Louisa, and Sandra

[Calder wrote a New Year's greeting on the aerial view of New York and drew a car speeding across the Brooklyn Bridge.]

20 Sandra CALDER, 49 Belsize Park, London NW3, to Dolores MIRÓ, 98, bd. Auguste-Blanqui, Paris 13ᵉ postmarked 20 November 1937 (figs. 79, 80)

Figs. 79, 80 Postcard to Dolores from Sandra, 20 November 1937

Querida Dolores, ven en Inglatierra a vernos, en este Barco, con tus padres y madres. Mil amitades, Sandra

Dear Dolores, Come to England in this ship with your father and mother to see us. A thousand friend-ships, Sandra
[The handwriting is Calder's. Sandra was two years old. Miró's daughter, Maria Dolores, was seven.]

21 CALDER, Roxbury, to MIRÓ family, 98, bd. Auguste-Blanqui, Paris 13ᵉ 28 February 1938

Votre gouache nous donne un grand plaisir – merci encore une fois. Ici, il fait beau, mais froid (aujourd'hui – 0°F). Nous allons tous très bien et espérons que vous tous, ainsi que toute la maison 98, faites la même chose. Hasta luego, viejos, Sandy

Your gouache gives us great pleasure – thank you once again. The weather is fine here, but cold (0° F today). We are all quite well and hope that all of you at no. 98 are too. See you later folks, Sandy
[For the gouache, see fig. 112.]

22* MIRÓ [98, bd. Auguste-Blanqui, Paris 13ᵉ] to CALDER family, Roxbury 9 March 1938

Merci pour votre aimable carte, qui nous a fait fort plaisir. Ici tout va bien et [nous] vous regrettons beau-coup. Dolores pense souvent à la petite. Il commence à faire beau. Nous vous envoyons tous les trois nos plus affectueuses salutations, Joan

Thank you for your kind card, which gave us so much pleasure. All is well here and we miss you a lot. Dolores often thinks of the little one. The weather is starting to be nice. We send all three of you our most affectionate greetings, Joan

23 CALDER family, Roxbury, to MIRÓ family, 98, bd. Auguste-Blanqui, Paris 13ᵉ postmarked 4 June 1938

Comment ça va, tous les 3? Bien, nous espérons. J'espère bâtir un petit atelier bientôt. Quand vous avez envie, faut venir nous voir. Très ami-calement à tout le monde, les Calders

How are all three of you doing? Well, we hope. I hope to build a little studio soon. When you feel like it, you must come to see us. Best regards to everyone, The Calders

Fig. 81 Postcard to Miró from Calder, 22 June 1938

24 CALDER, Roxbury, to MIRÓ, 98, bd. Auguste-Blanqui, Paris 13ᵉ postmarked 22 June 1938 (fig. 81) Postcard of "Empire State Building at Night, New York City"

"Busy Person's Correspondence Card – Time is Money – Check Items Desired" [Calder checked various boxes on the front of the novelty "Busy Person's Correspondence Card" in lieu of a message on the back. Strung together, his selections read:

Dear 'friend,' Do You Feel OKeh?
I Am 'Rushed,' 'Getting Fat.'
The Place Here Is 'Hot.'
I Do Lots of 'Working' [? Added by Calder], *'Thinking of You,' 'Making Whoopee.'*
I Need 'Cash.' 'Kisses.'
Business Is 'Perfect,' 'Improving,' 'In the Bag,' 'Slow,' 'Keeping Me Busy.'
I Wish You Would 'Send More Money.'
I Miss 'The Gang.'
I Will Be Seeing You 'pronto' [handwritten by Calder].
Yours 'With Love' Sandy (handwritten name).

25 MIRÓ [98, bd. Auguste-Blanqui, Paris 13ᵉ] to Alexander and Louisa CALDER, Roxbury
postmarked 12 July 1938

How are you Mister Calder? We are enjoy [illegible] much. We think [of] you, Alicia Raslan / Un bon souvenir, Pilar / Laura [Sweeney] / Eva Sulzer / Paul Nelson / Salud, Joan / We are returning on the Manhattan *Aug. 4 to NY so may see you soon. One of the nights! How is yours? Francine [Nelson] / Jean Hélion / [scribbled signature: James Johnson Sweeney] / [Francis] Picabia*

26 MIRÓ family, 10, baie de Cassis, Calanque de Port Miou [Bouches-du-Rhône], to Alexander and Louisa CALDER, Roxbury
10 August 1938

Chers Sandy et Louisa, nous sommes ici pour quelque temps. C'est un pays magnifique où nous nous plaisons beaucoup. Nous pensons souvent à vous et aimerions vous avoir ici. Embrassez Sandra. Meilleures amitiés de Joan, Pilar, et Dolores. / Bonjour, G[eorges]. Braque / Amitiés, M[arcelle]. Braque

Dear Sandy and Louisa, We are here for some time. It is a magnificent region where we are really enjoying ourselves. We think of you often and would love to have you here. Love to Sandra. Best regards from Joan, Pilar, and Dolores / Hello, Georges Braque / Regards, Marcelle Braque

27 CALDER [East 86th Street, New York, N.Y.] to Joan and Pilar MIRÓ, 98, bd. Auguste-Blanqui, Paris 13ᵉ
2 January 1939

Chers amis, on pense souvent à vous. Comment ça va là-bas? Ça serait gentil de vous voir bientôt, mais vraiment, on doit rester ici, à N.Y. jusqu'au printemps, e[t] puis, rentrer à Roxbury où je viens de faire construire un bel atelier, et que j'aimerais bien habiter. Bien des choses à vous tous, Sandy

Dear Friends, We think about you often. How are things over there? It would be nice to see you soon, but we really have to stay here in N.Y. until spring and then return to Roxbury, where I have just built a beautiful studio that I would like to live in. All the best to all of you, Sandy

28 Pilar and Joan MIRÓ, 98, bd. Auguste-Blanqui, Paris 13ᵉ, to CALDER family [Roxbury]
23 May 1939

Queridos amigos, Deseo sigáis con buena salud y que Luisa esté bien animada. Nosotros os recordamos siempre y desearíamos muchos veros a todos, especialmente a Sandra, que debe estar hecha una mujercita encantadora; M[arí]a. Dolores ha cambiado también mucho y está muy crecida y ya habla bien el francés. Espero que el pequeño llegará bien y que Luisa tendrá un parto bien feliz; aprovechando el viaje de una amiga de Catherine Dudley os he enviado un pequeño baberito, para el nuevo "calderito." Es solamente una pequeña fineza, bordada a mano, para demostraros que os recordamos, no envié nada a Sandra, porque temí molestar; será otra vez. Como podéis suponer, estoy apenada al ver que por ahora no podemos ir a vuestro país, menos mal que por ahora nuestras familias están bien. Besos a la niña de parte de Dolores y mía. A vosotros un abrazo, Vuestra amiga que os quiere, Pilar / Los Sert [Josep Lluís and Moncha, his wife] están en la Havana y quizás vendrán a Nueva York este verano.

Queridos Calderos, yo también os mando a todos un buen abrazo, y dad un beso al Calderillo, en cuanto saque la cabeza. Vi unas cosas tuyas en Cahiers d'art *y en la revista de arquitectura que me gustaron muchísimo. ¿Trabajas mucho? Me gustaría ver fotos. Yo trabajo siempre. ¡Qué tragedia con los refugiados! ¡Pobre España! Un beso, Sandra, y para vosotros un abrazo de vuestro amigo, Joan*

Dear friends, I hope you are in good health and that Louisa is in good spirits. We think of you always and wish we could see all of you, especially Sandra, who must be turning into a charming young lady. Maria Dolores has grown and changed much and speaks French well now. I hope the little one arrives safely and that Louisa has an easy labor. Taking advantage of a friend of Catherine Dudley, I've sent you a small bib for the new "little Calder." It's just a little detail, hand-embroidered, to show you that we're thinking of you. I didn't send anything for Sandra because I didn't want to bother, but

perhaps next time. As you can imagine, I'm very sad that for now, we'll be unable to travel to your country, but at least our families are well. Kisses for the girl from Dolores and me. A hug for you from your friend who loves you, Pilar / Josep Lluís and Moncha Sert are in Havana and they might come to New York this summer.

Dear Calderos, I also send you all a big hug, and give a kiss to the tiny Calder as soon as he pokes his head out. I saw some works of yours I really liked in Cahiers d'art and in an architectural magazine. Are you working much? I would like to see photos. I have been working a lot. What a tragedy with the refugees! I feel sorry for Spain! A kiss for Sandra, and for you, a hug from your friend, Joan
[The "little Calder" was Mary.]

29 Pilar MIRÓ [Carrer de Sant Nicolau, Palma] to Louisa CALDER [East 86th Street, New York, N.Y.]
24 January 1941

Chère Louisa, Nous avons été très contents de recevoir votre aimable lettre et vous souhaitons aussi une bonne année 1941, avec tous nos meilleurs vœux. Par Pierre [Matisse], nous avons souvent de vos nouvelles. Nous pensons tout le temps à vous tous et voudrions bien vous revoir bientôt. Comment vont les enfants? Ils doivent être beaux et forts. Et les amis? Dites-leur que nous pensons à eux. Mille bonnes choses à Georges [Duthuit], beau-frère de Pierre. Nous vous embrassons tous les trois à vous deux et à vos gamins. Bien affectueusement, Pilar

Dear Louisa, We were very happy to receive your kind letter and we also wish you a happy New Year 1941 with our best wishes. Through Pierre Matisse we often have news of you. We think of you all the time and

would love to see you again soon. How are the children? They must be fine and strong. And our friends? Tell them that we are thinking of them. Best regards to Georges Duthuit, Pierre's brother-in-law. All our love from the three of us, to you both and your little ones. Affectionately yours, Pilar

30 MIRÓ family, Montroig, to Alexander and Louisa CALDER [Roxbury]
15 August 1943

Mon cher Sandy, Il y a longtemps que nous n'avons pas de tes nouvelles. Ecris-nous, nous aurons un très grand plaisir à lire de tes nouvelles et de savoir ce que toi et ta famille devenez. Comment va Louisa, comment vont les enfants? Fais-nous parvenir les photos, nous serons très contents de les voir. Ici, nous allons tous très bien et pensons rester jusqu'au commencement d'octobre pour rentrer à Barcelone. Je t'enverrai des photos dès que j'en aurai l'occasion. Comment va le travail? Explique-moi ce que tu fais. Je travaille toujours beaucoup à des choses très variés. Explique-moi ce que deviennent les amis et fais-leur toutes mes meilleures amitiés. Mille bonnes choses à Louisa et embrasse les enfants que j'aimerais pouvoir revoir. Une poignée de main et toute mon amitié, Miró

Queridos amigos, Tengo muchas ganas de verlos y de poder abrazar a las nenas, que supongo habrán crecido mucho, lo mismo que yo. Por aquí me divierto mucho, a ver si cuando termine la guerra vienen a pasar una temporadita. Les abraza, M[ari]a. Dolores

Avec toute ma grande affection, Pilar

My dear Sandy, We haven't heard from you in a long time. Write to us. We would love to hear your news

and to know what is happening to you and your family. How is Louisa, how are the children? Send us some photos. We would be very happy to see them. Here, we are all doing very well and are thinking of staying on until the beginning of October before going home to Barcelona. I will send you some photos as soon as I have the chance. How is your work coming along? Tell me what you are doing. I am still working a lot on very different pieces. Tell me what our friends are up to and give them all my friendliest regards. All the best to Louisa and love to the children, whom I would dearly like to see again. A handshake to you and all my friendship, Miró

Dear friends, I would really like to see you and to hug the girls, who I guess have grown quite a bit, just like me. I am enjoying myself around here. Let's hope that when the war is over you can come to stay for a little while. Hugs, Maria Dolores / With all my love, Pilar

31 MIRÓ family, Barcelona, to Alexander and Louisa CALDER [Roxbury]
15 December 1944

Mi querido amigo, Perdona si no he contestado antes a tu carta del 15 abril, pero hace medio año falleció mi madre, no se si te habrás enterado. Tú ya la conocías, era una mujer muy simpática que encontramos a faltar mucho. Celebré mucho el buen éxito de tu exposición y todos hemos deplorado ese enojoso contratiempo en el incendio de tu taller. Aquí hablamos muy a menudo de vosotros. Esperemos que este próximo 1945 nos permitirá vernos de nuevo. ¿Y [Georges] Duthuit como está? ¿Y los [Paul and Francine] Nelson y Pierre Loeb? Me gustaría mucho que me dieras noticias de ellos, pues hace muchísimo tiempo que no sé nada. En Nueva York han recibido una

serie de pinturas mías, y el museo va a organizar una exposición mia. ¿Has visto estas pinturas? Sigo trabajando mucho, y supongo que tú también debes hacerlo. A Louisa, a tí y a las niñas os deseo un buen navidad y próspero año nuevo. Un abrazo para todos de Miró

Queridos amigos, Aunque no les escriba, les sigo recordando siempre con mucho cariño, y también pienso en lo feliz que seré cuándo nos veamos de nuevo y podré conocer a María [Mary Calder]. Siempre que veo sus esculturas o aquella corbata que Ud. hizo, pienso en lo que nos reíamos en Francia. Deseo que pasen unas felices Navidades y un próspero Año nuevo....y [illegible] vernos pronto. Les manda muchos recuerdos su amiga, M[ari]a. Dolores

Os deseo mucha salud y prosperidades para el próximo año. Besos a las nenas y un buen abrazo para los dos, Pilar

My dear friend, Pardon me for not answering your letter of 15 April earlier, but my mother died six months ago. I don't know if you heard. You knew her. She was a very charming lady whom we miss very much. I celebrated the success of your exhibition and we all regret the troublesome setback caused by the fire in your workshop. We speak of you often and hope to see you next year in 1945. How is Georges Duthuit? And Paul and Francine Nelson and Pierre Loeb? I would like to hear how they are doing. It's been a long time since I've heard anything. A group of my pictures has arrived in New York, and the museum is going to organize an exhibition of them. Have you seen them? I continue working a lot, and suppose you are doing the same. To you, Louisa, and the girls, a Merry Christmas and Happy New Year. A hug for all from Miró [The letter references Calder's retrospective exhibition at the Museum of Modern Art, New York, 29 Sep-*

tember 1943–16 January 1944, and a proposed exhibition at MoMA of Miró's paintings, later known as Constellations. This exhibition, in fact, took place at Pierre Matisse Gallery, New York, 9 January–3 February 1945.]

Dear friends, Although I do not write, I always think of you with great fondness, and I also think about how happy I will be when we can see each other again and I can meet Mary. Whenever I see your sculptures or that tie that you made, I think about how much we laughed in France. I hope you have a Merry Christmas and a prosperous New Year...and [illegible] see each other soon. Best regards from your friend, Maria Dolores

I wish you much health and prosperity for the coming year. Kisses for the little darlings and a big hug for the two of you, Pilar

Fig. 82 Postcard to Calder from Miró, with additional underarm hair supplied by Miró, 12 September 1945

32 MIRÓ [Montroig] to CALDER, Roxbury
postmarked 12 September 1945
(fig. 82)

¡Un abrazo petons, y hasta pronto, cavallot! Miró / [Joaquim] Gomis / Moncha [Sert] / [Joan] Prats / Pepet [Josep Lluís Sert]

A hug, kisses, and see you soon, you big stud! Miró / Joaquim Gomis / Moncha Sert / Joan Prats / Pepet [Josep Lluís Sert]
[Gomis was a photographer.]

33 MIRÓ family, Barcelona, to CALDER [Roxbury]
21 December 1945

Querido Sandy, Hace tiempo quería escribirte y darte las gracias al mismo tiempo por el libro que me mandaste consagrado a tu obra y que no he recibido hasta hace poco – me interesó muchísimo. Me has dicho que hacías esculturas en bronce, que tendría mucho interés en conocer. ¿Podrías mandarme fotos? Yo también hago esculturas a veces, es una cosa muy apasionante. Sigo trabajando siempre mucho y espero que ponto podréis ver cosas mías recientes en América. Seguramente iré pronto a París. ¿No piensas tú ir? Tengo grandes ganas de veros a todos, tus pequeños habrán crecido mucho. Les darás besos de mi parte y muchos saludos a Louisa. Os deseo a todos un feliz Navidad y un próspero año nuevo. Recibe un fuerte abrazo de tu amigo, Miró / Felicidades y un buen abrazo, Pilar / Recuerdos de M[ari]a. Dolores

Dear Sandy, I have wanted to write to thank you for the book you sent me about your work. I received it a short while ago. It interested me a great deal. You told me that you are making bronze sculptures. I would be very interested in seeing them. Could you send photos? I too make sculptures sometimes. It's a very exciting thing. I continue to work a lot and I hope that soon you can see recent pieces of mine in America. I will be traveling to Paris soon. Are you planning on going? I am very

eager to see you all. Your little ones will have grown a lot. Give kisses and my greetings to Louisa. I wish you all a Merry Christmas and a prosperous New Year. A big hug from your friend, Miró / Best wishes and a big hug, Pilar / Regards from Maria Dolores
[Calder inscribed Miró's letter with an encircled note to himself: "Sent Rats" which he changed to "Send Rats," suggesting that he had not sent the *Three Young Rats and Other Rhymes* at the time he inscribed it (see *Correspondence* 34) and that the "book about your work" mentioned by Miró was probably *Recent Work by Alexander Calder*, Buchholz Gallery/Curt Valentin, New York, 1944. He also circled Miró's request for photographs of bronzes.]

34* Alexander CALDER and James Johnson SWEENEY [Roxbury] to MIRÓ [Montroig]
July 1945 [Sent later] (fig. 83)

Para Todos Mirós in Vieja Amistad de Sandy Calder y James Johnson Sweeney

For all the Mirós in longstanding friendship, from Sandy Calder and James Johnson Sweeney
[Dedication inscribed in *Three Young Rats and Other Rhymes*, 1944.

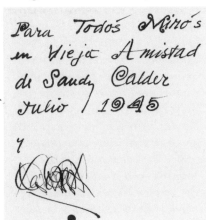

Fig. 83 Dedication inscribed in *Three Young Rats*

The book was illustrated by Calder and edited by Sweeney. The publisher was the dealer Curt Valentin. Calder may not have sent the book at the time he inscribed it. See also *Correspondence* 33, 35.]

35 MIRÓ family, Barcelona, to CALDER, Roxbury
12 February 1946

Querido Sandy, Acabo de recibir el libro que has tenido la amabilidad de mandarnos y que nos ha gustado a todos muchísimo. Los dibujos muy agudos y llenos de espíritu y el texto llenos de gracia. Te lo agradecemos mucho. Nos gustaría también que cuando tengas ocasión nos mandes una fotografía de todos vosotros, siempre os estamos recordando. Yo pienso ir pronto a París, enseguida que Pilar, que ahora está un poco enferma se ponga bien. ¿Tú no piensas ir? Será estupendo el día que podamos reunirnos otra vez. El año próximo me gustaría mucho venir a pasar una temporada en Nueva York. Recibí tu cablegrama por navidad, que te agradece mos, supongo que tú recibiste también la carta que te mandé. ¿Cómo va el trabajo? Yo sigo siempre trabajando mucho. Darás muchos besos a los niños de mi parte, y para ti y Louisa un fuerte abrazo de, Joan

Muy contentos del libro y condeseos de veros pronto, os mando un buen abrazo, con besos a las nenas, que deben de ser preciosas, Pilar

Un abrazo y besos a las niñas de M[ari]a. Dolores

Dear Sandy, I just received the book you were kind enough to send us. We all liked it very much. The drawings are sharp and full of spirit and the text is charming. We thank you for it very much. When you have a chance, send us a photo of all of you. We are always thinking of you. I'm planning to go to Paris soon, when Pilar, who

is a little unwell right now, gets better. Aren't you planning on going? The day we can get together again will be magnificent. Next year I would like to spend some time in New York. I received the Christmas telegram you sent us. Thank you very much. I assume you also received the letter I sent you. How is your work? I continue to work very hard. Give the children many kisses from me, and for you and Louisa, I send a big hug, Joan

We're very happy with the book and wish to see you soon. A hug for you with kisses for the little darlings, who I'm sure must be beautiful, Pilar

A hug and kisses for the girls from Maria Dolores
[Miró is presumably acknowledging receipt of *Three Young Rats and Other Rhymes*.]

36 MIRÓ family, Barcelona, to CALDER [Roxbury]
18 March 1946

Mon vieux Sandy, nous avons été éblouis en recevant ton magnifique colis. Les bracelets sont splendides, les crayons aussi beaux que l'arc-en-ciel et l'objet rayonnant sur un coin de la salle à manger où nous l'avons posé. Merci pour ton cadeau, digne d'un prince. Les reproductions de tes sculptures m'ont beaucoup intéressé, je les ai regardées plusieurs fois et ça a été une chose très inattendue pour moi, tu marches sur un chemin plein de très grandes possibilités. Bravo! La sculpture m'intéresse énormément en ce moment, depuis deux ans, pendant les vacances d'été, je ne fais que cela et c'est très bien pour un peintre d'en sortir de temps en temps de la vieille histoire de la toile et du châssis. J'avais l'intention d'aller à Paris ce printemps, mais nous sommes à nouveau coincés ici. Il faut espérer qu'un beau jour on pourra tout de

même arriver à se déplacer pour se dégourdir les muscles, ce que l'on a bien besoin, voyons! J'ai aussi très envie de venir à New-York te voir – auras-tu dans ton atelier un coin de mur où je puisse peindre quelque chose pour toi? Tu pourrais bien nous envoyer une photo de vous tous, ceci nous ferait grandement plaisir. Embrasse les enfants de ma part et toi et Louisa recevez toute l'affection de, Miró

No sé como expresarme, para deciros, lo contenta y agradecida que estoy, por vuestro delicado obsequio; mi pulsera es magnifica y luciéndola siempre, hará que os recuerde más y desee con más vehemencia, el veros pronto. Abrazos para todos en especial para las nenas. Pilar

Contentísima con su obsequio les abraza. M[ari]a. Dolores

My dear old Sandy, we were dazzled when we received your magnificent package. The bracelets are splendid, the pencils as beautiful as the rainbow, and your piece lights up a corner of the dining room where we have put it. Thank you for your princely gift. I was very interested in the reproductions of your sculptures. I have looked at them many times, and they are something completely unexpected. You are taking a path full of great possibilities. Bravo! Sculpture is of enormous interest to me right now. For the last two years, during summer vacation, that is all I have been doing and it's very good for a painter to get away from the old story of canvas and frame every now and again. I intended to go to Paris this spring, but we are again stuck here. One can only hope that one fine day, we will be able to go somewhere to relax, which, after all, is something we really need! I also want very much to come to New York to see you – is there a corner in your studio where I could paint something for you? Maybe you could

send us a photo of all of you; it would give us a great deal of pleasure. Hug the children for me and I send all my love to you and Louisa, Miró

I don't know how to express my happiness and how thankful I am for the fine gift; my bracelet is magnificent and I will wear it always in order to remember you more. I fervently hope that we can see each other soon. Hugs for everyone, especially the little darlings. Pilar

Very happy with my present, I give you a hug. Maria Dolores
[The colored pencils that Calder gave Miró were the high-quality Swiss brand Caran d'Ache. The piece lighting up a corner of the Miró dining room was a tabletop mobile (fig. 121) sent by Calder. Calder's sculptures discussed here are bronzes, as referenced in *Correspondence 33*.]

37 MIRÓ family, Barcelona, to CALDER [Roxbury]
21 December 1946

Mon vieux Sandy, Seulement quelques mots pour vous souhaiter à vous tous un joyeux noël et une bonne année 1947. Aussi, j'ai la grande joie de te dire que le huit février, nous prendrons l'avion à Lisbonne, pour nous rendre à New-York. Nous attendons ce voyage avec la plus grande ~~joie~~ impatience. Embrasse Louisa et les enfants et reçois une bonne tape sur les fesses de, Joan / Un buen abrazo y hasta pronto y felicidades, Pilar / Os abraza vuestra M[ari]a. Dolores. ¡Hasta bien pronto!

My dear old Sandy, Just a few words to wish all of you a Merry Christmas and a Happy New Year for 1947. I also am delighted to tell you that on 8 February we will be flying from Lisbon to New York. We are looking forward impatiently to this trip. A

hug for Louisa and the children and a good smack on the butt for you from, Joan / A good hug and see you soon and best wishes, Pilar / A hug for you all from your Maria Dolores. See you real soon!

38 Joan and Pilar MIRÓ [Barcelona] to CALDER family [Roxbury] [ca. 1 January 1947]

Joyeux Noël, bon Nouvel An, Joan / Merci de ta lettre et de ton aimable invitation, avec tous mes meilleurs vœux. Je vous embrasse bien, à tous, Pilar

Merry Christmas, happy New Year, Joan / Thank you for your letter and your kind invitation, with all my best wishes. A big hug to you all, Pilar
[On 12 February, after going to New York's La Guardia Airport to pick up the Mirós (who were delayed for three days), Calder attended a dinner at Pierre Matisse's with the Sweeneys and the Serts. It seems likely that the invitation referred to above was for this dinner.]

39 Pédro [unidentified], Alexander and Louisa CALDER, and MIRÓ, Roxbury to Willem SANDBERG, Stedelijk Museum, Amsterdam 7 March 1947

Amerika is ontzaglijk – Museum of Modern [Art] is grandioos. Je moet absoluut komen. Veel liefde van Pédro / Hallo, Hallo, Calder / Un amical souvenir, Miró / Louisa Calder

America is fantastic – Museum of Modern Art is spectacular. You absolutely must come. Much love from Pédro / Hello, Hello, Calder / Friendly memories, Miró / Louisa Calder
[Sandberg was the director of the museum.]

40* CALDER, Roxbury, to MIRÓ,
950 1st Avenue, New York, N.Y.
7 April 1947

*Le papier que tu as vu venait de
(s'appelle "WHATMAN")
E.H. + A.C. Friedrichs 140 W. 57 St.
J'en ai acheté d'autre récemment, qui
était moins bon. Sandy*

*The paper that you saw came from
(is called WHATMAN). E.H. + A.C.
Friedrichs 140 W. 57 St. I bought
some other paper recently, which was
not as good. Sandy*

41 MIRÓ, c/o de Rochemont, 235
East 46th Street, New York, N.Y.,
to CALDER, Roxbury
23 May 1947

*Mon cher Sandy, Il ne nous sera pas
possible de venir le jour que tu nous
dis, car j'aurai beaucoup de choses à
faire. J'espère qu'on aura le plaisir de
te voir un autre jour. A Louisa, aux
niñas et à toi mille bonnes choses de
nous trois, Joan*

*My dear Sandy, It will not be possi-
ble for us to come on the day you
said because I will have so much to
do. I hope that we will have the
pleasure of seeing you another day.
To Louisa, the girls, and you, all the
best from the three of us, Joan*

42 MIRÓ family, Palma, Mallorca,
to Alexander and Louisa CALDER,
Roxbury
25 December 1947

*Meilleurs vœux pour le nouvel an,
Dolores / Pilar / Miró*

*Best wishes for the New Year,
Dolores / Pilar / Miró*

43 MIRÓ, Hôtel Pont-Royal,
rue Montalembert, Paris 7ᵉ,
to CALDER [Roxbury]
25 February 1948

*Mon cher vieux, je suis ici pour
quelques jours. Comment ça va, toi
et la famille? Mon ami, l'éditeur,
Gérald Cramer, 6, rue Adhémar-
Fabri, Genève voudrait t'acheter un
petit mobile comme ceux qui sont
chez Mme Hoppenot, à Berne et me
charge de te le dire. Je peux lui
envoyer quelques photos, à son
adresse avec les prix. Kurt [Curt
Valentin] te remettrait l'argent en
son nom. Mille bonnes choses à
Louisa et aux fillettes. Et pour toi,
toute l'amitié de, Joan*

*My dear old friend, I am here for a
few days. How are you and your
family? My friend, the publisher
Gérald Cramer, 6, rue Adhémar-
Fabri, Geneva, would like to buy a
little mobile from you like those at
Mme Hoppenot's in Bern, and has
asked me to let you know. I can send
some photos to his address with
prices. Curt Valentin would deliver
the money to you on his behalf.
Many good wishes to Louisa and to
the little girls, and to you, all my
friendship, Joan*

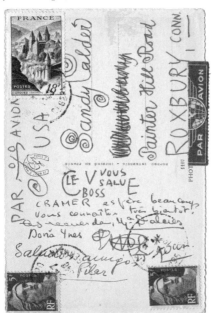

Fig. 84 Postcard to Calder from Miró et al.,
1948

[At the time of this letter, Gérald
Cramer, Swiss publisher and gallery
owner, was working on the publica-
tion of Paul Eluard's book, *A toute
épreuve*, with illustrations by Miró.
It finally appeared in 1958.]

44 MIRÓ [Hôtel Pont-Royal,
rue Montalembert, Paris 7ᵉ]
to CALDER, Roxbury
postmarked 1948 (fig. 84)

*CLE VOUS SALUE BOSS/
CRAMER espère beaucoup vous
connaître très bientôt! Os recuerda,
M[ari]a. Dolores / Doña Ynes
[Cramer] / [Arnau] Puig / Joan /
Saludos amigos, Pilar*

*Cle greets you boss /
Cramer is really looking forward
to meeting you very soon! Regards,
Maria Dolores / Doña Ynes
Cramer / Arnau Puig / Joan /
Greetings, friends, Pilar*
[Cle, Louis Gabriel Clayeux, was
director of Galerie Louis Carré,
Paris. Doña Ynes was Gérald
Cramer's wife. Arnau Puig was
Miró's assistant. Miró adds a signa-
ture between "par" and "avion": a
flying J. An eye at the end of its tail
plays on Miró (from mirar, to see, in
Catalan). Miró adapts Calder's wire
spiral to form the letters S, y, and C
in Calder's name. An arrow on the r
alludes to flight and possibly Paul
Klee.]

45 MIRÓ family, Barcelona, to
CALDER [Roxbury]
17 June 1948

*Mon cher Sandy, J'ai reçu ta lettre
avec les mesures pour les rideaux.
Justement il faut que j'en cherche
pour un atelier que je me suis fait
construire à Montroig. Je serai ravi
d'en choisir aussi pour toi. Je ferai ça
cet été, car à Reus ou à Tarragone je
trouverai des choses qui sont mieux
que ce qu'on vend à Barcelone.
[Joan] Prats veut t'envoyer aussi un*

grand panier comme celui que tu as trouvé à Cambrils autrefois, pour te remercier du beau mobile qu'il vient de recevoir. Nous enverrons tout cela ensemble. Je te souhaite un beau séjour au Brésil, c'est un pays qui m'est très sympathique et qui me donne très envie d'y aller. Mille bonnes choses à tous les amis de là-bas. Nous partons incessamment à Paris; dommage qu'on ne puisse pas s'y rencontrer. Embrasse tes fillettes et Louisa de ma part et à vous tous toute ma vieille et profonde amitié, Joan

Je pense toujours à vous tous, et vous envoie mes meilleurs souvenirs, Dolores / Abrazos, Pilar

My dear Sandy, I received your letter with the measurements for the curtains. As it happens, I need to look for some myself for the studio that I built in Montroig. I will be delighted to choose some for you also. I will do that this summer in Reus or Tarragona, because I will find better things there than are sold in Barcelona. Joan Prats wants to send you a large basket like the one you found at Cambrils, to thank you for the beautiful mobile that he just received. We will send it all together. I hope you have a great trip to Brazil, it is a country that appeals to me and I really want to go there. My best wishes to all our friends down there. We are constantly off to Paris; it's a pity that we can't meet there. Hug your little girls and Louisa for me and to all of you I send my deep and enduring friendship, Joan

I am always thinking of all of you, and send you my best wishes, Dolores / Hugs, Pilar

46 MIRÓ family [Barcelona] to Alexander and Louisa CALDER [Roxbury]
December 1948

Felices Navidades y próspero año nuevo, Dolores / Pilar / Joan

Merry Christmas and a prosperous New Year, Dolores / Pilar / Joan

47 MIRÓ, Paris, to CALDER [Roxbury]
12 March 1949

Mon cher Sandy, je suis venu ici pour quelques jours seulement. A la fin mai nous viendrons tous les trois ensemble pour quelque temps. J'ai parlé avec [Aimé] Maeght et [Louis] Clayeux, ils sont très emballés pour ton exposition. Moi, personnellement, je trouve qu'une exposition chez Maeght a beaucoup plus de tenue et de retentissement que chez Drouin, mais n'en parle à personne de ce que je viens de te dire. On m'a dit que tu viendras à Paris avec Louise, ça sera chouette, de nous y rencontrer. Puisque tu dois venir, il est préférable que à mon prochain voyage je t'apporte les rideaux et le pannier que tu peux emporter en Amérique, car en Espagne on n'en finit jamais avec ces sacrées démarches pour l'exportation. Embrasse Louisa et les enfants et reçois une tape de, Joan

My dear Sandy, I came here just for a few days at the end of May. All three of us will return together to spend some time here. I spoke with Aimé Maeght and Louis Clayeux and they are very enthusiastic about your exhibition. Personally, I think that an exhibition at Maeght's has much more standing and effect than one at Drouin's, but don't tell anyone I told you so. I hear that you will come to Paris with Louisa. It will be great to meet there. As you are coming, it's better that I bring the curtains and the basket to you on my next trip and you can take them back to America, because in Spain, the damn export procedures are endless. Hug Louisa and the children, and a smack for you from, Joan [Maeght was Miró's dealer in France.]

48 MIRÓ, Paris, to CALDER [Roxbury]
2 July 1949

Mon cher Sandy, je me suis occupé auprès de [Christian] Zervos et de [Aimé] Maeght de ton exposition. A mon avis, voilà ce qui se passe. Je crois que le Département de Relations Culturelles n'a pas beaucoup d'argent en ce moment, et c'est pour cela qu'on raconte des boniments. Fais-toi confirmer par lettre la date de ton exposition, et surtout que tout ce qui se rapporte aux frais de transport et de ton voyage soit bien spécifié, pour ne pas avoir de surprises après. Ici tout va bien, on voit beaucoup d'amis de New-York – les Sert [Josep Lluís and Moncha] et Curt [Valentin] sont à Paris. Je pars dans huit jours à Barcelone pour aller ensuite à Montroig. Pilar et Dolores sont restées en Espagne. Embrasse Louisa et les enfants. Très cordialement, Joan

My dear Sandy, I discussed your exhibition with Christian Zervos and Aimé Maeght. In my opinion, here is what is happening. I believe that the Department of Cultural Relations is short of money right now and this is why they are giving you lame excuses. Have the date of your exhibition confirmed in writing, and above all, make sure that all transportation and travel expenses are specified, so that there are no surprises later. Everything is going well here. I see friends from New York – Josep Lluís and Moncha Sert and Curt Valentin are in Paris. I leave for Barcelona in a week and from there will go to Montroig. Pilar and Dolores stayed behind in Spain. Love to Louisa and the children. Very cordially, Joan

49 MIRÓ family, Montroig, to Alexander and Louisa CALDER, Roxbury [ca. 1950]

Une affectueuse pensée de Tarragone / Aimé / Marguerite Maeght /

Passons la semaine et buvons la man-zanilla en pensant à vous. Affectueusement, [Louis] Clayeux / Amitiés, Giuli Maeght / Affectueuses pensées, Miró / Love for you all, Pilar / Dolores

A fond thought from Tarragona. Aimé and Marguerite Maeght / We're spending the week drinking manzanilla and thinking of you. Affectionately, Louis Clayeux / Best regards, Giuli Maeght / Fond thoughts, Miró / Love for you all, Pilar / Dolores
[Manzanilla is a sherry.]

Fig. 85 Letter to Calder from Miró et al., 16 July 1950

50 MIRÓ, Barcelona, to CALDER, Paris [forwarded to Trêfuie, Brittany] postmarked 16 July 1950 (fig. 85)

Your panier *will arrive in Paris if Air France will take it. Laura S[weeney]. / Je t'enverrais le panier. Joan Prats / Je m'excuse d'avoir filé à l'anglaise le jour de ton vernissage mais je prenais le train à 6h[eures]. Amitiés. Bonne chance. [Josep Llorens] Artigas / Je t'embrasse bien fort, toi et tes femmes, Joan / Pensamos siempre con vosotros Pilar / [scribbled signa-ture: James Johnson Sweeney]*

Your basket will arrive in Paris if Air France will take it, Laura Sweeney / I will send you the basket, Joan Prats / I apologize for leaving without say-ing goodbye the day of your opening, but I had to catch the train at 6 o'clock. Best regards. Good luck, Josep Llorens Artigas / Much love to you and your womenfolk, Joan / We're always thinking about you, Pilar / James Johnson Sweeney
[Letter written on Barcelona restau-rant menu. The opening referred to by the ceramicist Artigas was of *Calder: Mobiles & Stabiles* at Galerie Maeght, Paris, on 30 June 1950.]

51 MIRÓ family [Carrer Folga-roles, 9], Barcelona, to CALDER family, Roxbury 22 December 1950 (fig. 86)

Joyeux Noël, Bonne année, et que la Jérusalem promise soit une Barcelone éternelle, ruisselante de soleil et de manzanilla. Très affectueusement, Pilar / Miró / Dolores Muchos besos y felicidades, M[ari]a. Dolores

Merry Christmas, happy New Year, and may the promised Jerusalem be an everlasting Barcelona, bathed in sunlight and manzanilla. Very affec-

Fig. 86 Postcard to the Calders from the Mirós, 22 December 1950

tionately, Pilar / Miró / Dolores Many kisses and best wishes, Maria Dolores
[The handwriting is Pilar Miró's. The postcard showing a menhir was an apt choice following Calder's summer trip to Brittany.]

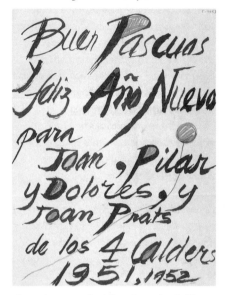

Fig. 87 Letter to the Mirós from the Calders, December 1951

52 CALDER family, Roxbury, to MIRÓ family, Barcelona postmarked December 1951 (fig. 87)

Buen Pascuas y feliz Año Nuevo para Joan, Pilar, y Dolores, y Joan Prats de los 4 Calders, 1951, 1952

Merry Christmas and happy New Year for Joan, Pilar, and Dolores, and Joan Prats from the four Calders, 1951, 1952
[Calder's greeting appears to imitate Miró's marks.]

53 Joan and Pilar MIRÓ [Carrer Folgaroles, 9], Barcelona, to Alexander and Louisa CALDER, Roxbury postmarked 1952

¡Olé! ¡Flamencos! ¿Cómo estáis? Un abrazo de Pilar / Calders! On est allé chez les escargots et on y mange que du poulet. Tout le monde est bien content, [Arnau] Puig / On

271

vous regrette beaucoup! Miró / [Arnau] Puig ne mange que de l'herbe. Affectueusement à tous [Jean] Hélion / Pegeen [Hélion]

Olé! Flamencos! How are you? A hug from Pilar / Calders! We went to eat snails but ended up having chicken. Everybody is in great form. Arnau Puig / We miss you very much! Miró / Arnau Puig is eating nothing! Love to everyone, Jean Hélion / Pegeen Hélion
[Pegeen, daughter of Peggy Guggenheim, was the very young wife of Jean Hélion. The postcard shows Los Caracoles restaurant, Barcelona. *Caracoles* refers to flamenco costume and dancing, hence the salutation.]

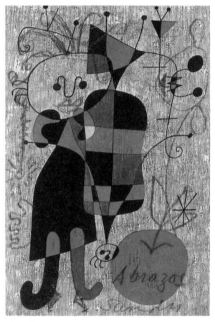

Fig. 88 Postcard to Miró from Calder et al., September 1952

54 CALDER [Berlin] to MIRÓ, Montroig
[September 1952] (fig. 88)

Abrazos, Sandy / Meilleurs souvenirs de Berlin! Will Grohmann / Greetings William M. Friedman / Gertrud Grohmann / Annemarie Zilz / voilà!
Hugs, Sandy / Best wishes from Berlin! Will Grohmann / Greetings!

William M. Friedman / Gertrud Grohmann / Annemarie Zilz / There we go!
[Image on postcard is Miró's *Painting (Figures and Dog in Front of the Sun)* 1949. Here, the card is reproduced upside down. Calder draws around the perimeter. Finally he sends an arrow into Miró's red sun and adds his greeting. Grohmann was a German critic and art historian. Gertrud was his wife.]

55 MIRÓ [Carrer Folgaroles, 9], Barcelona, to CALDER [Roxbury] 26 December 1955

Mon cher Sandy, Dolores m'a écrit qu'elle avait reçu pour moi, l'exemplaire du livre que tu as eu la gentillesse de m'expédier et que j'ai hâte de voir. Nous ne sommes pas encore fixés à Palma, en attendant à ce que la maison soit terminée. L'atelier construit d'après les plans de [Josep Lluís] Sert sera magnifique. Dolores habite déjà à Palma et a un beau garçon. Tous nos vœux de bonheur à Sandra et à son mari. J'ai été tout récemment à Paris et me suis entretenu avec les architectes de l'Unesco, ils m'ont dit que tu dois faire un grand mobile, bravo! Je dois réaliser un grand mur de 15m en céramique, en plein air. Pilar et moi t'envoyons à toi et à toute ta petite famille nos vœux les meilleurs pour 1956. Bien affectuosament, Joan

My dear Sandy, Dolores wrote to me that she had received the copy of the book that you so kindly sent for me and which I am anxious to see. We are not yet settled in Palma as we are waiting for the house to be finished. The studio, built to Sert's plans, will be magnificent. Dolores is already living in Palma and has a beautiful boy. Tell Sandra and her husband that we send our best wishes for their happiness. I was in Paris just recently and spoke with the UNESCO architects. They told me that you are going to make a large mobile. Bravo!

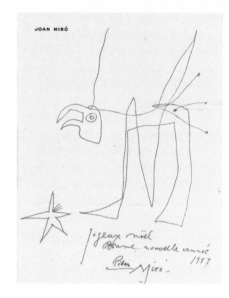

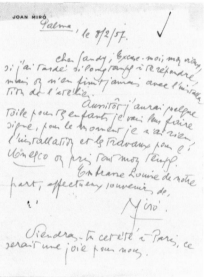

Figs. 89, 90 Letter to Calder from Miró, 8 February 1957

I have to create a large fifteen meter ceramic outdoor mural. Pilar and I send to you and to all your little family our best wishes for 1956. With great affection, Joan [*Affectuosament* demonstrates Miró's mingling of Catalan and French. For the works for UNESCO, see figs. 131, 132.]

56 MIRÓ ["Son Abrines," Calamayor, Palma] to CALDER [Roxbury] 8 February 1957 (figs. 89, 90)

Cher Sandy, Excuse-moi, mon vieux, si j'ai tardé si longtemps à te répon-

dre, mais on n'en finit jamais avec l'installation de l'atelier. Aussitôt, j'aurai quelque toile pour tes enfants, je vais leur faire signe, pour le moment je n'ai rien, l'installation et les travaux pour l'Unesco ont pris tout mon temps. Embrasse Louisa de notre part, affectueux souvenirs de, Miró [P.S.] Viendras-tu cet été à Paris, ce serait une joie pour nous. / Joyeux Noël, Bonne nouvelle année 1957, Pilar / Miró

Dear Sandy, Forgive me, my friend, for my tardy response, but the installation of the studio never ends. As soon as I have some canvas for your children, I will let them know. I have none at the moment. The installation and the UNESCO project have taken up all my time. Hug Louisa for us, fond greetings, Miró P.S. Will you come to Paris this summer? That would be a joy for us. / Merry Christmas, Happy New Year 1957, Pilar / Miró

Fig. 91 Envelope sent to Miró by Calder, 25 November 1958, Yvon Taillandier Collection

57 CALDER, Roxbury, to MIRÓ, c/o Peter Bellew, 12, rue Galilée, Paris 16ᵉ
postmarked 25 November 1958 (fig. 91)

[Calder's red arrow, a pun on "aero postale" written along its shaft, points to the stamp with Boeing's new 707. The arrow inspired Miró's painting *Friend's Message*, 1964 (Tate, London).]

58 Joan and Pilar MIRÓ, "Son Abrines," Calamayor, Palma, to CALDER, "François Premier," Saché
24 July 1960

Mon cher Sandy, Nous avons été navrés de quitter Paris sans venir vous rendre visite à la campagne. Un ami commun devait nous y emmener mais le jour qu'on avait fixé préalablement il en a été empêché par des raisons imprévues. Tu m'as dit que vous resteriez là pour assez longtemps, c'est donc entendu, quand nous reviendrons c'est avec grande joie que [nous] passerons te voir. Embrasse Louisa et les enfants de ma part. Bien cordialement, Joan / Je vous embrasse, Pilar

My dear Sandy, We were heartbroken to leave Paris without having come to visit you in the country. A mutual friend was going to take us, but on the day we had previously arranged, he was unable to do so due to unforeseen circumstances. You said that you would be staying there for quite a long time, so it's understood that when we return we will stop by to see you, with great pleasure. Give Louisa and the children a hug from me. Kind regards, Joan / Love to you all, Pilar

59 MIRÓ, "Son Abrines," Calamayor, Palma, to Alexander and Louisa CALDER, "François Premier," Saché
November 1960

Toutes nos félicitations aux parents et grands-parents. Nous vous embrassons tous, Miró

All our congratulations to the parents and grandparents. Love to all of you, Miró
[The congratulations may have been offered on the occasion of the second pregnancy of Sandra Davidson, the Calders' older daughter.]

60a CALDER, "François Premier," Saché, to Klaus PERLS, New York
November 1960 (fig. 92)

I met Miró in Dec. '29 when I called on him in his tin-arched studio in Montmartre. He showed me a large sheet of cardboard with a postcard, a cork, and a feather attached to it. I

Fig. 92 Calder's homage to Miró for Perls, November 1960

was puzzled! Then he came to see me in Montparnasse and I was on my knees, presenting my Circus. We became very good friends and attended many things together, including a gymnasium. I came to love his painting, his color, his personages, and we exchanged works. He made me a wonderful painting in 1933, and I gave him a sort of mechanized volcano, made of ebony. Gymnasium is a thing of the past, but Miró and I go on.
[They met in December 1928.]

60b MIRÓ, "Son Abrines," Calamayor, Palma, to Klaus PERLS, New York
12 November 1960 (fig. 93)

Mon vieux Sandy, ce costaud à l' / âme de rossignol qui souffle des mobiles / ce rossignol qui pose son

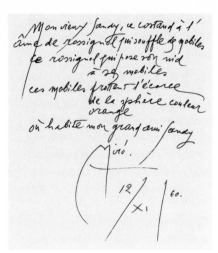

Fig. 93 Miró's homage to Calder for Perls, November 1960

nid / à ses mobiles / ces mobiles frottent l'écorce / de la sphère couleur orange / où habite mon grand ami Sandy / Miró

My old Sandy, this burly man with the / soul of a nightingale who blows mobiles / this nightingale who builds his nest / in his mobiles / these mobiles rub the skin / of the orange sphere / where my great friend Sandy lives / Miró
[Klaus Perls, Calder's New York dealer, asked both Calder and Miró to write about one another for the catalogue of the exhibition *Alexander Calder, Joan Miró* held at the Perls Galleries, New York (21 February–1 April, 1961). The artists wrote the preceding homages to one another.]

61* MIRÓ, "Son Abrines," Calamayor, Palma, to Klaus PERLS, New York
17 March 1964 (fig. 94)

You know, my dear friend, that I can't write, it's not my trade, far from it! Sometimes, when the spirit moves me, I do write poetic phrases, but this is not what you should have for a text about the first performances of Sandy's Circus in Paris. Such a thing requires a precise statement, something like the report of

a President's press conference. But I can tell you about a related event, moving in its simplicity and humanity.

Thirty-five years ago (that's an impressive number of years) Sandy and Louisa came to see me at Montroig, where I conceived The Farm; *where the trees, the mountains, the sky, the house, the vine-*

Fig. 94 Miró's foreword to Calder's Circus drawings portfolio, with a dedication and doodles by Calder

yards, have remained the same. There where the mules have always eaten carobs, and where we have the same warming red wine. Well then, one day I invited all my neighbors, the farmers and workmen of the district, to see the Circus that Calder had brought. Everyone was transfixed and totally overwhelmed by it. After the performance, while we were all having the traditional glass of red wine together, I realized what a festive occasion this had been for them.

Two months ago (a less impressive length of time) I saw on the screen of a movie theater in Montparnasse a filmed performance of the Circus; Sandy was just the same, and Louisa was as beautiful as a classic statue. But the spectators squirmed in their seats, bored, emotionless. They were cold, pseudointellectuals or else young girls who had come to pet in

the dark. How different from my country folk of The Farm, *that beloved farm where Pilar and I shared a glass of red wine with Hemingway and his wife a year before the Calder Circus.*

If this text hasn't disappointed you too much, you are welcome to publish it.
[Perls asked Miró to write a foreword to a Calder portfolio of circus drawings presented at Perls Galleries, New York, 13 October–14 November 1964. The original text from which the English translation was made is not known. Miró was mistaken about the number of years that had elapsed. See *Correspondence 8.*]

62 Joan and Pilar MIRÓ [Palma] to CALDER [Roxbury]
ca. January 1966

Joan Miró, Pilar Juncosa de Miró vous souhaitent de joyeuses Fêtes et une bonne année 1966 / Miró

Joan Miró and Pilar Juncosa de Miró wish you Happy Holidays and a happy New Year for 1966 / Miró
[The Mirós' names are preprinted.]

63 MIRÓ, "Son Abrines," Calamayor, Palma, to Alexander and Louisa CALDER ["François Premier," Saché]
10 February 1966

Chers Sandy et Louisa, Votre lettre nous a beaucoup touché. Dolores va bien, mais doit encore patienter pour quelques mois, la pauvre. Ça a été terrible, heureusement qu'elle n'était dans la voiture qu'avec sa belle-mère. Sa vie et sa jambe furent en péril, on est maintenant rassuré. Pilar et moi vous embrassons, Joan [P.S.] Je viens de rentrer de Saint-Paul. Ton stabile est magnifique. [Aimé] Maeght m'a beaucoup parlé de ta prochaine exposition, qui sera, paraît-il, très belle.

Dear Sandy and Louisa, We were very touched by your letter. Dolores is doing well but must be patient for some months, poor thing. It was dreadful. Luckily, only she and her mother-in-law were in the car. She was in danger of losing her leg and of dying, but we are now reassured. Love from Pilar and me, Joan.
P.S. I just returned from Saint-Paul. Your stabile is magnificent. Aimé Maeght told me at length about your next exhibition, which, it appears, will be very beautiful.

64 Joan and Pilar MIRÓ, Pont-Royal Hôtel, 2, rue Montalembert, Paris 7ᵉ, to Alexander and Louisa Calder ["Le Carroi," Saché] [ca. 1974]

Nous pensons beaucoup à vous deux, Louisa et Sandy. Malheureusement nous devons déjà partir et nous n'aurons pas le temps de passer vous voir, comme c'était notre intention, à notre prochain voyage il faut absolument que nous fassions un saut à Saché. Nous vous embrassons avec toute notre affection, Pilar, Joan

We think about you both a lot, Louisa and Sandy. Unfortunately, we have to leave already and we won't have time to come and see you, as had been our intention. On our next trip, we will absolutely have to pop over to see you at Saché. We send you all our love, Pilar, Joan
[Miró never made the promised trip to Saché.]

65 MIRÓ ["Son Abrines," Calamayor, Palma] to CALDER ["Le Carroi," Saché] 19 April 1976

Mon très cher Sandy, Avec Pilar, nous parlons souvent de toi et de ta famille et nous savons par des amis que vous allez tous très bien. Nous

comptons aller à Paris en mai, cette fois il faudra absolument que nous fassions un saut chez toi pour vous voir. La Fondation ouvre officiellement ses portes en juin, tu recevras en son temps une invitation, tu peux t'imaginer la joie que tous tes amis auraient si tu étais parmi nous à cette occasion. Le délais d'exportation pour la magnifique sculpture de toi qui est exposée à Barcelone, en dépôt, est prêt à expirer et on doit donc la renvoyer chez toi, ce qui est dramatique. J'ose te demander d'en faire don à la Fondation, ce qui serait sensationnel. Je te donnerais en échange, une grande toile que je ferais en pensant à ton œuvre et en hommage à notre vieille et profonde amitié. Ecris-moi un mot, pour régler ces démarches burocratiques. Je t'embrasse de tout cœur, Joan

My very dear Sandy, Pilar and I often talk about you and your family and know through friends that you are all doing very well. We are planning to go to Paris in May. This time we will absolutely have to get over to your place to see you. The Foundation opens its doors officially in June, you will receive an invitation in due course. You can imagine how overjoyed all of your friends would be if you were to be with us on that occasion. The deadline for exporting your magnificent sculpture on display in Barcelona is about to expire and we must send it home to you, which is tragic. I am taking the liberty of asking you to donate it to the Foundation. That would be fantastic. In exchange, I would give you a large canvas that I would paint while thinking about your work and as a tribute to our long, deep friendship. Drop me a note so that we can take care of these bureaucratic arrangements. With all my heartfelt love, Joan
[Calder's sculpture in question was *Four Wings*.]

66* CALDER, "Le Carroi," Saché, to MIRÓ ["Son Abrines," Calamayor, Palma] 23 April 1976

Cher Joan, Vous pouvez la garder, la sculpture, et je serais très content d'avoir une toile de toi en échange. Ce n'est pas que ça nous manque, parce que nous avons 4 grandes toiles de toi ici – et 2 grandes toiles de toi à Roxbury, et qq. [quelques] petites. Beaucoup de choses à Toi et à Pilar, et à Dolores et les gosses, Sandy

Dear Joan, You can keep the sculpture, and I would be very happy to have a canvas of yours in exchange. It's not that we have a shortage of them, because we have four big canvases by you here and two big ones by you at Roxbury and some small ones. Best wishes to you and Pilar and Dolores and the kids, Sandy
[Miró had given Calder two significant paintings, and over the years Calder purchased six other Miró paintings from the 1920s and 1930s. The work Miró painted specifically for Calder was *Figure with Three Strands of Hair, Birds, Constellations*, 1976.]

67* Louisa CALDER [New York] to Joan and Pilar MIRÓ, "Son Abrines," Calamayor, Palma

Cher Miró, chère Pilar, Merci de votre gentille lettre. Je reste ici à New York pour le moment. Je ne sais pas ce que je vais faire. Much love to all the family, Louisa

Dear Miró, dear Pilar, Thank you for your kind letter. I am staying here in New York for the time being. I don't know what I am going to do. Much love to all the family, Louisa.
[This letter was written after Calder's death on 11 November 1976.]

275

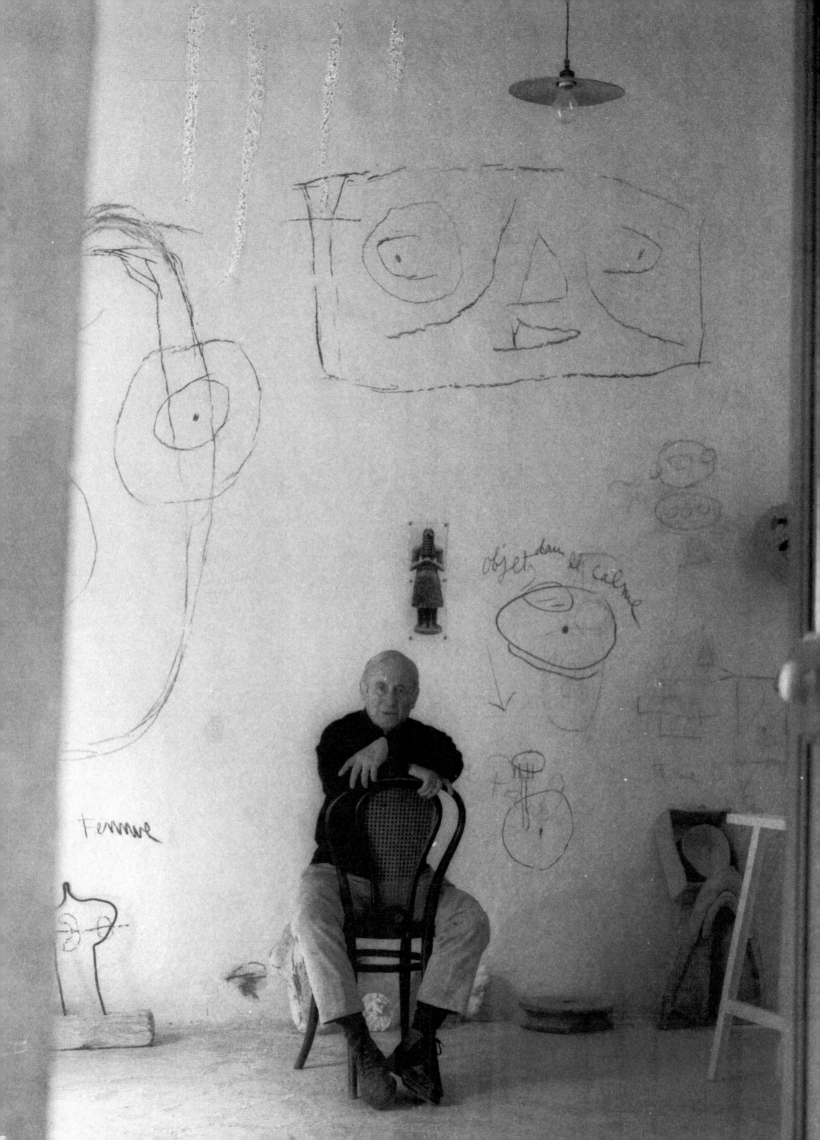

CHRONOLOGY

THE INTERSECTING LIVES OF
ALEXANDER CALDER AND JOAN MIRÓ

Susan Behrends Frank

1893

Joan Miró Ferrà is born on 20 April at Passatge del Crèdit, 4, Barcelona. His father, Miquel Miró Adzerias, is a goldsmith and watchmaker. His mother, Dolores Ferrà, is the daughter of a cabinetmaker in Palma de Mallorca.

1898

Alexander (Sandy) Calder is born on 22 July in Lawnton, Pennsylvania, the second child and only son of the sculptor Alexander Stirling Calder and the painter Nanette Lederer Calder, and the grandson of Alexander Milne Calder, also a sculptor.

1910–1912

Miró works as a bookkeeper in Barcelona. In 1911 he falls ill. While recovering at his parents' recently purchased farm (1910) in Montroig, he decides to become a painter.

1919

Calder graduates from the Stevens Institute of Technology in Hoboken, New Jersey, with a degree in mechanical engineering. He spends subsequent years in a variety of jobs.

1920

Miró makes his first trip to Paris in late February and stays for nearly four months, attending the Dada Festival at the Salle Gaveau on 26 May. In mid-June he returns to Barcelona and then to the farm in Montroig. This marks the start of an annual cycle of winter/spring months in Paris and summer/fall months in Spain that will continue through 1931.

1921

Miró has his first one-artist exhibition in Paris at the Galerie La Licorne (29 April–14 May), which includes *Horse, Pipe, and Red Flower,* 1920 (cat. 80). Conservative critics find promise in his work.

1923

Calder moves to New York and commits himself to painting, beginning classes at the Art Students League in September.

1924

Miró is in Paris from March to late June. André Breton's *First Manifesto of Surrealism* is published on 15 October, and on 1 December a new review entitled *La Révolution surréaliste* appears.

1925

Miró is in Paris from mid-January to early July. He meets Breton who purchases *The Gentleman,* 1924 (cat. 82), and *Catalan Landscape (The Hunter),* 1923–1924 (Dupin 90), that spring, the first of many works by Miró that Breton will own. From 12–27 June Galerie Pierre features Miró in a one-artist exhibition. It is Miró's first show at Galerie Pierre. The surrealist Benjamin Péret writes the catalogue preface and the design of the invitation includes the signatures of twenty-four artists and writers associated with the surrealists. Miró's recent work is featured, such as *Carnival of Harlequin,* 1924–1925 (cat. 83), *The Gentleman,* and *The Toys,* 1924 (cat. 81). The conservative critics are unimpressed by his new work.

By early July Miró is back in Spain where he begins working on his cycle of "dream" paintings, including *Birth of the World* (cat. 85). He returns to Paris for a few weeks in the fall, attending the opening of the first surrealist painting exhibition at Galerie Pierre (14–25 November), where *Carnival of Harlequin* is included alongside work by such artists as Jean Arp, Giorgio de Chirico, Max Ernst, Paul Klee, Man Ray, André Masson, Pablo Picasso, and Pierre Roy.

Calder spends the year in New York. He provides illustrations of the

Ringling Bros. and Barnum & Bailey Circus for the *National Police Gazette* and sketches the circus at their winter grounds in Florida; he also makes his first wire sculpture that fall.

1926

Miró returns to Paris in February. During April Miró and Ernst work on Serge Diaghilev's ballet *Romeo and Juliet* with the Ballets Russes in Monte Carlo. By 8 May Miró is living and working in Montmartre, in a studio at 22, rue Tourlaque, where Ernst and Arp are his neighbors. Miró returns to Spain after his father's death in Montroig on 9 July and spends the rest of the year in Montroig and Barcelona working on new paintings.

At the end of the year (19 November 1926–1 January 1927) Miró's work is shown for the first time in the United States, in the Société Anonyme's *International Exhibition of Modern Art.*

Fig. 95 Alexander Calder performing his Circus, 1929, Paris, photo Sasha Stone

Calder sails from New York for Europe, arriving in Paris 24 July. He establishes his first Paris studio at 22, rue Daguerre in Montparnasse and experiments with new materials and ideas. He makes his first sculptures consisting entirely of wire, including *Josephine Baker.* He also

begins making toys of wood, wire, and fabric that will become the *Cirque Calder*. He gives his first Circus performance during the fall and continues to give these performances periodically during the rest of his life.

1927

Miró arrives in Paris around 1 January with his new work. In Paris he meets the American art critic James Johnson Sweeney. He works on new paintings, including the Circus Horse series (cats. 91, 92), in preparation for a major exhibition the next spring at Galerie Georges Bernheim (1–15 May 1928). Miró is back in Spain by early July, principally in Montroig.

Calder stays in Paris until the fall when he returns to the United States to work with the Gould Manufacturing Company in Oshkosh, Wisconsin, designing a series of animal "Action Toys." In August he exhibits his animated toys in Paris at Galeries Jacques Seligmann. Paul Fratellini, of the famous *Cirque Fratellini* in Paris, sees Calder's Circus and admires the small-scale rubber and wire dog in the Circus known as *Miss Tamara* (see *Miss Tamara Model for Dog*, cat. 2). Calder creates a larger version of *Miss Tamara* for Paul Fratellini's brother Albert (fig. 96).

Fig. 96 Left to right: The Fratellini Brothers, François, Albert, and Paul, with Alexander Calder's rubber dog, *Miss Tamara*, Paris, April 1931, photo Thérèse Bonney

1928

Miró returns to Paris on 19 February. He attends the opening of his exhibition at Galerie Georges Bernheim. Organized by Pierre Loeb, the exhibition is a critical and commercial success, with all forty-one works being sold. In Paris Miró works on his first collage-objects, all known as Spanish Dancer. He deposits these works with Loeb before leaving for Barcelona on 5 June. Over the summer Loeb gives two of these collages to the prominent surrealists Louis Aragon and Breton. From 9 July until the Christmas holidays, Miró is in Spain, principally in Montroig.

Calder is in the United States until late October. He has his first solo exhibition of wire sculpture at the Weyhe Gallery, New York (20 February–3 March), and spends the summer working on wood and wire sculptures of animals and circus figures.

Calder returns to Paris around 3 November and rents a studio at 7, rue Cels. On 10 December Calder sends a formal letter to Miró in Montroig suggesting they meet when Miró returns to Paris, and uses the name of Elizabeth (Babe) Hawes of New York as his means of introduction to Miró (fig. 68).

Miró returns to Paris by 26 December and Calder meets him for the first time during a visit to Miró's Montmartre studio in the last days of 1928.

1929

Calder and Miró are together in Paris for the first six months of the year. They share common friends at La Coupole Bar. In January (18–28) Calder exhibits his large-scale wire sculptures *Romulus and Remus* and *Spring* (cat. 9) at the Salon de la Société des Artistes Indépendants, and at the end of January an exhibition of his wood and wire sculptures

opens at Galerie Billiet-Pierre Vorms (25 January–7 February).

On 12 February, the surrealists Breton, Aragon, and Raymond Queneau send out a letter requesting a statement from the recipients about their ideological position and view of collective action. Miró gives an equivocal response that manages, without offending Breton, to make clear his aversion to regimented group activities.

SPRING

Before 15 March Miró attends his first performance of Calder's Circus at Calder's rue Cels studio (figs. 95, 97). The American A. E. (Albert Eugene) Gallatin buys three Miró paintings from Pierre Loeb.

Fig. 97 Alexander Calder's *Strong Man* from his Circus, Paris, 1931, photo Brassaï

In May, Pathé Cinema produces a short film on Calder showing him at work in the rue Cels studio with Kiki de Montparnasse posing for a wire portrait (see *Kiki de Montparnasse*, cat. 13, fig. 59).

SUMMER

Calder leaves on 22 June for New York, taking the Circus with him. He tells Miró in a postcard that he is going to "carry him off to America."

Miró leaves Paris for Spain after 25 June.

FALL

Miró marries Pilar Juncosa on 12 October in Palma de Mallorca and by 22 November the newlyweds are in Paris. They move into an apartment at 3, rue François-Mouthon, where Miró uses one room as a studio. He gives up the studio at 22, rue Tourlaque.

WINTER

Calder creates his first mechanized sculpture, *Goldfish Bowl*, 1929 (cat. 12), as a Christmas present for his mother.

1930

After Christmas in Barcelona, Miró and Pilar return to 3, rue François-Mouthon, Paris, in early January. Miró works on a series of large canvases, including *Painting*, 1930 (cat. 99).

SPRING

In March Calder sails from New York for Europe on a Spanish freighter. In Barcelona, Calder searches for Miró, who is in Paris. Calder takes the train to Paris and sets up a studio at 7, villa Brune. He sees Miró before the latter returns to Spain in mid-May. Calder may very well see Miró's collages at a surrealist group exhibition entitled *La Peinture au défi* at Galerie Goemans (28 March–12 April). Miró is particularly enthusiastic about this exhibition and the catalogue essay written by Aragon.

Before leaving Paris Miró meets Pierre Matisse, son of the painter Henri Matisse.

Miró and Pilar leave for Spain before 14 May.

SUMMER

Miró's only child, Maria Dolores, is born 17 July in Barcelona. Miró and his family remain in Spain throughout the rest of the year.

FALL

Calder gives several performances of the Circus in the fall in his studio. Attendees include Le Corbusier, Fernand Léger, Piet Mondrian, the critic Carl Einstein, the Viennese architect Frederick Kiesler, and Theo van Doesburg. William (Binks) Einstein, an American artist from St. Louis, is Calder's *chef d'orchestre* at these performances.

In October Calder visits Mondrian's studio. For the next three weeks Calder makes geometric non-objective paintings and then begins making abstract wire sculptures, for example *Sphérique I*, 1930.

From mid-August to late November Miró works on four wood constructions, his first three-dimensional works, including *Construction*, 1930 (cat. 98). They are fabricated by a carpenter to Miró's specifications.[1]

1931

In early January the Mirós return to Paris to live at 3, rue François-Mouthon. In an interview with the Madrid journalist Francisco Melgar, Miró enumerates his differences with the surrealists and affirms his desire to destroy the rules of painting.[2]

On 17 January Calder marries Louisa James in Concord, Massachusetts. Five days later they sail for Europe, taking up residence in Paris at Calder's studio at 7, villa Brune.

Calder and Miró and their new families are together in Paris from late January to early June (fig. 98).

Fig. 98 Joan Miró with his wife, Pilar, and their baby daughter, Maria Dolores (born 17 July 1930), Paris, 15 March 1931

SPRING

Calder has his first one-artist exhibition of abstract wire sculpture at Galerie Percier, Paris (27 April–9 May), *Alexander Calder: Volumes-Vecteurs-Densités; Dessins-Portraits*. Calder's new abstract wire sculptures, such as *Croisière*, 1931, and *Sphérique I*, 1930, are in this show, as well as wire portraits of his friends. Among the featured wire portraits are those of *Joan Miró, Fernand Léger, Amédée Ozenfant*, and *Medusa* [Louisa] (see cats. 15, 14, 16, fig. 60).

At the opening Calder meets Picasso. Miró likely also attends. Léger's catalogue introduction connects Calder's work to Mondrian, Marcel Duchamp, Constantin Brancusi, and Arp, but not to Miró.

During April Miró completes four works on canvas entitled *Head of a Man* (cats. 100, 101). Each relies on the same circular line pattern to describe the head, but is unique in its orientation and color patterns.

On 2 May the Calders move to a rented house at 14, rue de la Colonie.

SUMMER

The Mirós leave Paris in early June for Barcelona and Palma, and in mid-to-late July for Montroig, where they stay until late November.

There Miró begins two different projects – a series of paintings on Ingres paper that emphasizes line and color as independent elements, and a group of ten painting-objects of relatively small scale incorporating various found materials, such as *Painting-Object*, 1931 (cat. 102).

In June members of the Abstraction-Création group, founded in February, visit Calder's studio to see his work and invite him to join the group, which includes Arp, Jean Hélion, Mondrian, Robert Delaunay, and Antoine Pevsner.[3] Before

mid-July, Calder is inspired by the kinetic energy of the family dog, Feathers, to make wire sculptures with moving armatures, for example *Mobile au plomb* (cat. 18, fig. 99). He writes enthusiastically about them to his parents on 12 July.[4]

From August to mid-September Calder and Louisa vacation in Palma de Mallorca, where they visit Pilar Miró's family. The Calders spend a month in the small coastal village of Paguera.

FALL
After returning to Paris in mid-September, Calder creates objects that involve motion, relying on cranks and electric motors. Duchamp suggests that the new work should be called "mobiles," a pun in French that incorporates both motion and motive. Not long after (February), Arp suggests the word "stabiles" for Calder's non-motorized constructions exhibited earlier at Galerie Percier. Around 1 October, Calder sends Miró a postcard inviting him to attend the Circus later that month and to see his new "mobile" work.

WINTER
After 27 November, to about 24 December, Miró is in Paris at 3, rue François-Mouthon. He meets with Calder and encourages him to see his exhibition of painting-objects and 1930 wood constructions at Galerie Pierre (18 December 1931–8 January 1932). Not one painting is included in this show. The critic [Estratios] Tériade, in an article in *L'Intransigeant* (21 December 1931), likens Miró's objects to toys that can elicit the childlike in the viewer.[5] Léonide Massine, choreographer of the ballets *Parade* (1917) and *Mercure* (1924), sees the exhibition. He is intrigued by the painting-objects and their relationship to toys and play.[6]

Miró leaves Paris before 24 December, returning to Barcelona for Christmas. In January financial difficulties force him to give up the apartment in Paris.

1932
Miró, Pilar, and the baby now live year-round in Spain. Miró uses one room in his mother's apartment in Barcelona as his studio. In January he is invited by Boris Kochno and Massine to design the set, stage curtain, costumes, and props for *Jeux d'enfants*, the first production of the new Ballets Russes de Monte Carlo. Calder writes to his parents about Miró's work for the Ballets Russes, expressing his own desire to work on a ballet project (figs. 6, 9).[7]

Loeb of Galerie Pierre is having financial difficulties and is unable to maintain his stable of artists. On 14 February, Miró writes to Matisse, asking for a show.[8]

On 14 February Miró leaves Barcelona for Monte Carlo.

Jeux d'enfants opens 14 April at the Théâtre de Monte Carlo and is well received. Miró returns to Barcelona after 15 April.

SPRING
In April the Calders leave Paris for New York, renting their house (14, rue de la Colonie) to Gabrielle Picabia, Francis Picabia's first wife. On 2 April Calder writes to Miró offering him use of the Paris house.

Calder has an exhibition (12 May–11 June) at the Julien Levy Gallery, New York, *Calder: Mobiles, Abstract Sculptures*. A review of the show in the *Worcester Times* (21 May) compares Calder's wire work to Miró's paintings and the work of other surrealist abstractionists.[9] This is the first review that recognizes an affinity between the two artists.

SUMMER
Miró attends the premiere of *Jeux d'enfants* at the Théâtre des Champs-Elysées in Paris on 11 June and returns to Barcelona around 20 June.

Calder and Louisa are visiting family in the United States and write to Miró on 20 June and again on 19 July of their plan for a September visit with Miró in Montroig.

Miró is in Montroig by 8 July and begins a series of twelve small paintings on wood, including *Flame in Space and Naked Woman* (cat. 103) and *Figure* (cat. 104).

FALL
The Calders arrive in Barcelona with their dog Feathers, around 9 September. They spend time in the city with Miró's friends, the Catalan critic Sebastià Gasch and the hatmaker Joan Prats, a boyhood friend. On 12 September the Calders take a train to Montroig. Miró writes to Gasch that day thanking him for taking care of the Calders and inviting him to the farm for a Circus performance: "We will wait for you to perform the Circus, so you can have an idea and it could be a scoop for an interesting article."[10]

Fig. 99 Interior of Joan Prats' apartment with lithographs from Joan Miró's Barcelona series, 1944, and Alexander Calder's *Mobile au plomb* (cat. 18), on the chest, Barcelona, ca. 1970–1971, photo Francesc Català-Roca

Miró takes the Calders for day trips to the coastal town of Cambrils and to Tarragona. Calder produces a series of objects during the visit, including tin cans transformed into ashtrays.[11]

On 19 September Calder performs the Circus at Miró's farm for the Mirós, their farmhands, and their neighbors. Gasch attends. Louisa runs the gramophone. Miró tells Calder the next day that his favorite part is the bits of floating paper, referring to the Circus singer to whom the fluttering doves "flew" by traversing down the wires to her shoulders.[12]

The Calders return to Barcelona before 29 September. Calder meets with Amics de l'Art Nou (ADLAN), a group organized by Prats to promote avant-garde art. At ADLAN's initiative, Calder performs the Circus in the hall of the Grup d'Arquitectes i Tècnics Catalans per al Progrés de l'Arquitectura Contemporània (GATCPAC) to a select group of Barcelona's intellectuals and sophisticated bourgeoisie. A Calder mobile is exhibited in the display case at the hall.[13] Gasch writes a lengthy review of Calder for *Mirador* (Barcelona, 29 September 1932): "Calder's circus excited us deeply. Just like the big child of a painter Miró and the fifty peasants from Montroig in front of whom Calder recently gave one of his representations he has created a definitive synthesis of the circus ... Calder's circus figurines ... are a pure sculptural delight."

In late September or early October the Calders return by train to Paris.

On 1–25 November, Miró has his first one-artist exhibition at the Pierre Matisse Gallery in New York, with works on paper lent by Galerie Pierre.

Sometime before 13 December, Miró goes to Paris with the new series of small paintings on wood and the objects and stays with the Calders.[14] On 13-16 December Miró has a one-artist exhibition of his recent paintings and objects at Galerie Pierre Colle (Paris). Calder and Miró discuss the possibility of making an "object" together.[15] During this visit Miró suggests that Calder have a show of his drawings in Barcelona and give performances of the Circus there.

Miró returns to Barcelona for the holidays.

1933
Calder exhibits in Paris at the *Abstraction-Création* exhibition (19–31 January). Miró arranges for Calder to receive an invitation from Spanish writer Ramón Gómez de la Serna (renowned in Paris and Spain for his writings on the circus) to perform the Circus in Madrid for the Sociedad de Cursos y Conferencias at the Residencia de Estudiantes.[16]

On 29 January Calder and Louisa leave for Madrid. In February works by Calder are exhibited at the Sociedad de Cursos y Conferencias at the Residencia de Estudiantes, Madrid.[17] Calder performs his Circus at the Residencia on 1 and 2 February for the society's members. It is advertised as "The Smallest Circus in the World:" "He [Calder] is a poet who has converted his metaphors into toys that are somewhere between the real and the unreal, ... simple shells of suggestion, linear machinery for evocative fantasy."[18]

Calder exhibits drawings and sculpture at Galería Syra in Barcelona in February. His performances of the Circus in Barcelona on 11 and 12 February are reviewed in the local newspaper by Sebastià Gasch (*La Publicitat*, 19 February).[19] Miró

likely attends all the Barcelona events. Calder renews his acquaintance with Prats.

From February [16] to early March the Calders travel from Barcelona to Rome to visit Louisa's godmother.[20] In March Calder writes to Miró, noting similarities between Miró's paintings with blue backgrounds, such as *Painting (Personage, The Fratellini Brothers)*, 1927 (cat. 96), and Italian frescoes.

SPRING
On 3 March Miró is in Barcelona and completes the first large-scale painting based on the earliest of the eighteen collages he has produced between 26 January and 11 February. The paintings are executed in the order of the collages, which Miró attached to the walls of his studio for inspiration (see cats. 107–112).[21]

The Calders return to their house in Paris on 10 March.

Calder exhibits at Galerie Pierre Colle in Paris (16–18 May), *Présentation des œuvres récentes de Calder*. Possibly accompanied by Arp, Calder meets Salvador Dalí there shortly before the show opens.[22]

SUMMER
Miró exhibits four works, including painting-objects from 1931, in the *Exposition surréaliste* at Galerie Pierre Colle (7–18 June). The surrealist object (aka the object of symbolic function) is in great evidence in this exhibition.

Hélion organizes a group exhibition, *Arp, Calder, Hélion, Miró, Pevsner, et* [Kurt] *Séligmann*, at Galerie Pierre, 9–24 June. Hélion, a close friend of Pierre Loeb, has elicited Miró's participation with a letter on 14 April: "Do you remember what I asked you last winter, if you would agree to exhibit with four or five friends? ... It seems we six can ...

make a hole in the mediocrity of this season....Calder told me...that you wish to exhibit your more recent work; we hope for that...."[23] It is the first time Calder and Miró are in an exhibition together and the first time Miró has exhibited with artists affiliated with Abstraction-Création. Calder exhibits *Object with Red Discs*, 1931, and *Cône d'ébène*, 1933 (cat. 21), while Miró exhibits a collage and a painting, *Cloud and Birds*, 1927 (cat. 94). The catalogue is written by Anatole Jakovski. Calder meets Sweeney at the exhibition.

On 13 June, in Barcelona, Miró finishes the last of eighteen paintings based on the series of collages. By 22 June he is in Paris, bringing with him these new paintings in order to arrange for their exhibition in the fall. He stays with the Calders, who are about to move back to the United States. They have decided to give up their lease and leave Paris at the end of June. Miró gives Calder a large painting (cat. 113) and signs it on the back: "à Louisa et Sandy Calder, / avec ma plus affectueuse amitié. / Miró. / Paris 24 Juin 1933."[24] Calder gives Miró "a kind of mechanized volcano, made of ebony."[25] This is the first known exchange of gifts between the two artists.

Before leaving Paris the Calders meet the architect Paul Nelson and his wife Francine whom they will meet again in New York in 1936. Accompanied by Hélion, the Calders return to New York in July, taking Miró's painting with them. The Calders search for a permanent home. In August they purchase an eighteenth-century farmhouse in Roxbury, Connecticut.

Miró returns to Palma in early July knowing that Christian Zervos wants to devote an entire issue of *Cahiers d'art* to him. During the summer Miró works on a multipanel mural for Pierre Loeb's apartment

that may be intended for the Loeb nursery. It is conceived as a continuous frieze of four long panels (*Murals I-II-III*, 1933 cat. 114a–c, figs. 30–32).[26]

FALL / WINTER

In September Calder begins converting the Roxbury farmhouse into usable living space and the icehouse into a dirt-floored studio.

Miró works in Montroig until mid-October when he and Pilar return to Barcelona. He goes to Paris for a few weeks for the opening of his one-artist exhibition, organized by Loeb, at Galerie Georges Bernheim (30 October–13 November). The entire series of eighteen large paintings based on collages is exhibited. On 5 November Miró writes to Matisse in New York about his exhibition at Georges Bernheim and his enthusiasm about Matisse's intention to organize a similar exhibition in New York. Miró exhibits with the surrealists at the Salon des Surindépendants (27 October–26 November) and probably attends the opening. Wassily Kandinsky is the guest of honor. After 9 November Miró is in Barcelona with his family.

On 15 November Calder receives a wire from Massine of the Ballets Russes de Monte Carlo asking him to come to London at his own expense to "bolster up a ballet which had been very badly done" by someone else.[27] He writes Miró a postcard that same day mentioning the telegram from Massine. On 31 December Miró advises Calder not to work for them under such compromised circumstances. Calder decides not to go to London.

Miró's second one-artist exhibition at the Pierre Matisse Gallery in New York opens 29 December (to 18 January 1934) (figs. 14, 26). This is the American debut of Miró's small paintings on wood from 1932

(such as *Flame in Space and Naked Woman*, cat. 103 and *Figure*, cat. 104) and his large 1933 paintings derived from collage (cats. 107–112). Miró writes to Matisse on 7 February 1934 that he is pleased with the exhibition and the catalogue but would have preferred the title *Painting* instead of *Composition* (which evokes abstract things in a dogmatic or superficial sense). Miró concludes by telling Matisse: "Calder is a very nice fellow and a friend who I like a lot. You should see what he's doing."[28]

1934

Miró is in Barcelona for the first two months of the year, living and working in his mother's apartment. Sometime during the year he sends Calder a small drawing (fig. 100).

Fig. 100 Joan Miró, *Untitled*, 1934, pencil, ink, and oil on corrugated cardboard, 30.5 x 30.5 cm (12 x 12 in.), private collection; gift to Alexander Calder in 1934

SPRING

In March Alfred H. Barr Jr. purchases Calder's motorized mobile, *A Universe*, for the Museum of Modern Art (MoMA), New York (from the *First Municipal Art Exhibition*, Rockefeller Center). Calder, having seen Miró's recent exhibition at the Pierre Matisse Gallery, approaches Matisse about an exhibition and finds him receptive.[29] On 23 March Calder writes to Miró in Barcelona that he will be exhibiting with Matisse in April and will send photos (fig. 74).

Calder has his first exhibition at the Pierre Matisse Gallery, *Mobiles by Alexander Calder* (6–28 April). Sweeney writes the preface to the catalogue. Most of the work in the show dates from the previous winter and includes the motorized *A Universe*, purchased by Barr a month earlier for MoMA. The show includes both wind-driven works, like *Object with Red Discs*, and motorized works.

Miró signs his first contract with Pierre Matisse on 1 April. Matisse will pay Miró a monthly stipend and will receive one-half of Miró's work. Pierre Loeb continues to be Miró's agent in France.

Around 2 May Miró spends two days in Paris, probably related to his exhibition at Galerie des Cahiers d'Art on 3–19 May. *Cahiers d'art* (under Zervos) publishes an entire issue (nos. 1–4, 1934) devoted to Miró. It serves as the catalogue to the exhibition. Miró designs two pochoir prints for the review and executes one of them as a separate painting (cat. 105).

SUMMER

On 12 July Calder writes to Miró, telling him he is studying Spanish.

Calder and Louisa spend the summer in Roxbury where Calder experiments with open "frames" and constructs his first outdoor sculptures. He writes to Sweeney on 27 July asking for the address of Henry McBride (the first American critic to appreciate and champion Miró's work, as early as December 1928), to give to Miró.[30]

The Abstraction-Création group falls apart in Paris because of differences among the members. Calder writes to Sweeney on 11 August that he will get out, too.[31]

FALL

Louisa is pregnant, and sometime before 20 September Calder takes her to Concord, Massachusetts, to stay with her parents while he remains in Roxbury and shuttles back and forth to Concord. By 22 September Calder has been to the Wadsworth Atheneum in Hartford, Connecticut, and has seen the museum's new purchase – Miró's *Painting*, one of the 1933 series of large works inspired by the parallel series of collages. The Wadsworth Atheneum is the first museum to purchase work by Miró. Calder gives a playful description of it in a postcard to Sweeney: "The Hartford museum has a swell big Miró dark gray with brilliant spots of white, and a Mexican Sombrero drawn in black line in lower left."[32]

On 6 October a general strike is declared in Spain by anti-fascist leaders and Catalan separatists invite the anti-fascists to establish a provisional government in Barcelona. The nationalists ruthlessly suppress the attempted revolution. In response, Miró works from October to mid-November on a series of fifteen large pastels of isolated, brutalized figures, his "Peintures sauvages."

By 11 November Miró returns to Barcelona from Montroig; around 25 November he leaves with Pilar on a brief trip to Paris to divide his new work between the dealers Loeb and Matisse. He sees Sweeney a couple of times and is able to show him his new work.[33] He returns to Barcelona in December.

WINTER

On 17 December Miró writes to Matisse from Barcelona, notifying him that he has given one of the new "Peintures sauvages" to Breton because it seemed important to remain on good terms with Breton as "the Surrealists have become *official personalities* in Paris."[34]

1935

Miró lives in Barcelona until mid-June. He works on a group of new paintings on uniform cardboard panels, completing *Portrait of a Young Girl* (cat. 115) on 1 February.

Miró has a one-artist exhibition at the Pierre Matisse Gallery, New York (10 January–9 February), which includes the large "Peintures sauvages" pastels. On the second day of the show, A. E. Gallatin acquires Miró's *Painting*, 1933 (cat. 107).

Fig. 101 Hans Erni in his studio in Lucerne, ca. 1943, with Alexander Calder's mobile (cat. 22), which Erni received as a gift in 1935; the mobile was exhibited in *Thèse, Antithèse, Synthèse* (Lucerne, 1935), photo Hans Erni

SPRING

Calder and Miró are included in a large group exhibition at the Kunstmuseum Luzern (Switzerland), *Thèse, Antithèse, Synthèse* (24 February–31 March), contrasting cubism and abstraction with dada and surrealism. This is the second exhibition to include both artists.

The Calders' first daughter, Sandra, is born on 20 April, Miró's birthday. By early May the Calder family returns to Roxbury.

SUMMER

Miró is in Paris before 18 June, bringing with him his recent paintings on cardboard. He has a one-artist exhibition of the new work at Galerie Pierre (2–20 July). Accompanied by the architect Josep Lluís Sert, he visits Kandinsky.

Miró is back in Montroig by 12 July. He sends Calder yellow shirts (one for Sweeney) and a Spanish grammar book to encourage Calder's practice of the language.[35]

On 10 November, Sweeney writes to Miró, thanking him for the shirt and mentioning that he has seen Miró's work at Galerie Pierre and likes it very much.[36]

FALL
Miró returns to Barcelona in late October from Montroig.

Calder is included in the *Abstract Art* exhibition at the Wadsworth Atheneum in Hartford, Connecticut (22 October–17 November). Calder's *Little Blue Panel*, 1934 (cat. 23, fig. 102), is in the exhibition and is purchased by the Atheneum.

On 13 November Calder, Léger, the collector Gallatin, and others send Miró a postcard expressing "Health and friendship!"

Sometime after 16 November Miró goes to Prague for the first time for an international group exhibition (29 November–2 January 1936). One of Miró's 1933 paintings based on collage (cat. 109) is purchased by the collection of the Association of Friends of the Modern Gallery

Fig. 102 Left to right: Fernand Léger, Louisa Calder, Mme Simone Herman, and Alexander Calder in the Avery Court, Wadsworth Atheneum, Hartford, Connecticut, December 1935; Calder's *Little Blue Panel* (cat. 23) is visible on far right

in Prague. Miró writes to Calder, updating him about this trip and expresses an interest in Calder's current work.[37]

WINTER
Miró is back in Barcelona by 11 December.

The Calders spend the winter in an apartment at East 86th Street and Second Avenue in New York. For the next several years this becomes their winter home. Calder rents a small store and uses it as a studio.[38]

Fig. 103 Alexander Calder with his daughter Sandra (born 20 April 1935); photograph sent to Miró in early 1936

1936
Miró lives and works in Barcelona until early June. Two years after acquiring its first work by Calder, MoMA acquires its first painting by Miró, *Catalan Landscape (The Hunter)*, 1923–1924 (Dupin 90), originally owned by Breton.

On 10–29 February the Calder exhibition, *Mobiles and Objects by Alexander Calder*, is shown at the Pierre Matisse Gallery in New York. Again, some of the work is motorized while other pieces are powered

only by air currents. A critic links Calder's work with Miró's painting. The headline of the *New York World-Telegram* review (15 February) proclaims, "Calder's 'Mobiles' Are Like Living Miró Abstractions."

Calder and Miró are included in *Abstract and Concrete: An Exhibition of Abstract Painting and Sculpture Today* at Gallery 41 in Oxford, England, 15–22 February. The show travels to the University of Liverpool, then to the Lefevre Gallery, London, and the Gordon Fraser Gallery, Cambridge. It features work by Calder, Naum Gabo, Alberto Giacometti, Hélion, Barbara Hepworth, Kandinsky, Miró, László Moholy-Nagy, Mondrian, Henry Moore, Ben Nicholson, and John Piper. One of the eighteen paintings from Miró's 1933 series based on the eighteen collages is featured (cat. 110), and Calder exhibits *T and Swallow*, 1936 (cat. 30).[39] It is the second time that Miró's work is exhibited with a group that promotes pure abstraction.

SPRING
Calder and Miró are included in MoMA's major group exhibition, *Cubism and Abstract Art* (2 March–19 April), organized by Barr.

SUMMER
Calder and Miró are included in the *International Surrealist Exhibition* (11 June–4 July) at the New Burlington Galleries, London. The catalogue preface is by Breton, the introduction by Herbert Read. Miró is in London for the opening.

The Spanish Civil War begins 17–18 July in Morocco, spreading to the mainland within a day.

Miró returns to Spain from London on 14 July, just days before the war begins; he stays in Montroig until late September.

Fig. 104 Joan Miró in the Galerie Pierre, Paris, photo A. E. Gallatin

FALL

Miró returns to Barcelona with his family before 28 September. A month later (before 28 October) he goes alone to Paris with his recent work, leaving behind about one hundred works in progress in Barcelona (fig. 104).[40] Before 16 November Miró and the Sweeneys join five hundred demonstrators in Paris in a show of sympathy for Catalonia and Spain. On 16 November Miró writes to Matisse from Paris: "My wife writes that she is having great trouble getting her passport....If she can't come here with my daughter, I will go back to Spain to be with my little family, despite the risks of certain dangers...."[41]

WINTER

On 16 December Pilar and Dolores arrive in Paris. The Miró family lives at the Hôtel Récamier through February 1937. In an 18 December letter to Matisse, Miró indicates that the family will "remain in Paris until life returns to normal in Catalonia."[42]

Miró's mother refuses to leave Spain despite his urging.[43]

The Calders spend the winter in New York at their apartment at East 86th Street, where they live across the hall from the Nelsons and the Nitzschkés (Oscar and wife Ritou).

Calder and Miró are featured in MoMA's important group exhibition, organized by Barr, *Fantastic Art, Dada, Surrealism* (7 December 1936–17 January 1937). Barr places Calder in the section "Artists Independent of the Dada-Surrealist Movements," while Miró is in the "Dada and Surrealism" section.

1937

On 4 January the Calders send Miró a postcard, relieved that Pilar and Dolores have arrived in Paris. On 24 January Miró begins using the mezzanine at Loeb's Galerie Pierre as studio space.

LATE WINTER/EARLY SPRING

Calder has an exhibition, *Stabiles and Mobiles* (23 February–13 March), at the Pierre Matisse Gallery, New York (figs. 16, 40). His first large bolted stabile is exhibited in this show (*Devil Fish*, cat. 33). Other important new work in the show

Fig. 105 Alexina (Teeny) Matisse with her children Jackie and Paul in their New York apartment on 58th Street with Miró's *Still Life (Still Life with Lamp)* (cat. 97)

includes *Tightrope* (cat. 25), *Big Bird* (cat. 32), *White Panel*, and *Cello on a Spindle* (cats. 26, 28). The critic Edwin Alden Jewell writes in the *New York Times* that Calder's works are "bringing Miró to life."[44]

Fig. 106 Pierre Matisse and Alexander Calder with *Tightrope* (cat. 25), New York City studio, 1936, photo Herbert Matter

SPRING

Before 7 March, Miró, Pilar, and Dolores move to 98, bd. Auguste-Blanqui, the same building occupied by the Nelsons (who have returned to Paris from New York) and Hélion. Miró is able to use a room "with good light" as a studio and gives up the space at Galerie Pierre.[45] In March Miró designs a stamp in support of the republican resistance in Spain (fig. 108).

The Calders move out of their New York apartment and sail for Europe on 15 April. They are met at Le Havre by the Nelsons, with whom they stay in Varengeville-sur-Mer (Normandy) before traveling on to Paris. The Mirós also come to Varengeville to see the Calders and the Nelsons.[46]

By 25 April the Calders are in Paris, living at 80, bd. Arago (fig. 107). They have many visitors, including Miró, who writes to Sweeney on 6 June of his frequent visits with his "good friends," the Calders.[47] On 3 June Calder performs the Circus at 80, bd. Arago for his many friends.

THE SPANISH PAVILION PROJECT

Miró is commissioned by the Spanish republican government, still embattled in the civil war, to paint a monumental mural for the Spanish Pavilion at the Paris World's Fair. On

25 April Miró writes to Matisse about his commission for the mural and mentions the Calders: "Calder is already here; we've talked about you and New York a lot.... The stamp ['Aidez l'Espagne'] has still not been printed."[48]

Fig. 107 Louisa and Alexander Calder, their daughter Sandra, and the dog Feathers in Paris, 1937

In late April Calder accompanies Miró to the Spanish Pavilion site, which is still under construction. Calder meets the architects, Josep Lluís Sert and Luis Lacasa, and offers to help in any way he can.[49] Sert turns him down because he is not Spanish.

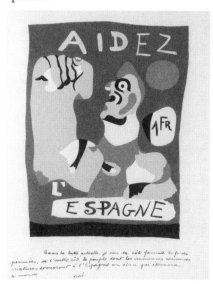

Fig. 108 Joan Miró, design for stamp *Aidez l'Espagne*, 1937

The Paris World's Fair officially opens on 24 May even though not all the pavilions are finished.

In mid-May Sert reconsiders Calder's offer and approaches him through Miró, commissioning him to do the *Mercury Fountain* for the Spanish Pavilion.[50] It is the first major commission of Calder's career to be realized. It is also the first time that Calder and Miró have been joined together by commissions for architectural projects.

Within a short time Calder makes a model for Sert's approval. In late June the *Mercury Fountain* is installed in the central courtyard in the Spanish Pavilion directly in front of Picasso's *Guernica* (although the mercury will not be placed in it until the press opening, 10 July).[51] Picasso and Sert are on hand.

In June Miró begins painting the eighteen-foot-tall mural *The Reaper (Catalan Peasant in Revolt)*. It is painted in situ in oil on six Celotex panels that cover the wall of a stairway in the northeast corner of the pavilion (figs. 18, 109), taking approximately two weeks to finish.[52]

On 12 July the Spanish Pavilion opens to the public with special festivities (fig. 19).

The exhibition *Fantastic Art: Miró and Calder* opens at the Honolulu Academy of Arts (1–15 June). Calder exhibits *Two Acrobats*, ca. 1928 (cat. 8). This is the first exhibition to feature only Calder and Miró. On 29 May the *Honolulu Star Bulletin* carries an article about the exhibition claiming that Calder does not like the "surrealist" appellation of his work.[53]

SUMMER

The Calders rent a house in Varengeville not far from the Nelsons. The group in Varengeville for the

Fig. 109 Joan Miró's mural, *The Reaper*, 1937, installed in the stairway of the Spanish Pavilion, Paris, 1937, photo Pierre Matisse

summer, after the opening of the Spanish Pavilion, includes the Mirós, the Braques, the Matisses, the Loebs, the [Georges] Duthuits, and others (figs. 110, 111). Calder describes the community of friends "6 miles from Dieppe" in a 26 September letter to Sweeney. Visitors include Nicholson and Hepworth, John and Myfanwy Piper, the Légers and [Herbert] Read.[54]

Fig. 110 Pilar Miró and Paul Nelson with Dolores Miró and Sandra Calder, Varengeville-sur-Mer, summer 1937

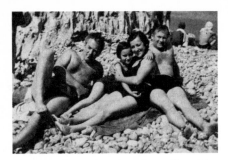

Fig. 111 Left to right: Alexander Calder with Dolores, Pilar, and Joan Miró on the beach at Varengeville, summer 1937, photo Hans Hartung

FALL

The Mirós leave Varengeville for Paris by mid-October. The Calders arrive in England on 21 October and rent an apartment in Belsize Park, London. Calder takes a studio in Camden Town.

On 20 November Calder composes a postcard in Spanish for his daughter, Sandra, age two, to send to Dolores Miró, age seven, in Paris (figs. 79, 80).

Spanish Pavilion closes 25 November.

A review of *Calder: Mobiles and Stabiles*, at the Mayor Gallery in London (1–24 December) in the *Scotsman* (8 December) observes that Calder "is intent upon turning the delicate line drawings of Klee and Miró into wire… and to give the effect in space of pictures like theirs."[55]

1938

On 30 January, the nationalists form a new government with General Francisco Franco as chief of the Spanish State.

Miró and his family are still living in Paris at 98, bd. Auguste-Blanqui. The Spanish Pavilion is dismantled in the early months of the year.[56] Calder arranges for the *Mercury Fountain* to be deposited in a warehouse in Paris belonging to a friend, the colorist Maurice Lefebvre-Foinet.[57] Miró's mural *The Reaper* is dismantled, crated, possibly shipped to Valencia, and ultimately lost.[58]

LATE WINTER

In February the Calders leave London for the United States. Calder will not be in Europe again until 1946.

Miró sends Calder a small gouache (fig. 112). On 28 February, Calder, now home in Roxbury, writes Miró a thank-you note.

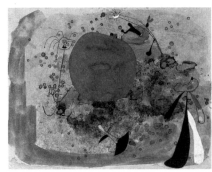

Fig. 112 Joan Miró, *Untitled*, 1937, gouache and watercolor on paper, 71.1 x 55.9 cm (28 x 22 in.), private collection; gift to Alexander Calder in 1938

SUMMER

Calder sends Miró a postcard on 4 June describing his intention to build a small studio at Roxbury. On 22 June Calder sends Miró a joke postcard (of the Empire State Building, fig. 81). On 12 July, the 98, bd. Auguste-Blanqui group – the Mirós, Paul Nelson, Hélion, and others – send Calder a postcard.

The Nelsons lend Miró their house in Varengeville for part of the summer, and he works on a concrete mural (fresco) in their living room. Sometime, possibly in early August, the Mirós go to Cassis, Bouches-du-Rhône, in southern France for a vacation. Braque is also there. The Mirós and Braque send the Calders a postcard on 10 August.

FALL

The Mirós are back in Paris before the end of August at 98, bd. Auguste-Blanqui (fig. 113). In September Miró completes a large painting as a nursery decoration for Pierre Matisse's children, *Woman Haunted by the Passage of the Bird-Dragonfly, Omen of Bad News*

(cat. 118). He writes a dedication on the back of the painting: "'Pour Jacky, Peter and Pauley / Matisse' / Joan Miró. / IX–1938." The title is given to the painting by Miró at the time of the Munich Accords of 29 and 30 September 1938, in which Great Britain, France, and Italy cede the Sudeten territory to Germany.[59]

In October Calder begins building a large studio in Roxbury and enthusiastically writes about it to Miró in a New Year's card.

WINTER

The Calders move to their New York apartment. Louisa is pregnant and wants to have the baby in New York.

1939

During the winter of 1938–1939 General Franco's troops threaten Catalonia, a republican stronghold. Miró's mother is at the farm in Montroig. On 2 January Miró writes to Matisse about his concern for his mother's safety as the rebels are getting closer. On 26 January Franco's troops take Barcelona, occupying Catalonia. On 14 February Miró learns that his friend Prats has been imprisoned.[60]

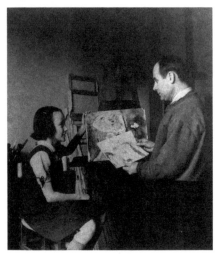

Fig. 113 Joan Miró and his daughter Dolores in his bedroom studio, Paris, fall 1938, photo Denise Bellon

Miró has a one-artist exhibition of recent paintings in New York at the Pierre Matisse Gallery (10 April–6 May). Calder is preparing his own show at Pierre Matisse (9–27 May), *Calder: Mobiles-Stabiles*, which is to open three days after Miró's closes. Included in Calder's exhibition of fifteen works are two versions of *Spherical Triangle*, 1938 (cat. 38). The critic Margaret Breuning sees a relationship between the two artists in her June 1939 review in the *Magazine of Art*: "[Calder's] fluency of planes, lines, [and] colors in constantly changing relations might well be used as an initiatory lesson to such modern painting as Miró's, for it presents much the same problems of resolution of familiar elements...."[61]

Miró and Pilar write to the Calders from Paris on 23 May, wishing them well with the soon-to-arrive baby (Mary) and expressing concern for the refugees in Spain. In spite of the uncertain political situation that affects his personal life, Miró is still very interested in Calder's current work and asks to see photographs. The Calders' second child, Mary, is born on 25 May.

SUMMER

As the political situation in Europe deteriorates, Miró makes plans to leave Paris. He stores a number of canvases at the same well-known artists' supply store and warehouse in Paris where Calder has stored the *Mercury Fountain* (Lefebvre-Foinet). Before 25 August the Mirós move to a rented cottage in Varengeville, where they stay until May 1940, when Germany invades France.

The Calders move back to Roxbury. The Spanish refugees Sert and his wife Moncha stay with the Calders in Roxbury before moving to Boston, where Sert will lecture at Harvard University.

FALL/WINTER

On 1 September Germany invades Poland. World War II begins 3 September with Great Britain and France declaring war on Germany.

Miró works on two series of small paintings, including works on burlap (cats. 119–121).

1940

On 21 January Miró begins a series of twenty-three paintings, the last of which is finished on 12 September 1941. These new works, eventually known as "Constellations," are executed on pages from the same watercolor paper block purchased at Castelucho, an artists' materials shop in Paris, and thus are all exactly the same modest size.[62] In a 4 February letter to Matisse, Miró describes the series as: "one of the most important things I have done, and even though the formats are small, they give the impression of large frescoes.... I can't even send you the finished ones, since I must have them all in front of me the whole time – to maintain the momentum and mental state I need in order to do the entire group."[63] A new painting in the series is finished every few days. Miró continues to work on the Constellations as he relocates from Varengeville to Palma to Montroig over the course of the next twenty months. Miró keeps the Constellations with him until the end of the war.

Calder spends the year working on elegant versions of the mobile, such as *Thirteen Spines* (cat. 46) and *Little Spider* (cat. 43), and further elaborations of the stabile such as *Hollow Egg* (cat. 42).

SPRING

Although Matisse will not receive new work from Miró until 1945, he continues to exhibit and promote the artist's work during the war. For example, *Joan Miró: Exhibition of Early Paintings, 1918–1925*, is at Pierre Matisse (12–31 March) and includes *Carnival of Harlequin*, 1924–1925 (cat. 83), which is then purchased by the Albright-Knox Art Gallery (Buffalo, New York).

Calder exhibits new work at Pierre Matisse (14 May–1 June). The large stabile *Black Beast* (cat. 45, fig. 64), nearly nine feet high and thirteen feet long, is exhibited and represents a continuing expansion of the large bolted constructions. The exhibition also features Calder's inventive, large-scale mobile, *Eucalyptus* and *Thirteen Spines* (cat. 46).

SUMMER

In late May the Germans bomb Normandy. Miró and his family consider going to the United States but decide ultimately to return to Spain. In a 6 June letter to Matisse, Miró explains the decision, emphasizing his family's safety and the need for renewed contact with the Catalan countryside. Around 20 May, with war conditions intensifying, the Mirós leave Varengeville. Miró takes with him the ten finished Constellations. In late July the Mirós are in Palma, and Pilar's family takes them in. By 22 August Miró has resumed work on the Constellations. Paris falls to the Germans on 14 June and on 22 June France signs an armistice with Germany. In August Franco's nationalist government is firmly established and recognized as the new government of Spain.

1941

The Mirós and the Calders continue to correspond and use Pierre Matisse as an additional conduit for information.

SPRING

Calder and Miró have one-artist exhibitions at Pierre Matisse during the spring. Miró exhibits 4–29 March, Calder 27 May–14 June.

SUMMER

Sometime after 12 June the Mirós leave Palma, going to Montroig for the first time since 1936.

FALL

In the fall Miró goes to Barcelona, but by 15 November he is back in Palma and stays there until the following summer.

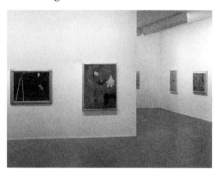

Fig. 114 Installation view of *Joan Miró*, MoMA, 1941–1942

WINTER

Miró has his first major museum retrospective, organized by Sweeney, at MoMA in New York (18 November 1941–11 January 1942) (fig. 114). Sweeney also writes the catalogue. The exhibition, in modified form, will travel to four different venues. A retrospective exhibition of Salvador Dalí's work, organized by James Thrall Soby, is shown at MoMA simultaneously with the Miró retrospective. Calder still keeps a New York winter workshop.

On 7 December, the Japanese bomb Pearl Harbor and the United States enters World War II.

1942

Miró and his family continue living in Palma. He sees almost no one.

On 14 February Agnes Rindge, a friend of Calder for several years, writes to Calder about possibly pairing his work with that of Miró when Vassar College hosts MoMA's retrospective exhibition the next month: "We are having the Modern Museum's Miró show next month.

How would you like to fetch over a few mobiles to sparkle it up?...I think you two would be harmonious together...."[64]

When the Miró retrospective moves to Vassar College (7–28 March), an equal number of works by Calder is included in the show. Rindge writes to Calder shortly after the opening about the success of this pairing up: "We have never had more fun or more of a gallery success. Your pieces gave just that fillip to the Mirós that got them off being too flat and squiggly....The combination of them worked out marvelously...."[65]

SUMMER

A Calder show at Pierre Matisse Gallery, *Calder: Recent Work* (19 May–6 June) includes *Horizontal Spines* (cat. 52) and *Wheat* (cat. 54). Calder applies to the Marine Corps on 21 September. He is rejected.

Miró briefly stops in Barcelona before 11 July on his way to Montroig, where he stays until late October.

FALL

In New York, the Coordinating Council of French Relief Societies exhibits *First Papers of Surrealism* (October–November). The curators are Breton and Duchamp. Calder and Miró are both included in this exhibition.

Before the end of October Miró and his family move back into his mother's apartment in Barcelona. Miró takes a top-floor apartment at this address as his studio.

WINTER

Calder begins working on sculptures made of carved bits of hardwood and wire. They are given the name "Constellations" after consultation with Sweeney and Duchamp.

Calder's first Constellation stands on a table and has a carved shape, painted red, at one end. Calder is completely unaware of Miró's "Constellation" series from 1940–1941, which Miró has kept with him in Spain and has only written about in the most general terms to Matisse.

1943, SPRING

Calder exhibits *Calder: Constellations* at the Pierre Matisse Gallery in New York (18 May–5 June). It is his last exhibition with Pierre Matisse, as the two men have a falling out over the pricing of Calder's work. Miró continues to have exhibitions at the Pierre Matisse Gallery the rest of his life, with Matisse acting as his agent in the United States.

SUMMER

Miró spends the summer in Montroig and on 15 August writes to Calder asking for news of family and friends and for information about Calder's own work.

FALL

Just as Sweeney organized Miró's first museum retrospective at MoMA in November 1941, he now does the same for Calder. *Alexander Calder* opens 29 September at MoMA (fig. 116). The show is a big success.

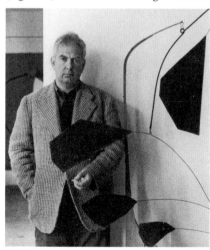

Fig. 115 Alexander Calder standing beside *Red Post, Black Leaves* (cat. 48), 20 September 1943, New York, photo Arnold Newman

Scheduled to close 28 November, it is extended to 16 January 1944. Sweeney writes the catalogue and is the curator for the exhibition, with Duchamp's assistance. Calder gives performances of the Circus in the museum penthouse. Although the model for the *Mercury Fountain* made for Sert in 1937 is lost in the Spanish Civil War, Calder makes a replica for the exhibition.

Fig. 116 Installation view of *Alexander Calder*, MoMA, 1943–1944

Miró and his family leave the farm in Montroig to return to Barcelona.

WINTER
The icehouse studio and part of the Roxbury farmhouse are destroyed by fire on 4 December while the Calders are absent. The one thing Calder worries about is the painting Miró gave him in Paris in June 1933 (cat. 113). The painting survives the fire. The Calders stay with Yves Tanguy and Kay Sage in Woodbury, Connecticut, while the Roxbury house is repaired.

1944
On 27 May Miró's mother, Dolores Ferrà, dies.

In March Miró arranges for the Constellations to discreetly cross the Spanish border with the assistance of Paolo Duarte. Miró intends to send the paintings to MoMA in New York with the proposal that the series be exhibited together, preferably in chronological order.[66] Only twenty-two paintings are sent to the United States, as *Morning Star* (cat. 122) has been given to Pilar.

Matisse advances the money for the entire shipment when it arrives in America.[67] Without Miró's knowledge, Matisse makes plans to exhibit the works at his gallery.

Miró, isolated and without much information from the United States, writes to Calder on 15 December, congratulating him on his MoMA retrospective and inquiring about his own anticipated exhibition of Constellations at MoMA.

1945
From 9 January to 3 February, the Pierre Matisse Gallery shows Miró's Constellations (cats. 123–131). Despite Miró's desire for all of the Constellations to be shown together, Matisse, in discussion with Sert, Sweeney, Breton, and Duarte, decides to exhibit only sixteen of the paintings at any one time, adding the other six in rotation during the course of the show.[68]

Fig. 117 "La pinacoteca" with Joan Miró's collection of folk objects, Barcelona, ca. 1944, photo Joaquim Gomis

In January Miró begins work on a series of large paintings related to his 1940–1941 Constellations. These include *Woman Dreaming of Escape* (cat. 134) and *Woman in the Night* (cats. 135, 136).

Calder's father, Alexander Stirling Calder, dies on 6 January and is buried in Philadelphia.

Germany surrenders on 7 May.

On 26 May Miró completes *Dancer Hearing an Organ Playing in a Gothic Cathedral* (cat. 137).

SUMMER
The war over, Miró writes to Matisse on 18 June about his need to free himself of financial worries, and also to Loeb on 30 August, expressing similar thoughts.[69]

On 2 July Miró completes *The Port* (cat. 138) and on 7 July he completes *Spanish Dancer* (cat. 139). He goes to Montroig, where he stays until late September.

FALL
On 8 October Miró completes *The Bull Race* (cat. 140), another large painting in the series related to the Constellations.

Calder makes a series of small-scale works, many from scraps trimmed in the process of making other objects. Duchamp visits the Roxbury studio and suggests Calder send the miniatures to Paris for a show. Calder creates larger, collapsible works that can be shipped and reassembled in Paris.

WINTER
In December Miró makes terracotta maquettes for his first bronze *Birds* (fig. 119). His first bronze sculptures will follow in April (cats. 144, 145). On 21 December Miró writes to Calder. He is particularly interested in Calder's bronze sculptures and asks to see photographs.

1946
Miró writes to Calder from Barcelona on 12 February, inquiring about his work and expressing his desire to see him again soon.

Calder sends gifts to the Mirós – a bracelet for Pilar, colored pencils for

Miró, a tabletop mobile/stabile (fig. 121), and photographs of his sculpture. Miró writes a thank-you letter on 18 March and expresses great interest in Calder's sculptures.

SUMMER

Calder flies to Paris on 5–6 June to prepare for his one-artist exhibition, arranged through Duchamp, at Galerie Louis Carré. The show, however, is delayed until the fall and Calder returns to New York.

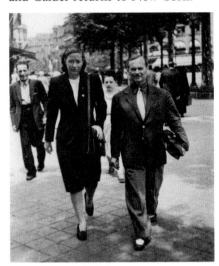

Fig. 118 Alexina (Teeny) Matisse and Joan Miró in Barcelona, July 1946; Teeny (Mrs. Pierre) Matisse traveled to Barcelona to discuss a new contract with Miró

Matisse writes to Miró on 16 August, offering to purchase all his work from 1942 to 1946 and to contract for the work from 1947 to 1949 (fig. 118). He assures Miró that Loeb is in agreement.

FALL

Miró replies to Matisse on 3 September (from Montroig), outlining his plans for an exhibition in New York. Miró says America is "full of dynamism and vitality" and that he "should be in New York…my work will benefit from the shock."[70]

On 23 September Calder returns to Paris to install *Alexander Calder: Mobiles, Stabiles, Constellations* at Galerie Louis Carré (25 October–16 November) (fig. 120). Sweeney and Jean-Paul Sartre both write for

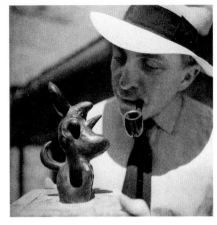

Fig. 119 Joan Prats with Joan Miró's *Moon Bird* (cat. 144), Barcelona, 1946, photo Joaquim Gomis

the catalogue. Henri Matisse attends the opening. This is Calder's first exhibition in Paris since 1938. He exhibits *S-Shaped Vine* (cat. 65), *Lily of Force* (cat. 63), and *Thirteen Spines* (cat. 46), among others. Calder sails from Le Havre for New York 19–30 November.

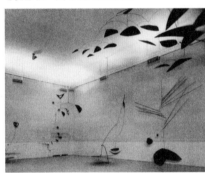

Fig. 120 Installation view of *Alexander Calder: Mobiles, Stabiles, Constellations* at Galerie Louis Carré, Paris, 1946

WINTER

In December Pierre Matisse concludes arrangements for a commission for Miró from Thomas Emery's Sons, Inc., to create a mural in the Gourmet Restaurant of the new Terrace Plaza Hotel in Cincinnati, Ohio, a building designed by Skidmore, Owings & Merrill. The mural will be more than thirty feet long and Miró will have to travel to the United States to paint it. That year Calder also receives a commission from Thomas Emery's Sons, Inc., to design and construct a mobile for the lobby of the same

hotel. This is the second time that Calder and Miró work together on commissions for the same building.

On 21 December Miró writes to Calder about his impending trip to the United States. Calder offers to pick up the Mirós on their arrival in New York.

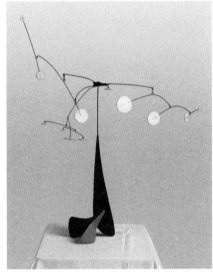

Fig. 121 Alexander Calder, *Mobile/Stabile*, ca. 1941, sheet metal, wire, and paint, 47 x 42.5 x 40.5 cm (18 ¼ x 16 ½ x 15 ¾ in.), private collection; gift to Joan Miró in 1946

Fig. 122 Installation view at the Cincinnati Art Museum of *Four Modern Sculptors: Brancusi, Calder, Lipchitz, Moore*, organized by the Cincinnati Modern Art Society, 1946

1947

Miró, Pilar, and Dolores arrive at La Guardia, New York, on 12 February. Calder meets them and takes them to an apartment at 950 First Avenue.[71] Miró does not return to Spain until 15 October. He paints the large mural for Cincinnati in Carl Holty's studio at 149 East 119th Street (cat. 143).

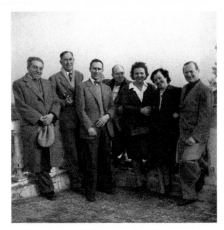

Fig. 123 Left to right: Joan Prats, Mr. Gilks, Leroy Makepeace (U.S. embassy official who facilitated Miró's U.S. visa), Mr. Williams (U.S. Vice Consul, Barcelona), Odette Charbonnier de Gomis, Pilar and Joan Miró, Montroig, ca. January 1947, photo Joaquim Gomis

SPRING

Around 7 March the Mirós make their first of several visits to the Calders in Roxbury.[72] During one of these visits, Calder performs the Circus for them.[73]

On 20 April Miró and Sandra Calder celebrate their birthdays (Miró is 54 and Sandra is 12) at the Calders' apartment on East 72nd Street in New York. Miró gives Sandra a drawing and she gives Miró a drawing of a butterfly. Calder gives Miró a figure (*Personage for Joan Miró*) constructed of animal bones that he found near his home in Roxbury.[74] Miró will display this little "bone man" in his studio in the years that follow (fig. 142).

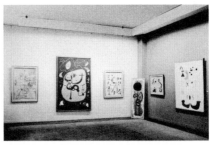

Fig. 124 Installation view of *Joan Miró: Paintings, Gouaches, Pastels, and Bronzes, 1942–1946*, at Pierre Matisse Gallery, New York, 1947 (with cat. 137)

Miró travels to Cincinnati with Matisse before 11 April to see the site for the mural. On 15 April Miró and his dealer (Matisse) sign a contract with Thomas Emery's Sons. It requires him to submit sketches for approval on or before 22 May. On 15 May Calder completes and signs a drawing for Thomas Emery's Sons, explaining how to assemble his mobile for the Cincinnati hotel, which he titles *Twenty Leaves and an Apple* (cat. 66).

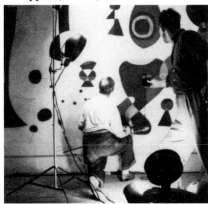

Fig. 125 Thomas Bouchard filming Joan Miró at work on the Cincinnati Mural, New York, ca. mid-June 1947

While working on the Cincinnati Mural (fig. 125) Miró also works on a related painting, *Women and Bird in the Night* (cat. 142), which he intends as a gift for Calder. Calder constructs a large mobile with a span of nearly twelve feet, entitled *Black Polygons* (cat. 69), as a present for Miró. Sometime after 5 May the two men exchange these gifts.[75]

SUMMER

On 28 June Miró is in Roxbury for a weekend with the Calders (fig. 126).[76]

The exhibition *Le Surréalisme en 1947: Exposition internationale du surréalisme* opens 7 July in Paris at Galerie Maeght. The installation is designed by Frederick Kiesler. Miró's banner for the Salle de Superstition, painted in New York, is included in the exhibition. Calder does a lithograph for the catalogue.

Fig. 126 Dolores Miró in Roxbury in Calder's aluminum boat, summer 1947

Sometime before mid-August, Miró moves into Sert's apartment at 15 East 59th Street for the rest of his stay in New York.

FALL

In September Arnold Newman photographs Miró in Holty's studio with the Cincinnati Mural (fig. 67). By 14 October the mural is finished and plans are made to exhibit it at MoMA. Miró leaves New York with his family on 15 October; they arrive in Barcelona at the end of the month.

WINTER

Miró, back in Barcelona at Passatge del Crèdit, 4, writes to Matisse on 1 December about how much he enjoyed the trip to America and how, working in complete isolation, he seeks to forget the misfortunes of Europe.[77]

In December Calder converts the fire-damaged icehouse studio in Roxbury into a big living room.

1948

Miró goes to Paris before 18 February, his first visit there since May 1940. He stays for several weeks. On 25 February Miró writes to Calder from Paris about a potential client (the Swiss publisher and gallery dealer Gérald Cramer) for Calder's work and offers to facilitate the deal.

293

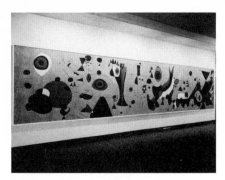

Fig. 127 Joan Miró, Cincinnati Mural, Cincinnati 1947, on view at MoMA, 1948

Miró's mural is exhibited at MoMA (3 March–4 April) before being sent to Cincinnati for installation in the Gourmet Restaurant at the Terrace Plaza Hotel (fig. 127).

Miró writes to Calder on 17 June, acknowledging receipt of curtain measurements and promising to buy the curtain material for Calder in Reus or Tarragona.

Miró has his first one-artist exhibition at Galerie Maeght, Paris (19 November–18 December). This event marks Miró's re-emergence on the art scene in Paris. Aimé Maeght is now Miró's agent in France (after Loeb ends his contract with Matisse in December 1947), continuing in that role until Miró's death.[78]

1949
Through Zervos, Calder is put in touch with Maeght. Plans are made for him to exhibit in Paris at Galerie Maeght the following year. Miró writes to Calder on 12 March, expressing his belief that a show at this gallery will have an impact.

Miró facilitates Calder's upcoming Paris exhibition, describing his efforts in a letter to Calder on 2 July.

1950
In January Harvard University commissions a mural from Miró (fig. 130).

The Calders sail from New York to Le Havre 4–10 May and rent an apartment on rue Penthièvre, Paris, until 31 August, when they return to New York.

Miró's one-artist exhibition of sculpture, objects, and prints at Galerie Maeght, Paris, opens 2 June. Miró is again able to see the Calders. He makes a drawing for Sandra Calder in honor of their shared birthday (fig. 129).

After 16 July the Mirós reside at Carrer Folgaroles, 9, Barcelona.

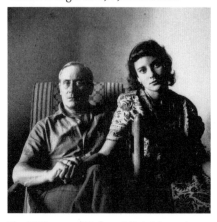

Fig. 128 Joan and Dolores Miró, Montroig, September 1948, photo Irving Penn

Calder: Mobiles & Stabiles opens at Galerie Maeght (30 June–27 July). It is Calder's first exhibition there. Maeght now represents both artists in Paris.

1951
The Contemporary Arts Association in Houston has a *Calder-Miró* exhibition (14 October–4 November). This is the first pairing of the two artists after the war.

1952
Calder arrives in Paris on 19 March, Louisa on 26 April. Calder has a one-artist exhibition, *Alexander Calder: Mobiles*, at Galerie Maeght (6–10 May). Calder and Louisa return to New York on 7 June.

On 1 June Miró flies to New York. He travels to Cincinnati to see his

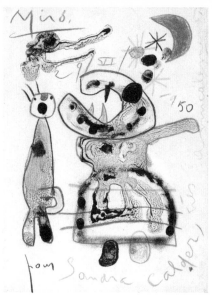

Fig. 129 Joan Miró, *Drawing for Sandra*, 1950, colored pencil and gouache on paper, 39 x 29 cm (15 ⅜ x 11 ½ in.), private collection; gift to Sandra Calder

mural on 4 June and then on to Harvard to see his mural there before returning to Barcelona on 10 June.

In mid-September Calder travels to Bonn, Germany, accepting an invitation from the German foreign ministry to tour West Germany. He visits Munich, then Mannheim and Darmstadt. Calder is in Berlin from 23–29 September and, with Will Grohmann and William Friedman, sends a postcard to Miró.

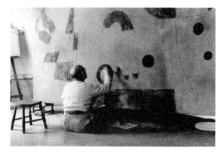

Fig. 130 Joan Miró at work on the Harvard Mural in his Barcelona studio, fall 1950

1953
The Calders move to France at the end of June, ultimately purchasing a dilapidated seventeenth-century stone house, known as "François Premier," in Saché. Thereafter they alternate lengthy stays in France with stays in Roxbury.

1954

Miró also plans to change his environment to stimulate his work. With his financial situation much improved, Miró arranges to move to Mallorca and divide his time between Palma and Paris. In June he purchases property in Palma and asks Sert to design a large studio there for him. In a 17 April letter to Matisse from Palma, Miró states his belief that the move is for the best: "We are about to buy a house near Palma on a splendid piece of land. Dividing my time between here and Paris, and from time to time making a trip to New York will be ideal for both work and health."[79]

1955

By 20 October Miró is invited to design two ceramic walls (*Wall of the Moon* and *Wall of the Sun*) for the new UNESCO headquarters in Paris. Calder also receives a commission for this building and Miró congratulates him in a 26 December letter.

Calder submits his maquette for a standing mobile, *La spirale,* to the UNESCO Committee of Art Advisors for approval in March 1957. It is installed in Paris in spring 1958 (fig. 132). Miró works with Josep Llorens Artigas on the ceramic walls for the next few years. They are installed in fall 1958 (fig. 131).

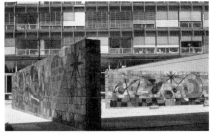

Fig. 131 Joan Miró, *Wall of the Sun*, 1957–1958, and *Wall of the Moon*, both ceramic murals at UNESCO headquarters, Paris, photo Michel Claude

1956

In the fall Miró gives up his studio and the apartment in Barcelona. He moves to Palma, into the Villa Son

Abrines and the large studio designed by Sert. Miró retrieves from a Paris warehouse work stored there since 1939. While organizing the new studio, he rediscovers sketchbooks, drawings, and projects from his entire career.

1957

Miró writes to Calder on 8 February explaining that his delay in writing is due to his recent move.

The Calder family arrives in Spain on 25 July for a short trip, visiting Miró's colleague and friend, Artigas, in Gallifa (Barcelona) before returning to France on 30 July.

1958

Calder sends Miró a letter postmarked 25 November. On the outside of the envelope Calder has drawn a large red arrow (fig. 91). The envelope and Calder's arrow inspire Miró's large-scale 1964 painting *Message from a Friend* (Dupin 1173).

1959

Miró makes his third visit to the United States (21 April–29 May) to see his retrospective exhibition at MoMA (18 March–10 May). He stays in New York but makes small excursions, including one to see Calder in Roxbury.[80]

1960

Miró writes to Calder on 24 July about his disappointment that a visit to Saché did not work out.

In September Miró acquires a seventeenth-century house, Son Boter, near his home in Palma to be his second studio.

1961

Calder's new gallery dealer, Klaus Perls, arranges *Alexander Calder, Joan Miró,* an exhibition at Perls Galleries, New York (21 February–1 April), pairing the two old friends (fig. 133). Perls asks each man to

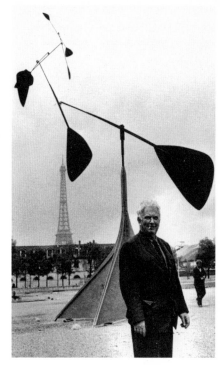

Fig. 132 Alexander Calder with *La spirale* at the Palais de l'UNESCO, 1958, photo Lore Hammerschmid

write a text about the other and these texts become the catalogue (figs. 92, 93). While Calder's text is a description of their first meeting and their early friendship, Miró's writes a poem about his dear friend. John Canaday reviews the show for the *New York Times* (26 February 1961) with a headline proclaiming a "Just About Perfect Show."

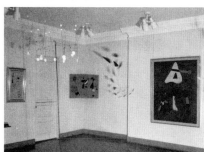

Fig. 133 Installation view of *Alexander Calder, Joan Miró*, Perls Galleries, New York, 1961 (with cats. 142, 110)

1964

The inauguration of the Fondation Maeght at Saint-Paul-de-Vence takes place on 28 July. Sculptures and a labyrinth are by Miró.

1965

Miró flies to New York from Paris on 23 October. He visits Calder in Roxbury.

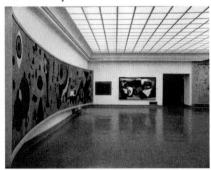

Fig. 134 Cincinnati Art Museum, installation view of Miró's Cincinnati Mural, October 1965

1966

Miró writes to Calder on 10 February to thank him for his concern about Dolores after a car accident and expressly admires his stabile in Saint-Paul-de-Vence.

Calder: Gouaches et Totems, opens on 18 February at Galerie Maeght in Paris.

1968

To celebrate Calder's seventieth birthday, Klaus Perls gives an intimate party at the Colombe d'Or in Saint-Paul-de-Vence on 21 July. Miró attends. The following day the Fondation Maeght hosts a dinner for Miró to celebrate his retrospective exhibition in the year of his seventy-fifth birthday (fig. 135). The exhibition is on view 23 July– 30 September. These joint celebrations are covered in the *New York Times* (23 July) with the headline, "Calder and Miró, Now Past 70, Feted in France / Artists Trade Compliments at Respective Parties; Future Vivid to Sculptor – Painter Looks Ahead." The review by Paul Waldo Schwartz continues: "'Miró,' Mr. Calder said, 'is my favorite painter along with Matisse, yes and Klee.... I don't know how he is able to invent things as he does. There's this ribaldry in Miró that he

manages so well. I was trained as an engineer and to me the actual mechanics always fascinate.'"[81]

1969

Fondation Maeght in Saint-Paul-de-Vence organizes a Calder retrospective (2 April–31 May) with a monumental, walk-through stabile, *Morning Cobweb*, at the entrance. Miró attends the opening.

Miró incorporates a cast of an animal jawbone given to him by Calder in 1947 (figs. 137, 138) into his bronze sculpture *Maternité* (fig. 136).

Fig. 135 Joan Miró and Alexander Calder, with Miró's *The Pitchfork*, Fondation Maeght, Saint-Paul-de-Vence, July 1968

1970–1971

The Calders move into a new house they have built ("Le Carroi") next to the studio in Saché. Miró and Sert begin planning for what will become the Centre d'Estudis d'Art Contemporani, Fundació Joan Miró, Barcelona. In 1971 Calder agrees to give the *Mercury Fountain* to the Fundació Joan Miró as construction for the building is about to begin.[82]

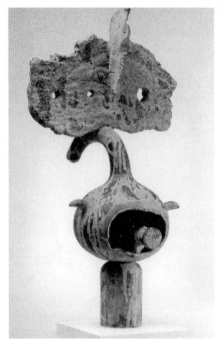

Fig. 136 Joan Miró, *Maternité*, 1969, bronze, height 83 cm (32⅝ in.), *exemplaire nominatif* for Fundació Pilar i Joan Miró, Palma de Mallorca

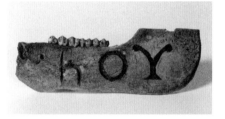

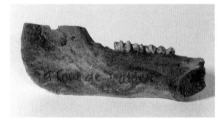

Figs. 137, 138 Animal jawbone inscribed by Alexander Calder, "Hoy/a casa de Calder" (Today/in the House of Calder), 1947; gift to Joan Miró

1972

In September-October Calder has a one-artist exhibition at the Sala Pelaires in Palma de Mallorca. Miró writes the introduction to the catalogue, which is like an illustrated poem (pp. 1–3, 310–312). In anticipation of Calder's arrival for this show, Miró paints a work entitled *Bird with Beautiful Plumage in Front of the Sun I* (finished 28 May).

After the opening Calder donates the mobile *Nancy* to the city of Palma.[83] This is Calder's last visit to Palma.

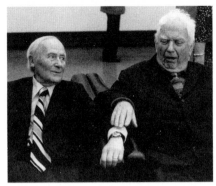

Fig. 139 Joan Miró and Alexander Calder at the Grand Palais, Paris, May 1974, on the occasion of the opening of Miró's retrospective exhibition

1974
Miró is in Paris in May during the installation of his retrospective at the Grand Palais. Organized by Jean Leymarie, Jacques Dupin, and Isabelle Fontaine, the retrospective opens at the Grand Palais (17 May–13 October). Calder attends the opening festivities (fig. 139).

Fig. 140 Alexander Calder overseeing the installation of his *Mercury Fountain* at the Fundació Joan Miró in Barcelona, June 1975; photo Francesc Català-Roca

1975
In June the *Mercury Fountain* is installed at the Fundació Joan Miró in Barcelona under Calder's supervision (fig. 140).

On 10 June the Centre d'Estudis d'Art Contemporani, Fundació Joan Miró, has its unofficial opening in a building designed by Josep Lluís Sert in Barcelona at Parc de Montjuïc.

Franco dies on 20 November.

1976
On 19 April Miró invites Calder to the official opening of the Fundació Joan Miró and asks him to give the Fundació his sculpture *Four Wings*, which has been in Barcelona for some time: "In exchange I would give you a large canvas that I would paint while thinking about you and about our long, close friendship...."[84] Calder immediately agrees to the exchange (23 April). The Calders attend the official opening of the Fundació Joan Miró, Barcelona, on 18 June.

On 11 November Calder dies of a heart attack in New York.

Fig. 141 Joan Miró admiring Alexander Calder's *Black Polygons*, 1947, at his home, Son Abrines, Palma de Mallorca, April 1978

1977
Galería Maeght organizes *Calder: Exposició Antológica (1932–1976)* in Barcelona (April–May). On 10 March Miró writes a poem about Calder that is published in the catalogue as a painting-poem (p. 309).

1983
Miró dies on 25 December in Palma de Mallorca.

Fig. 142 Joan Miró in his red studio at on Boter, Palma de Mallorca, in 1969, with the bone *Personage* given to him by Alexander Calder in 1947, photo Francesc Català-Roca

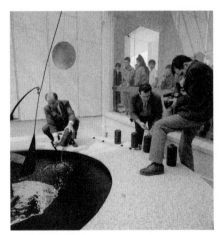

Fig. 143 Flowing mercury (from the mines of Almadén, Spain) into Calder's *Mercury Fountain* at the Fundació Joan Miró, Barcelona, May 1990, photo Francesc Català-Roca

In constructing this chronology, the author has relied heavily on Anne Umland, "Chronology," in Carolyn Lanchner, *Joan Miró* [exh. cat., The Museum of Modern Art] (New York, 1993), Alexander Calder, *Calder, An Autobiography with Pictures* (New York, 1977), and Alexander S.C. Rower, "Chronology," in Marla Prather with contributions by Arnauld Pierre and Alexander S.C. Rower, *Alexander Calder: 1898–1976* [exh. cat., National Gallery of Art] (Washington, 1998). Other sources are noted throughout.

I wish to thank my colleagues Elizabeth Hutton Turner, Elsa Smithgall, and Oliver Wick for their advice and careful reading of this chronology, and Leigh Weisblat for her diligent and meticulous research at the Pierpont Morgan Library and in the archives of the Calder Foundation.

[1] Jeffett 1992, 36–42, for general discussion of these four wood constructions, esp. 38 n. 6. See also Umland in New York 1993, 354 nn. 389, 390.

[2] Francisco Melgar, "Spanish Artists in Paris: Juan [sic] Miró," in *Ahora* (24 January 1931), as translated in Rowell 1986, 116–117.

[3] Courtesy Calder Foundation (hereafter "CF"), Calder letter to Nanette and Alexander Stirling Calder, 1 July 1931.

[4] CF, Calder letter to Nanette and Alexander Stirling Calder, dated Sunday, 12 July 1931.

[5] Jeffett 1992, 69 and n. 25.

[6] Jeffett 1992, 69–70, and Léonide Massine, "L'art de Joan Miró...." *Cahiers d'art* 9, nos. 1–4 (1934), 50.

[7] CF, Calder letter to Nanette and Alexander Stirling Calder, March 1932.

[8] Pierre Matisse Gallery correspondence (hereafter "PMG"), Pierpont Morgan Library, Miró to Matisse, 14 February 1932.

[9] Gutman in *Worcester Times* (21 May 1932).

[10] CF, Miró and Calder letter to Sebastià Gasch, 12 September 1932, from Montroig (*Correspondence* 8).

[11] Joan Punyet Miró, "Alexander Calder and Joan Miró: A Friendship, a Complicity," in Barcelona 1997, 167 and n. 21.

[12] Calder 1977, 139. Sperling in *Journal of American Culture* (Winter 1994), 11.

[13] The Calder object reproduced in Gasch's *Mirador* article (29 September 1932) is the same object, now lost, reproduced in Herbert Read's *Surrealism* (1936), but turned on its side, on the far right of a shelf behind Calder in the 1931 photograph of the sculptor in his studio at 14, rue de la Colonie. Two other objects were reproduced in the 1932 edition of *AC* that carried Gasch's review. These were

the *Object with Red Discs (aka Calderberry Bush)*, now at the Whitney Museum of American Art, and *Object with Red Ball* (private collection). It is not known whether one of these three objects was actually the one exhibited in Barcelona on this occasion.

[14] CF, Louisa Calder letter to her mother, around December 1932.

[15] CF, Calder unpublished manuscripts, "Evolution," 1952–1956, 122.

[16] CF, Calder unpublished manuscripts, 18 June 1956, 147.

[17] Founded in 1910, the Residencia de Estudiantes was Spain's main cultural center before the Spanish Civil War in 1936 and is well known as a center for the reception and development of international avant-garde ideas. Visitors of note, invited by either the Sociedad de Cursos y Conferencias or the Comité Hispano-Inglés, included Albert Einstein, Walter Gropius, Marie Curie, Igor Stravinsky, Le Corbusier, Henri Bergson, Paul Valéry, and Max Jacob.

[18] CF, Sociedad de Cursos y Conferencias announcement, February 1932.

[19] CF, Louisa Calder to her mother, 11 February 1933, indicates that the first performance of the Circus in Barcelona will be that night and then again the next night.

[20] CF, Louisa Calder to her mother, 11 February 1933.

[21] Dupin 1962, 253.

[22] Calder 1977, 142, and CF, Calder unpublished manuscripts, 1952–1956, 122.

[23] Fundació Pilar i Joan Miró, Palma de Mallorca (hereafter "FPJM"), Hélion letter to Miró dated 14 April 1933.

[24] Umland in New York, 1993, 355 n. 450, states that *Painting* (Dupin 431, The Museum of Modern Art, New York) is the last of the series of eighteen paintings. Although Dupin includes this painting given to Calder as one of the series of eighteen paintings based on collage (Dupin 432), it is doubtful that this is the case. There is no known collage for this work, and the entire series of eighteen was exhibited at Galerie Georges Bernheim 30 October–13 November, four months after Calder left Paris.

[25] Alexander Calder statement in New York 1961. It is not known what became of the volcano. See Barcelona 1997, 167.

[26] Freedberg 1986, 533–534, 582 n. 20.

[27] Calder letter of 26 May 1934 to Ben Nicholson, as quoted in Arnauld Pierre, "Staging Movement," in Washington, 1998, 346 n. 10, and FPJM, Calder postcard to Miró, 15 November 1933.

[28] Rowell 1986, 124, and PMG, Miró to Matisse, 7 February 1934.

[29] Pierre Matisse recollected in a 4 May 1973 interview with Joan Marter that the Miró exhibition consisted of works on paper. This, of course, was the first Miró exhibition at Pierre Matisse Gallery (PMG) in November 1932. Calder was in Paris at that time. It must have been the second Miró exhibition at PMG, which Calder saw after he had returned to the United States. See Marter 1991, 141, 275 n. 100.

[30] CF, Calder letter to James Johnson Sweeney, 27 July 1934.

[31] CF, Calder letter to James Johnson Sweeney, 11 August 1934.

[32] CF, Calder postcard to James Johnson Sweeney, 22 September 1934.

[33] CF, James Johnson Sweeney letter to Calder, 1 January 1935.

[34] Rowell 1986, 125.

[35] CF, Calder letter to Sweeney, 9 August 1935. For more of the conversation about the yellow shirts see Calder's 27 August letter to Sweeney and Sweeney's 30 August letter to Calder.

[36] CF files, Sweeney to Miró, 10 November 1935, "Cunard White Star," onboard *Aquitania*, envelope postmarked 21 November 1935.

[37] The San Francisco exhibition referred to in Miró's letter may be a group exhibition entitled, *Selected Watercolors by Lurçat, Miró, and Dufy* (4 August–2 September 1935), which included Miró's *Portrait of a Young Girl*, 1935 (New Orleans Museum of Art) (cat. 115).

[38] Rower in Washington, 1998, 73, indicates that the apartment was originally rented in winter of 1934–1935, but this seems unlikely since that was the winter Louisa was pregnant and staying with her parents in Concord, Massachusetts. Traveling from New York to Concord to see Louisa would have been a much longer commute for Calder than the commute from Roxbury. Calder's autobiography only generally recalls that the New York apartment was established a year or two before the winter of 1936. Calder 1977, 156.

[39] CF, Exhibition Files. The painting by Miró is clearly visible in an installation shot published in Martin, Nicholson, and Gabo, reprint 1971, 280.

[40] Miró letter to Matisse 12 January 1937, from Paris, in Rowell 1986, 146.

[41] Rowell 1986, 131–132.

[42] Rowell 1986, 133.

[43] Cirici 1976, 83.

[44] *New York Times* (28 February 1937).

[45] Umland in New York 1993, 357 n. 565.

[46] CF, Calder letter to Nanette and Alexander Stirling Calder, 26 April 1937.

298

47 CF, Miró letter to Sweeney, 6 June 1937.

48 Umland in New York 1993, 333 (entry for 25 April).

49 Freedberg 1986, 526–527, 580 n. 6, 596 n. 88; and Calder 1977, 158.

50 Calder in *Stevens Indicator* (May 1938), 3. Sert had first seen Calder's work in Barcelona in 1932 when Calder performed the Circus at the GATCPAC Hall. The original fountain for the Spanish Pavilion by Alberto Sánchez was deemed too conservative for a modern (International Style) building and the accompanying political message. Having to find an alternative on short notice in Paris, Sert turned to Calder, the only person he believed would be able to step in and provide a solution. Freedberg 1986, 474, 504 n. 10.

51 Freedberg 1986, 661 n. 55.

52 CF, Miró's 6 June 1937 letter to Sweeney indicates that he intends to begin work on the pavilion mural the next day. See Umland in New York 1993, 357 nn. 576, 577, and Freedberg 1986, 527–528, 581 nn. 10, 11.

53 "At the Honolulu Academy of Arts," *Honolulu Star Bulletin* (29 May 1937).

54 CF, Calder letter to Sweeney, 26 September 1937.

55 *The Scotsman* (8 December 1937).

56 Freedberg 1986, 212–213, 259 nn. 186, 187.

57 After many years Calder retrieved the *Mercury Fountain* from this Paris warehouse and placed it in his studio in Saché, France. Freedberg 1986, 499, 523 n. 77.

58 Freedberg 1986, 576-578, 600 nn. 101–108.

59 Dupin and Lelong-Mainaud 1999–2002, vol. 2, cat. 596. The mural was installed in Matisse's apartment, at the top of the wall just below the ceiling molding. Freedberg 1986, 896, 908 n. 6.

60 Umland in New York 1993, 334 (entry for 14 February), 358 n. 602. Prats remained in prison for six or seven months, suffering terrible conditions that eroded his health. Cirici 1976, 85.

61 Margaret Breuning, "Calder Mobiles and Stabiles," *Magazine of Art* (June 1939), 361.

62 Lillian Tone, "The Journey of Miró's Constellations," in *MoMA Magazine* (Fall 1993), 3 and note 4. Miró's series of twenty-three paintings only acquired the appellation "Constellations" in 1959 when they were published as a book, with poems for each, by Breton.

63 Rowell 1986, 168.

64 CF, Rindge to Calder, 14 February 1942.

65 CF, Rindge to Calder, Maundy Thursday, 1942.

66 Tone 1993, 3, and Umland in New York 1993, 336, 359 n. 662.

67 Tone 1993, 5.

68 Umland in New York 1993, 337, 359 n. 673.

69 Rowell 1986, 197–198.

70 Umland in New York 1993, 337.

71 CF, Calder letter to Keith Warner, 15 February 1947.

72 Postcard to W. Sandberg, director of the Stedelijk Museum, Amsterdam, 7 March 1947 (*Correspondence* 39). Also CF, Calder letter to Christian Zervos, 28 March 1947.

73 CF, unpublished Calder manuscripts 1954–1955, 155.

74 Barcelona 1997, 171.

75 Barcelona 1997, 171.

76 Miró/Calder postcard to LeRoy Makepeace (Barcelona), 28 June, courtesy Mrs. LeRoy Makepeace.

77 Umland in New York 1993, 338, gives a partial translation of 1 December letter to Matisse.

78 Since December 1947 Miró had been seeking a new French partner after Pierre Loeb annulled the 1946 agreement with Matisse relative to Miró's work. Matisse worked out the arrangement for Maeght to resume the contract abandoned by Loeb. Umland in New York 1993, 339.

79 Umland in New York 1993, 340.

80 See Miró's 14 April letter to Matisse stating that while in New York he wants to see Sert and Calder, as quoted in Umland in New York 1993, 341.

81 Schwartz in *New York Times* (23 July 1968).

82 Freedberg 1986, 499. The fountain is moved to Barcelona from Saché in 1973, see Rower in Washington 1998, 294.

83 Barcelona 1997, 172–173.

84 CF, Miró to Calder, 19 April 1976 (*Correspondence* 65).

BIBLIOGRAPHY

ARCHIVAL MATERIALS

Alexander Calder papers, scrapbook, memorabilia clippings, and photographs, 1927–1932, donated by the artist in 1963, Archives of American Art, Smithsonian Institution, Washington, D.C.

Calder Foundation, New York.

Cincinnati Art Museum (curatorial files).

Fundació Joan Miró, Barcelona, Spain.

Fundació Pilar i Joan Miró, Palma de Mallorca, Spain.

The Pierpont Morgan Library, New York (The Pierre Matisse Gallery Archives, 1931–1989 [1970–1989 restricted] MA 5020).

Clay Spohn memoirs, papers, Archives of American Art, Smithsonian Institution, Washington, D.C.

Successió Miró, Palma de Mallorca, Spain.

ARTICLES, BOOKS, CATALOGUES

Alexander Calder: mobiles, stabiles, constellations. Exh. cat., Galerie Louis Carré. Paris, 1946.

Ashton, Dore. "Cosmos and Chaos at the Guggenheim." *Arts and Architecture* 81, no. 3 (March 1964), 6–7.

Axis 5, 1936.

Barr, Alfred H. Jr. *Cubism and Abstract Art.* Exh. cat., The Museum of Modern Art. New York, 1936; reprint 1974.

Berch, Bettina. *Radical by Design: The Life and Style of Elizabeth Hawes.* New York, 1988.

Breton, André. *Surrealism and Painting.* Translated by Simon Watson Taylor. London, 1972.

Breuning, Margaret. "Calder Mobiles and Stabiles." *Magazine of Art* 32, no. 6 (June 1939), 361.

Cahiers d'art 9, nos. 1–4 (1934). Entire issue devoted to Joan Miró.

Calder. Exh. cat., Sala Pelaires. Palma de Mallorca, 1972.

Calder: Circus, Ink Drawings 1931–1932. Exh. cat., Perls Galleries. New York, 1964.

Calder: Exposició Antológica (1932–1976). Exh. cat., Galería Maeght. Barcelona, 1977.

Calder: Gravity and Grace. Exh. cat., Museo Guggenheim Bilbao with Museo Nacional Centro de Arte Reina Sofía. Bilbao, 2003.

Calder-Miró. Exh. cat., Perls Galleries. New York, 1961.

Calder-Miró: Exhibition of Paintings and Sculpture. Exh. cat., Contemporary Arts Museum of Houston in association with Contemporary Arts Association of Houston. Houston, 1951.

Calder and Miró. Exh. cat., Nassau County Museum of Art. Rosalyn Harbor, N.Y., 1998.

Calder, Alexander. *Calder, an Autobiography with Pictures.* 1966, rev. ed., introduction by Jean Davidson. New York, 1977.

———. "Comment réaliser l'art?" *Abstraction–Création, Art Non-Figuratif* 1 (1932), 6.

———. "The Ides of Art: 14 Sculptors Write." *The Tiger's Eye* 1 (15 June 1948), 74.

———. "Mercury Fountain." *Stevens Indicator* 55, no. 3 (May 1938), 2–3, 7.

———. "Mercury Fountain." *Technology Review* 40, no. 5 (March 1938), 202.

———. "What Abstract Art Means to Me." *The Museum of Modern Art Bulletin* 18 (Spring 1951), 8–9.

Callaghan, Morley. *That Summer in Paris; Memories of Tangled Friendships with Hemingway, Fitzgerald, and Some Others.* New York, 1979.

Canaday, John. "Calder and Miró." *New York Times* (26 February 1961).

A Child's Summer with Calder and Miró. Exh. cat., Museum of Fine Arts. Houston, 1972.

Cirici, Alexandre. *Presència de Joan Prats.* Barcelona, 1976.

Combalía, Victoria. *El Descubrimiento de Miró: Miró y sus Críticos, 1918–1929.* Barcelona, 1990.

Constellations. Exh. cat., Pierre Matisse Gallery with George Wittenborn Art Books. New York, 1959.

Cramer, Patrick, *Joan Miró: Catalogue raisonné des livres illustrés.* Geneva, 1989.

Detzel, Helen. "What Does Hotel Mural Show? 'Nothing,' Says Spanish Artist." *Cincinnati Times Star* (11 June 1952).

Dupin, Jacques. *Joan Miró: Life and Work.* New York, 1962.

———. *Miró.* Rev. ed. Paris, 1993.

———, and Ariane Lelong-Mainaud. *Joan Miró: Catalogue Raisonné. Paintings.* 6 vols. Paris, 1999–2004.

Elan Vital, oder, Das Auge des Eros: Kandinsky, Klee, Arp, Miró, Calder. Exh. cat., Haus der Kunst. Munich, 1994.

Evans, Myfanwy, ed. *The Painter's Object.* London, 1937.

Fantastic Art, Dada, Surrealism. Edited by Alfred H. Barr Jr. Exh. cat., The Museum of Modern Art. New York, 1936.

Fineberg, Jonathan. *The Innocent Eye: Children's Art and the Modern Artist.* Princeton, 1997.

"Four Reproductions of the Work of Joan Miró (*The Farm, The Table, Portrait of the Artist,* and *The House of the Palms*)." *The Little Review: Quarterly Journal of Arts and Letters* (Spring 1923).

Freedberg, Catherine Blanton. *The Spanish Pavilion at the Paris World's Fair,* 2 vols. New York, 1986.

Gasch, Sebastià. "El circ d'un escultor." *Mirador* 4, no. 191 (29 September 1932).

———. "El escultor americano Calder." *AC* 2, no. 7 (1932), 43.

———. *Escrits d'Art d'Avantguarda (1925–1938).* Barcelona, 1987.

———. "Joan Miró." *Cahiers de Belgique* 2, no. 6 (June 1929), 202–205.

Gray, Cleve. "Calder's Circus." *Art in America* 52, no. 5 (1964), 22–48.

Griswold, William M., et al. *Pierre Matisse and His Artists,* Exh. cat., The Pierpont Morgan Library, New York, 2002.

Gutman, Walter. "In the Galleries: Wire-Work Art." *Worcester Times* (21 May 1932).

Haskell, Douglas. "Design in Industry, or Art as a Toy." *Creative Art* 4, no. 2 (February 1929), 56–57.

Hawes, Elizabeth. "More Than Modern–Wiry Art: Sandy Calder Sculptures in a New Medium." *Charm* 9, no. 3 (April 1928), 47, 68.

Hayes, Margaret Calder. *Three Alexander Calders.* Middlebury, Vt., 1977.

Holty, Carl. "Artistic Creativity." *Bulletin of the Atomic Scientists* 15, no. 2 (February 1959), 77–81.

Holtzman, Harry, and Martin S. James, eds. *The New Art—The New Life: The Collected Writings of Piet Mondrian.* Boston, 1996.

Honolulu Star-Bulletin. "At the Honolulu Academy of Arts" (29 May 1937).

———. "Hilarity at the Academy" (1 June 1937).

Hyman, Timothy, and Roger Malbert. *Carnivalesque.* London, 2000.

International Surrealist Exhibition. Exh. cat., New Burlington Galleries. London, 1936.

Jakovski, Anatole. *Arp, Calder, Hélion, Miró, Pevsner, Séligman.* Exh. cat., Galerie Pierre. Paris, 1933.

Jeffett, William. "Objects into Sculpture; Sculpture into Objects: A Study of the Sculpture of Joan Miró in the Context of the Parisian and Catalan Avant-gardes." Ph.D. thesis, Courtauld Institute of Art, Univ. of London, 1992.

Jewell, Edward Alden. "Fantasy Rears Its Head." *New York Times* (28 February 1937).

Joan Miró 1893–1993. Exh. cat., Fundació Joan Miró. Barcelona, 1993.

Joan Miró. In *Derrière le miroir,* nos. 14–15. Exh. cat., Galerie Maeght. Paris, 1948.

Joan Miró: Snail Woman Flower Star. Edited by Stephan von Wiese and Sylvia Martin. Exh. cat., Museum Kunst Palast. Düsseldorf, 2002.

Krauss, Rosalind, and Margit Rowell. *Joan Miró: Magnetic Fields.* Exh. cat., Solomon R. Guggenheim Foundation. New York, 1972.

Kuh, Katherine, ed. *The Artist's Voice: Talks with Seventeen Artists.* New York, 1962.

Lanchner, Carolyn. *Joan Miró.* Exh. cat., The Museum of Modern Art. New York, 1993.

Leiris, Michel. "Joan Miró." *The Little Review: Quarterly Journal of Arts and Letters* (Spring–Summer 1926), 8–9.

Lipman, Jean, ed. *Calder's Universe.* Exh. cat., Whitney Museum of American Art, New York, 1976.

Marter, Joan M. *Alexander Calder.* Cambridge, England, 1991.

Martin, J. L., Ben Nicholson, and Naum Gabo, eds. *Circle: International Survey of Constructive Art.* 1937, reprint New York, 1971.

McBride, Henry. "Attractions in the Galleries." *New York Sun* (21 May 1943).

———. "Joan Miró Is Here: Noted Spanish Painter Comes to New York to See His Own Pictures." *New York Sun* (16 May 1947), 31.

Menand, Louis. *The Metaphysical Club.* New York, 2001.

Millard, Charles W. *Miró, Selected Paintings.* Exh. cat., Hirshhorn Museum and Sculpture Garden, Smithsonian Institution. Washington, 1980.

Miró/Calder. Exh. cat., Galerie Beyeler. Basel, 1972.

Miró-Calder. Exh. cat., Fuji Television Gallery Co., Ltd. Tokyo, 1972.

Miró and Calder. Exh. cat., Gallery Urban. New York, 1939.

Miró en Escena. Exh. cat., Fundació Joan Miró in collaboration with Institut del Teatre. Barcelona, 1994.

Miró: Graphics; Calder: Mobiles; Ch'I Pai shih: Paintings. Exh. cat., Grosvenor Gallery. London, 1964.

Miró, Joan. *Ceci est la couleur de mes rêves, entretiens avec Georges Raillard.* Paris, 1977.

———. Preface for Cleve Gray, "Calder's Circus." *Art in America* 52, no. 5 (October, 1964), 22.

Motherwell, Robert. "The Significance of Miró." *ArtNews* 58, no. 4 (May 1959), 32–33, 65–67.

Mumford, Lewis. "The Art Galleries: Platitudes in Paint–Charm and Humanity–The Jokes of Miró." *The New Yorker* 10, no. 50 (26 January 1935), 50–54.

New York Times. "For a Big Show in France, Calder 'Oughs' His Works" (3 April 1969).

New York World-Telegram. "Calder's 'Mobiles' Are Like Living Miró Abstractions" (15 February 1936).

———. "Objects to Art Being Static, So He Keeps It in Motion" (11 June 1932).

Osborn, Robert. "Calder's International Monuments." *Art in America* 57, No. 2 (March–April 1969), 32–49.

Pabellón Español 1937: Exposición Internacional de París. Centro de Arte Reina Sofía. Palma, 1987.

Picon, Gaëtan, ed. *Joan Miró: Carnets catalans. Dessins et textes inédits,* 2 vols. Geneva, 1976.

Prather, Marla, with contributions by Arnauld Pierre and Alexander S.C. Rower. *Alexander Calder: 1898–1976.* Exh. cat., National Gallery of Art. Washington, 1998.

Punyet Miró, Joan, et al. *Calder.* Exh. cat., Fundació Joan Miró. Barcelona, 1997.

Read, Herbert, ed. *Surrealism.* 1936, reprint New York, 1971.

Rich, Daniel Catton, ed. *The Flow of Art: Essays and Criticism of Henry McBride.* New York, 1975.

Riley, Maude. "New Temperas and Ceramics by Miró." *The Art Digest* 19, no. 7 (1 January 1945), 13.

Rodman, Selden, ed. *Conversations with Artists.* New York, 1957, 136–142.

Rogers, Millard F. Jr. *Spanish Paintings in the Cincinnati Art Museum.* Cincinnati, 1978.

Rose, Barbara. "Joy, Excitement Keynote Calder's Work." *Canadian Art* 22, no. 3 (May/June 1965), 30–33.

———, et al. *Miró in America.* Exh. cat., Museum of Fine Arts. Houston, 1982.

Rowell, Margit. *Joan Miró: Campo de Estrellas.* Exh. cat., Museo Nacional Centro de Arte Reina Sofía. Madrid, 1993.

———, ed. *Joan Miró: Ecrit et entretiens,* Paris, 1995.

———, ed. *Joan Miró: Selected Writings and Interviews.* Boston, 1986.

Rubin, William. *Miró in the Collection of The Museum of Modern Art,* Exh. cat., The Museum of Modern Art, New York, 1973.

Russell, John. *Matisse: Father and Son*, New York, 1999.

Sartre, Jean-Paul. "Existentialist on Mobilist: Calder's Newest Works Judged by France's Newest Philosopher." *ArtNews* 46 (December 1947), 22, 55–56.

Schwartz, Paul Waldo. "Calder and Miró, Now Past 70, Feted in France." *New York Times* (23 July 1968).

The Scotsman. "An American Wire-Sculptor: 'Mobiles and Stabiles'" (8 December 1937).

Shattuck, Roger. "Music and Mobiles – When Calder and Satie Joined Forces." *New York Times* (6 November 1977).

Sicre, José Gómez. "Joan Miró in New York." Translated by George C. Compton. *Right Angle* 1, no. 10 (7 January 1948), 5–6.

Soby, James Thrall. "Calder, Matisse, Miró, Matta." *Arts and Architecture* 66, no. 4 (April 1949), 26–28.

"Some Dancing Stars: Seen on Stage." *Vogue* (July 1926), 34–37, 77.

Sperling, L. Joy. "The Popular Source of 'Calder's Circus: The Humpty Dumpty Circus,' Ringling Brothers and Barnum and Bailey, and the Cirque Medrano." *Journal of American Culture* 17, no. 4 (1994), 1–14.

Staempfli, George W. "Interview with Alexander Calder." *Quadrum* 6 (1959), 9–11.

Sweeney, James Johnson. *Alexander Calder*. Exh. cat., The Museum of Modern Art. New York, 1943, rev. ed. 1951.

———. "Alexander Calder." *Axis* 3 (July 1935), 19–21.

———. "Joan Miró: Comment and Interview." *Partisan Review* 15, no. 2 (February 1948), 206–212.

———. *Joan Miró*. Exh. cat., The Museum of Modern Art. New York, 1941.

———. "Miró and Dalí." *The New Republic* 81 (6 February 1935), 360.

Taillandier, Yvon. "*Message to a Friend.*" *Homage to Joan Miró: Special Issue of the XXe Siècle Review*, ed. G. di San Lazzaro (1972), 85–87.

Thèse, Antithèse, Synthèse. Exh. cat., Kunstmuseum Luzern. Switzerland, 1935.

Tone, Lilian. "The Journey of Miró's Constellations." *MoMA Magazine* 3, no. 15 (Fall 1993), 1–6.

Tuchman, Phyllis. "Alexander Calder's Almadén Mercury Fountain." *Marsyas* 16 (1972–1973), 97–106.

Turner, Elizabeth Hutton. *Americans in Paris: Man Ray, Gerald Murphy, Stuart Davis, Alexander Calder*. Exh. cat., The Phillips Collection. Washington, 1996.

Zafran, Eric M., with Elizabeth Mankin Kornhauser and Cynthia Roman. *Calder in Connecticut*. Exh. cat., Wadsworth Atheneum Museum of Art. Hartford, 2000.

INDEX

PHOTOGRAPHIC CREDITS

Photographs of works of art reproduced in this book have been provided in most cases by the owners of the works or their representatives identified in the captions. The individual works that appear in this book may be protected by copyright in the United States of America or elsewhere and thus may not be reproduced in any form without the permission of the copyright owners. The following copyright and/or other photo credits appear at the request of the artists' heirs and representatives and/or the owners of individual works.

All works of Alexander Calder:
© 2004 Calder Foundation, New York/Artists Rights Society (ARS), New York, and ProLitteris, Zurich.

All works of Joan Miró:
© 2004 Successió Miró, Palma de Mallorca/Artists Rights Society (ARS), New York, and ProLitteris, Zurich.

© Addison Gallery of American Art, Phillips Academy, Andover, MA, all rights reserved, cat. 52
Albright-Knox Art Gallery, Buffalo, cat. 83
Art Institute of Chicago, © 2000 all rights reserved, cat. 104; © 1989 all rights reserved, cat. 129
© Art Resource, New York, courtesy Calder Foundation, New York, cats. 10, 11, 12, 16, 21, 25, 29, 32, 33, 45, 47, 53, 58, 60, 63, 71, 73, 74, 142
Manuel de Agustin, courtesy Successió Miró, Palma de Mallorca, fig. 49
© Raoul Barba, courtesy Fundació Joan Miró, Barcelona, with permission of Daniel Aubry, figs. 6, 9
Christian Baur, Basel, cat. 132
© Denise Bellon, Paris, courtesy Successió Miró, Palma de Mallorca, fig. 113
Berkeley Art Museum, University of California, photo Ben Blackwell, cats. 2, 5, 6
© Thérèse Bonney, Bibliothèque historique de la ville de Paris, figs. 1, 96
Brassaï, courtesy Calder Foundation, New York, fig. 97
Louis Brem, Lucerne, cat. 22
The Eli and Edythe L. Broad Collection, cat. 65

Budd Studio, Weintrop Brothers, New York, courtesy Successió Miró, Palma de Mallorca, fig. 141
Calder Foundation, New York, figs. 7, 8, 10, 73, 82, 84, 85, 86, 89, 90, 92, 100, 107, 112, 120, 129, 133; photo Gordon Christmas, pp. 1–3 and 310–312, cats. 1, 3, 4, 7, 113
Caratsch de Pury & Luxembourg, Zurich, cat. 119
Carnegie Museum of Art, Pittsburgh, photo Peter Harholdt, cat. 49
Francesc Català-Roca, Archive, Barcelona, fig. 19
Francesc Català-Roca, Barcelona, figs. 61, 99, 140, 142, 143, and p. 276
Cincinnati Art Museum, Archives, figs. 47, 134
Cincinnati Art Museum, photo Tony Walsh, fig. 50; cats. 66, 143
Colección Cisneros, Caracas, photo Gregg Stanger, New York, cat. 123
A.C. Cooper, London, cat. 138
Crowne Plaza Hotel, Cincinnati, fig. 56
The Engle Family, USA, cat. 39
© Hans Erni, Lucerne, fig. 101
Pierre-Alain Ferrazzini, Geneva, cat. 91
Aaron I. Fleischman, cat. 38
Varian Fry, courtesy Successió Miró, Palma de Mallorca, fig. 33
The Fukuoka Art Museum Collection, Japan, cat. 137
Fundació Joan Miró, Barcelona, figs. 13, 15, 24, 25, 30, 31, 32, cats. 103, 122, 134
Fundació Pilar i Joan Miró, Palma de Mallorca, figs. 48, 52, 72, 75, 79, 80; photo Joan Ramon Bonet Verdaguer, figs. 53, 76, 77, 78, 81, 87, 88, 136
Galerie Beyeler, Basel, cat. 54
Galerie Patrick Cramer, Geneva, fig. 62
Galerie Larock-Granoff, Paris, cat. 14
Galería Guillermo de Osma, Madrid, cat. 100
Claude Gaspari/Galerie Maeght, Paris, courtesy Successió Miró, Palma de Mallorca, fig. 139
Joaquim Gomis © Arxiu Joaquim Gomis, Barcelona, figs. 12, 34, 66, 117, 119, 123
Guggenheim, Asher Associates, New York, cat. 48
© The Solomon R. Guggenheim Foundation, New York; photo David Heald, cats. 9, 135
Lore Hammerschmid, courtesy Calder Foundation, New York, fig. 132

Hans Hartung, courtesy Calder Foundation, New York, fig. 111
Phyllis Hattis Fine Arts, New York, cat. 67
Hugo P. Herdeg, courtesy Calder Foundation, New York, fig. 17
Samuel and Ronnie Heyman, New York, cat. 124
Hirshhorn Museum and Sculpture Garden, Washington, photo Lee Stalsworth, cats. 31, 92
Honolulu Academy of Arts, cat. 8
George Hoyningen-Huene, Condé Nast Publications Inc., New York (5 February 1930), p. 88
IVAM, Instituto Valenciano de Arte Moderno, Generalitat Valenciana, Valencia, photo Juan García Rosell, cat. 24
© André Kertész, courtesy Calder Foundation, New York, fig. 2
© 2003 Kimbell Art Museum, Fort Worth, photo Michael Bodycomb, cat. 125
Kokaido Gallery, Tokyo, cat. 105
Kukje Gallery, Seoul, cat. 36
Kunsthaus Zürich, cats. 28, 102, 117
Kunstmuseum Bern, photo Peter Lauri, cat. 108
Kunstmuseum Winterthur, cat. 50
LAC AG Basel, photo Robert Bayer, cats. 68, 96, 99
Francis Lombrail, cat. 141
MACBA Collection, Fundació Museu d'Art Contemporani de Barcelona, cats. 19, 20
Marsh Photographic Studio, Cincinnati, courtesy Fundació Pilar i Joan Miró, Palma de Mallorca, fig. 51
Jacqueline Matisse Monnier, Paris, fig. 105, Foto Reportage Urgel/R. De La Rosa, Barcelona, fig. 118
© Herbert Matter, courtesy Calder Fondation, New York, figs. 11, 16, 35, 63, 64, 106
© Herbert Matter, Digital Image, courtesy The Museum of Modern Art, New York, fig. 27
Fenner Milton, cat. 56
Moderna Museet, Stockholm, cat. 44; photo Tord Lund, Statens Konstmuseer, cat. 81
© 2004 The Pierpont Morgan Library, Pierre Matisse Gallery Archives, MA 5020, figs. 14, 26, 29, 41, 42, 43, 44, 45, 46, 124; Herbert Matter, fig. 40; A.E. Gallatin, fig. 104

ILLUSTRATIONS

Cover
Alexander Calder and Joan Miró at the
opening of Alexander Calder's retrospective,
Fondation Maeght, Saint-Paul-de-Vence,
early April 1969, Photo Jacques Robert,
Cagnes-s/Mer, courtesy Calder Foundation

Pages 1–3 and 310–312
Joan Miró, homage to Alexander Calder,
first and last three pages of original gouache
painting-poem, created for *Calder*
[exh. cat., Sala Pelaires], Palma de Mallorca,
1972, courtesy Calder Foundation, New York;
full translation and transcription, front and
back flaps

Page 7
Alexander Calder, word play on "Joan Miró"
on back of Joan Prats' business card, courtesy
Successió Miró, Palma de Mallorca.
In Paris, rue de Miromesnil and the metro
station of the same name are near the former
Galerie Maeght, which represented both artists

Pages 12, 14, and 26
Joan Miró and Alexander Calder at the
opening of Alexander Calder's retrospective,
Fondation Maeght, Saint-Paul-de-Vence,
early April 1969, photo Ugo Mulas

Page 54
Joan Miró in Carl Holty's studio, New York,
with the Cincinnati Mural (cat. 143),
September 1947, photo Arnold Newman

Page 88
Alexander Calder in his studio with
his Circus, Paris, May 1930, photo George
Hoyningen-Huene, courtesy Condé Nast
Publications Inc., New York

Page 256
Alexander Calder in his Roxbury studio, 1944,
photo Eric Schaal, courtesy Calder
Foundation, New York

Page 276
Joan Miró in his sculpture studio Son Boter,
Palma de Mallorca, in front of his wall
drawings, 1969, photo Francesc Català-Roca

Page 309
Joan Miró's last homage to Alexander Calder
originated as a gouache painting-poem,
dated 10 March 1977. It was first published
complete with typed transcription in the
catalogue of the exhibition *Calder: Exposició
Antológica (1932–1976)*, held April–May 1977
at Galería Maeght, Barcelona

This exhibition is made possible through the generous support of Ford Motor Company.

Additional support provided by generous grants from the National Endowment for the Arts.

NATIONAL ENDOWMENT FOR THE ARTS

Gerry and Marguerite Lenfest
Jon and Mary Shirley Foundation
The Aaron I. Fleischman Foundation
The Broad Art Foundation
Embassy of Spain, Washington, D.C.

ESPAÑA
ACCIÓN
CULTURAL
EXTERIOR

This exhibition is supported by an indemnity from the Federal Council on the Arts and Humanities.

Published on the occasion
of the exhibition *Calder, Miró*
Fondation Beyeler, Riehen/Basel,
2 May–5 September 2004
The Phillips Collection, Washington, D.C.
9 October 2004–23 January 2005

Exhibition organized by
Fondation Beyeler, Riehen/Basel, and
The Phillips Collection, Washington, D.C.
Catalogue produced by
The Phillips Collection, Washington, D.C., and
Fondation Beyeler, Riehen/Basel
Director of Publications, The Phillips Collection:
Johanna Halford-MacLeod
Director of Publications, Fondation Beyeler:
Delia Ciuha
Editors: Ulrike Mills and Jürgen Geiger
Designer: Heinz Hiltbrunner
Photolithography: Lac AG, Robert Bayer
Layouts: Peter Ling
Translators: Alboum Associates and
John W. Gabriel (texts by Ernst Beyeler and
Oliver Wick)

Published in 2004 by
Philip Wilson Publishers
7 Deane House, 27 Greenwood Place
London NW5 1LB

in collaboration with:
Fondation Beyeler
Baselstrasse 77
CH 4125 Riehen/Basel, Switzerland
www.beyeler.com

The Phillips Collection
1600 Twenty-first Street, NW
Washington, D.C. 20009-1090
www.phillipscollection.org

Library of Congress
Cataloging-in-Publication Data
Calder, Miró/edited by Elizabeth Hutton Turner
and Oliver Wick.
p. cm.
Issued in connection with the exhibition
Calder, Miró, held May 2–Sept. 5, 2004,
Fondation Beyeler, Riehen/Basel, and Oct. 9,
2004–Jan. 23, 2005, The Phillips Collection,
Washington, D.C.
Includes bibliographical references and index.

ISBN 0-943044-31-6 (softcover ed.)
ISBN 0-85667-575-X (hardcover ed.)

1. Calder, Alexander, 1898–1976—
Friends and associates-Exhibitions.
2. Calder, Alexander, 1898–1976—
Correspondence-Exhibitions.
3. Miró, Joan, 1893–1983—
Friends and associates-Exhibitions.
4. Miró, Joan, 1893–1983—
Correspondence-Exhibitions.
I. Turner, Elizabeth Hutton, 1952—
II. Wick, Oliver, 1962—
III. Fondation Beyeler
IV. Phillips Collection

NB237.C28A4 2004
730'.92–dc22
200404465

Composed in Didot (Linotype), Futura, and
Stempel Garamond.
Printed in Italy on Munken Print Extra 115 gsm
Biber Furioso 150 gsm

El teu cor s'ha apagat
a l'aixecar-se el dia
Les teves cendres fòren escampades
per el jardí
Les teves cendres volàren cap el cel
per fer l'amor amb els estels

Sandy,
Sandy,
Les teves cendres acaricien
les flors de l'arc-de Sant Martí
que pessigolleigen el blau del cel.

Joan Miró

Your face has become dark,
and, upon the day's awakening,
Your ashes will disperse themselves
throughout the garden.
Your ashes will fly to the sky,
to make love with the stars.

Sandy,
Sandy,
Your ashes caress
The rainbow flowers
That tickle the blue of the sky.

Joan Miró

AiMONS